BILL CUNNINGHAM

ON THE STREET

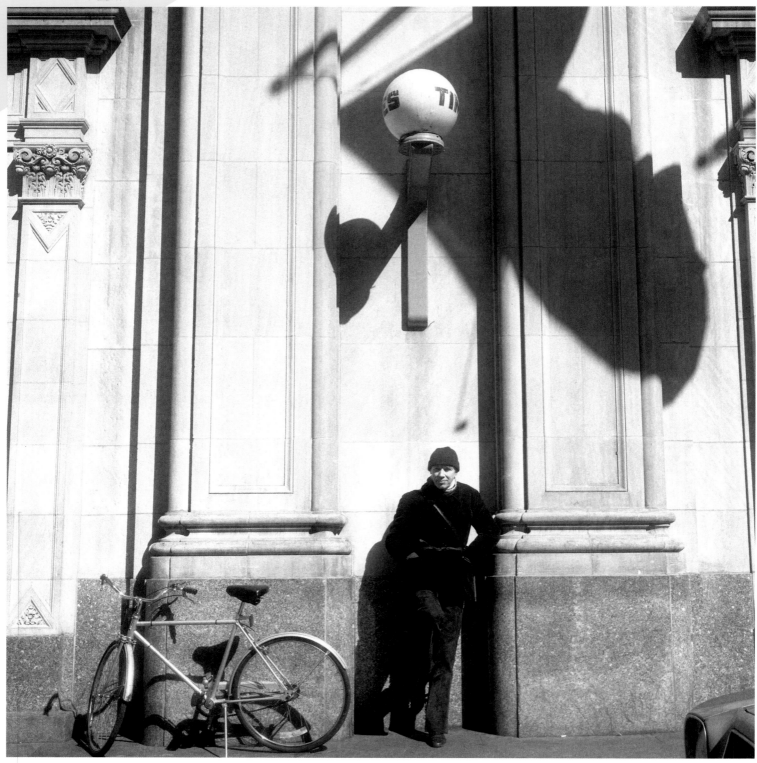

THE NEW YORK TIMES

Photography edited by Tiina Loite

BILL CUNNINGHAM

Five Decades of

Iconic Photography

ON THE STREET

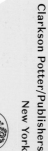

Clarkson Potter/Publishers
New York

CONTENTS

Chapter opener
introductions
by Alexandra Jacobs,
deputy editor,
Styles section,
The New York Times

PREFACE

TIINA LOITE,
former photography editor, *The New York Times* Styles section

Bill Cunningham was a photographer, yet he always liked to insist he wasn't. "I'm not a real photographer," he would say. "I'm a columnist who writes with pictures."

I knew and worked with Bill for more than thirty years as a photo editor at *The New York Times.* When I was asked to select and organize his work for this book, I did not kid myself about what that would involve. Bill worked seemingly around the clock, virtually every day of the year. My rough guess was that the number of photographs to research would equal the number on the national debt clock. As it turned out, I was pretty close.

I began in familiar territory, with the tens of thousands of pictures Bill took for *The Times,* starting in the 1970s. This process was painstaking, months-long, and made more difficult by the paper's database, which the years, moves, and human foibles had left incomplete. But to gain a full understanding of Bill's range, it was important to look carefully at as many of the photos as were accessible, both those that had been published and those that had not.

And then there was Bill's own personal archive, which is the fashion world's equivalent of King Tut's tomb. He kept this massive trove in his apartment, and after he died, it was transferred under the care of his niece, Trish Simonson, to an art-storage facility in Rockland County, just north of New York City. There, file cabinets and boxes—so numerous that forklifts are required to transfer them to a hangarlike room for viewing—overflow with prints, negatives, contact sheets, correspondence, clippings, notebooks, and more. Some drawers are so packed with files that they are nearly impenetrable.

What struck me most while searching through this remarkable material was that Bill was a man who absolutely loved his job. Was it even really a job? I think it was just Bill. More important, he understood the relevance of his work. The folders containing his negatives are also packed with layouts and absolutely every other piece of paper pertaining to that week's column. When I looked at shots of blizzards from the 1970s, for example, he had noted how many inches of snow had fallen and how fast the wind was blowing. When I looked at the shots from a luncheon, even the printed menu and Bill's phone message slips remained. All this supplemental material seemed to be more than notes to himself. I felt like it was there to benefit those who might look through this collection in the future, as I was now. Bill knew; Bill always knew.

He was famous for not spending much money on cameras—or bicycles, or clothing, or even file folders. Many of the "folders" in his cabinets were simply large envelopes that colleagues had discarded. When *The Times* went digital and eliminated its photo lab, Bill continued to use film, taking it to a one-hour developer. He was encouraged to consider digital cameras, with colleagues even bringing technicians to the office to tutor him, but he would always mysteriously disappear when they arrived. Eventually, though, when the number of one-hour labs around the city dwindled, he finally surrendered.

So how to go about choosing what is to appear in this book? First, I had to accept that many wonderful images would be omitted—many of these images were missing and still I could have filled thousand-page volumes with what was available. Second, I knew that no matter what, some people would be upset by what is left out. Third, I tried to not have Bill be one of them.

His signature in his On the Street column in *The Times* was a large number of small photographs illustrating a particular theme, which varied from issue to issue. He focused on the ensemble, or on a specific part of it, a hat perhaps, or a shoe. Bill also photographed things around the city to accent or accessorize his layouts—yellow daffodils to run alongside a layout of yellow clothing, for example. To him, the more pictures, the more densely packed the page, the better. He loved cropping, as seen at left, and shoehorning as many photos as he could into those layouts. It brought a look of mischievous glee to his face, even as he would then say, "This is all just filler around the ads, kids."

But in looking at the totality of his photographs (or at least something relatively close to it), I found so many images that were wonderful just as they were, no cropping needed. The approach for this book was to let his photographs be photographs, so we see the trees for the forest. While photos of similar styles are still grouped together—reminiscent of the column—the reader can see how the images play off of one another, how they play off of images on the facing page. Many pages have only one photo on them (OK, Bill's probably not happy). This book is not a collection of Bill's columns. It is a collection of his photographs.

Because Bill Cunningham was a real photographer.

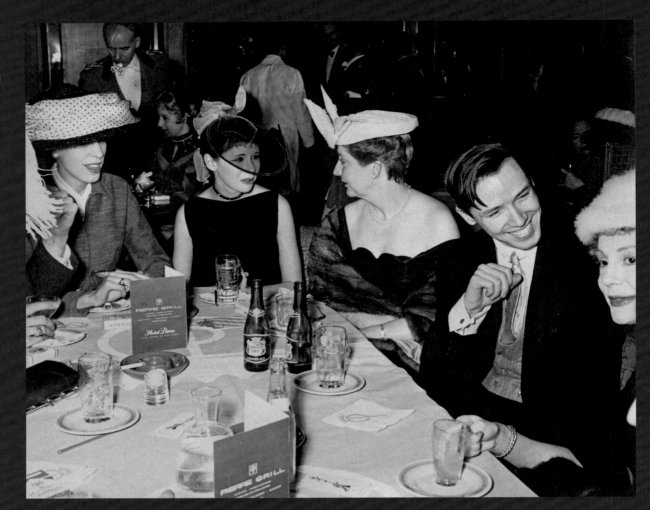

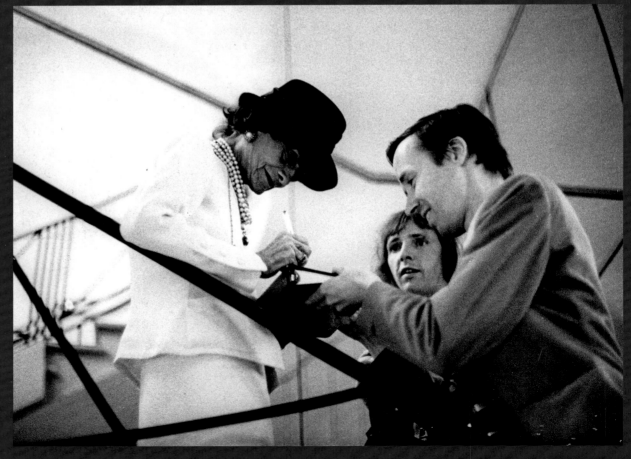

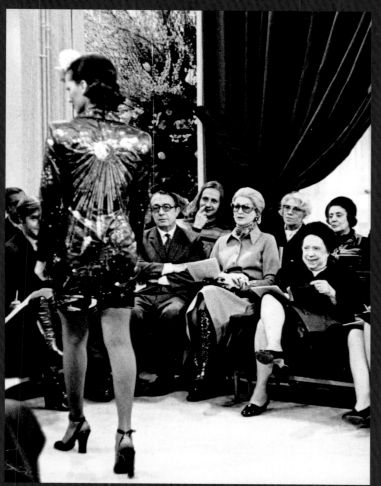

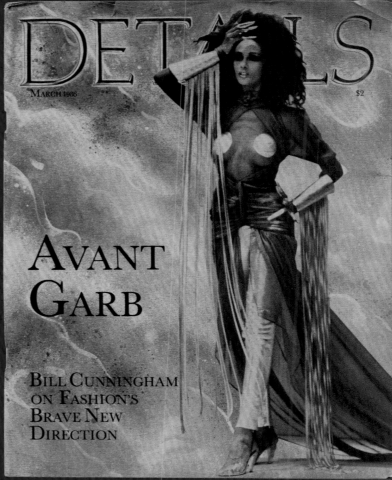

DETAILS

MARCH 1986 $2

AVANT GARB

BILL CUNNINGHAM ON FASHION'S BRAVE NEW DIRECTION

Above left: Bill's photograph from the Yves Saint Laurent couture show, 1971. In the front row on the right is the designer Elsa Schiaparelli. On the back of the photo, Bill wrote, "Schiaparelli laughing at St. L. imitation of her famous '38 beading designs."
Above right: The March 1986 cover of *Details* magazine. The cover photo, taken by Bill, shows the model Iman wearing Thierry Mugler. *Left:* Editta Sherman in one of the *Facades* photographs.

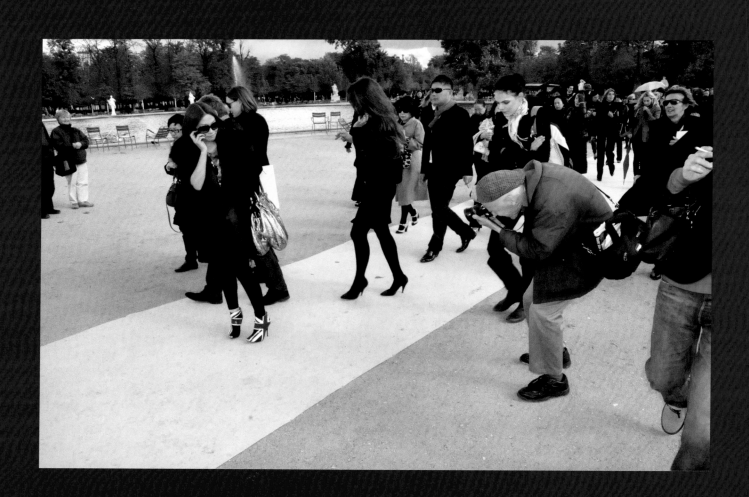

INTRODUCTION
ALL ABOUT BILL

CATHY HORYN,
former fashion critic,
The New York Times

This collection of Bill Cunningham's street photography, edited by Tiina Loite, is the first volume drawn from his vast personal archive. It contains images that originally appeared in *The New York Times,* where his popular On the Street column ran beginning in 1985, as well as many, many more that he published earlier in magazines like *Vogue* and *Town & Country,* and then filed away for future reference. In cases where an individual captivated him over a long period of time—such as Anna Wintour, whom he first noticed in the early 1970s when she was an unknown junior editor in London—you may assume that some images have never been seen until now. Even those that appeared in *The Times* are being seen anew here, outside the spatial confines of the paper.

As we move from decade to decade, starting in the 1970s—around the time when Bill's photos began appearing in *The Times*—through his death in 2016, you'll see the evolution of style, of trends, and of the everyday, both in New York City and in Paris—Bill's two favorite places in the world. The book also highlights a few fascinations Bill carried with him always, including his muses, urban dogs, and, of course, people wearing hats—a nod to his early career as a milliner.

Bill was prolific indeed. In addition to his street work, most weeks he managed to shoot between fifteen and twenty parties, which he featured in his Evening Hours column on the page facing On the Street. The result was an up-to-the-minute, kaleidoscopic report on the changes in fashion as observed by a man who missed almost nothing. He chronicled the first wave of women to ditch their heels and commute to work in sneakers, the return of the zoot suit, the phenomenon of low-riding jeans, the vogue for camouflage, and a hundred different ways New Yorkers stylishly brave a storm. He believed that a true portrait of fashion—and, by inference, the times—depended on seeing how real people dressed, whether kids in deconstructed sweatshirts or big spenders at a charity event. The runway wasn't enough, so he hit the streets every day with his camera.

Such dedication, along with the spartan way Bill lived—in one of the last bohemian apartments above Carnegie Hall, surrounded by battered filing cabinets, sleeping on a cot supported only by milk crates—earned him enormous admiration and respect. At the same time, this man who noticed everything was himself dressed purposely not to be noticed, in khakis and a series of ill-fitting blue smocks he picked up for a few euros on his trips to Paris for the collections. He was perfectly charming but full of demurrals. He appeared secretive about his background. (For years, the assumption around *The Times* was that he came from a rich Boston family, in part because he seemed to know every blue blood since the *Mayflower.* But in reality, he was a son of a postal worker and a homemaker from suburban Boston.)

On the rare occasions when he did talk about his photography—or, anyway, was *asked*—he made it sound amateur, calling it "bottom of the barrel" and insisting he wasn't a real photographer at all but, rather, a "recorder." Whether or not Bill was obeying a higher law and guarding his creative methods in order to keep his mind free, all those qualities—the diffidence, the humble garb—fed into his mythology. To an extent, that's what we got in the interviews he gave late in his life, in *The Times* and *The New Yorker,* in the well-received 2010 documentary *Bill Cunningham New York,* and in the 2018 documentary *The Times of Bill Cunningham,* drawn from an extended interview he gave to a reporter in the mid-1990s.

But with the opening of his archive, we have gleaned a different view of this remarkable man. It's not that the earlier portraits were inaccurate; they just weren't complete. Among his papers was a memoir of his childhood in a Boston suburb and his first career as a milliner in New York; he designed hats between 1948, when he moved to the city, and 1962. Published in 2018 as *Fashion Climbing,* the book shows that Bill was anything but diffident. He was nervy and ambitious. He was a party animal! He posed as a waiter—complete with a napkin on his arm—to sneak into a couture show. He sought out and befriended the two women who owned Chez Ninon, the Park Avenue shop renowned for its quiet taste and roster of society clients, including Jacqueline Kennedy. He cold-called Hubert de Givenchy, one of the biggest names at the time, and was actually granted a meeting. And if none of that blows your mind, he shared his first apartment at Carnegie Hall, a duplex, with Norman Mailer and his third wife, Lady Jeanne Campbell.

So much for the oblate of Seventh Avenue. As a youth, Bill was so confident about the life he wanted—a life at the innermost part of the fashion world—that he didn't allow even his

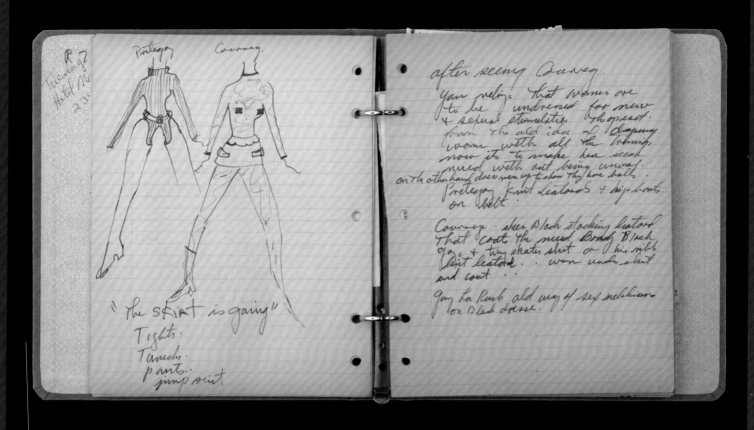

R
Tuesday 7
Hotel M
2 3.

Privilege Courrey.

"the skirt is going"

Tights.
Tunics.
pants.
jump suit

after seeing Courrey.

You realize that women are
to be undressed for new
& sexual stimulation. & go next
from the old idea of draping
women with all the trimings
now its to make her sexad
nued with out being unsexy.
on the other hand dress men up to show they have balls..

Privilege knit leotards & hip boots
on belt.

Courrey. sheer black stocking leotard
that coat the need Broad Black
gloves & tiny skaters shirt on his with
knit leotard.. worn under shirt
and coat..

Guy La Roch old may of sex nebulion
on black dresses.

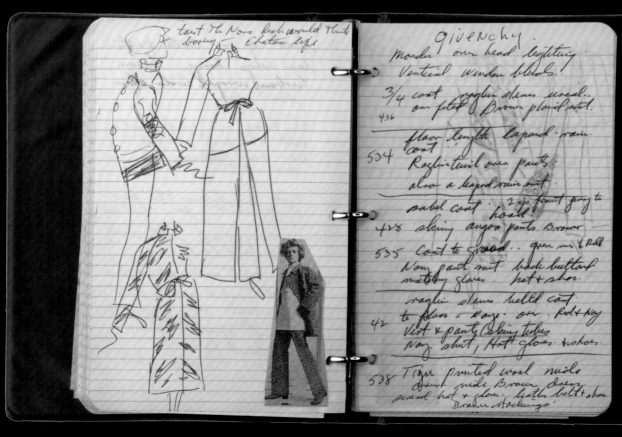

taret the Nova Rich would think
boring — Chatam left

Givenchy.
Morder over head lightning
Vertical Window blinds.
3/4 coat raglan sleeve unreal..
our fitted Brown plaid coat.
436
floor length lapard rain
coat
534 Raglin twill over pants
also a leopard rain suit
sabel coat hood 2 zip front going to
428 skinny angoa pants Brown
535 Coat to ground.. open no 6 Roll
Navy pant suit black button
matching gloves. hat & shoes.
raglin sleeves belld coat
to floor - Navy. over. Red & Navy
42 Vest & pants skinny tubes
Navy shirt, Hat gloves & shoes.
538 Town printed wool midi
down mid Brown dress
swed hat & glove. leather belt & shoes
Brown stockings.

conservative parents' shaming, the beatings he received when he tried on his sisters' dresses, to get to him. (And despite how he left things in the book, Bill, a devout Catholic, maintained close ties with his parents until the end of their lives. In the late '70s, according to his niece, Trish Simonson, he spent two weeks with them every summer at their cottage in Duxbury, Massachusetts.)

The writer Louis Menand once said about the problems of writing a history, "You are almost completely cut off, by a wall of print, from the life you have set out to represent." These words feel true of Bill and the import of his work. It's been blocked behind a misty wall of unexamined information. Paradoxically, his archive helps let in some light.

I visited the archive with Tiina. I was curious to see the files for myself. What immediately stood out was how far into the future Bill could see. In the memoir, he boasted of having extra-long antennae for anticipating the fashion mood and that this feeling pushed his creativity as a milliner—sometimes over the edge. For his final collection, he did space helmets: "naked of trimming, just pure shape, molded like the cones of rockets and racing headgear." That was two years before André Courrèges' futuristic simplicity dominated the fashion world.

The point is, Bill acted on instinct, and once he moved into journalism, in 1963, and later photography, in 1967, this instinct served him similarly. That he picked out Anna Wintour is one indication. How did he know, beyond the fact that she looked adorable in the clothes and was the daughter of a prominent journalist, that she was someone special to watch? He just did. Moreover, he kept feeding her file, so that over time, he held a comprehensive visual record of one of the most fascinating people in fashion. But there are other clues, in his files and elsewhere. Bill excelled at journalism from the start. When he sensed that the convention of hat-wearing was dying, he closed shop and joined *Women's Wear Daily,* the trade publication, and also added freelance gigs with a few regional papers. By 1966, he was the *Chicago Tribune*'s "roving fashion reporter," based in New York.

In preparing this introduction, I decided to read his reporting at the *Tribune.* It was astonishing. Between 1965 and 1969, he covered virtually every major event and personality in what was a very happening era. He wrote about underground movies, Electric Circus, Max's Kansas City, the Chelsea Hotel ("the most ravishing array of creative folk in all New York"), Andy Warhol,

Halston, Joan "Tiger" Morse's famous loft party, Diana Vreeland, Betsey Johnson, and Happenings. (After reading his lively if somewhat subjective accounts, I wonder if he didn't pen his secret memoir around the same time.)

The idea of him taking pictures was almost a stroke of luck, like so much else that happened to Bill. In 1965, while in London, he met the photographer David Montgomery through their mutual friends, the illustrator Antonio Lopez and his partner, Juan Ramos, who also lived above Carnegie Hall. When Montgomery came to visit Lopez the next year, he noticed that Bill, who at the time favored fisherman knit sweaters, was furiously scribbling notes on a pad.

"I said to him, 'Why bother doing that?'" Montgomery, now in his eighties, recalled. "'Here's a camera. Use that.'" The camera was an Olympus Pen-D half-frame. About the size of a pack of cigarettes, it could shoot seventy-two frames. "He picked it up pretty good," Montgomery said, adding, "The thing about Bill was, when you look at the photographs, they're right in the core of the matter."

Because of Bill's background in fashion, his instincts, and, frankly, his ego, his pictures assumed an authority equal to his writing. He didn't publish his pictures, at least not in the *Tribune,* until 1967, and the subjects were mostly fashion shows and VIPs at events. That year, he photographed a charity show featuring Givenchy's collection. His thrill at being allowed to shoot backstage—a big deal then—was right on the surface, as he noted in his story: "Givenchy, who usually runs from the camera, allowed . . . the photographer" free rein.

Bill began shooting for *The Times* in the mid-'70s, though he continued to freelance for magazines, and in 1982 he helped launch *Details.* Freedom was important to him, and he didn't join *The Times* staff until 1994. As he once said, "Money's the cheapest thing. Liberty and freedom is the most expensive." In the tradition of early-twentieth-century street photographers, notably Jacques Henri Lartigue and the Seeberger Brothers in Paris, who photographed fashionable women at racecourses or promenading in parks, Bill positioned himself at busy shopping corners, like Fifth Avenue and Fifty-Seventh Street, and outside chic restaurants. Le Cirque was a favorite. It was there that he snapped photos of socialites like Blaine Trump and Pat Buckley, and on another occasion Richard Nixon and Henry Kissinger. His files from the '70s and '80s are absolutely saturated with the glamour

Notebooks Bill kept during his coverage of the Paris fashion shows in the late 1960s.

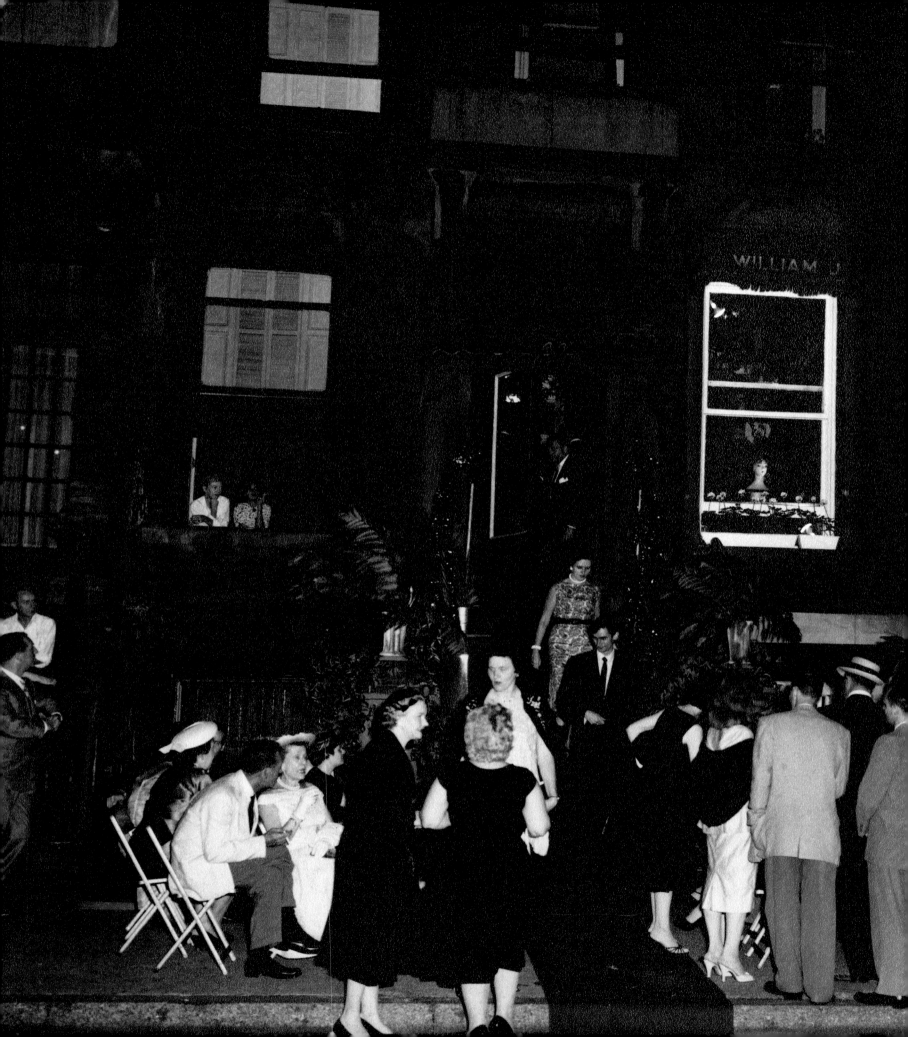

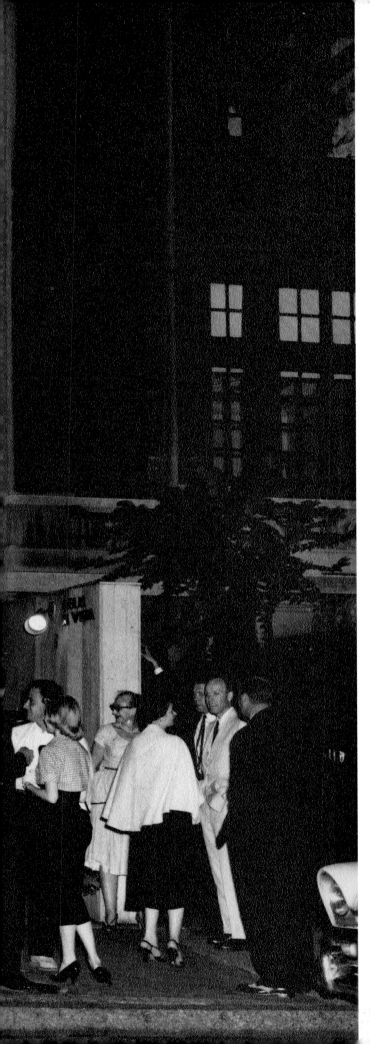

Bill lived in this brownstone on West Fifty-Fourth Street in Manhattan, and he displayed his William J hats in the first-floor window.

of that era. It helped that he plainly knew where the action was—whether it was the allure of Yves Saint Laurent and his gang or the scene at Studio 54. He also annotated his files—again, with foresight—by including press clippings of the events. When the couturier Charles James died, in 1978, Bill went back to an image he had shot two weeks earlier at Studio 54, and recorded that it was the last photo he had taken of the great man.

This type of imagery seemed to serve as a bridge to the street fashion he shot increasingly in the late '70s, when the people he photographed were generally unknown—and unaware of the spindly man darting through the crowd with his camera. That may be why his earlier black-and-white images—before *The Times* moved into color—have an unusual degree of spontaneity.

But the unifying element in all of Bill's work, from his innovative hats to his searching news reports, to the photographs in this wonderful book, is that the ideas flow forward. As much as Bill savored the history of fashion and its eccentric cast of legends, he never allowed nostalgia to creep into his pictures. To the end of his life, he remained vigorously, joyfully in stride with the times. "Child," he would say to a middle-aged person, "fashion is about today." This book represents a lifetime of putting that belief to the pavement.

THE '70s

These were the bad old days of New York City, but boy, were they a lot of fun. Out of garbage-strewn, crime-ridden streets, flamboyantly garbed women seemed to sprout like flowers—long-stemmed ones, the look du jour being lean and leggy (and sometimes braless).

The hippie youth culture of the 1960s had been adopted by top designers like Yves Saint Laurent and reinterpreted in luxurious fabrics; at restaurants like the Russian Tea Room and La Côte Basque, socialites effectively masqueraded as peasants. After the national shock of Watergate and lingering stagflation, the romantic, flowing feeling of fashion—and an increasing interest in vintage clothing—showed a growing nostalgia for simpler, less cynical times.

Heightened by the defection of Mikhail Baryshnikov, balletomania influenced dress, but movies did so even more, from the vests and shag haircut of Jane Fonda in *Klute* to the baggy, layered menswear of Diane Keaton in *Annie Hall.* And then the city was gripped by *Saturday Night Fever,* which reflected the new, pulsing excitement of discotheques led by Studio 54: both cliquish and democratic, with men able to peacock in a way they hadn't since the zoot-suit era. By day, office workers were "dressing for success" in crisp tailoring, but when the sun set, they squeezed into Lurex. And no matter what the hour, Bill seemed to always be on the clock.

Previous spread: Giorgio di Sant' Angelo, Nan Kempner, and Geraldo Rivera at Sly Stone's wedding, Madison Square Garden, June 1974. *Opposite:* An ensemble that epitomized the disco era.

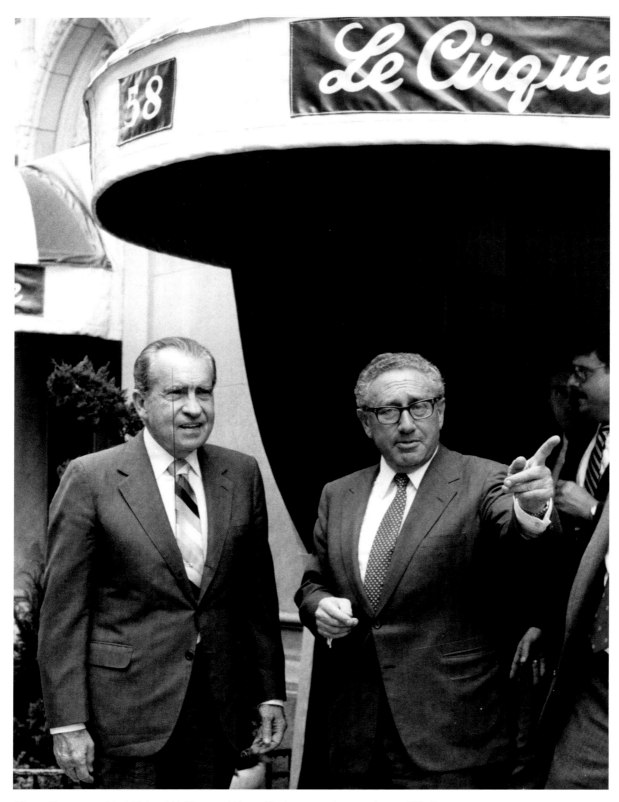

Above: Former president Richard M. Nixon and Henry Kissinger, exact year unknown. Bill often waited outside the restaurant Le Cirque to photograph people coming and going from lunch.
Opposite: The scene at a discotheque, 1978.

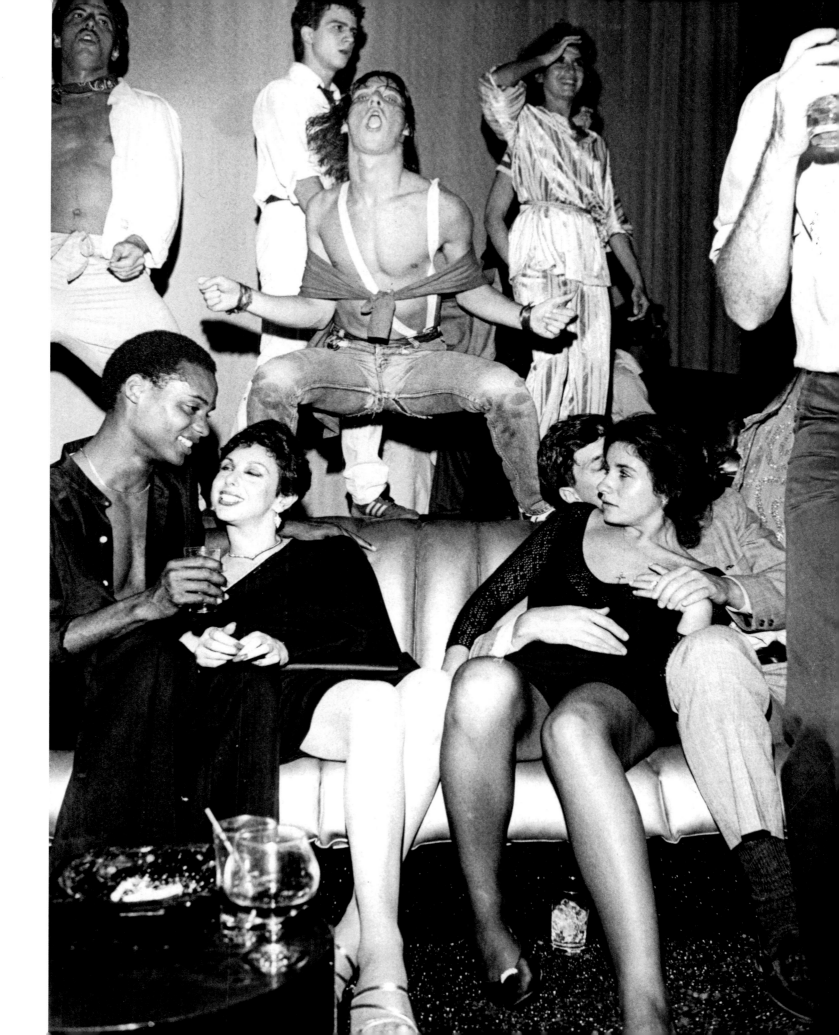

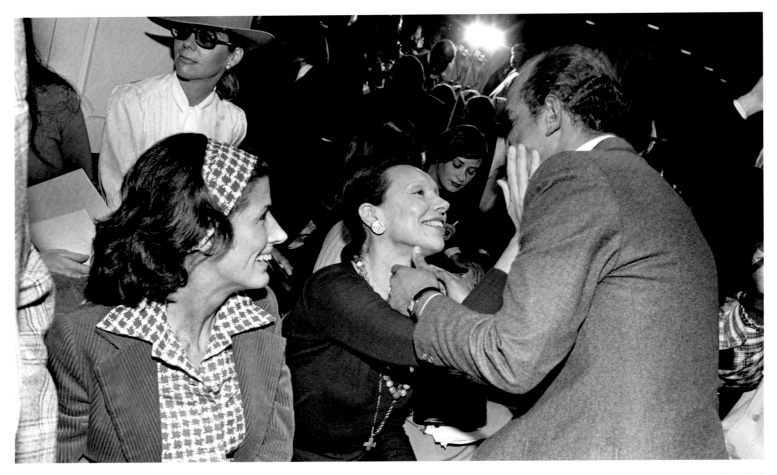

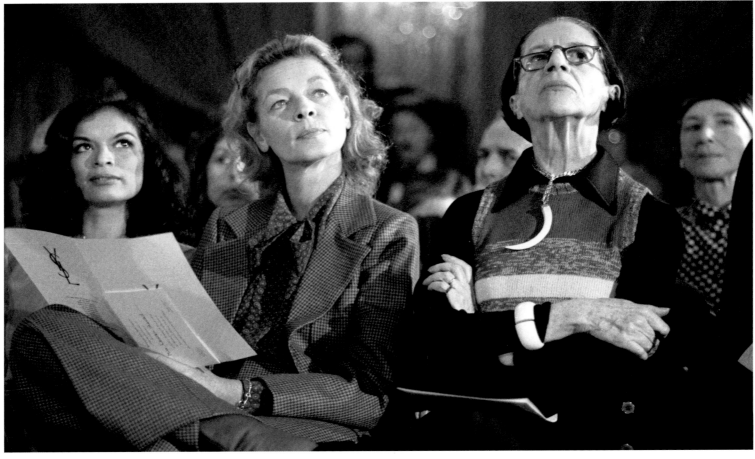

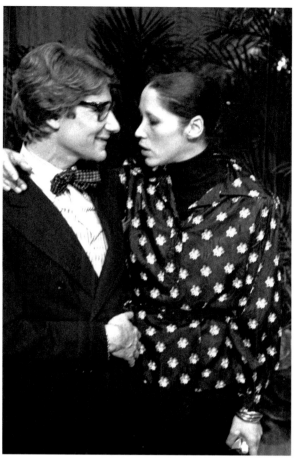

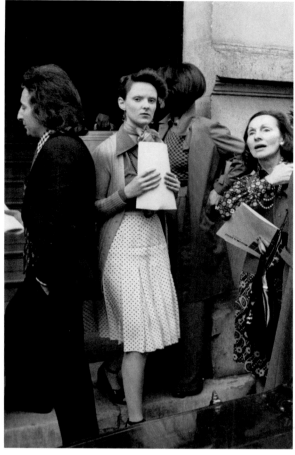

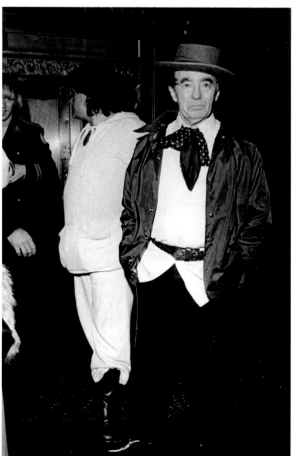

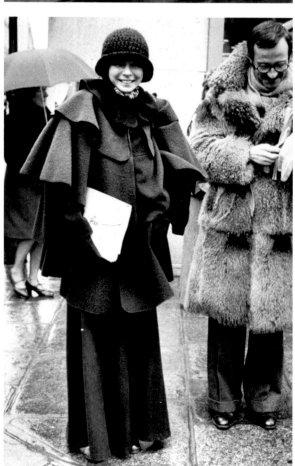

Clockwise from top left: Yves Saint Laurent and Marina Schiano; Grace Coddington, 1972; Anna Wintour, 1973; Charles James in Studio 54, 1978. On the back of the print, Bill wrote, "The last photo I took of C. James."
Opposite, above: Nancy Kissinger, Françoise de la Renta, and Oscar de la Renta. *Opposite, below:* Bianca Jagger, Lauren Bacall, and Diana Vreeland in the front row at an Yves Saint Laurent couture show in New York, 1974.

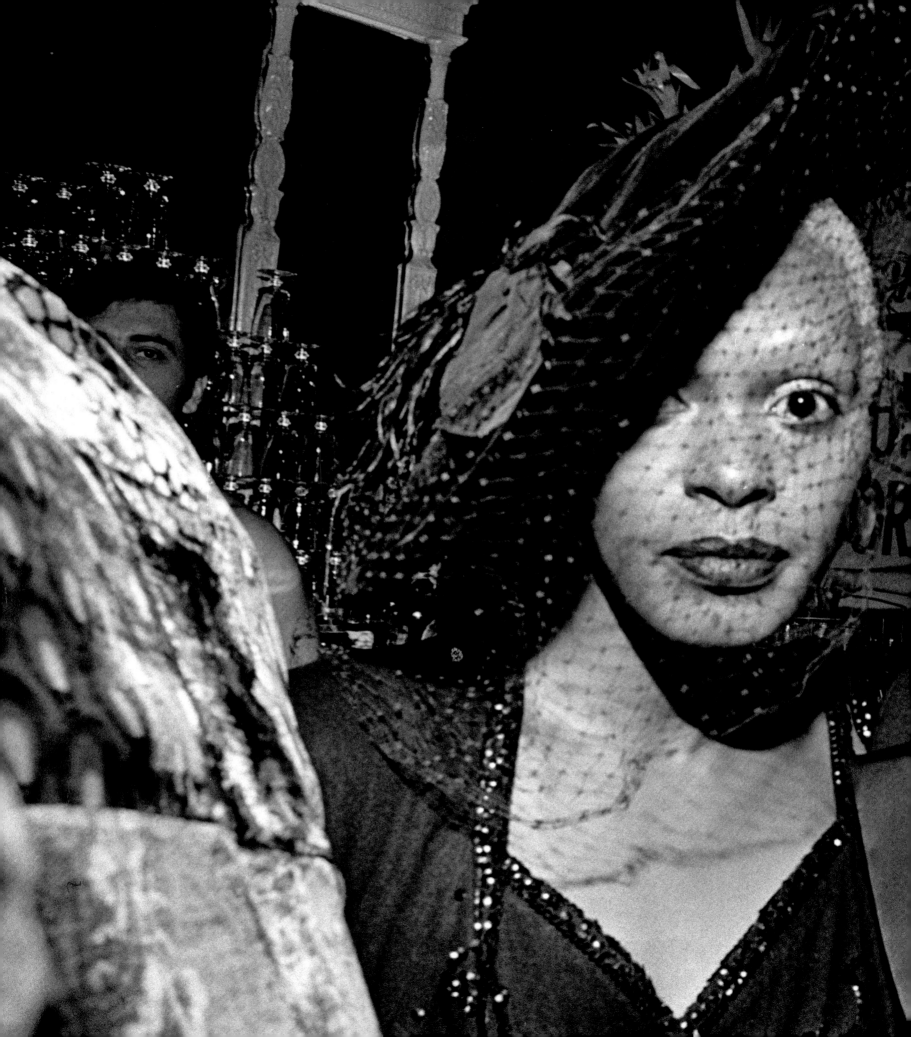

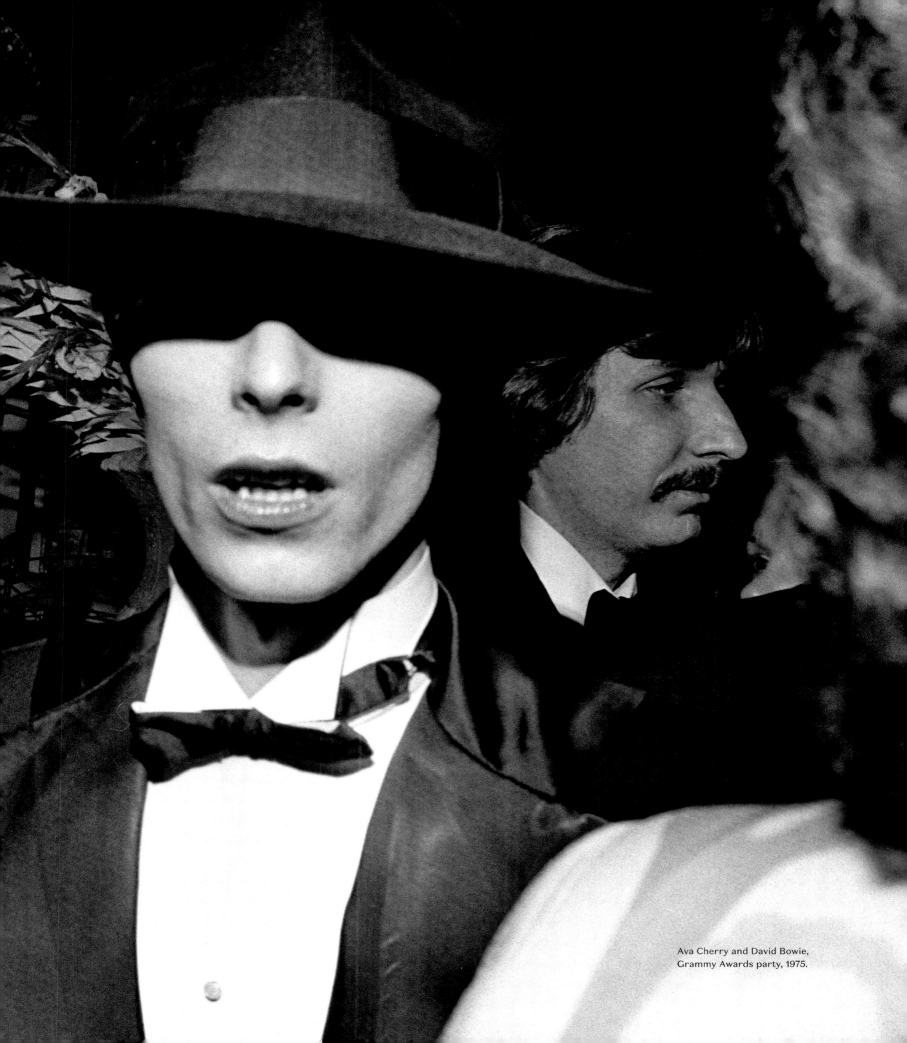

Ava Cherry and David Bowie,
Grammy Awards party, 1975.

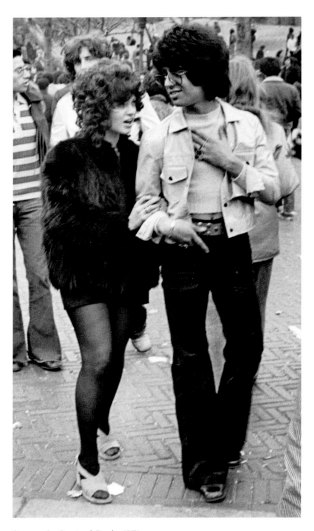

Scenes in Central Park, 1971.

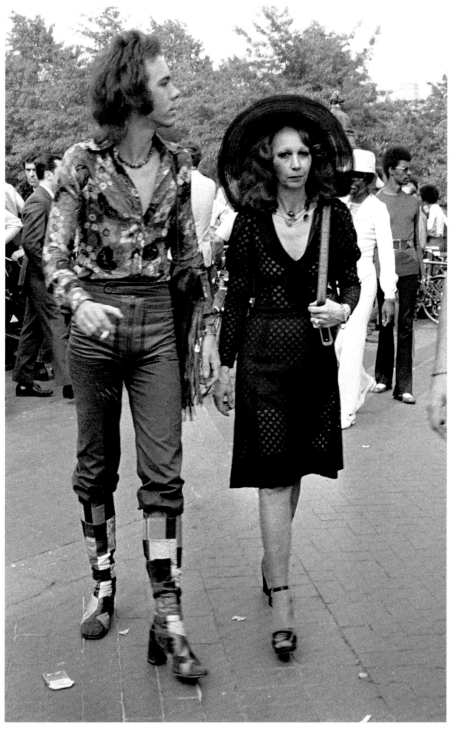

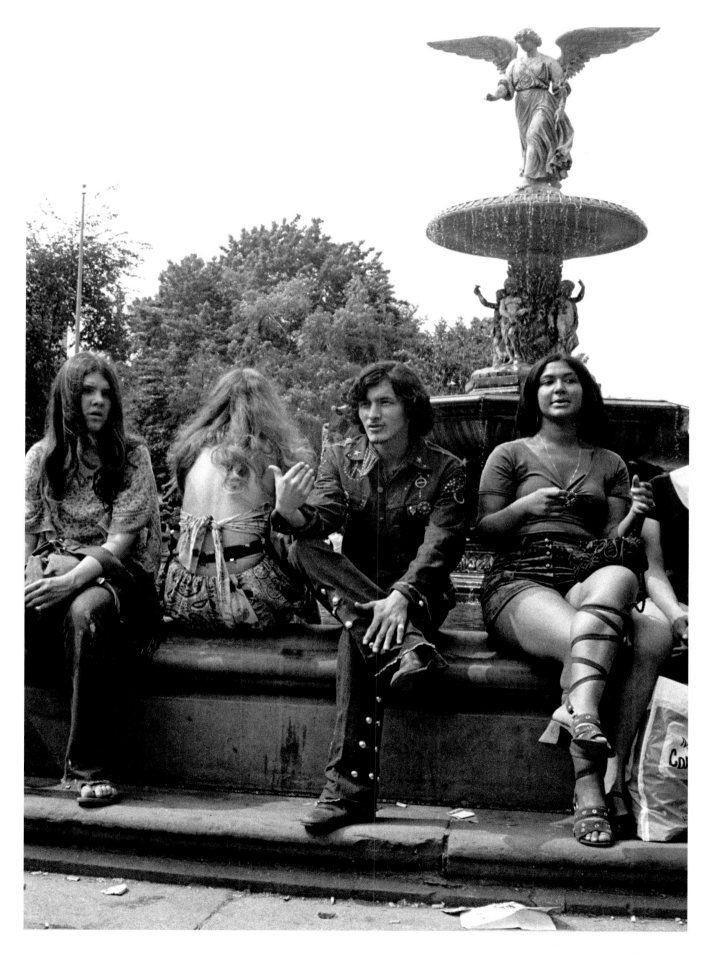

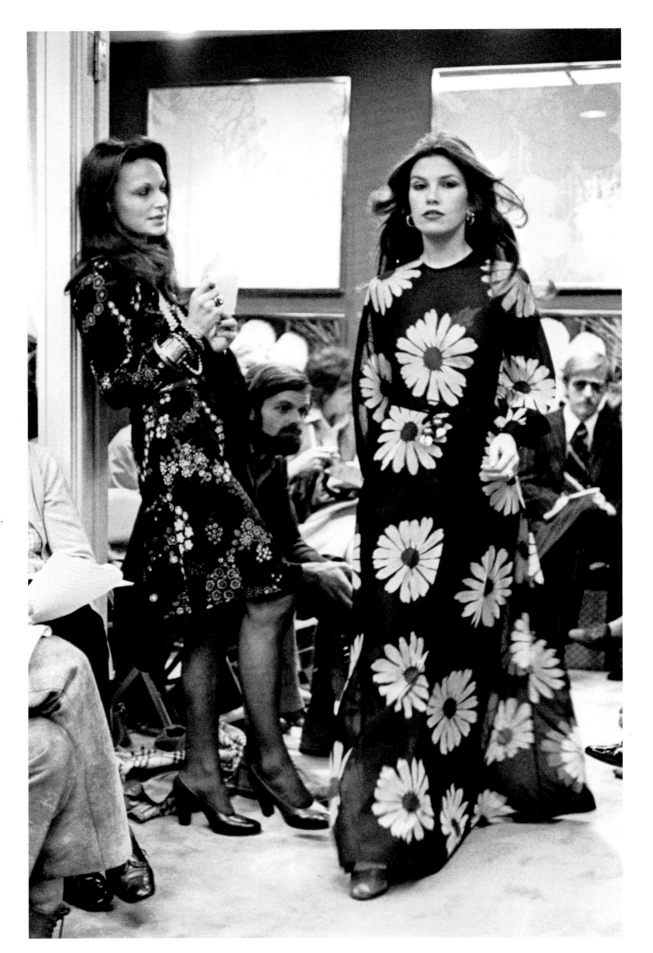

From left to right:
The designer Diane von Furstenberg at a fashion show, 1973, the designer Arnold Scaasi with a client, and the actress Ultra Violet.

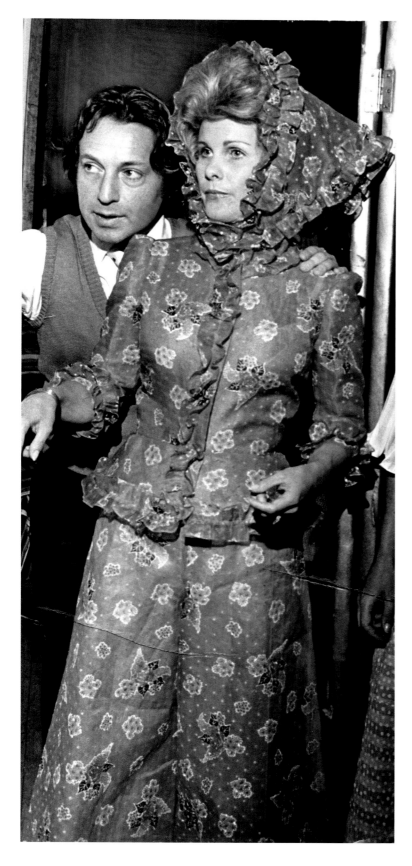

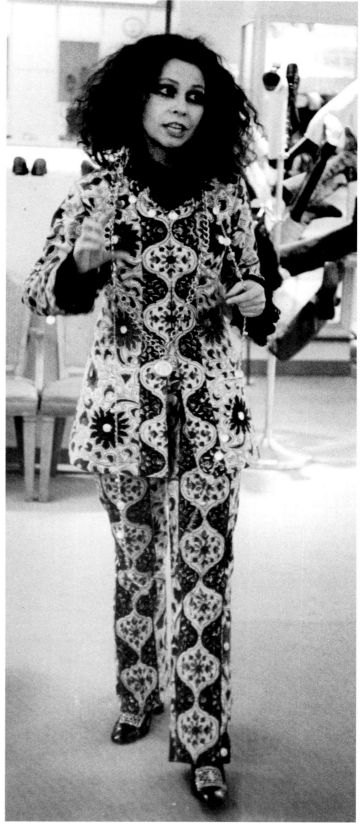

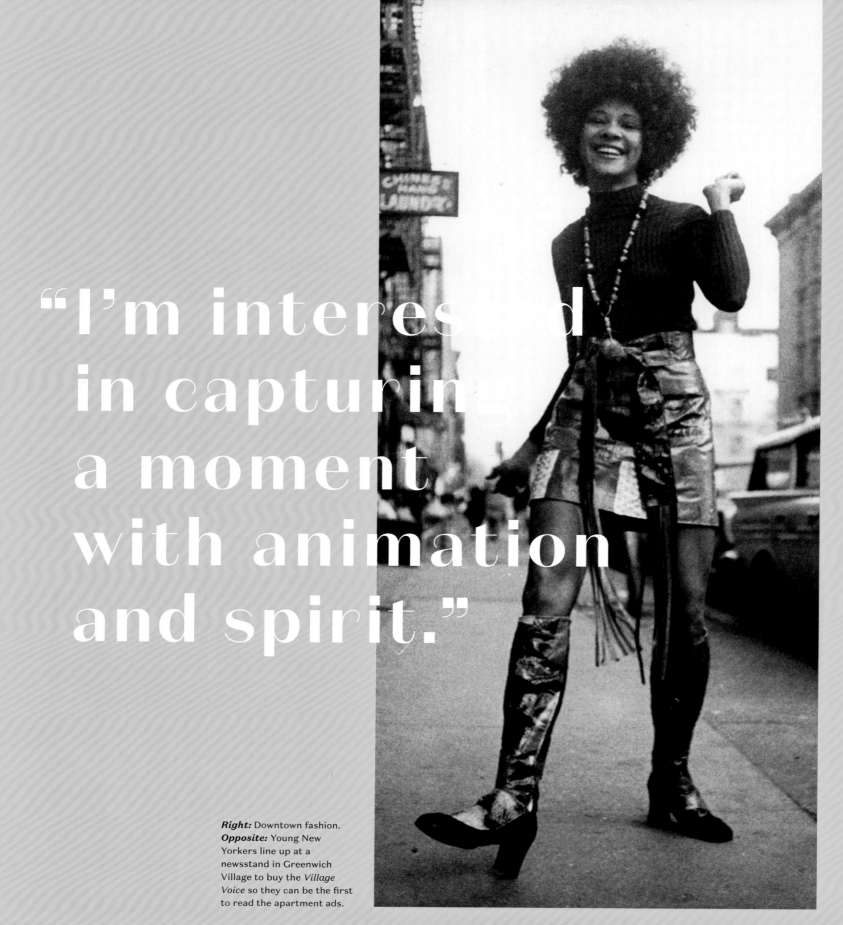

"I'm interested in capturing a moment with animation and spirit."

Right: Downtown fashion.
Opposite: Young New Yorkers line up at a newsstand in Greenwich Village to buy the *Village Voice* so they can be the first to read the apartment ads.

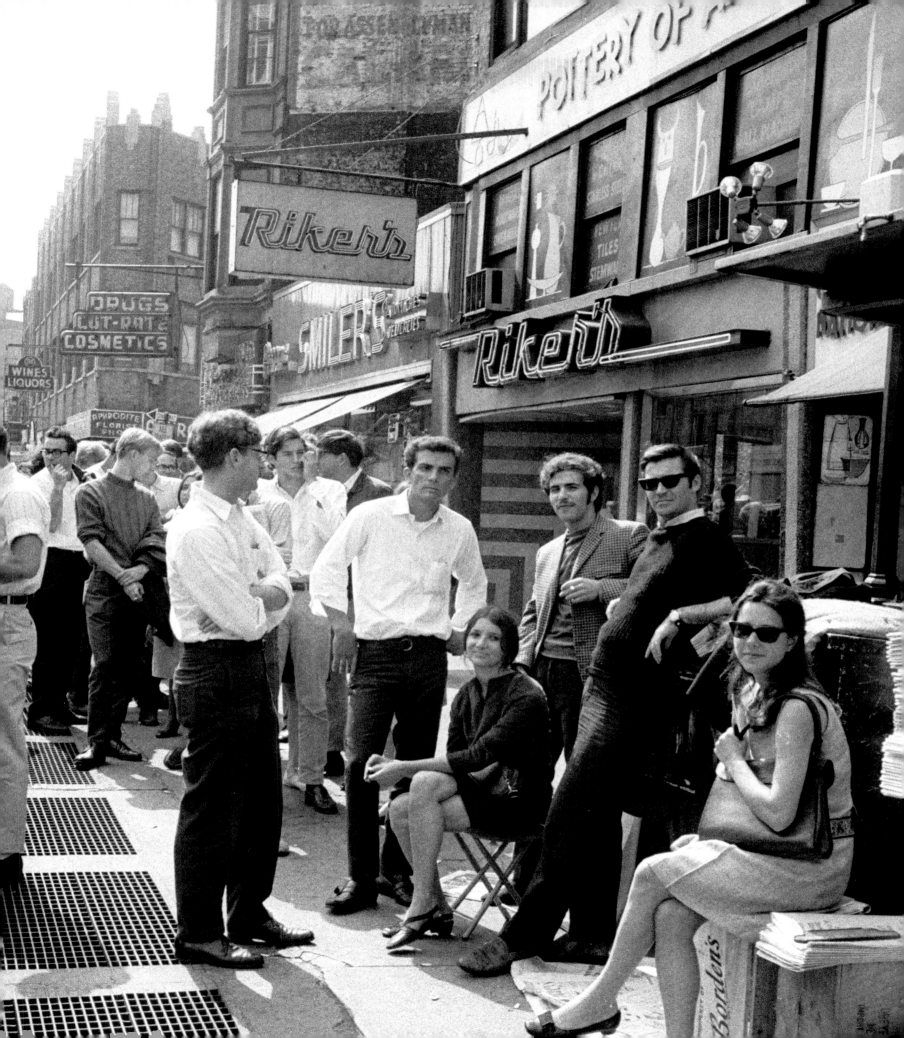

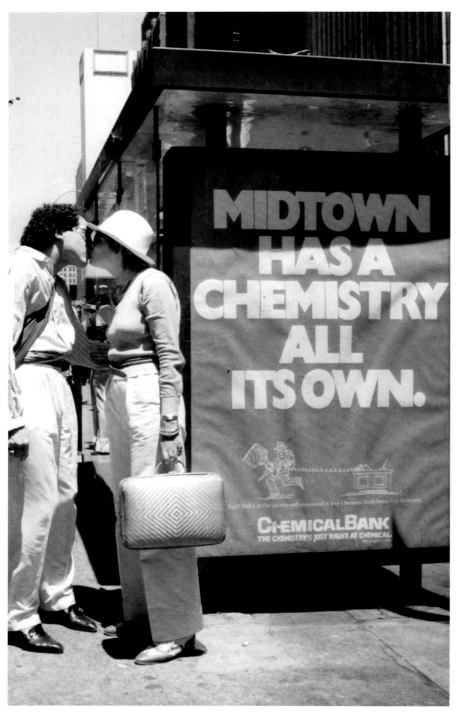

Above: A 1978 photo juxtaposing New Yorkers and a popular advertising campaign of the time. *Right:* A suit from 1979 *(above)*; a long knotted scarf serves as an accessory on a tunic *(below)*.

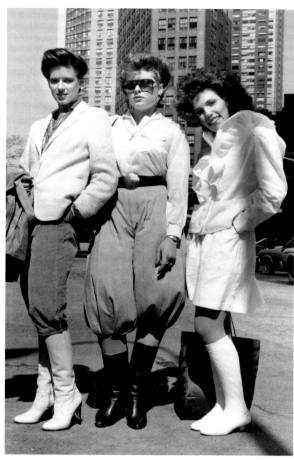

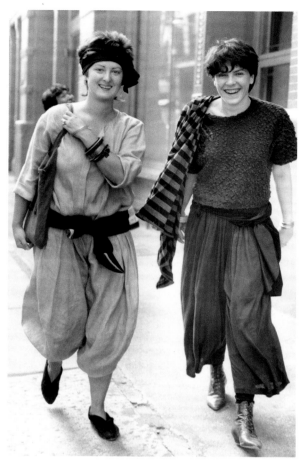

"Fashion is easy this summer. The greater the volume of air between clothes and body, the greater the look," Bill wrote in the 1970s. Harem and gaucho pants are seen everywhere.

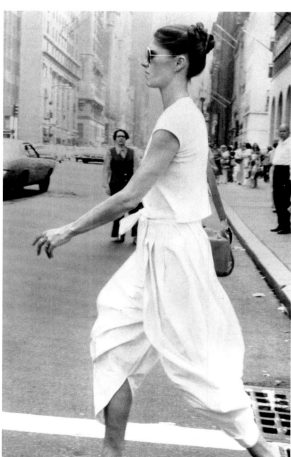

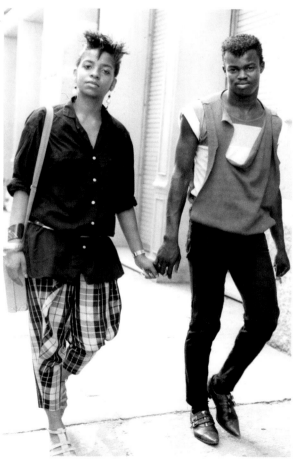

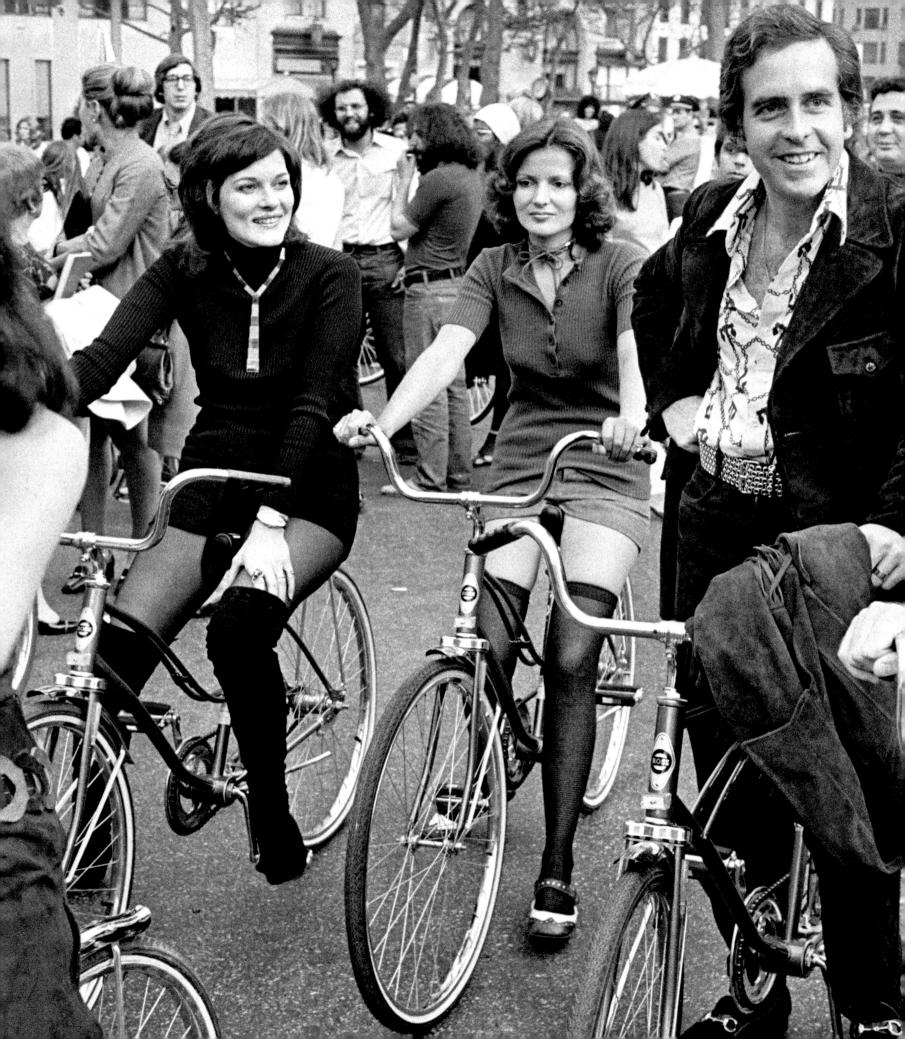

Above: André Leon Talley with models from a Givenchy fashion show held at Saks Fifth Avenue in 1979. *Opposite:* Bicycle riders, 1971.

"Tails may come one to an animal," Bill wrote in his column on the foxtail trend, "but when it comes to wearing them, art doesn't imitate nature."

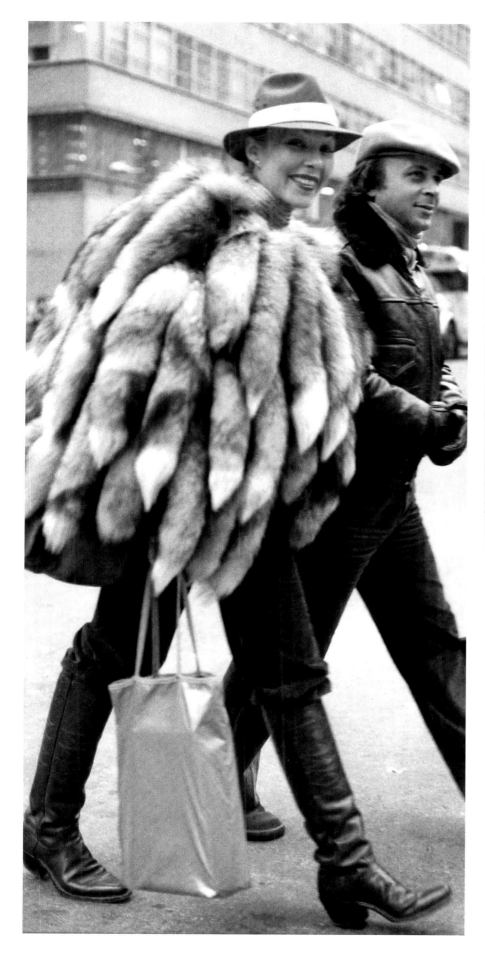

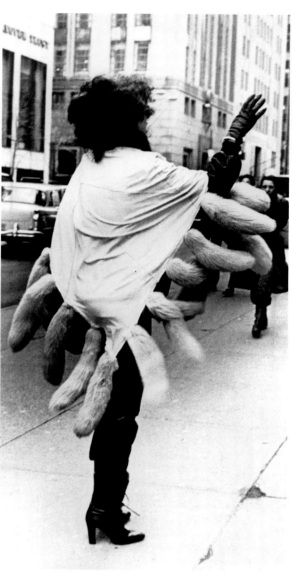

Above: Elizabeth Taylor and Halston, at the designer's show in 1978. Halston was one of the premiere fashion designers of the 1970s and had a large celebrity clientele. Like Bill, he also began his career as a milliner, having designed the pillbox hat Jacqueline Kennedy wore to her husband's 1961 presidential inauguration. *Opposite:* Andy Warhol and Santa Claus on Fifth Avenue.

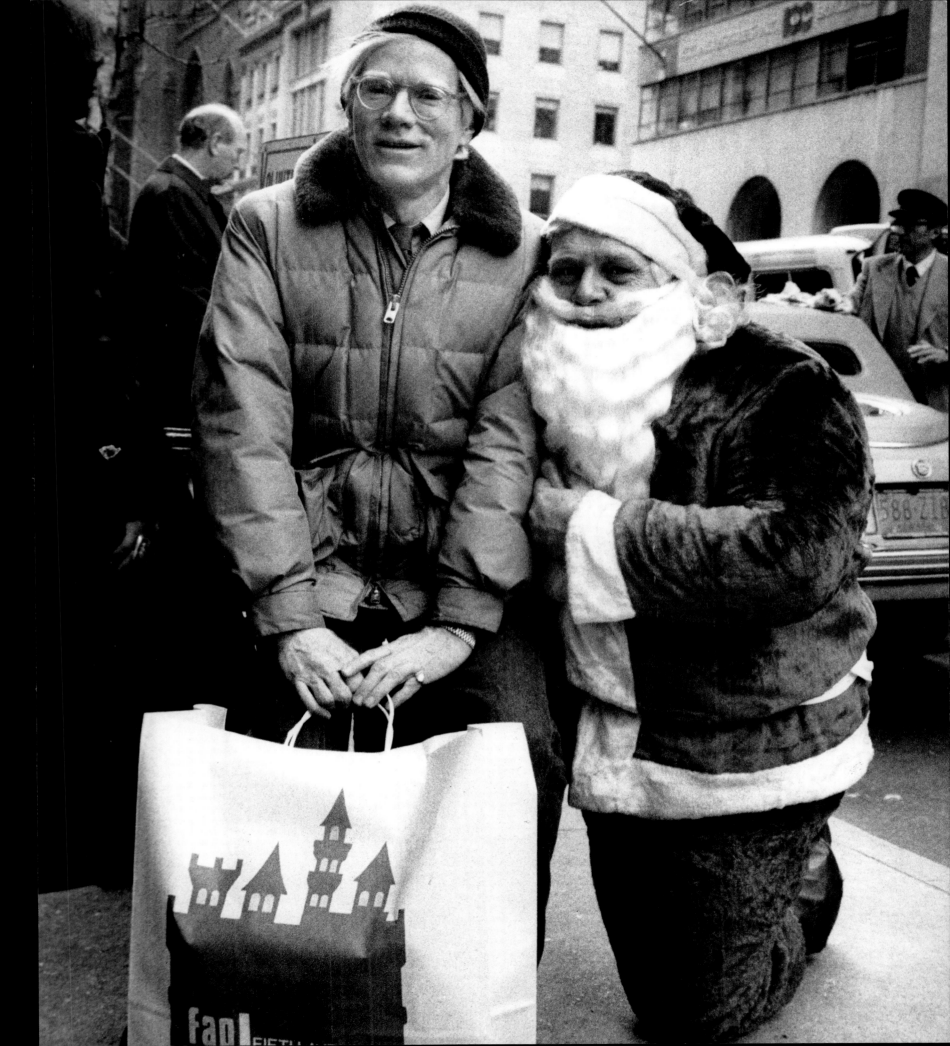

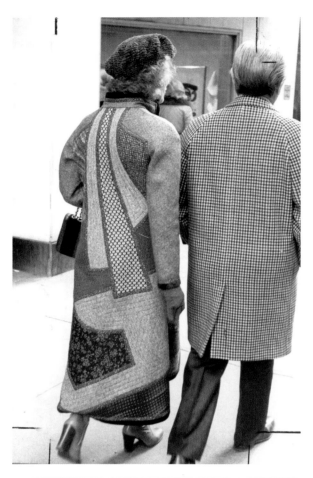

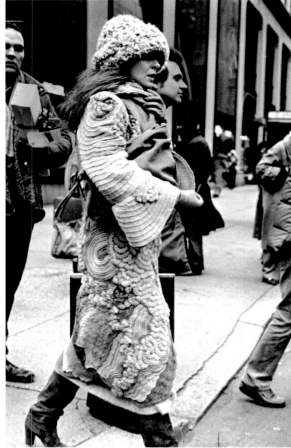

Bill referred to coats like these, from the late 1970s, as "wearable art."
Lower right: Editta Sherman, Bill's neighbor at Carnegie Hall and also the model in his *Facades* series.
Opposite: Kim Hastreiter, future co-founder and co-editor in chief of *Paper* magazine, wearing a Hudson Bay coat, 1978.

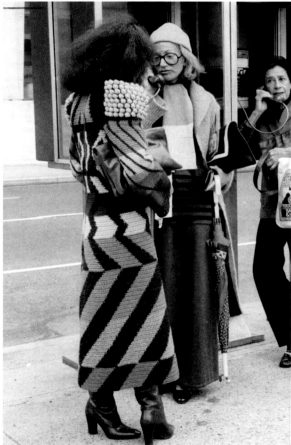

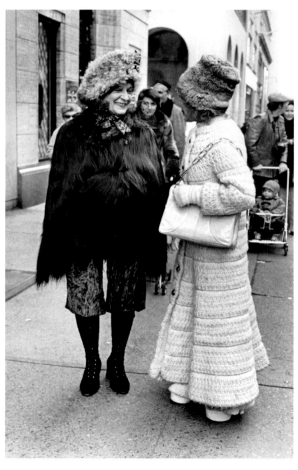

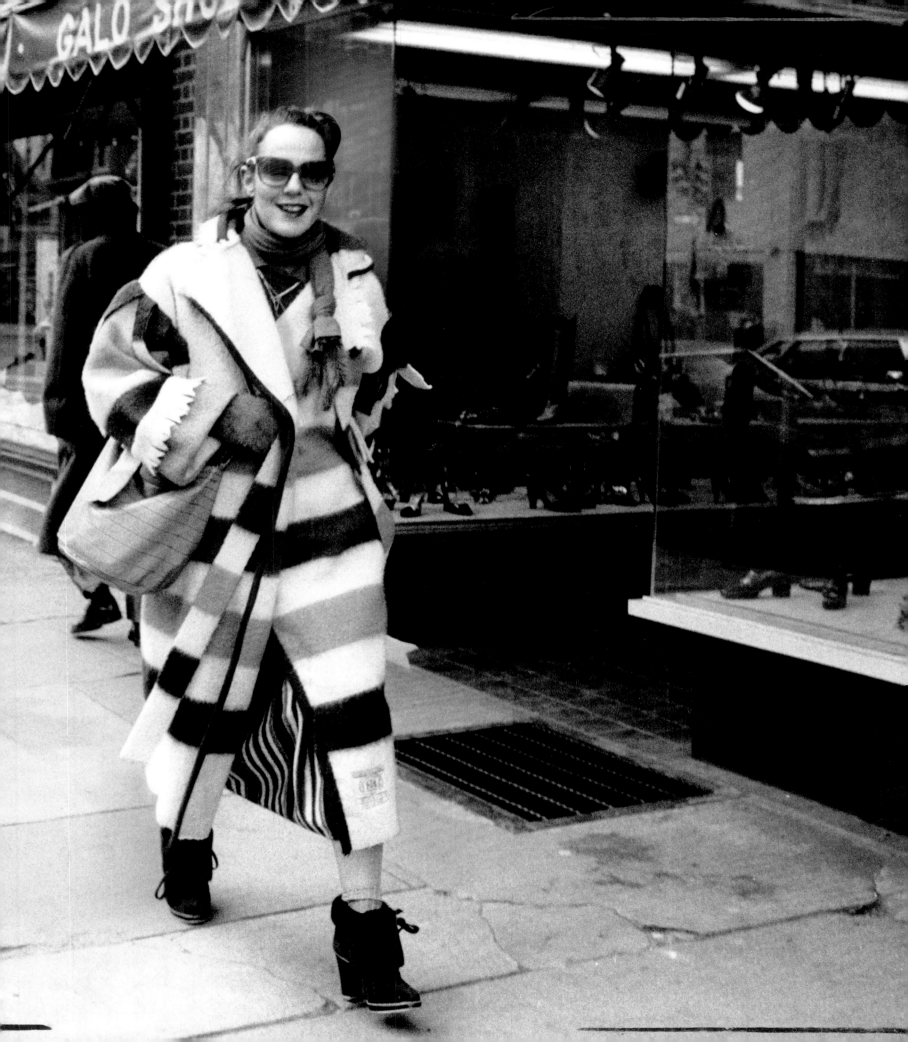

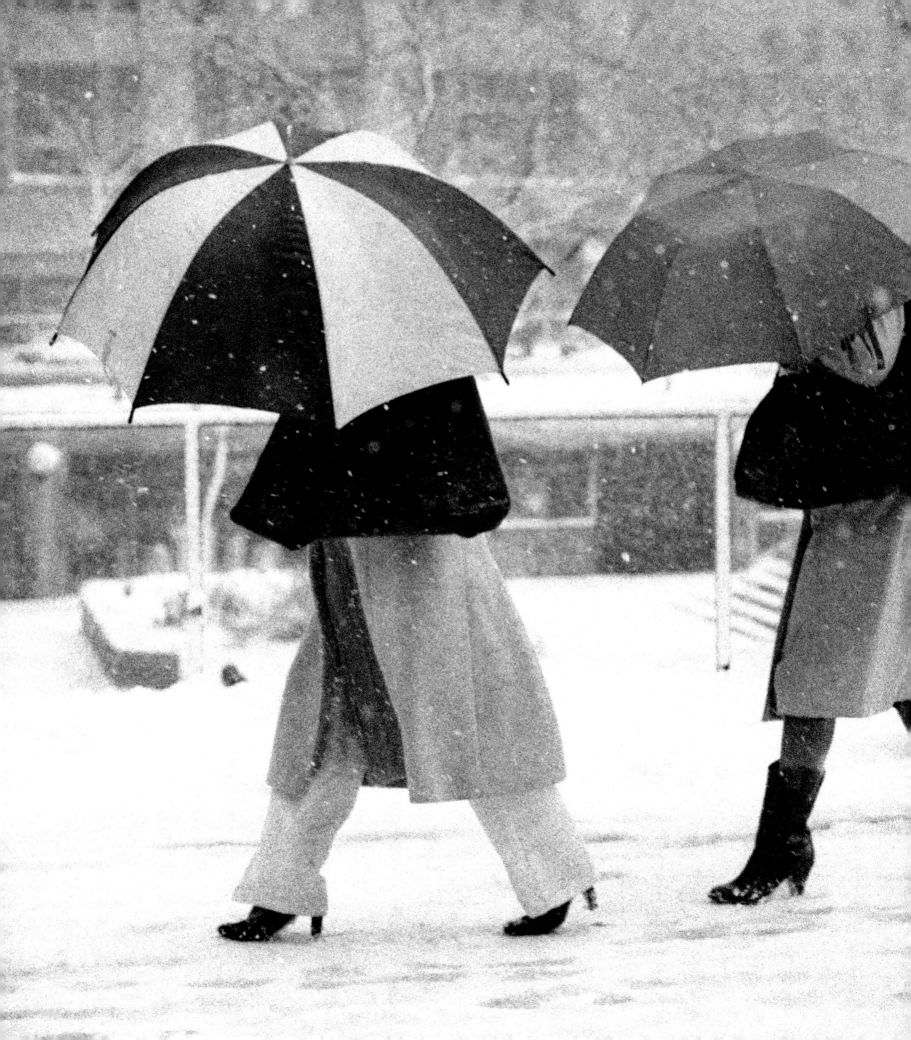

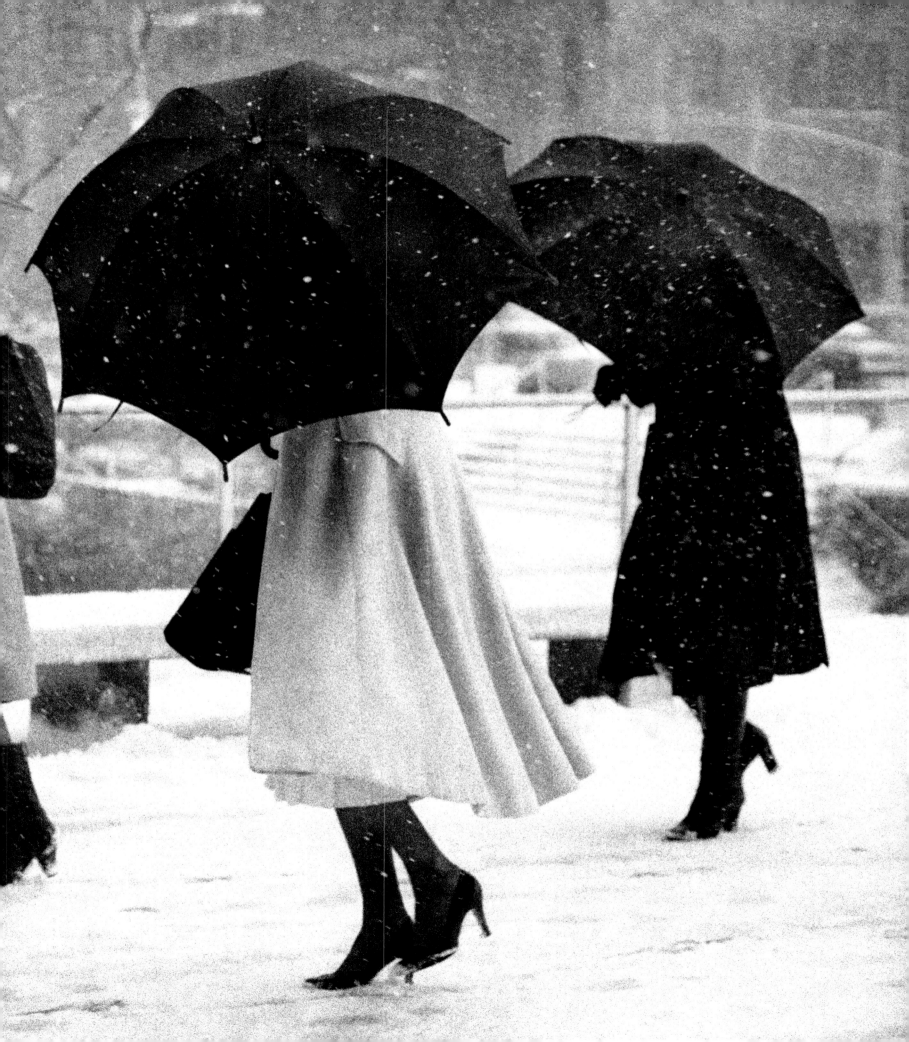

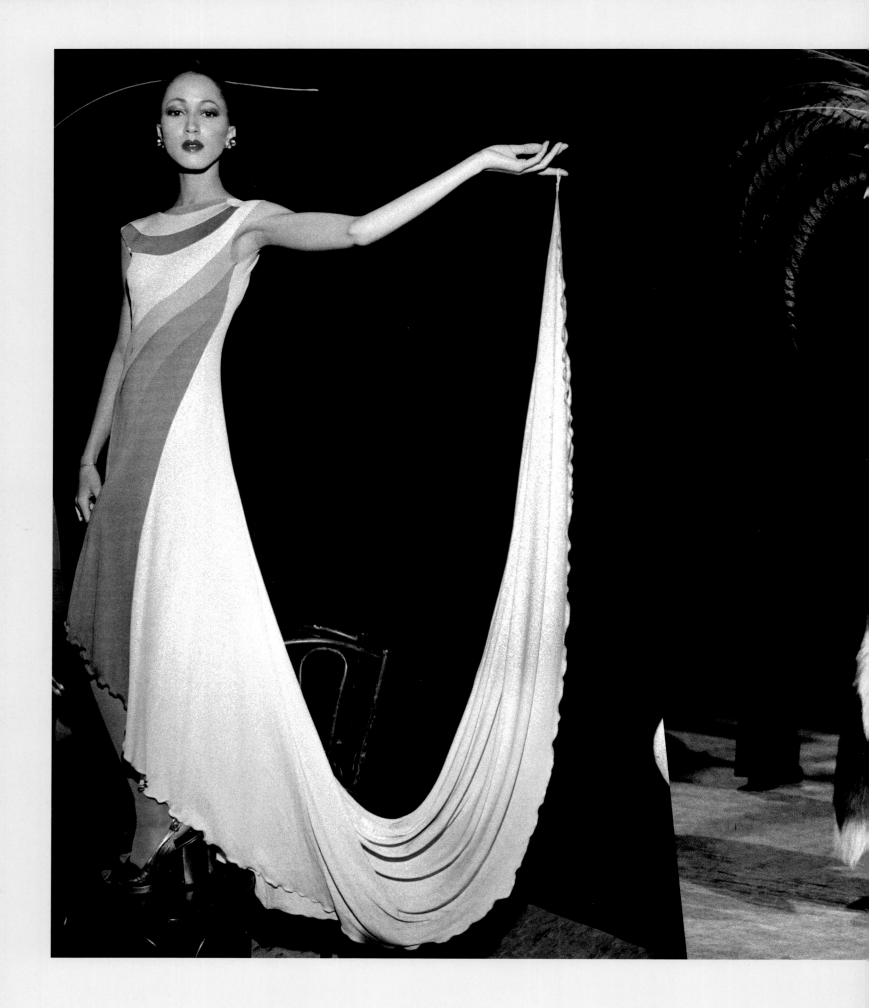

BATTLE of VERSAILLES

RUTH LA FERLA
reporter, *The New York Times* Styles section

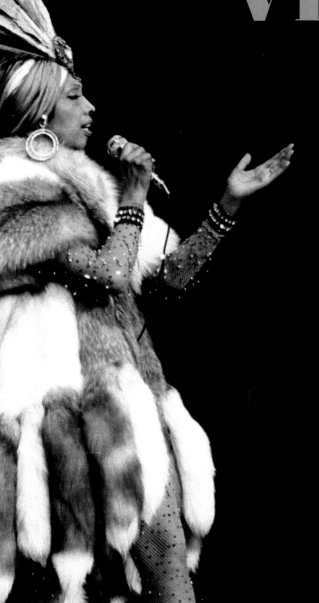

The model Pat Cleveland, at left, wearing a dress by Stephen Burrows, and at right, the entertainer Josephine Baker, who was representing the French team.

Reminiscing several years before his death about a fashion extravaganza that came to be memorialized as the Battle of Versailles, Bill Cunningham succumbed to a surge of emotion.

The decades-old memory that moved him to tears, he told his audience during a talk at the 92nd Street Y in New York, was a procession of mostly black models dressed in the vibrantly hued, lettuce-hemmed confections of the American designer Stephen Burrows, vogueing and shimmying at the Royal Opera of Versailles.

That performance, a crowning moment in a spectacular face-off between the stars of French couture and their Seventh Avenue would-be rivals, was, in Bill's ecstatic phrase, "the most exciting fashion show in my life I've ever seen."

November 28, 1973, in retrospect, was all that and more—a pivotal point in the history of contemporary fashion, the moment that ushered brash, unfussy, and unfettered American style onto the world stage.

"By the time the curtain came down on the evening's spectacle, history had been made and the industry had been forever transformed," the fashion critic Robin Givhan wrote in her book *The Battle of Versailles.*

The event she describes originated not as a contest but rather as a benefit for the restoration of the Château de Versailles, the former residence of the French kings. Eleanor Lambert, the energetic promoter

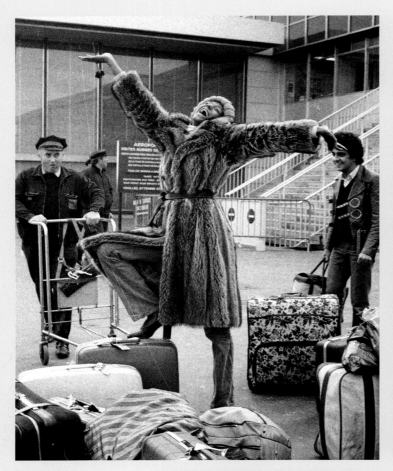

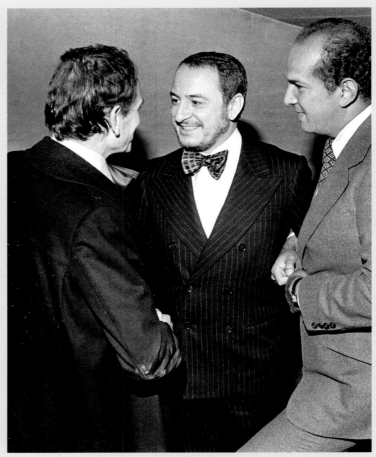

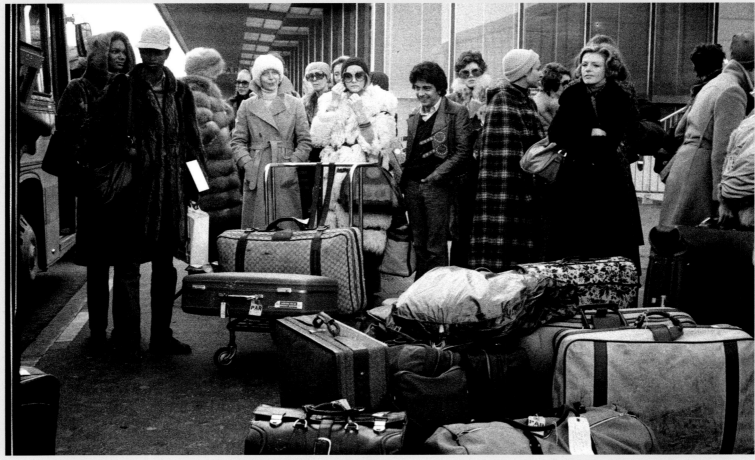

Left and below:
Kay Thompson, the choreographer of the American show; Oscar de la Renta and Jacqueline de Ribes, the French designer and aristocrat, who was attending the show.
Opposite, clockwise from above left: The model Billie Blair upon landing in Paris with the American team; Pierre Cardin, Pierre Bergé, and Oscar de la Renta; the Americans arrive in Paris.

of American fashion; Gérald Van der Kemp, the Versailles curator; and Marie-Hélène de Rothschild, the evening's sponsor, invited a roster of some six hundred luminaries, including Princess Grace of Monaco, Andy Warhol, Hélène Rochas, Gloria Guinness, and the Duchess of Windsor.

Guests were treated to a spectacle that was, in Bill's recollection, "something from the era of Louis XIV." Fantastical gilded set pieces—spaceships, outsize pumpkin coaches, and lavish floats—accompanied a fashion parade led by the stars of French couture: Yves Saint Laurent, Pierre Cardin, Emanuel Ungaro, Marc Bohan of Christian Dior, and Hubert de Givenchy. Dressed in a sequined catsuit and warbling "Mon pays et Paris," Josephine Baker closed the show, performing against a backdrop of stripper poles, which were in place as the props for fourteen dancers from the Crazy Horse cabaret.

Top this, the French seemed to call to the American upstarts: Bill Blass, Halston, Oscar de la Renta, Anne Klein, and Burrows, the lone African American in this lineup, whose lithe models all but walked off with the show. In brash contrast to the stately Gallic pageant, the Americans played against nothing more elaborate than illustrator Joe Eula's hastily improvised rendering of the Eiffel Tower, which was the set for Liza Minnelli's curtain raiser, a sprightly rendition of "Bonjour, Paris." The choreographer Kay Thompson had insisted on a brisk pace: "Zoom, zoom, zoom! One, two, three!" recalled Enid

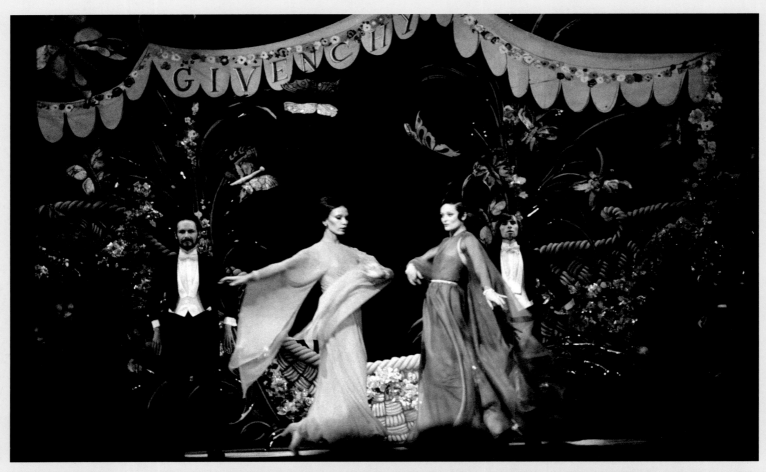

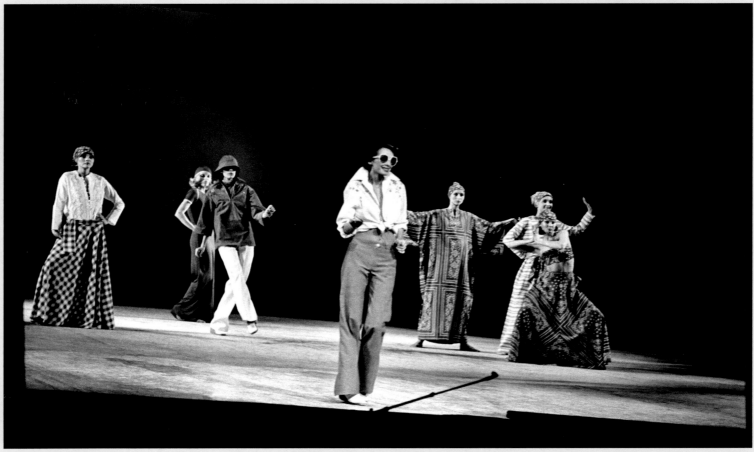

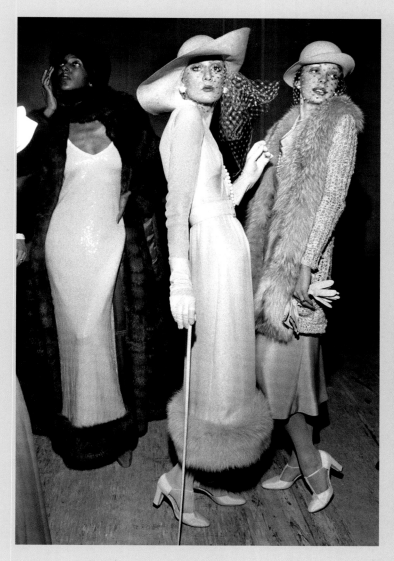

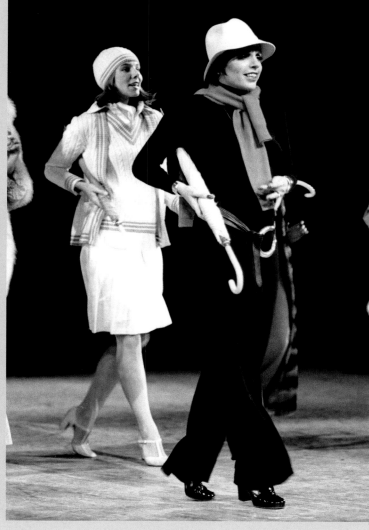

Nemy, who reported the event for *The New York Times.* "It was completely different from any kind of show."

Whoops and cheers greeted the finale; programs were tossed into the air. For sheer audacity and swagger, the Americans, it seemed, had trounced the French. "It was as if on this cold night, all the windows of Versailles had been blown open," Lambert said.

Plenty of verbiage has since been expended on this show of shows. But the last word, and the most imperishable images, would belong to Bill. Expounding on Versailles' enduring impact, he recalled Bethann Hardison, one of Burrows's regal models. Swathed in saffron-colored silk, "she crossed the stage on a diagonal," Bill said, "and looked the fiercest look she could possibly have looked at the crowned heads of Europe."

The audience was stunned, he remembered. "This was the America they hadn't seen."

Above, left: Models in Bill Blass designs.
Above, right: Liza Minnelli, during a rehearsal, opens the American segment of the show singing "Bonjour, Paris."
Opposite, above: The Givenchy segment of the French show.
Opposite, below: Models in Anne Klein creations.

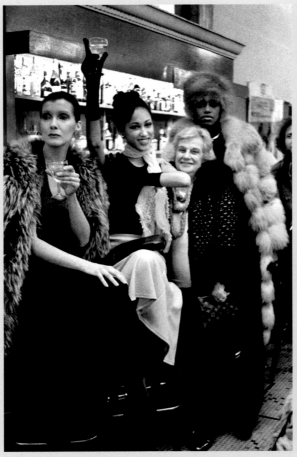

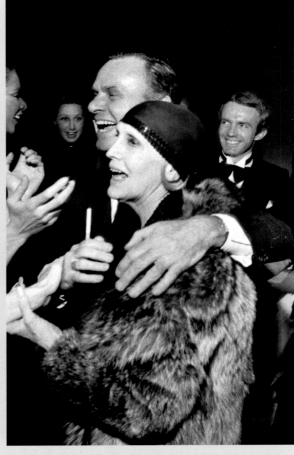

Clockwise from top left: American models Nancy North, Pat Cleveland, and Amina Warsuma (standing, wearing hat); Bill Blass and Kay Thompson, and in background *(left)*, Donna Karan, who was assistant to the designer Anne Klein; *(from left)* Pat Cleveland, Ramona Saunders, Josephine Baker, Bethann Hardison, Billie Blair, and Norma Jean Darden; Pat Cleveland and Bethann Hardison.
Opposite, clockwise from top left: Yves Saint Laurent and French entertainer Zizi Jeanmaire; Liza Minnelli and Andy Warhol; Bill Blass and the fashion editor Carrie Donovan; Liza Minnelli and Princess Grace of Monaco; Halston with the Duchess of Windsor.

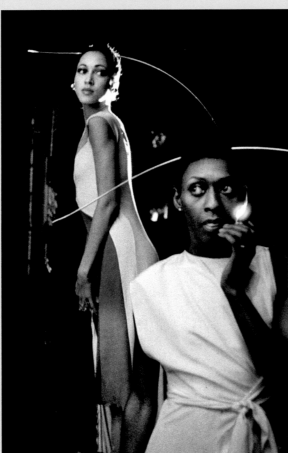

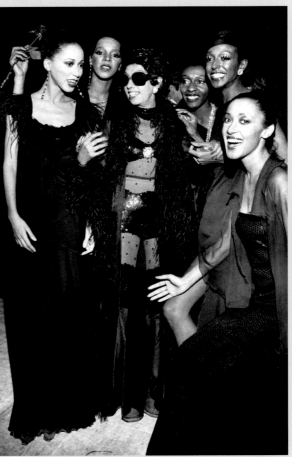

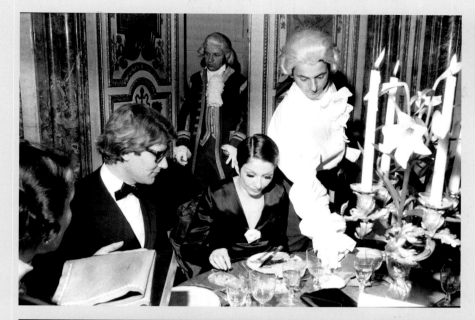

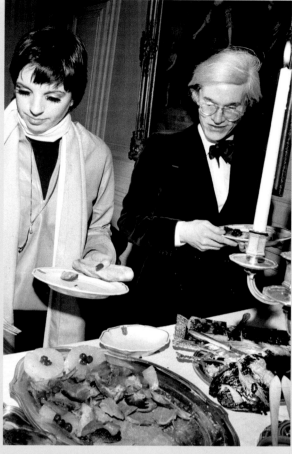

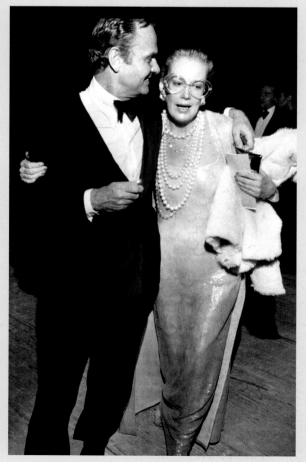

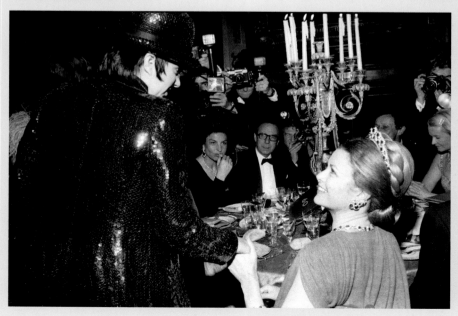

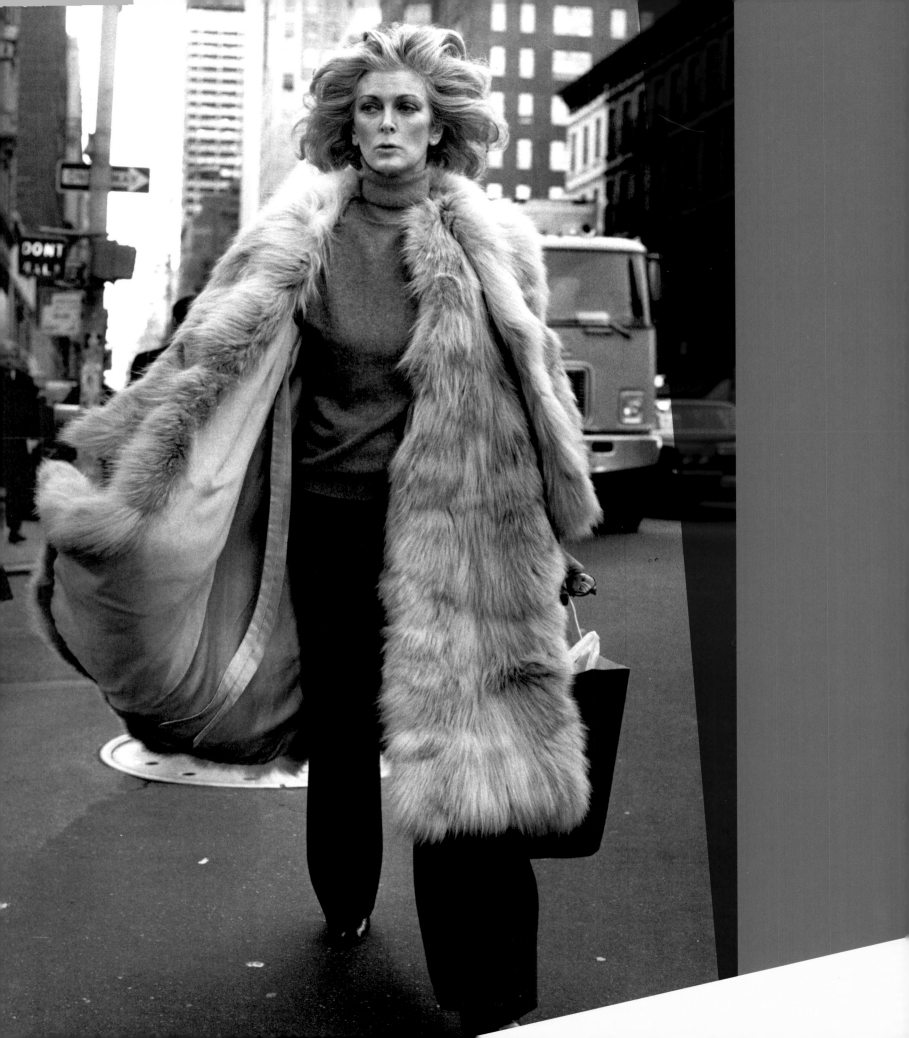

THE '80s

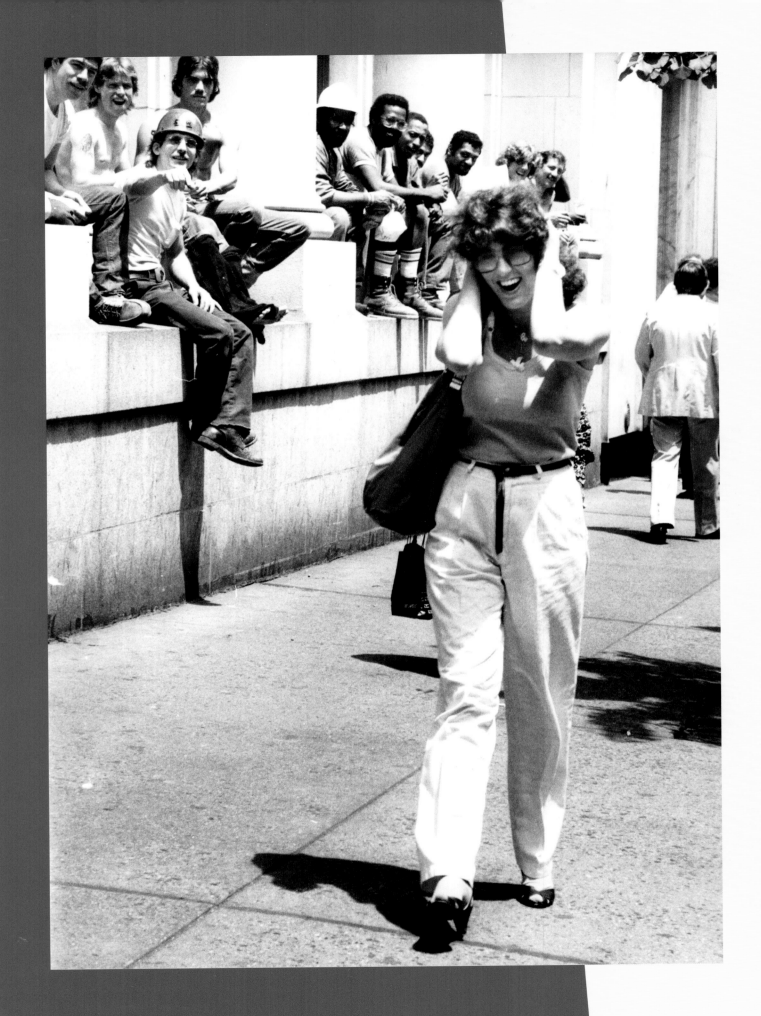

A citywide transit strike as the decade began engendered a signature outfit of this time: pinstriped power suits and pantyhose worn with puffy white sneakers (the high-heeled pumps were stuffed into a briefcase). Hemlines gradually inched above the knee and came to be topped by padded shoulders. Women were dressing for both provocation and battle.

Physical fitness had become a preoccupation, with New Yorkers showing off newly toned bodies in bike shorts and muscle shirts, accompanied by boom boxes and a brand-new invention: the Walkman, whose descendants would forever change how people interacted on the street. Some were listening to rap; others new wave, and others followed a singer named simply Madonna, copying her lace gloves, rubber bracelets, Day-Glo colors, and irreverently layered crucifixes.

Religious, racial, and economic divides were deepening, but you couldn't always see it in people's clothes. Jeans had become baggy, bleached, and distressed, even briefly acid-washed. In the winter, pedestrians wore puffy down jackets formerly de rigueur in the backcountry, with Norma Kamali designing an especially cocoon-like "sleeping bag coat." Puffy, too, were the bouffant skirts created by Christian Lacroix, which seemed to encapsulate perfectly the economic ebullience of these years—until the stock-market crash of 1987, when they suddenly represented only folly and excess. The stage had been cleared for Japanese and Belgian avant-garde designers, whose asymmetric and deconstructed looks were often rendered in fashion's perennial noncolor: basic black.

Previous spread: The model Carmen Dell'Orefice, 1981.

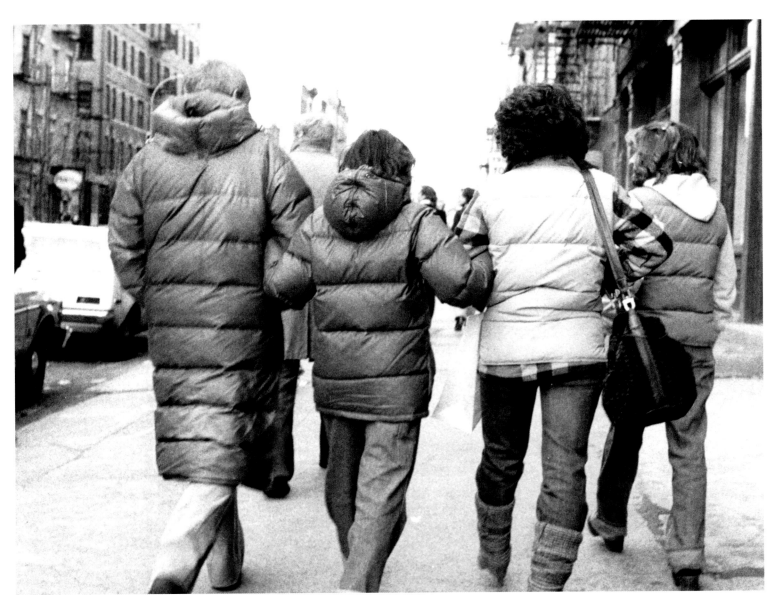

Above: Down coats, jackets, and vests were a common sight in the 1980s. *Opposite:* While Bill was photographing this woman and her shiny coat, in 1986, a mugging occurred in the background.

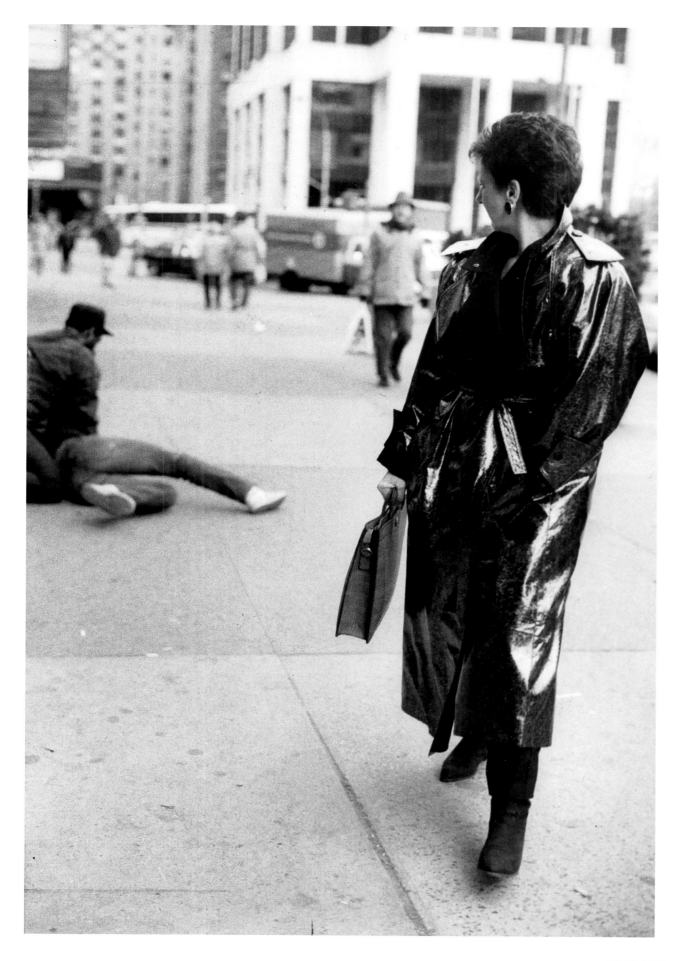

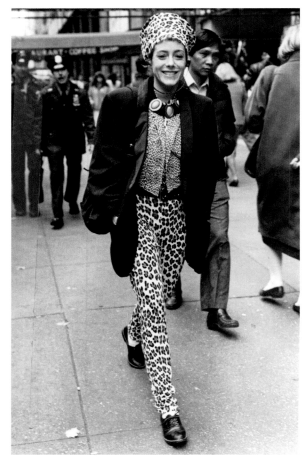

"The leopard motif has been carried beyond mere spots," Bill said in one of his columns.

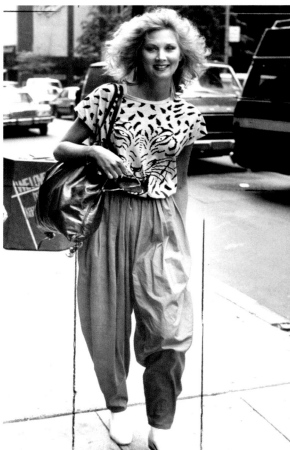

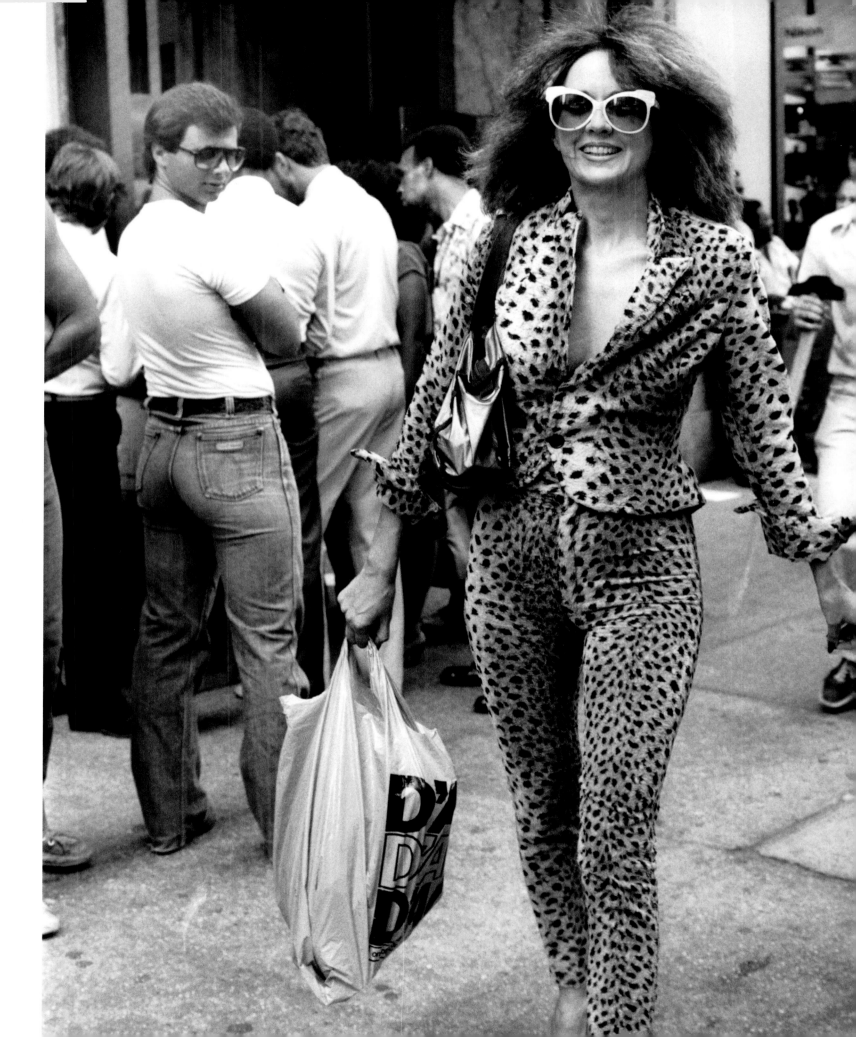

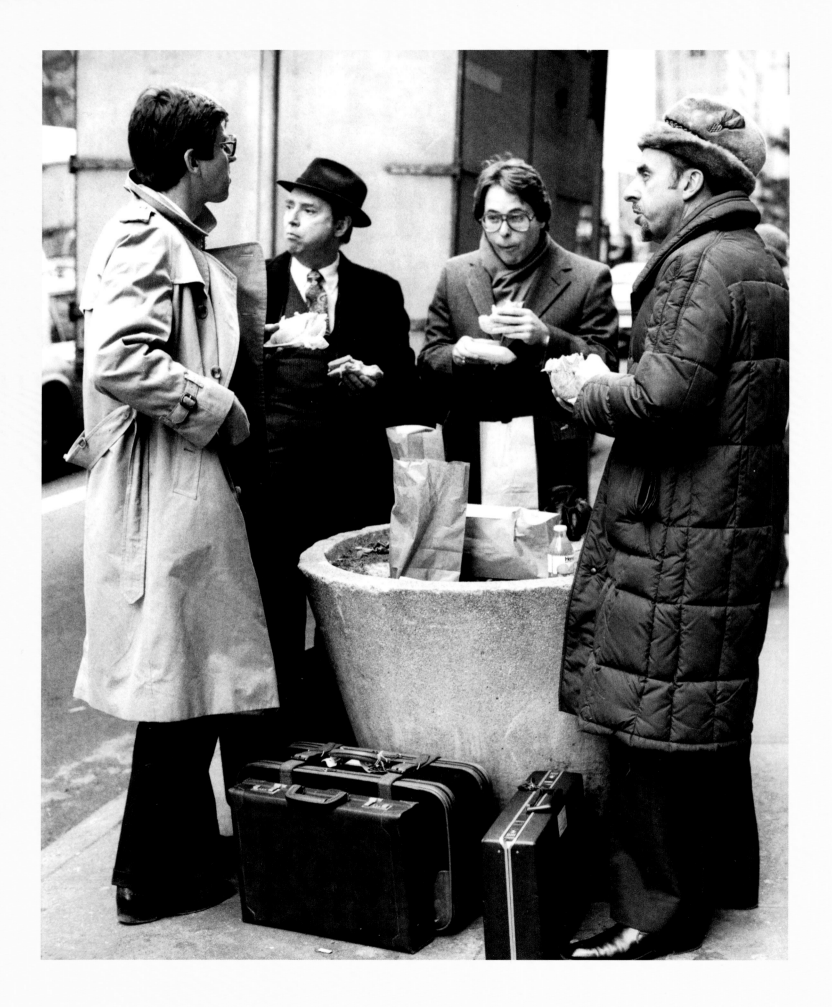

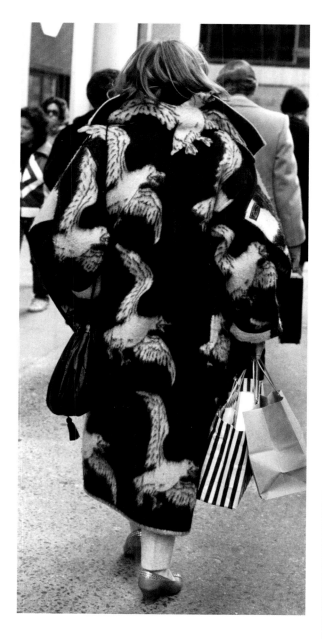

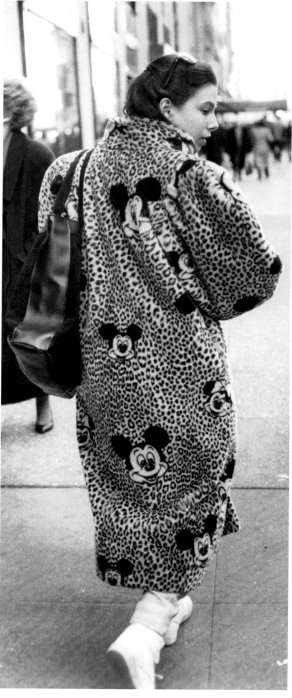

Left: Birds and animals were appearing on designer coats, and fake fur coats featuring Mickey Mouse were quite popular.
Opposite: Businessmen enjoy an alfresco lunch.

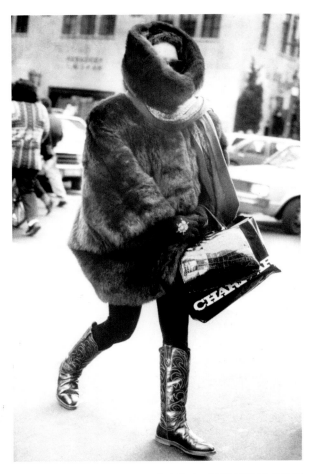

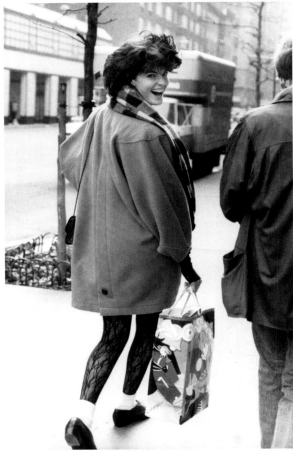

Right: Winter coats and jackets, along with bags from the long-gone stores Charivari and Bonwit Teller, and a bag that states its purpose. *Opposite:* Shorter coats—many in bright colors—were favored by women, including Sandra Martin of *Essence (left)* and Barbara Walters *(top right)*.

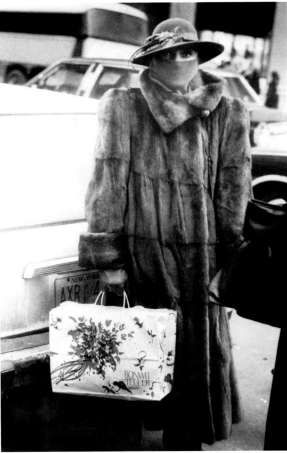

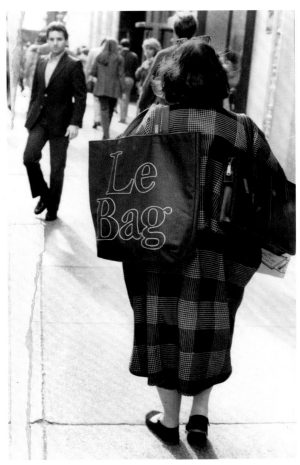

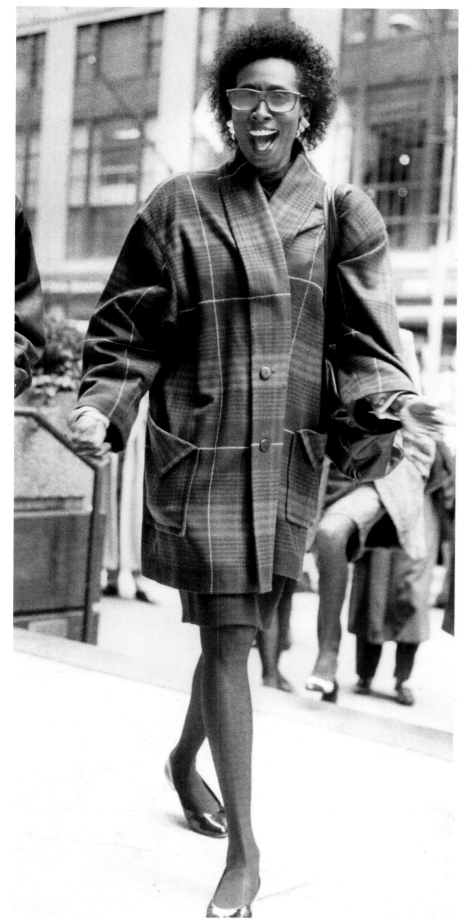

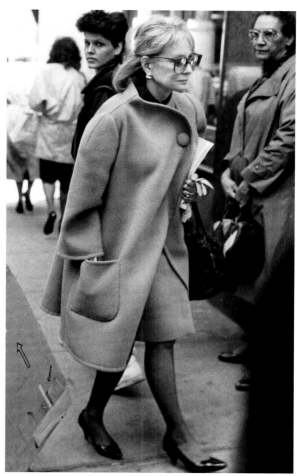

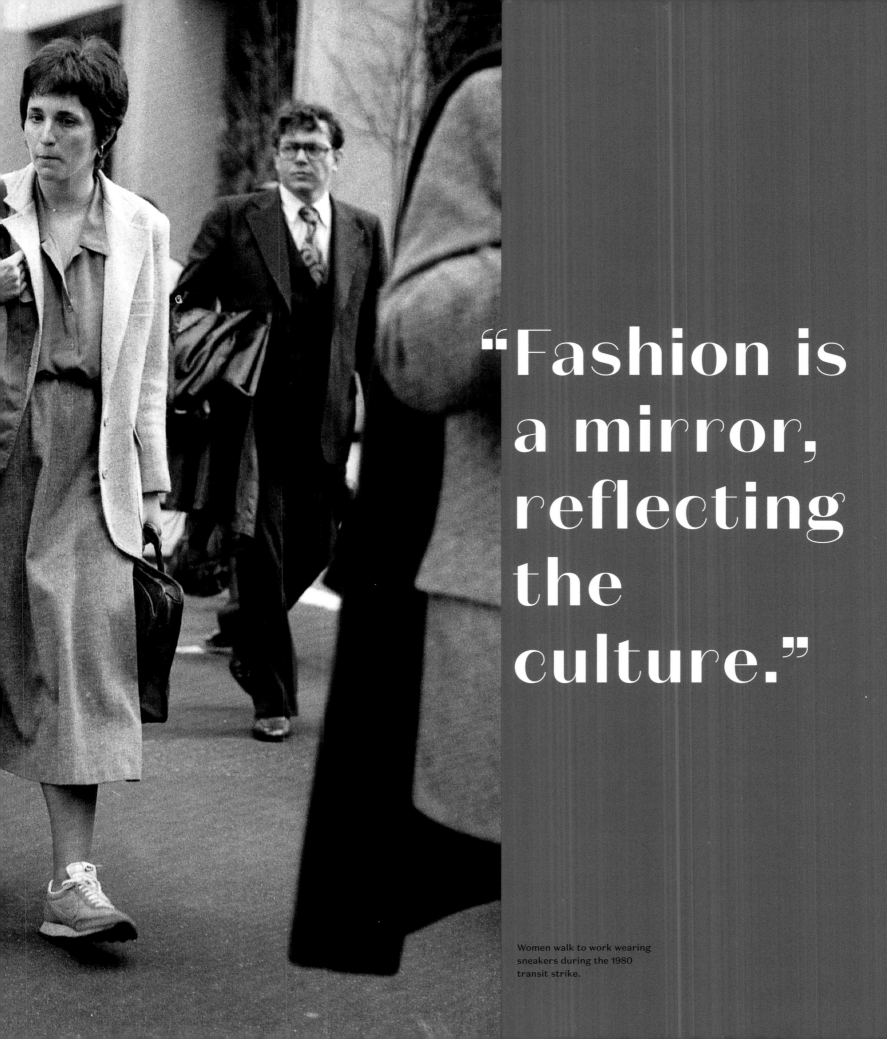

"Fashion is a mirror, reflecting the culture."

Women walk to work wearing sneakers during the 1980 transit strike.

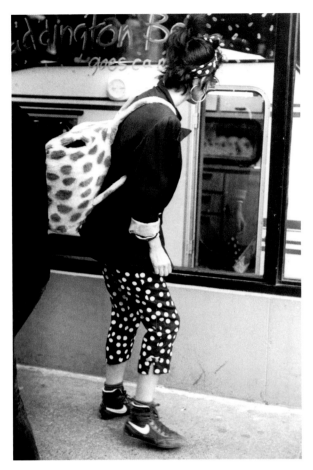

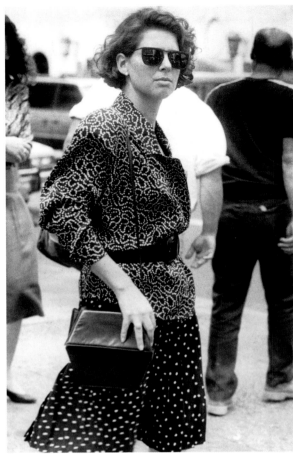

Polka dots and stripes challenge designers and customers to take these staples and push them into more interesting territory. *Right:* Dots appear on clothing and accessories and are even created on existing clothing by poking holes in a sweater and shoes to continue the motif *(below right)*. *Opposite:* Stripes, seen here, can be counted on to elongate the torso when vertical and signal a sense of whimsy when horizontal. Louise Doktor combines stripes with a windowpane pattern *(below right)*.

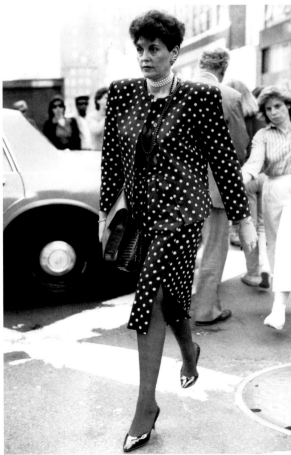

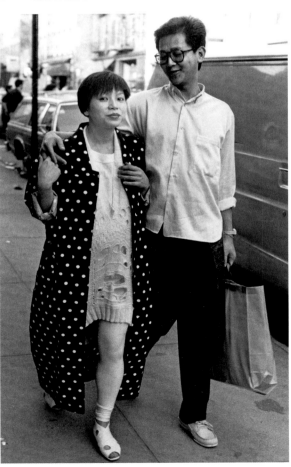

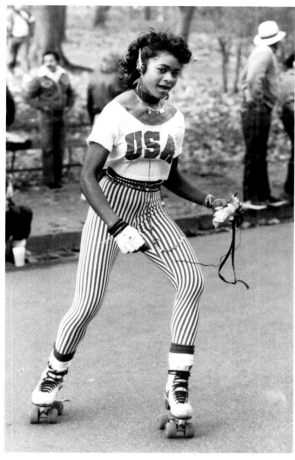

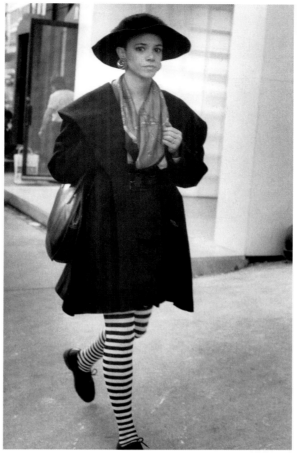

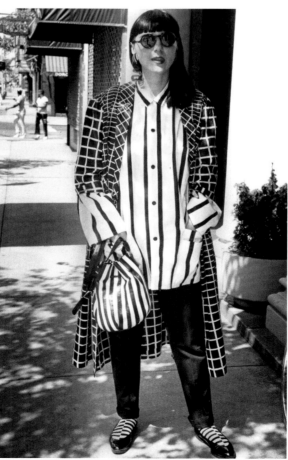

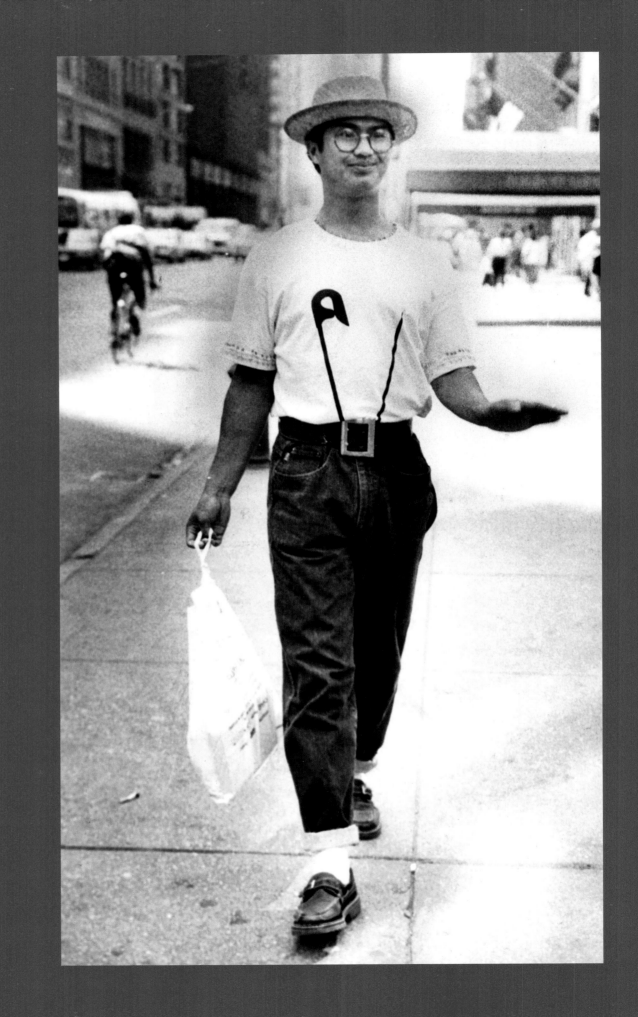

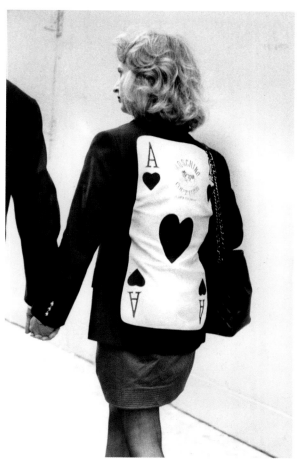

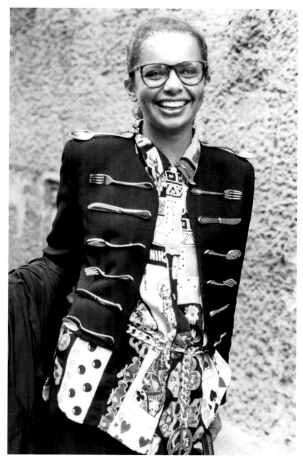

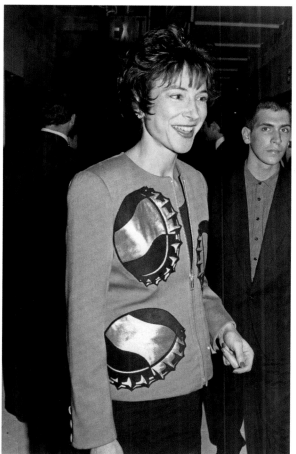

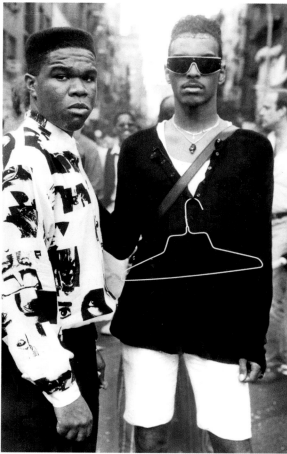

Bill was always eager to document those who dressed with a sense of humor. The designer Christian Roth adopted what Bill called a "Warholian approach" to his line of jackets, decorating them with giant appliqués of bottle caps, and Franco Moschino opted for an ace of hearts on his jacket designs. While a white shirt was printed with a safety pin *(opposite)*, Bill noted, "For most original—and least expensive—decoration, the award goes to the clotheshorse who dangled a white hanger from a black V-neck sweater" *(below right)*.

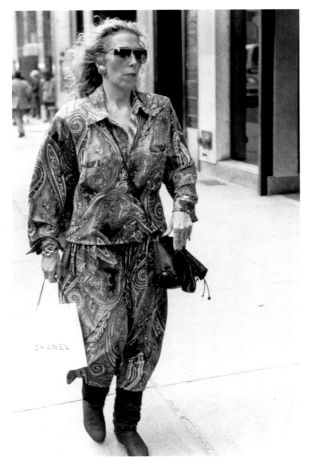

Paisley and bold patterns were everywhere, along with what Bill referred to as updated twin sets *(opposite)*. ***Below left:*** The designer Marc Jacobs, with Bill's muse Louise Doktor, at an event in honor of his first collection for the Sketchbook label.

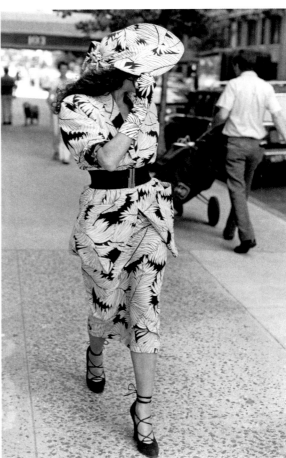

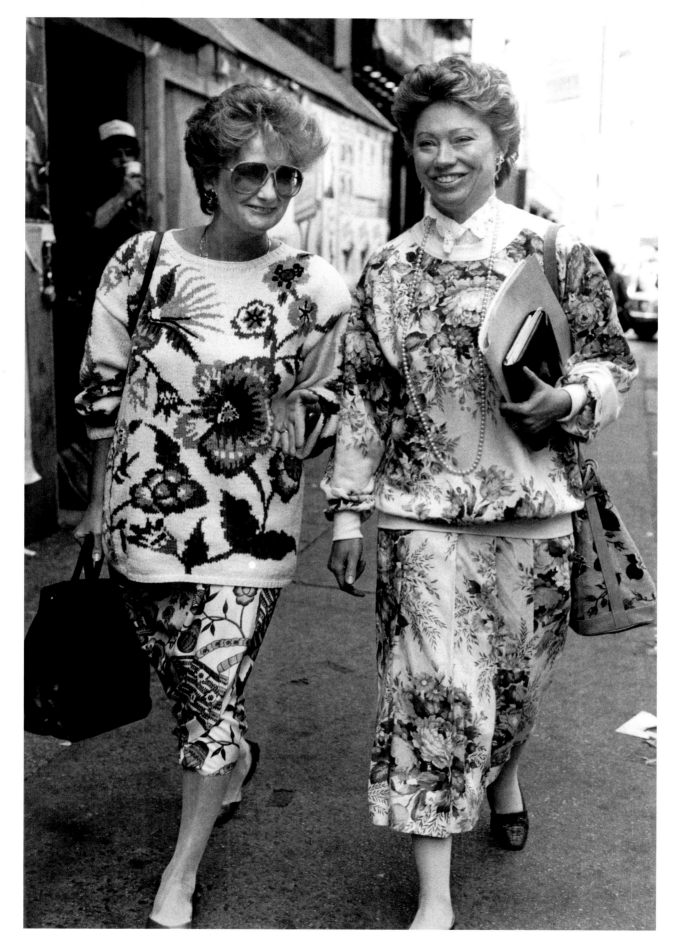

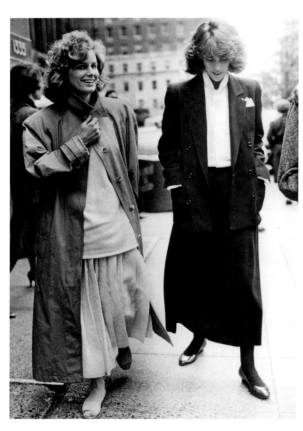

"Swashbuckling" is how Bill described the long coats popular in the early 1980s. Skirt lengths were similarly long, and an ankle-length trumpet skirt *(opposite page)* was worn with an oversize sweater.

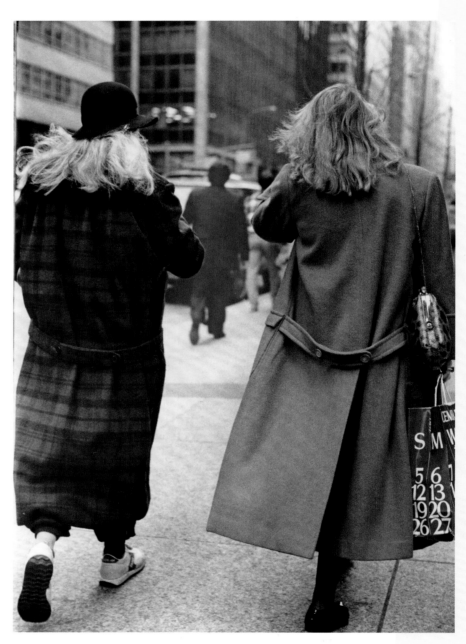

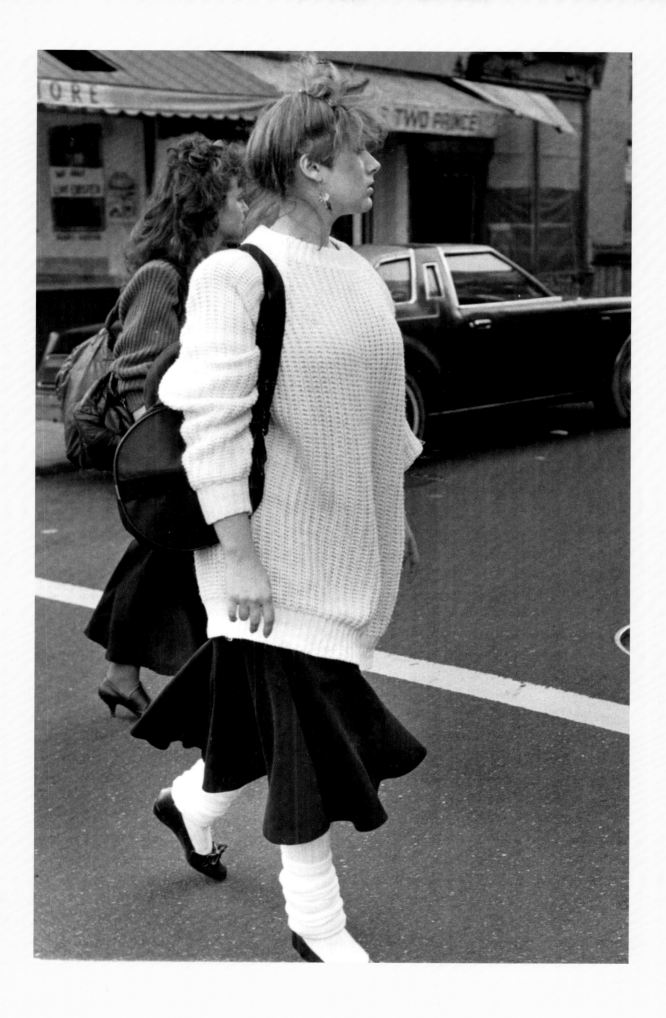

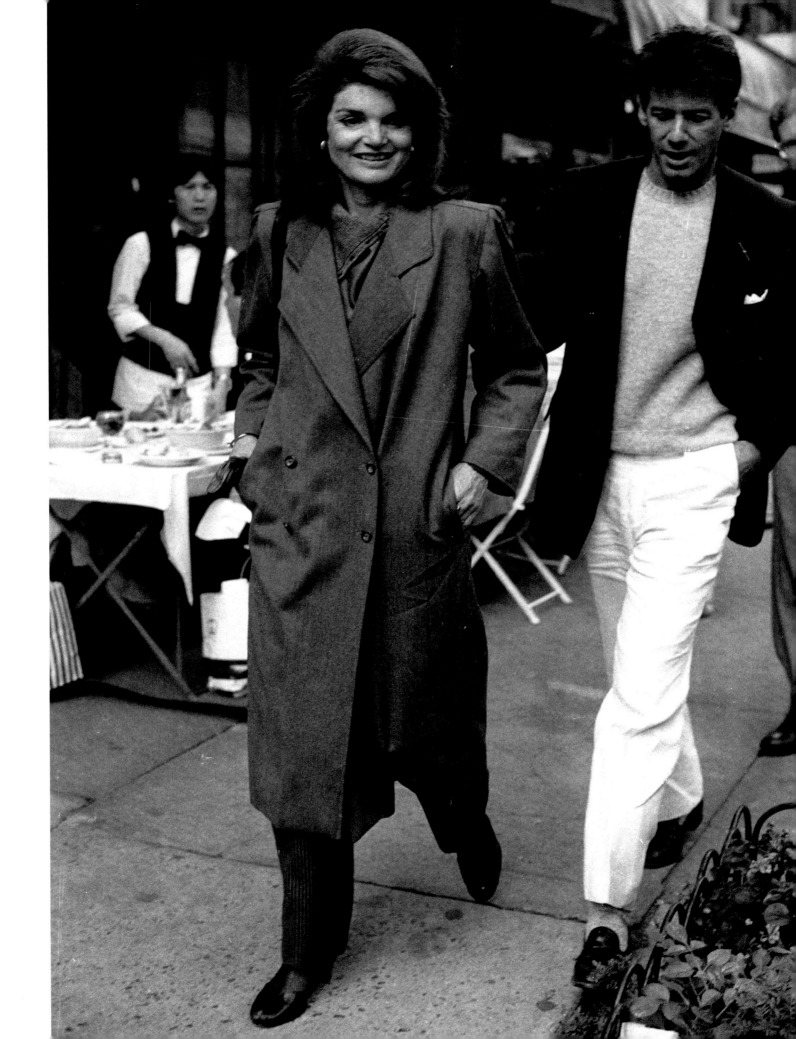

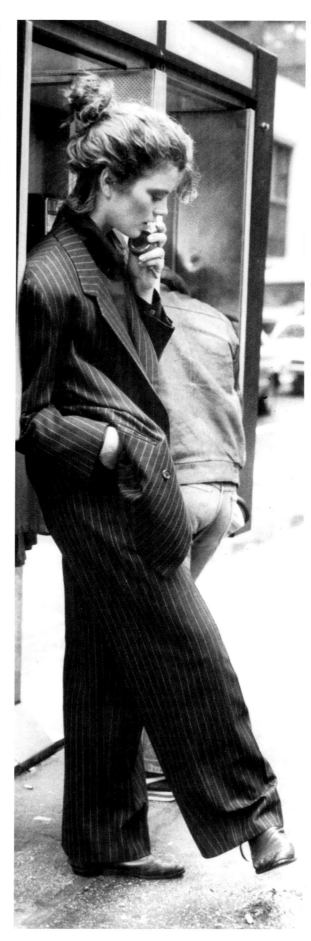

Left: Women's trouser legs expanded and became more fluid in the late 1980s. "The word for trousers right now is epic, with roomy, loosely cut legs that almost appear as if they could set sail in a good breeze," Bill wrote. *Opposite:* Jacqueline Kennedy Onassis and the designer Calvin Klein, 1983.

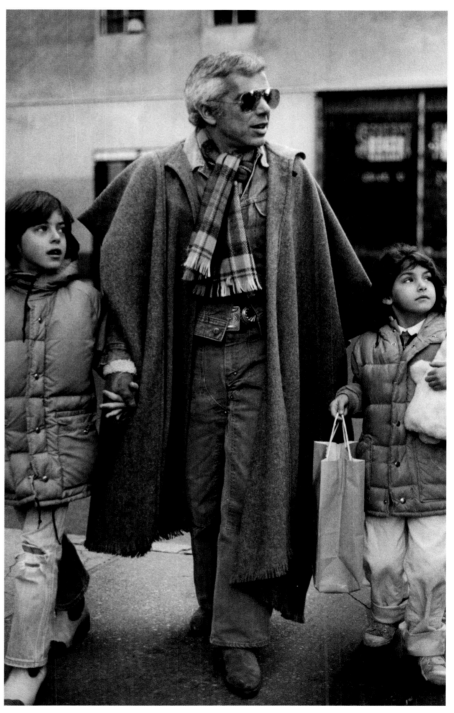

Left: The socialite Nina Griscom. *Above:* The designer Ralph Lauren with son David and daughter Dylan, 1980. *Opposite:* Claude Montana's soft pantsuits with plunging lapels.

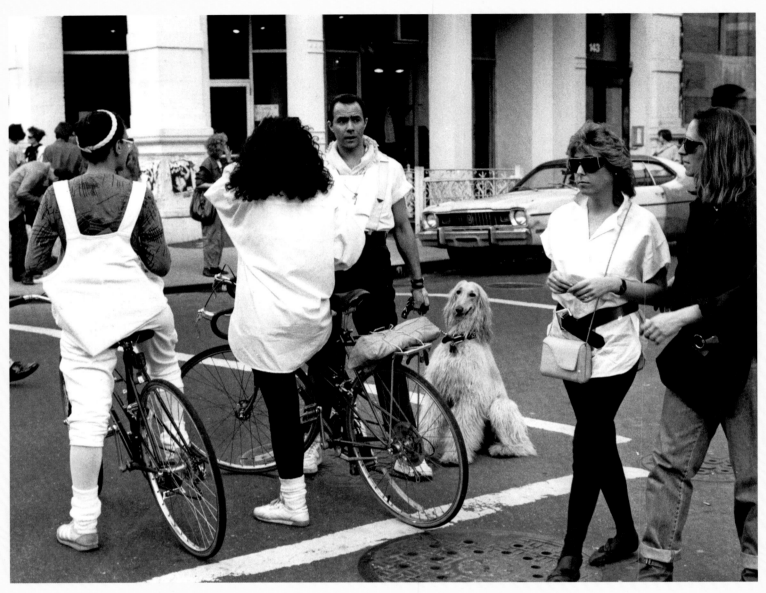

"There are a lot of shirttails flapping in the spring breezes these days that are not likely to get tucked in," Bill wrote. "They are part of oversize shirts meant to cover about the same area as a beach blanket."

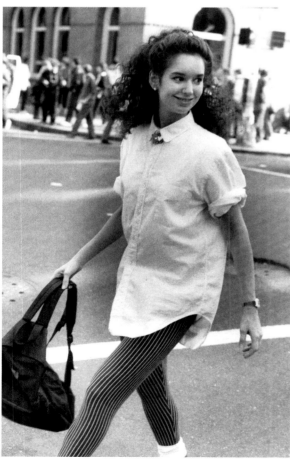

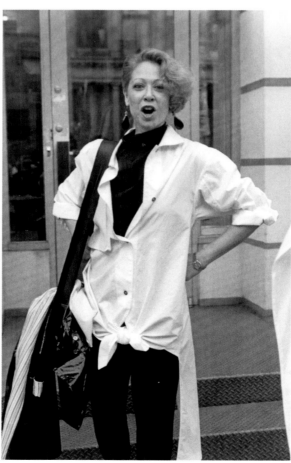

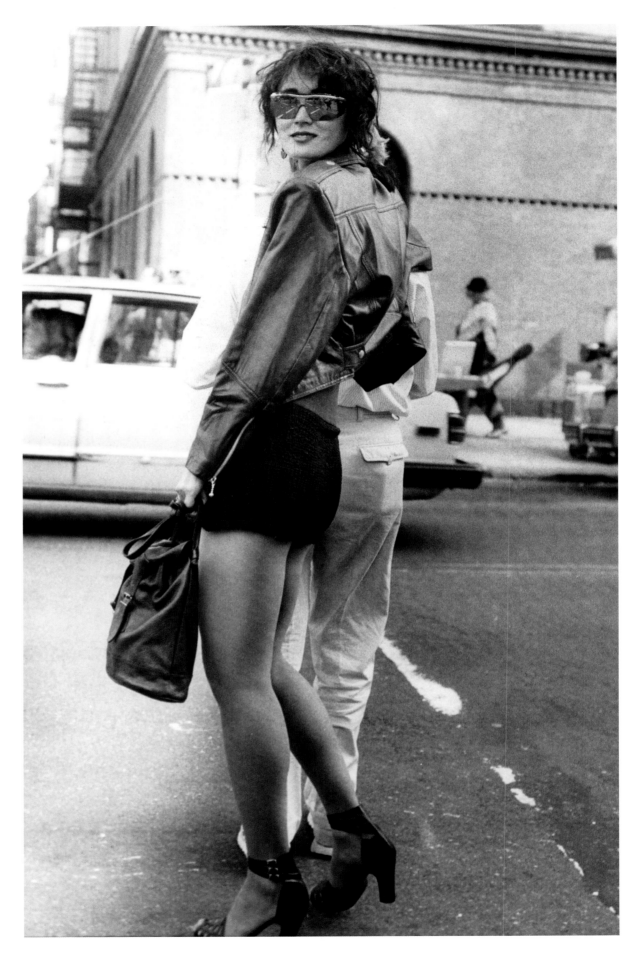

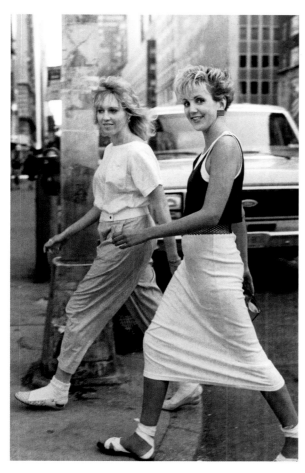

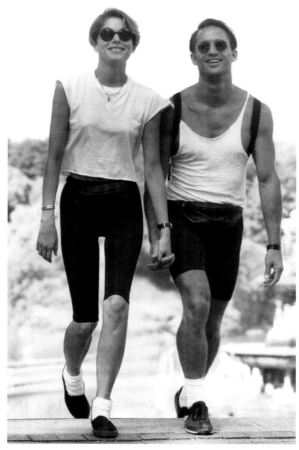

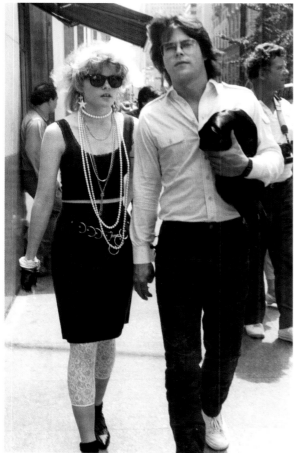

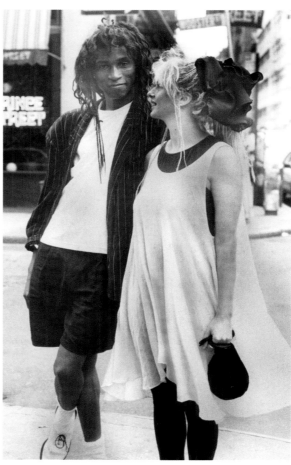

Left, above: Skirts were being made of knitted and stretch fabrics, and Lycra stretch pants or racing pants were seen on nonracing, stylish New Yorkers. *Left, below:* Madonna's influence and downtown daywear. *Opposite:* Bill noticed a marked rise in hemlines in SoHo and Greenwich Village, 1987.

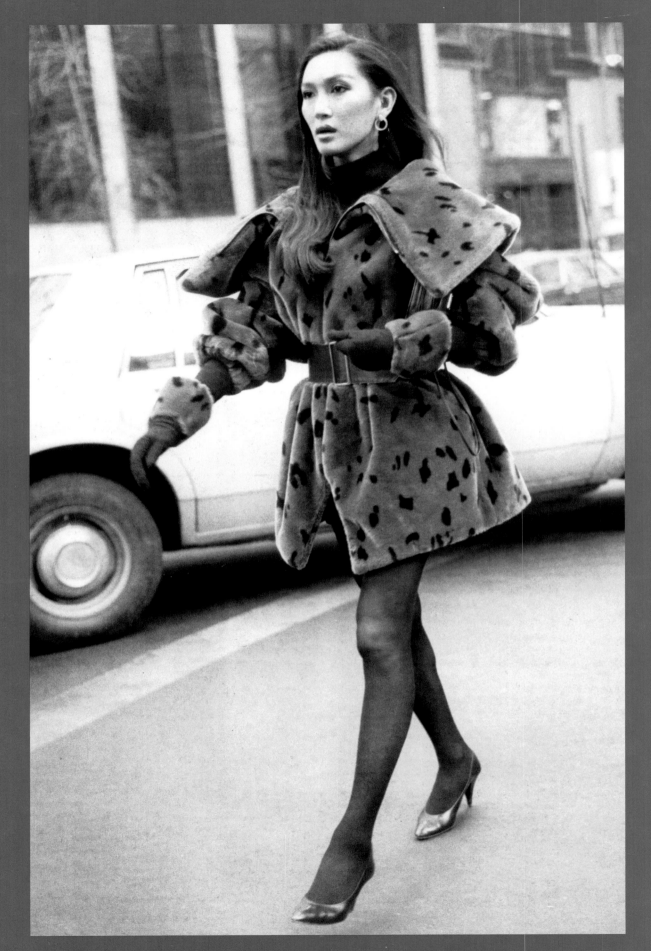

"The waist . . . has come out in the cold this winter," Bill wrote, referring to the hourglass shape of coats and jackets. "The dramatic silhouette of a chic, slim woman in a peplum is a proven head-turner."

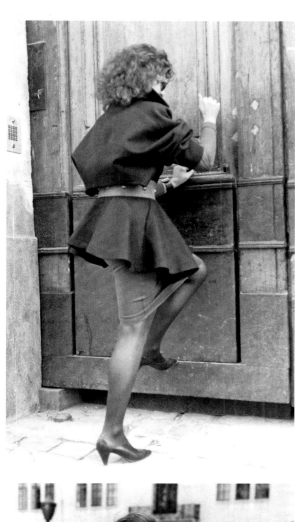

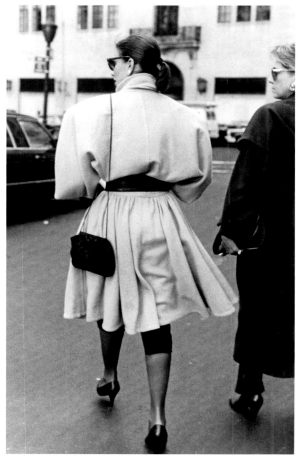

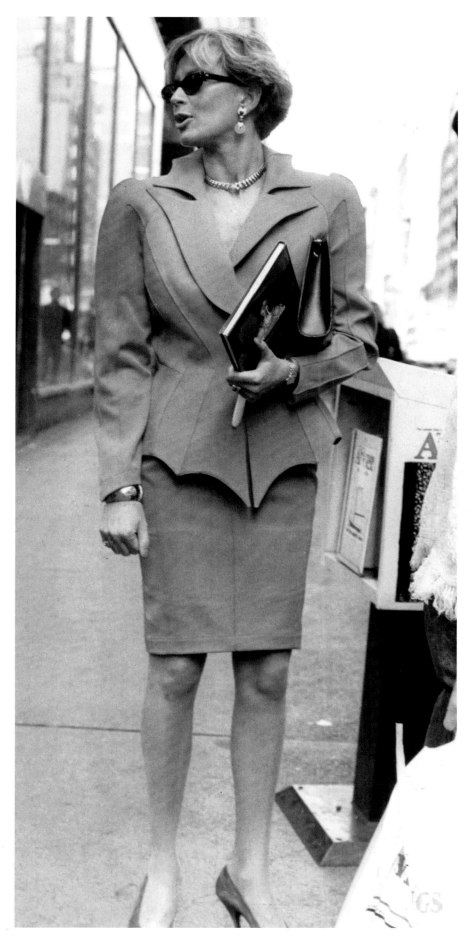

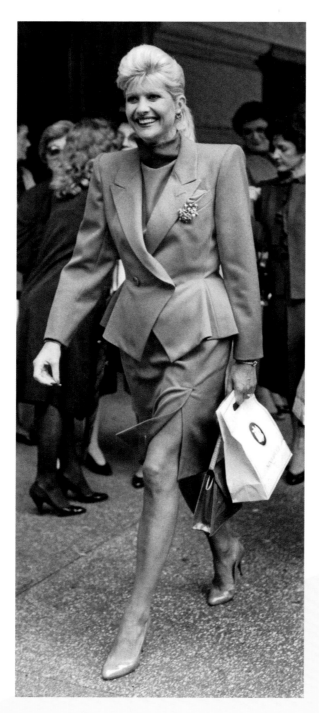

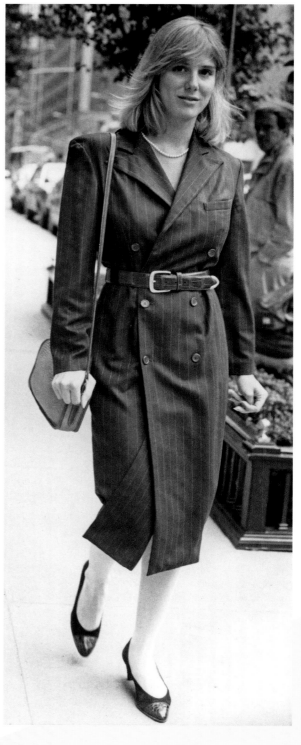

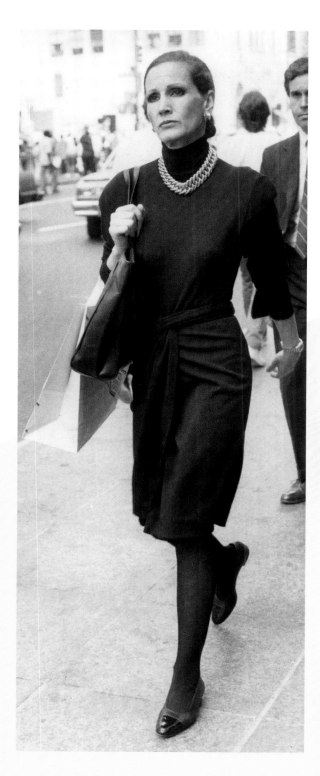

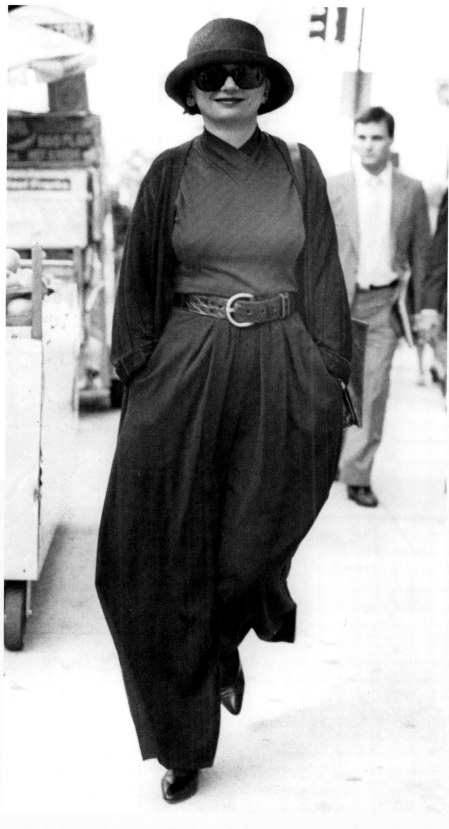

Left: Donna Karan's draped black jersey skirt and jersey bodysuit, usually worn with gold jewelry. Trousers also seemed draped, with a soft, billowy look. *Opposite:* Shoulder pads were a staple of what was called "power dressing" in the 1980s. Ivana Trump *(left)* in a suit, seen alongside a coatdress with broad shoulders.

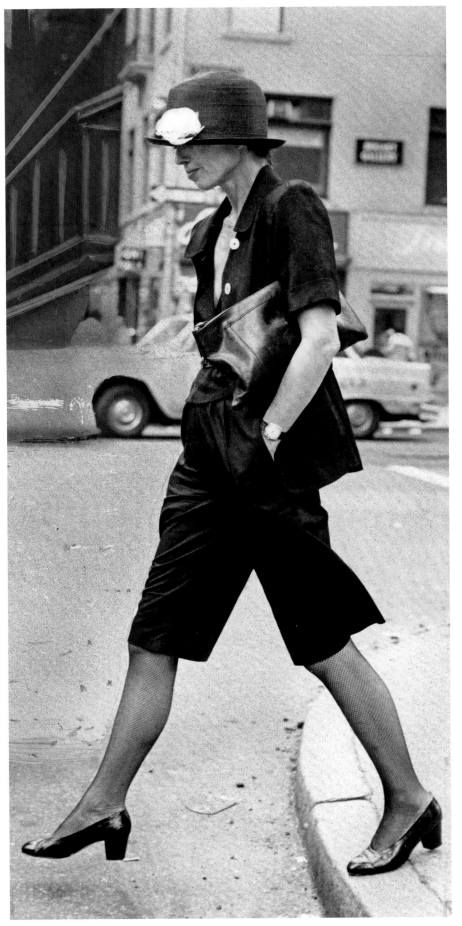

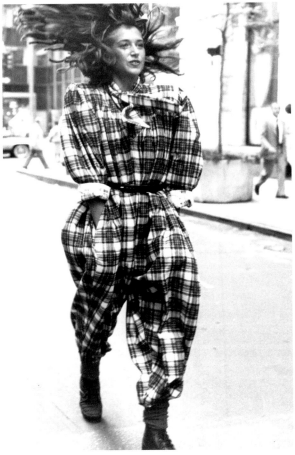

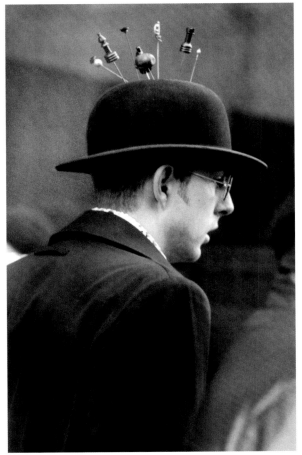

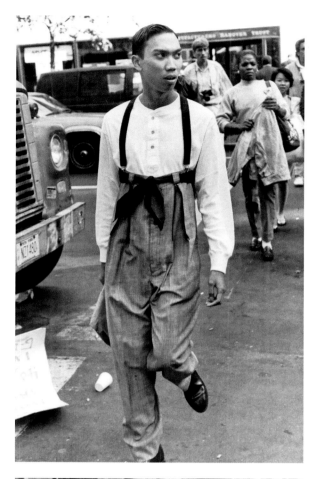

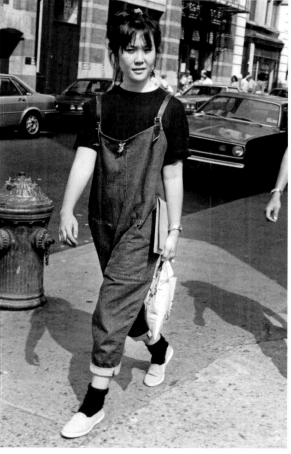

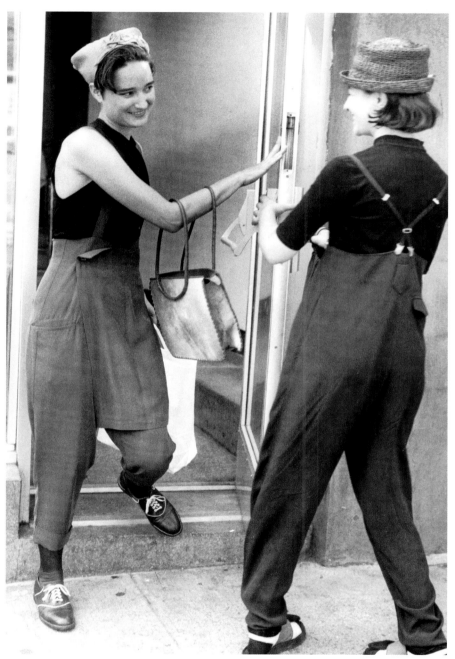

Left: Suspenders became a new accessory for men and women who used them to hold up generously sized trousers.
Opposite: Gaucho pants were a common sight in the early 1980s, as well as jumpsuits that also showcased an ample amount of yardage in the leg. It should be noted that the photo of the gaucho pants was retouched per Bill's instructions. The original frame had a passerby on the left side. He was removed and the background filled in.

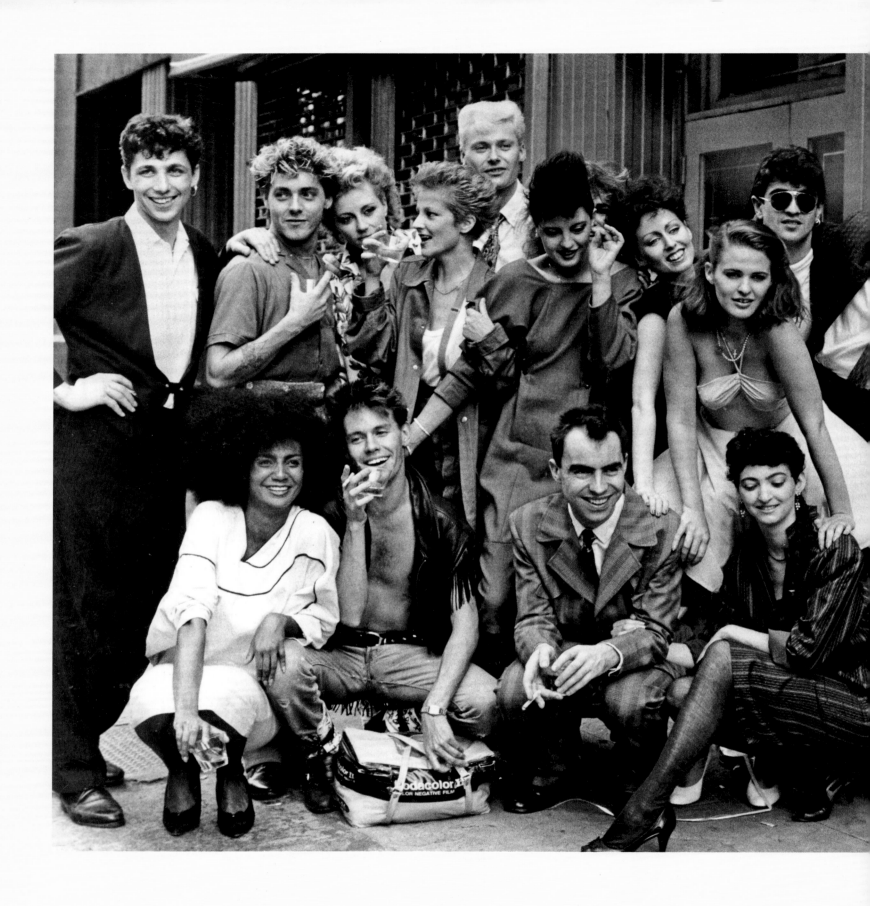

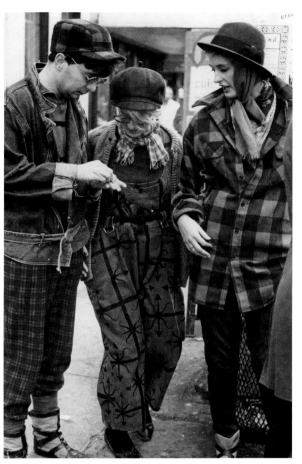

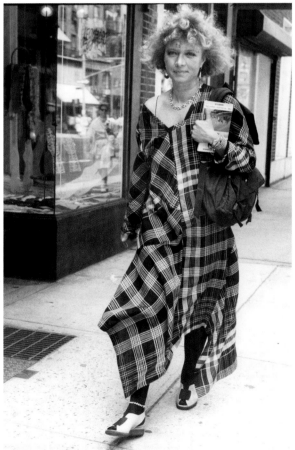

Above and left: Downtown fashion starts to move uptown; Bill wrote, "The newly transplanted styles range from updated versions of old-time glamour to looks that seem inspired by the urchins and chimney sweeps of Charles Dickens."
Opposite: After a small show of fashions, a lively crowd of English designers and guests spilled onto Broome Street in SoHo, 1982.

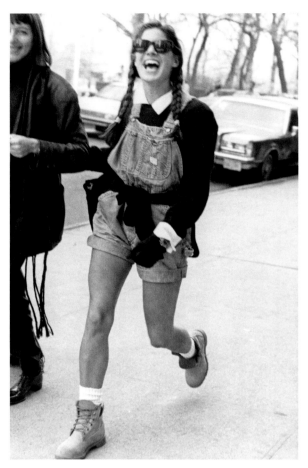

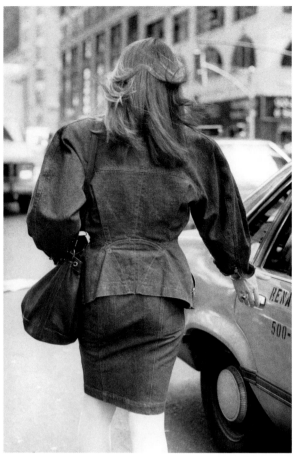

Denim goes in every fashion direction. Short overalls, suits, dresses, shirts, and a cropped men's jacket. And we also see the emergence of what was then called a "belt bag" *(below right)*.

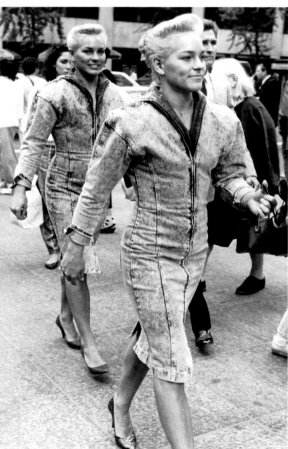

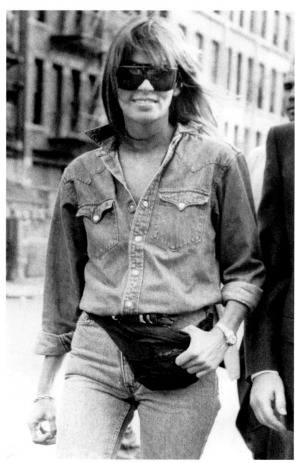

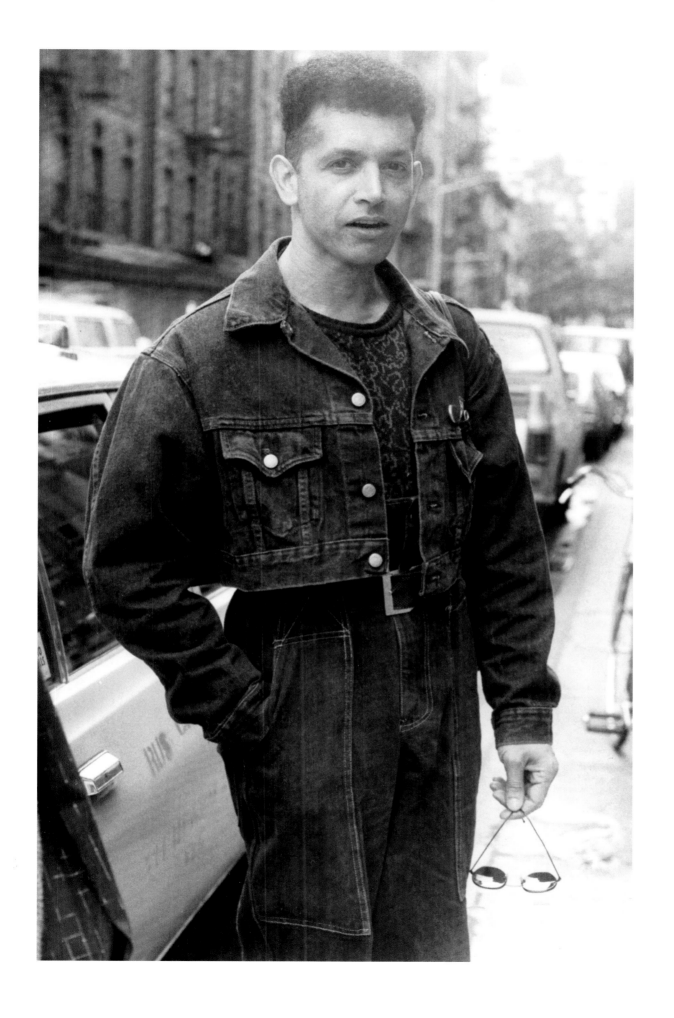

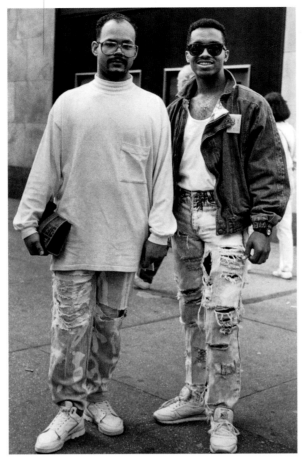

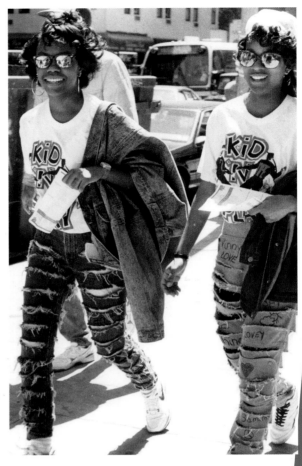

Bill wrote a column on "the blue-jean fad du jour: shredding, tearing and fraying. The focal point here is the knee, which shows through a hole torn out of the jeans to reveal it. The object is to make the hole look as if it resulted from long, hard wear."

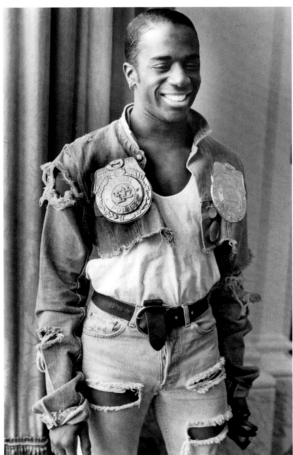

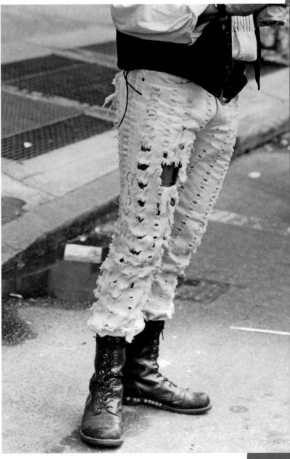

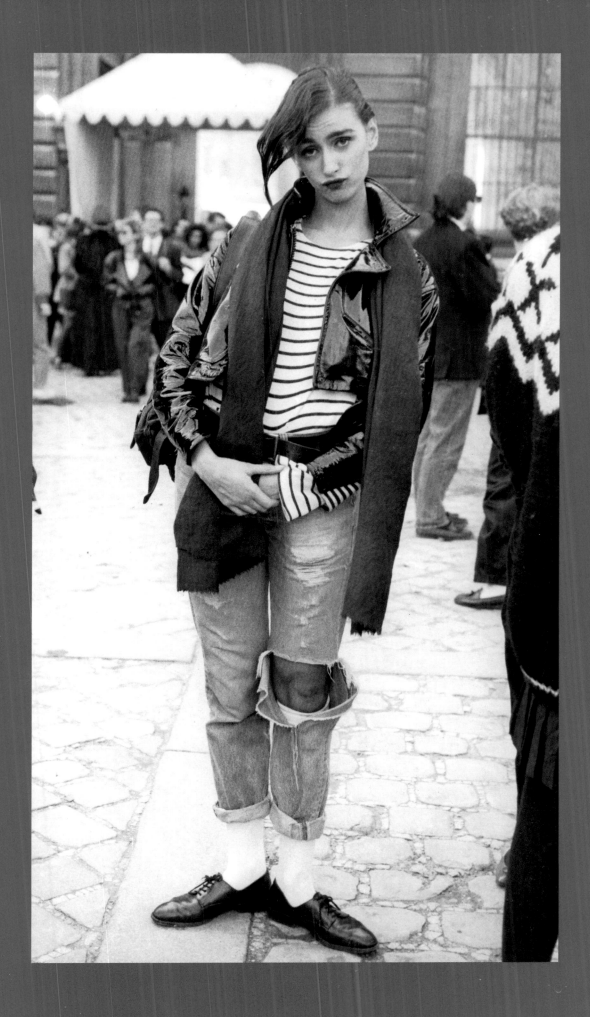

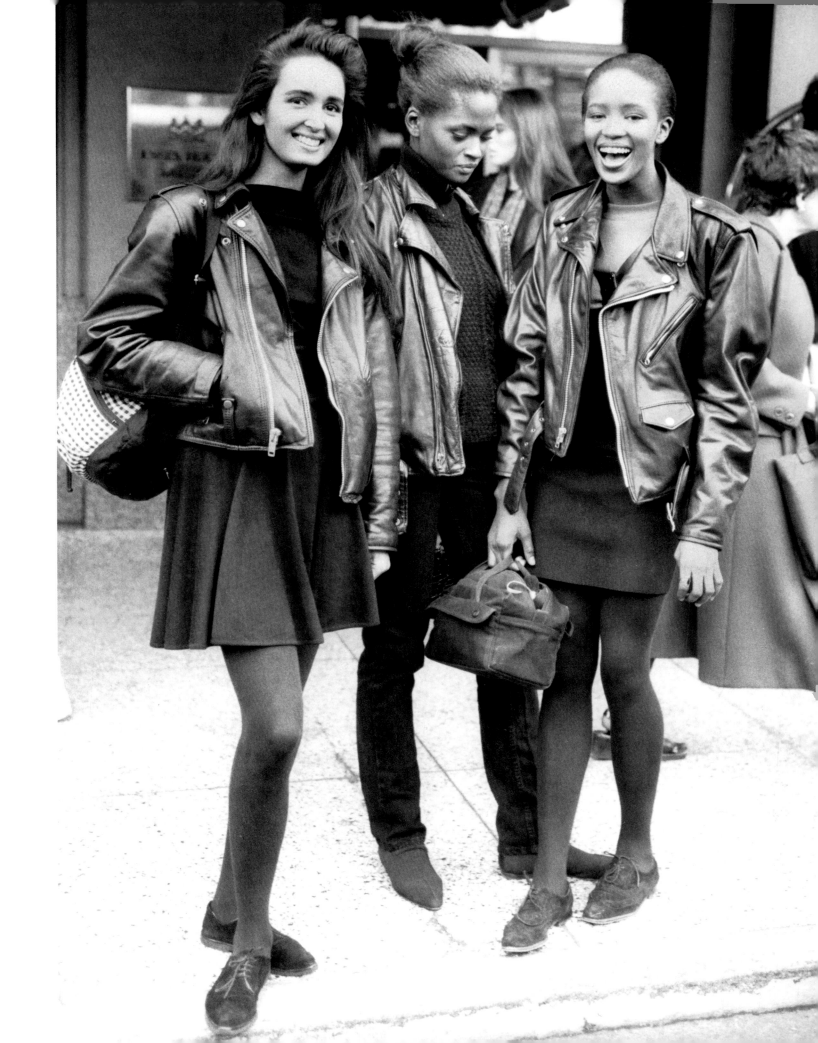

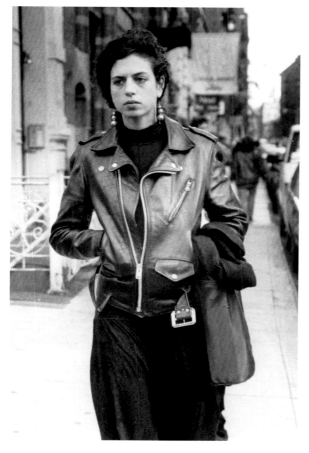

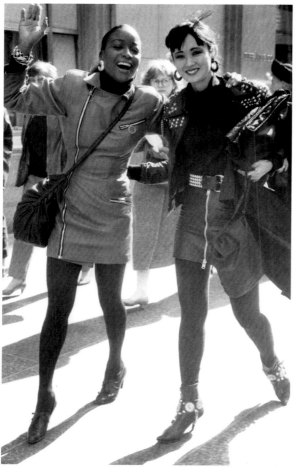

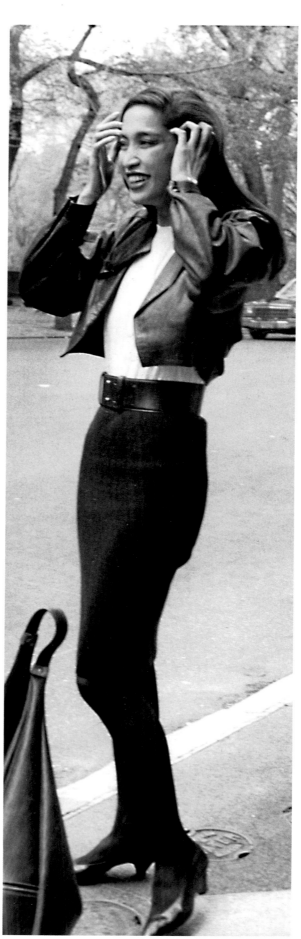

Left: Leather jackets were also seen in more fitted versions and in bolero styles. *Opposite:* Leather motorcycle jackets on the models Gail Elliott, Karen Alexander, and Naomi Campbell, 1987.

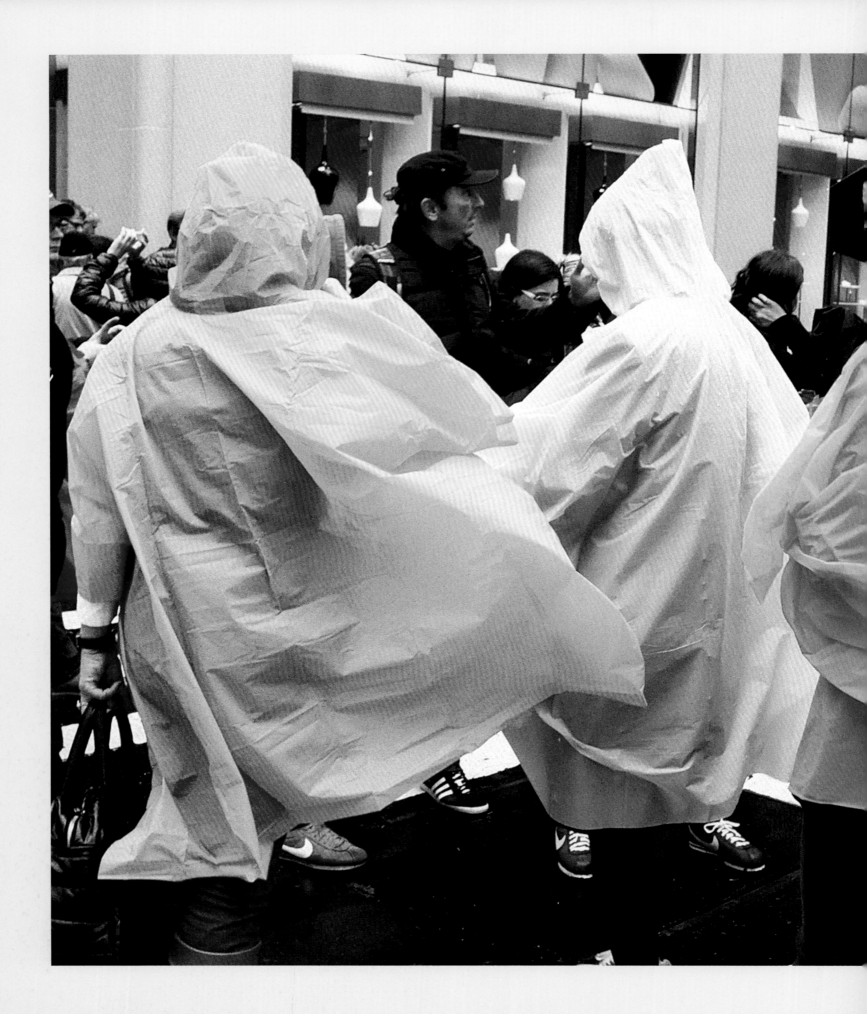

WHATEVER the WEATHER

PENELOPE GREEN
reporter, *The New York Times* Styles section

Bill loved weather. Real weather, which mostly meant florid, fantastic inclemency: blizzards, windstorms, and pelting rain. Maybe it was the New Englander in him. He captured the ballet of New Yorkers with their umbrellas, elegant and comedic, reveling in the moment when the humans lose control and the umbrellas reverse themselves. Slushy puddles—and how people navigated them—were another favorite.

"The snobs are so above it all, they think the waters will part for them even as they sink to their ankles," Bill, ever the populist, wrote in one December column.

On a gusty March day, he snared women with their hair aloft, including one whose curls rose like flames above her. The wind might prompt a history lesson, as he once shared a tidbit about Twenty-Third Street and Fifth Avenue. It was a corner that came to be known as "23 Skidoo" in the 1920s, he wrote, "because of the admonishment police would shout at men who waited there to see the wind lift the skirts of female passers-by."

Bill's own foul-weather gear was a cheap black plastic rain poncho that resembled a garbage bag and was prone to rips. He

People were back out on the city streets the day after Superstorm Sandy in 2012. This photograph is an example of Bill's ability to find fashion and style virtually anywhere.

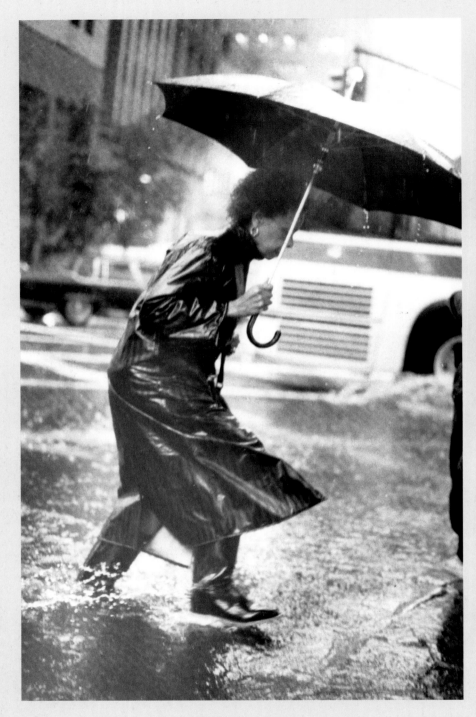

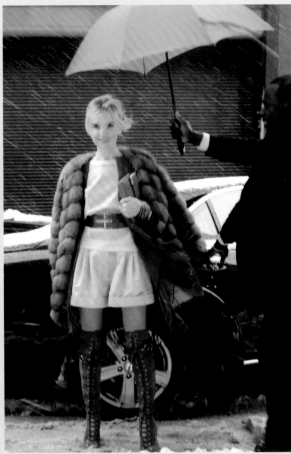

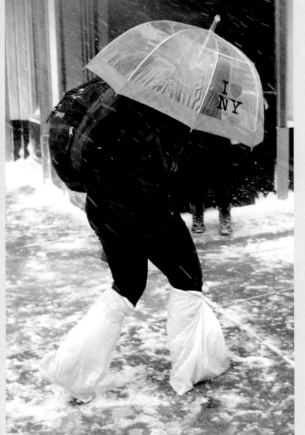

repaired it frequently with duct tape, as he did the pockets of his blue jacket.

Weather, Bill knew, was the great leveler.

"When it rains, it's a whole different scene. Or when there's a blizzard, it's the best time," he told the filmmakers of *Bill Cunningham New York,* the 2011 documentary. "Things happen; people forget about you. If they see you, they don't go putting on airs. They're the way they are. Then you're in business."

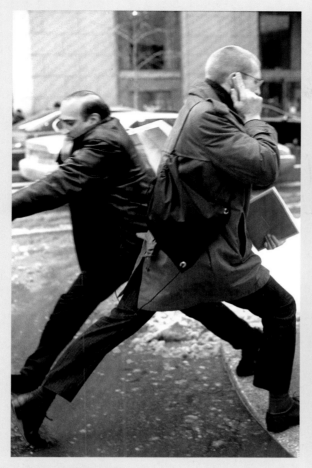

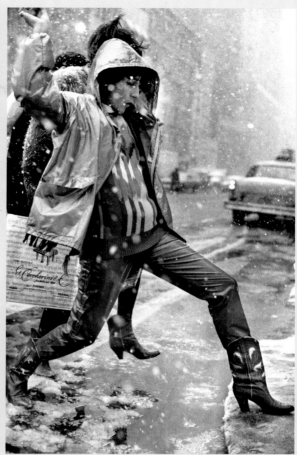

Bill did several columns filled with "puddle jumpers," capturing the athletic and balletic movement of some people and the "oops" moments of others.

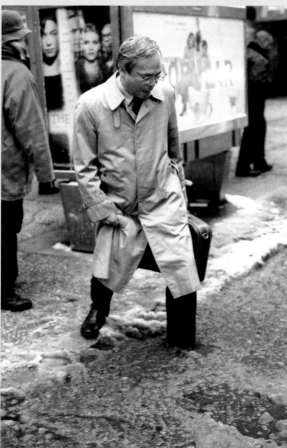

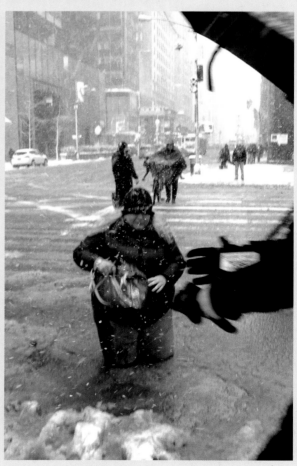

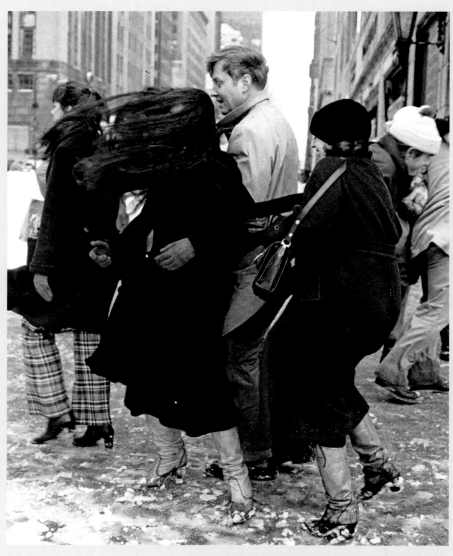
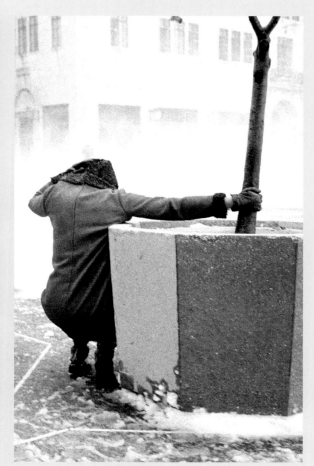
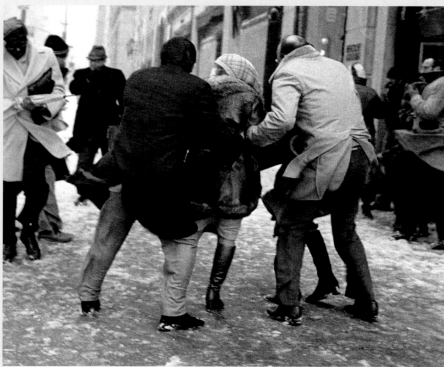
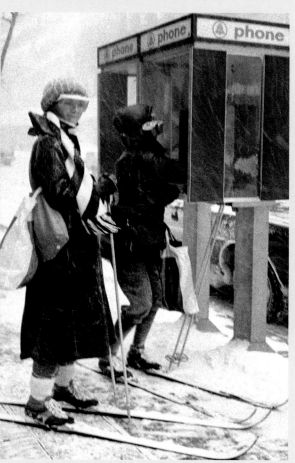

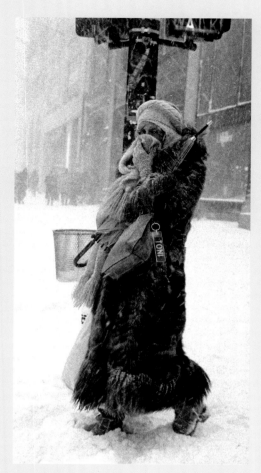
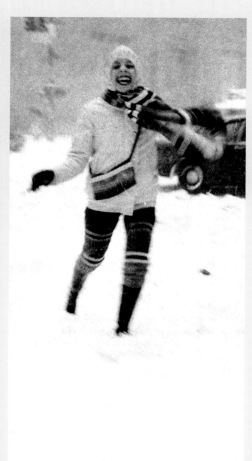
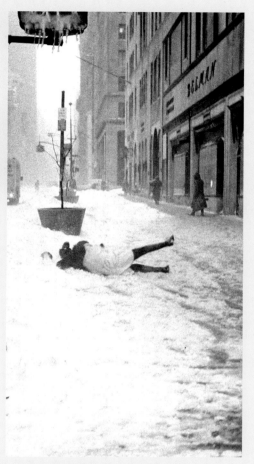
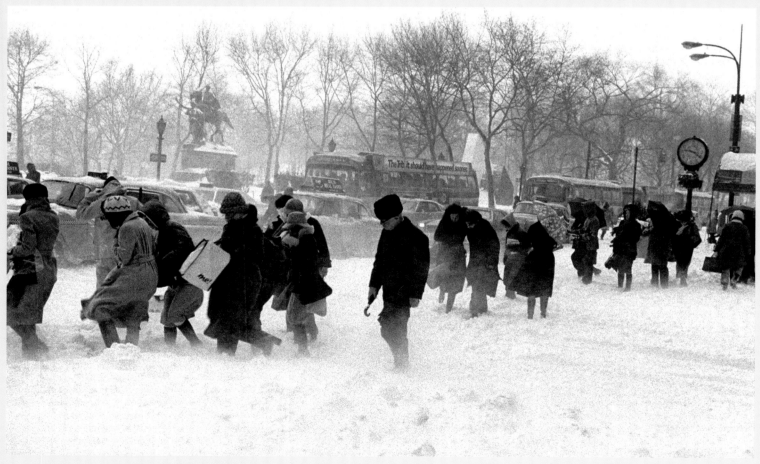

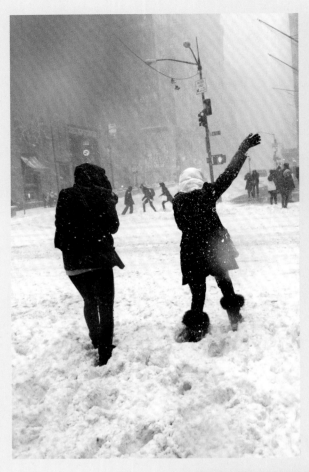

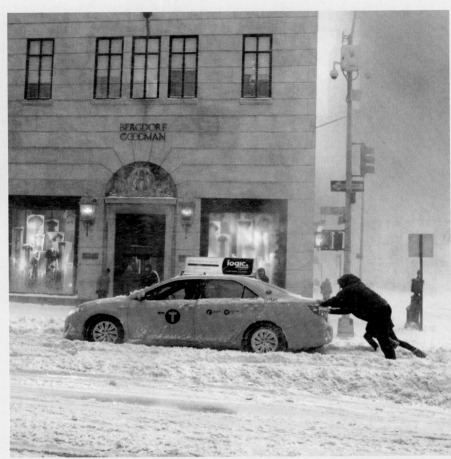

Most of the black-and-white photographs on the previous pages are from a blizzard in January 1978. Bill noted that winds were gusting up to fifty miles per hour. He was braving the elements himself and shooting perhaps less for fashion, more for humor.

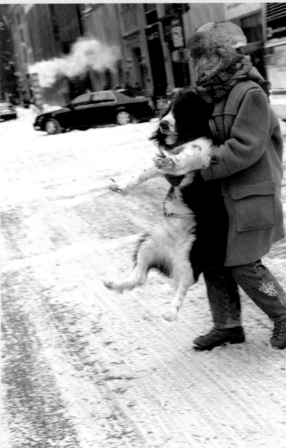

The worse the weather, the clearer the moments of absurdity became.

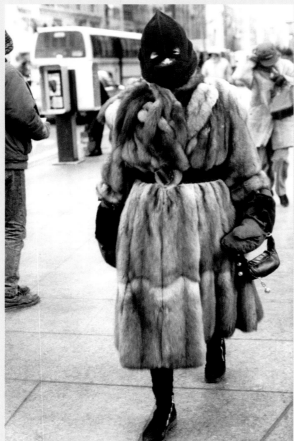

In summer, Bill let fashion illustrate how New Yorkers stayed cool. One woman *(opposite)* found a dress with an air vent in the back.

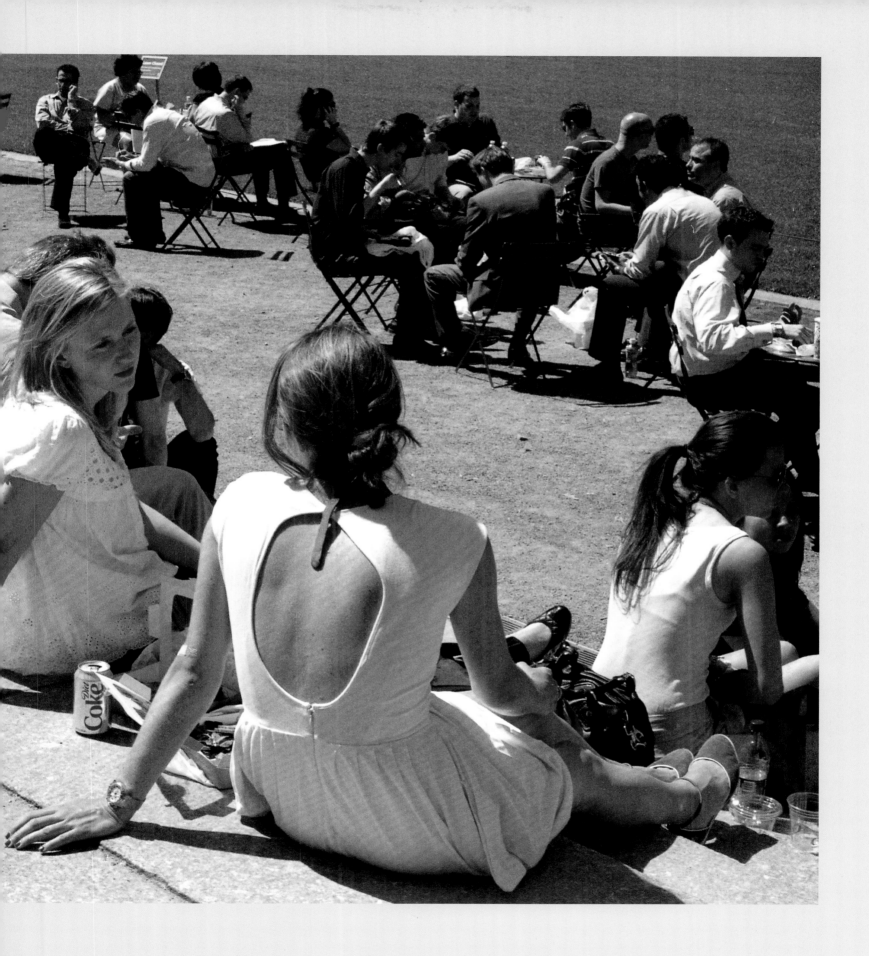

Another woman dressed to match Madison Square Park in the spring.

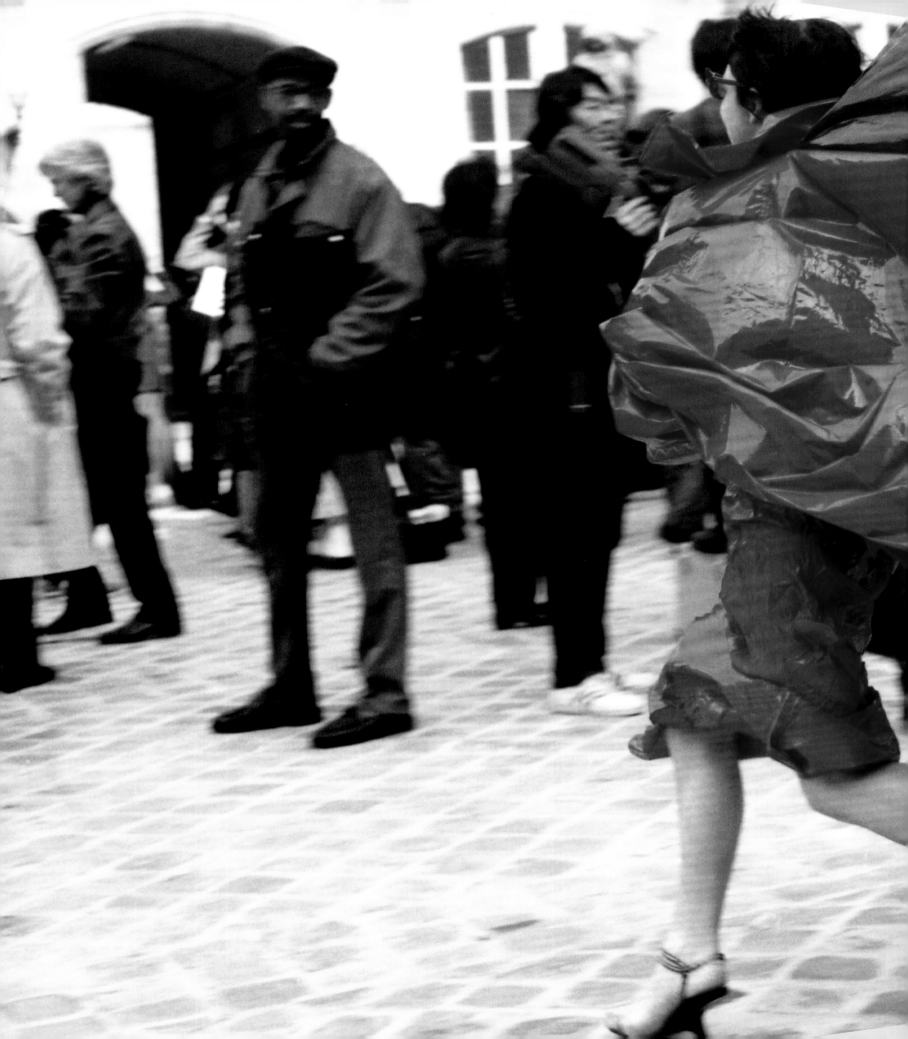

THE '90s

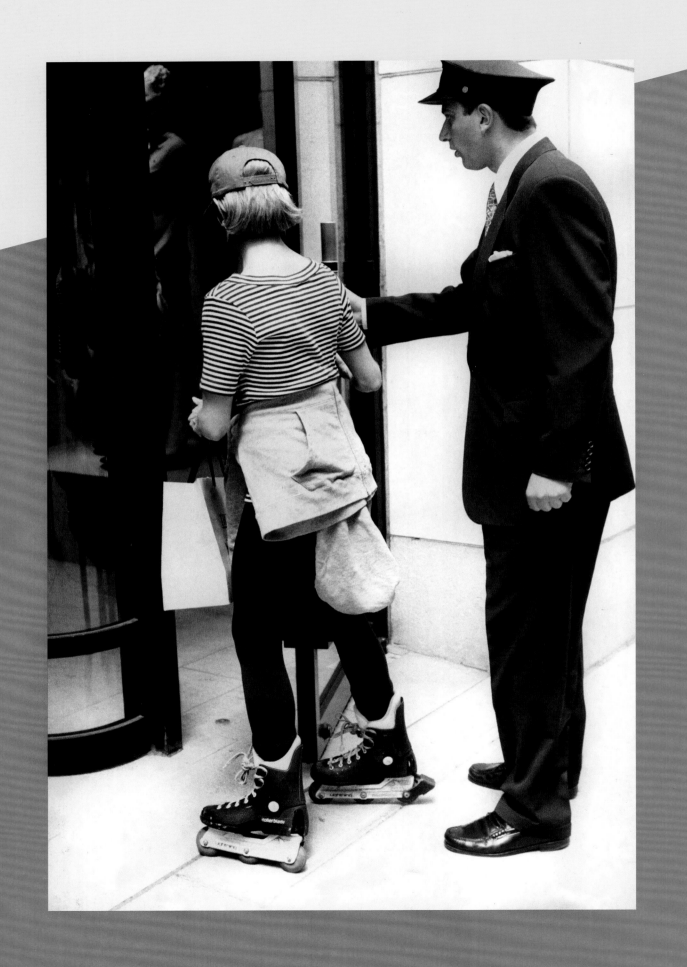

Bill's onetime client Jacqueline Kennedy Onassis died in 1994; she had arguably been the city's most fashionable woman. When her son's fiancée, Carolyn Bessette, stepped out of their Tribeca apartment two years later, blinking at the paparazzi, she rehabilitated the much-maligned midi and confirmed a new mode: minimalism.

A favorite of Bessette's, Prada was the ascendant label of the time, most evidently in the small nylon backpacks that regularly adorned adult women's shoulders. Having made considerable strides in the urban workplace, on their off hours women could now afford such playful schoolgirl references, which included thigh-high stockings, kilts, suspenders, and overalls. Some had even taken up skating again, wearing Rollerblades in the streets. Following the relaxed suiting silhouettes pioneered by Giorgio Armani, a new custom known as Casual Friday was eagerly adopted by both sexes, with many obeying the Gap's dictum: "Everyone in khakis!"

Having been ruffled, tiered, and structured like pastry in previous years, dresses of this era were stripped down to the point where they might forgivably be confused with slips. Skin was in, and tattoos proliferated, along with piercings. Floral prints were popular—but so, too, was camouflage. And designer logos, long hidden discreetly inside collars and seams, were now splashed pell-mell all over the outside of garments.

The paparazzi's pursuit of another fashion idol, Princess Diana, doomed her. But Bill had achieved status as a very different kind of photographer, one whose appearance on the street stylish women eagerly anticipated and even explicitly dressed for.

Previous spread: The stylist Isabella Blow in Paris, 1999. *Opposite:* "Are in-line skates about to become as ubiquitous as sneakers?" Bill asked. The woman pictured skated into the Barneys Madison Avenue store.

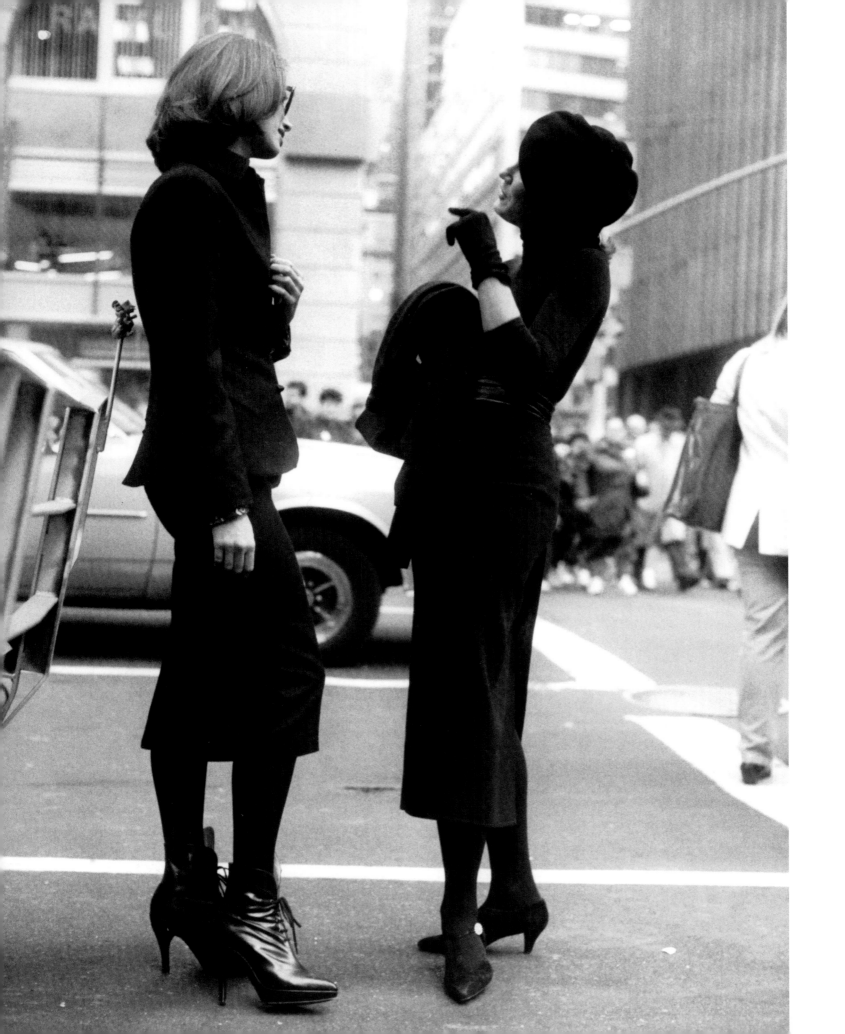

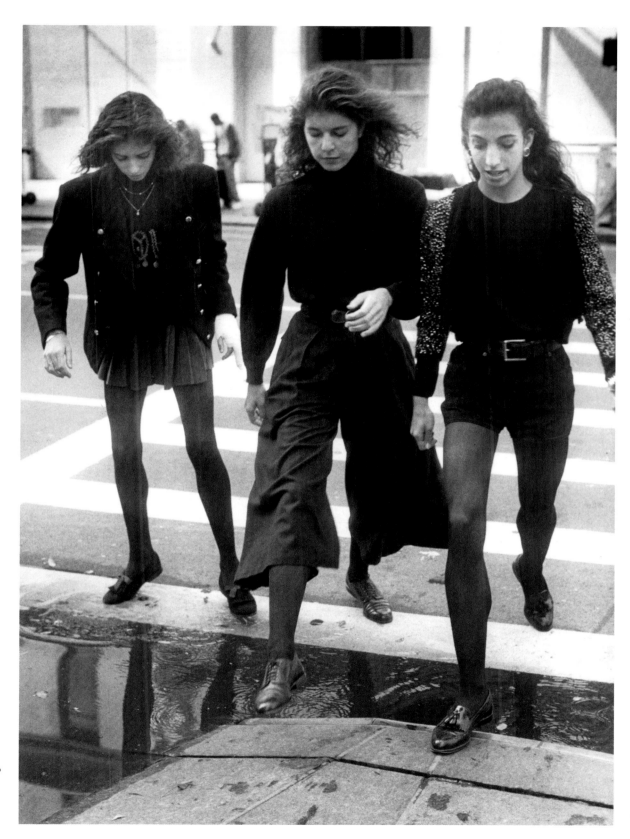

When covering New York Fashion Week in the fall of 1991, Bill summed up what he observed: "Length is a matter of choice, as long as everything is black. Skirts were long and short, full and narrow. Trousers were long or short, fitted or flared." He was especially excited about having captured the two women on the opposite page. "Their clothes spoke volumes about why fashion changes—boredom with the familiar."

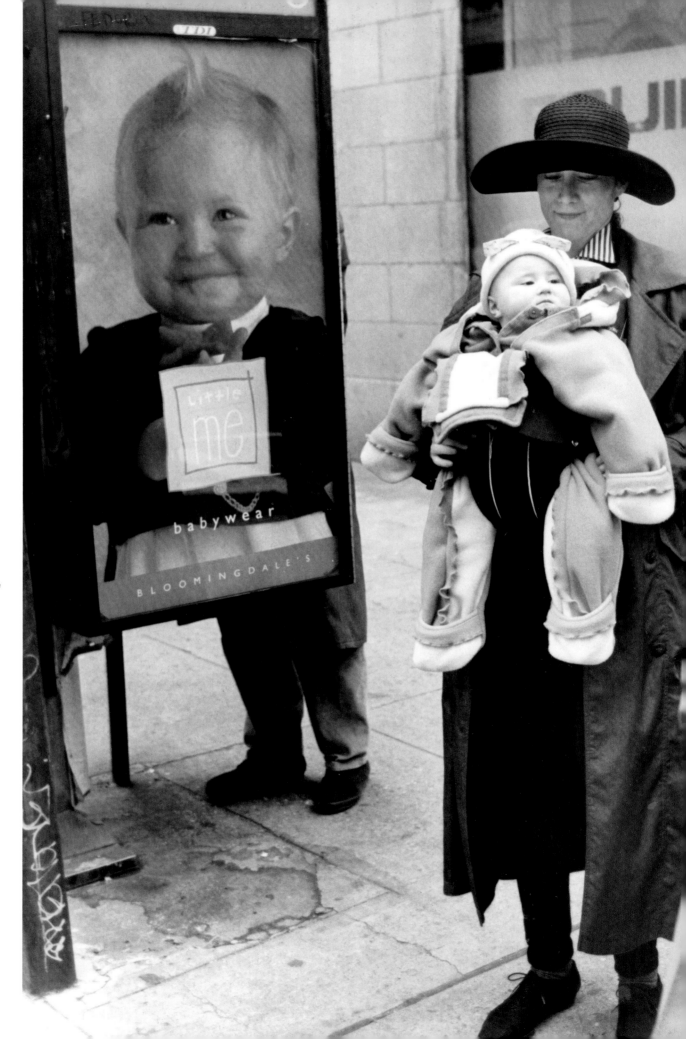

Right: Bill loved to focus on children during the holidays, and he used this photograph to show a baby bundled up in the cold. In order to accommodate more photographs in the column, Bill cropped out the baby on the poster, using only a severe crop of the mother and child in his layout, sacrificing the humor in this juxtaposition. *Opposite:* Many chose to bundle up in coats with a military influence.

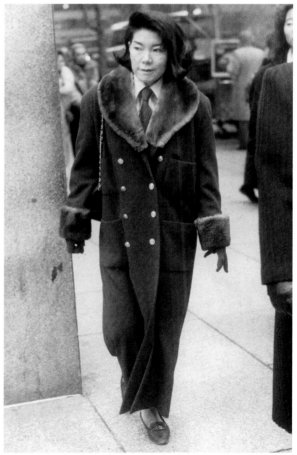

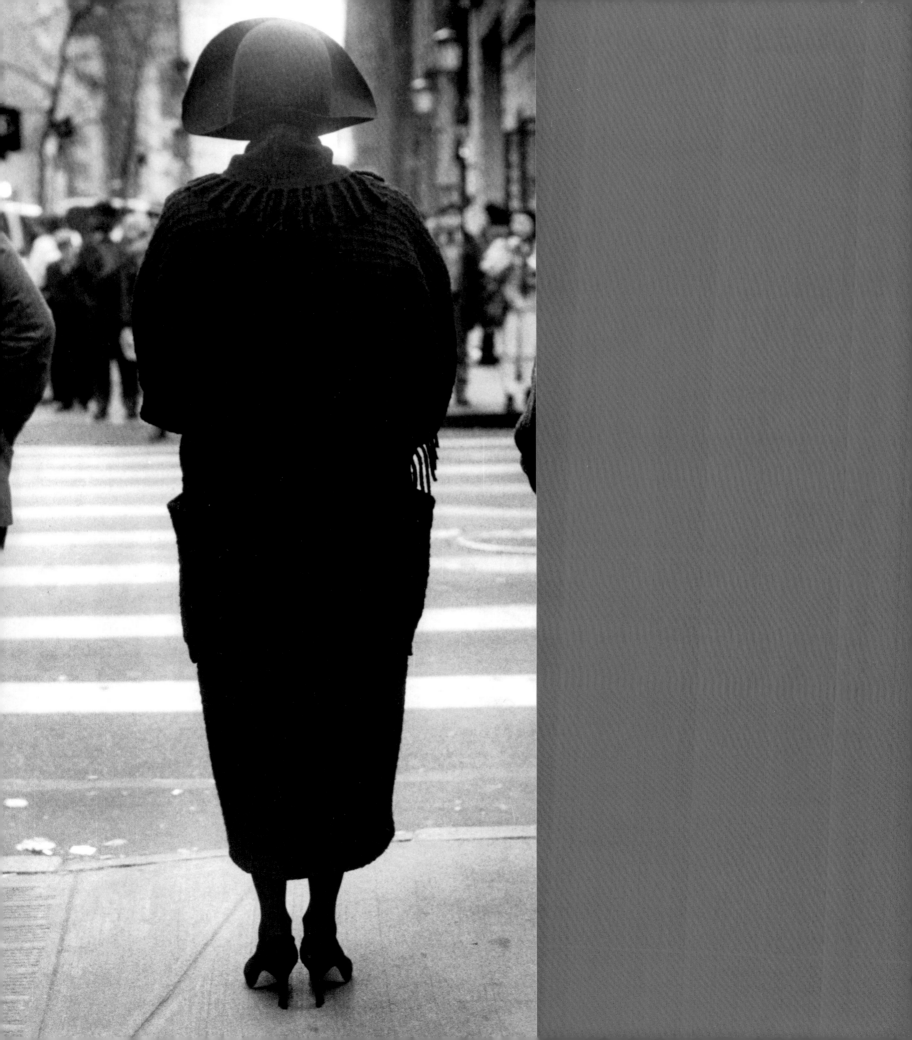

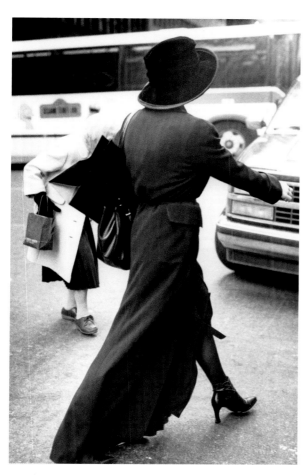

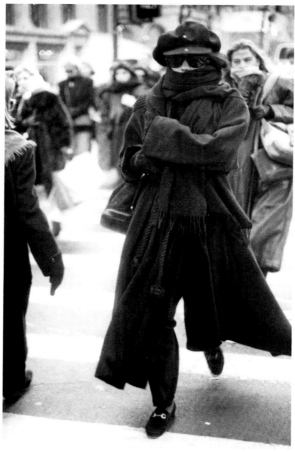

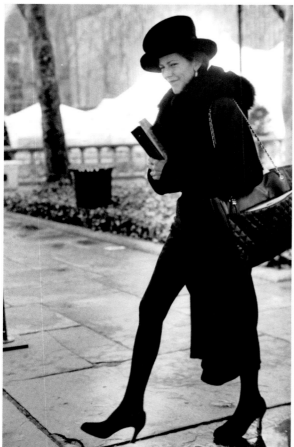

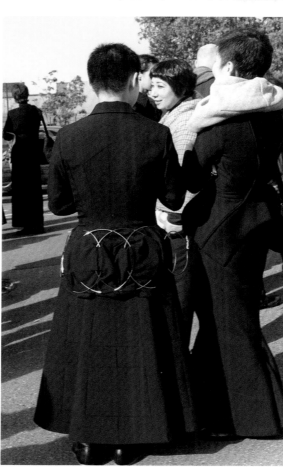

Coats with slender lines, architectural embellishments, and perhaps a touch of Edgar Allan Poe, according to Bill. Some of the wearers added dramatic hats.

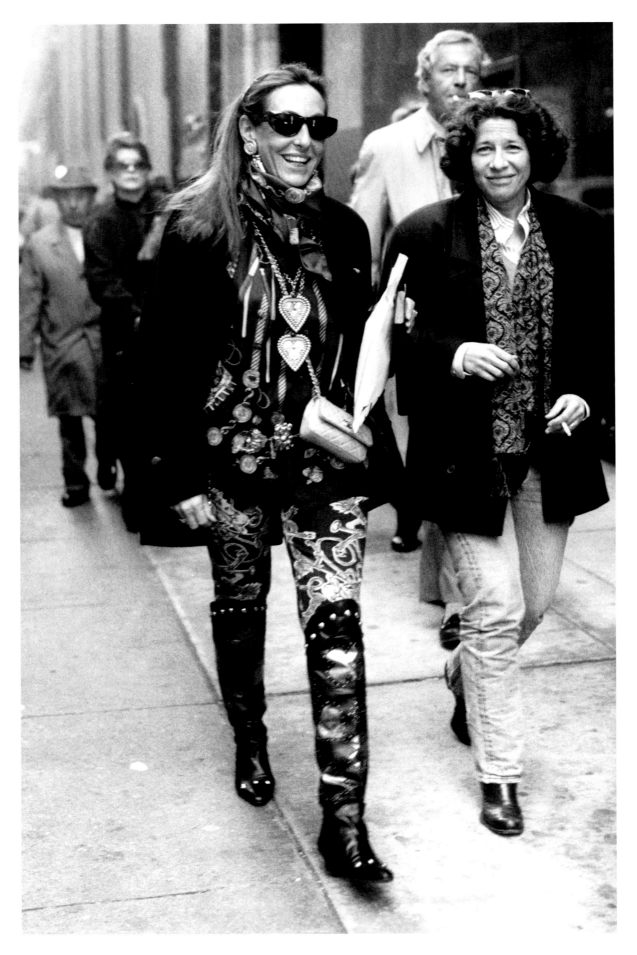

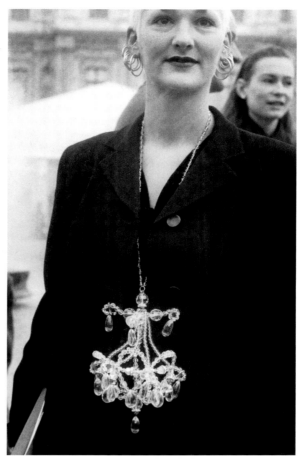

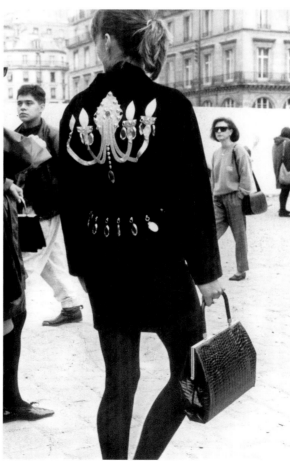

Left: Here we see a giant jeweled fly on a classic coat, and one woman wore a miniature crystal chandelier dangling from her neck. *Opposite:* Bill often did columns on whimsical accessories. The stylist Carlyne Cerf de Dudzeele and the writer Fran Lebowitz enjoyed the trend, too.

The waist was seen exposed and also corseted. The trend of wearing corsets as outerwear Bill attributed to Madonna and the designer Jean-Paul Gaultier, whose cage jacket is seen at left.

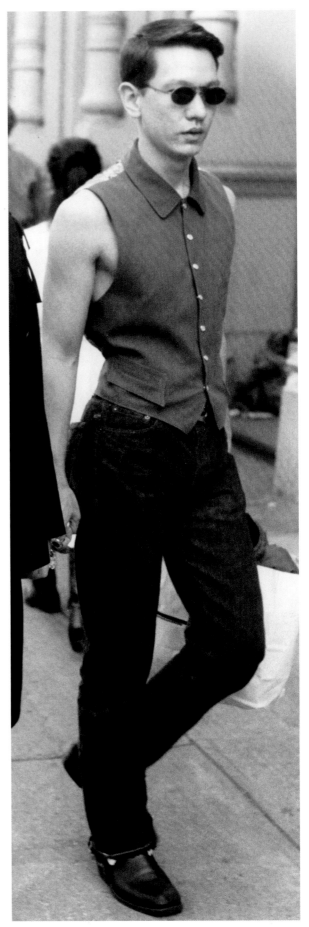

Right: Vests, but reinterpreted. One is essentially a sleeveless denim jacket, another is a vest worn as a men's shirt, and the third finds the vest acting much like a corset. "The vest has lost its gender identity and become a fashion trend with both men and women," Bill wrote. *Opposite:* A participant at Wigstock was a walking billboard for Chanel *(right)*, while others used their own hair and a hat with pompoms to gain some height.

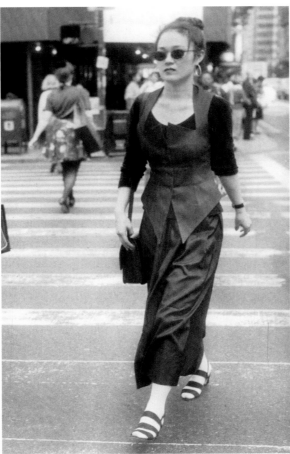

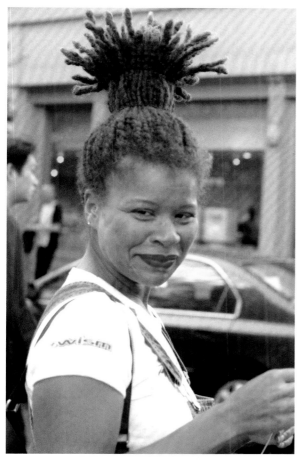

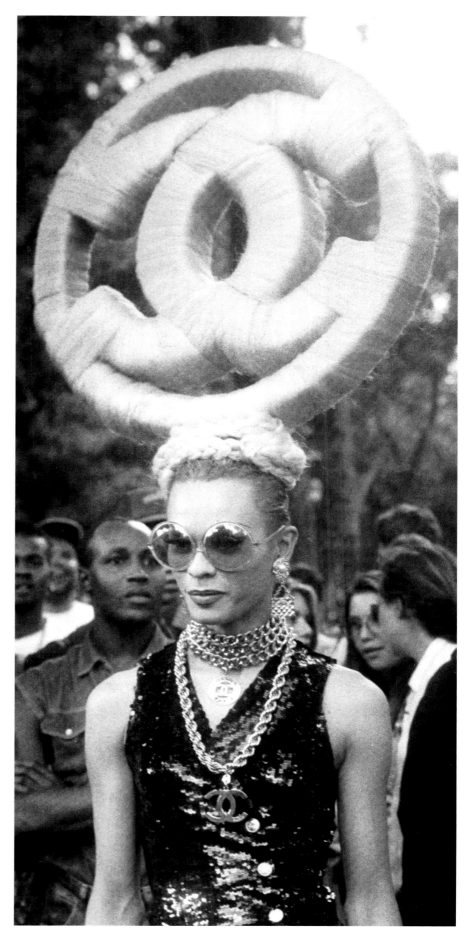

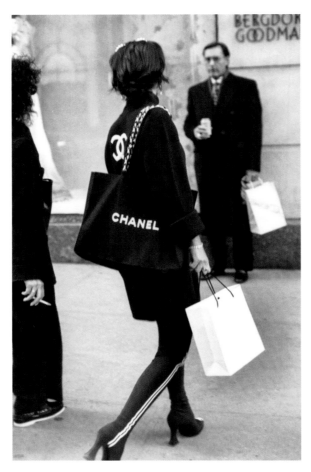

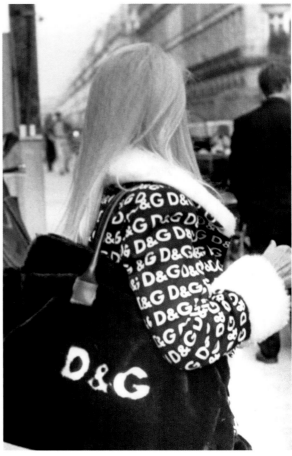

Right: "As the century closes, the shouting of logos has reached a high pitch," Bill wrote. *Opposite, left:* Bill worked the crowd at the annual Puerto Rican Day Parade, where many young men (and a few women) were wearing live pythons as accessories. He counted nineteen snake sightings between Fiftieth and Sixtieth Streets. *Opposite:* Here's what might happen to one of these snakes *(below right);* Franca Sozzani, editor in chief of *Vogue Italia,* in an ostrich coat *(top right).*

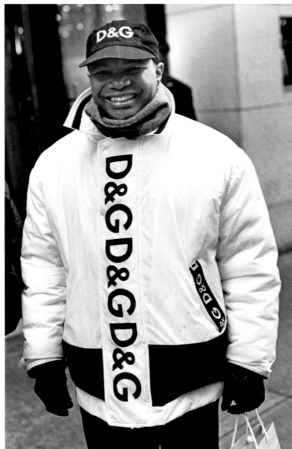

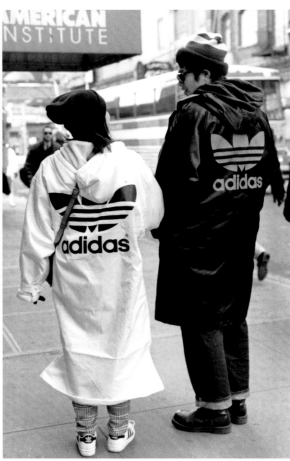

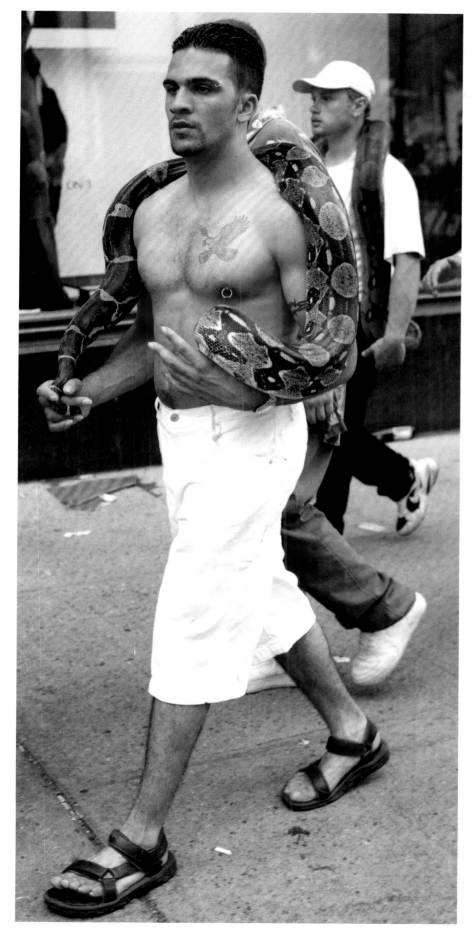

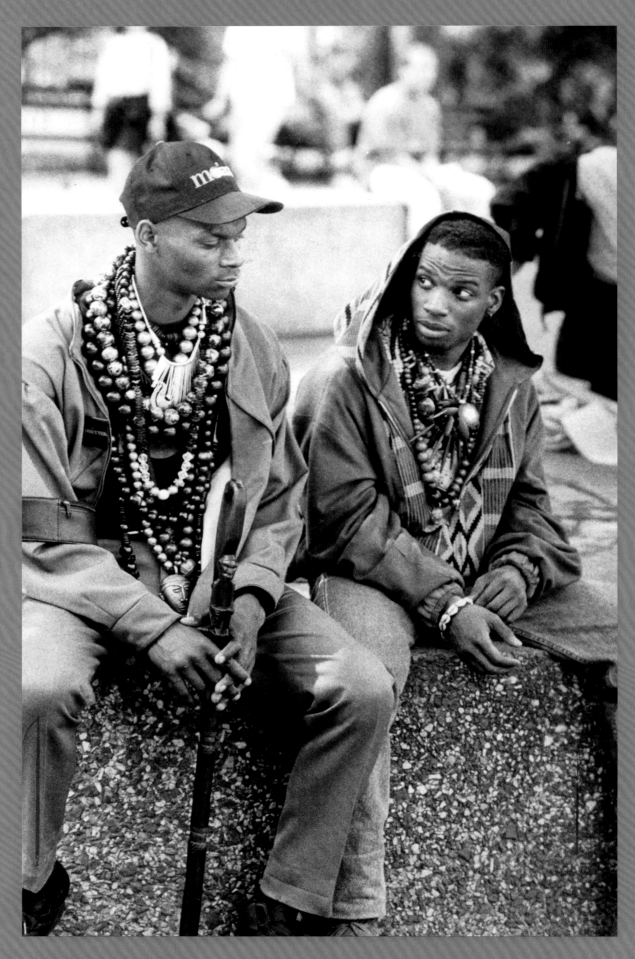

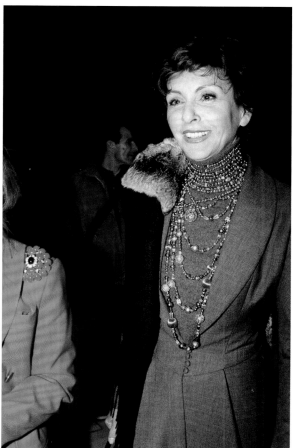

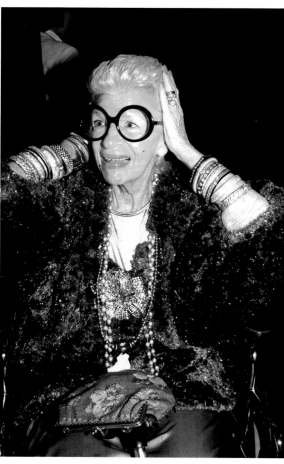

Left: Fashion accessories, whimsical, plentiful, proclaiming the wearer's individuality. Carlyne Cerf de Dudzeele *(top left)*; Amy Fine Collins *(top right)*; Iris Apfel *(bottom right)*. Woman at bottom left is unidentified.
Opposite: Bill wrote, "An exotic mix of fabrics, chunky beaded necklaces, distinctive hairstyles and clunky-soled shoes are making a fashion statement that reflects the influences of reggae and rap music."

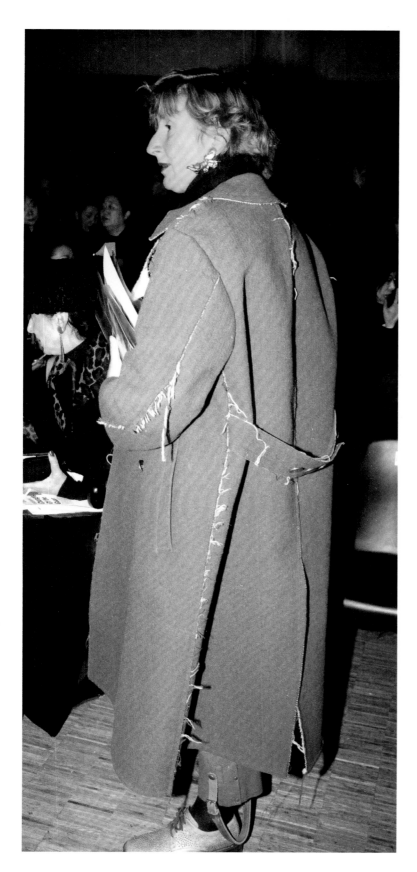

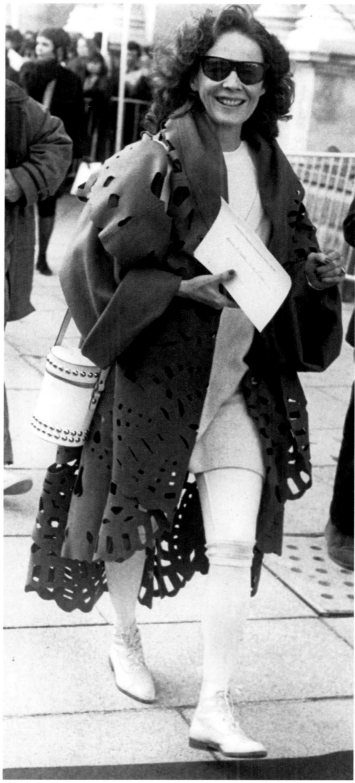

Coat styles provided variety through the decade. *Left:* Deconstructionism in fashion was a dominant trend. *Above:* A wool coat with lacy cutouts. *Opposite:* A loose coat with drawstring hood *(left)*. A dramatically turned-up collar adds flair *(right)*.

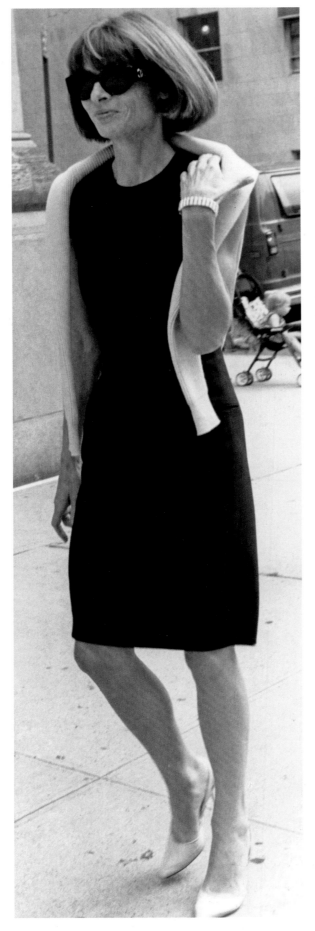

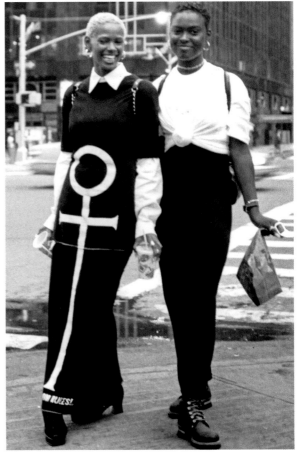

While New Yorkers can seem as if they are addicted to wearing black, Bill observed that "many people accentuate the black with just a dash of white or ivory." He also noted that black was seen in new formulas in daywear. "The trend-setter was a femme fatale in a body-encasing dress alighting from a cab on Fifth Avenue." *Opposite, left:* Anna Wintour.

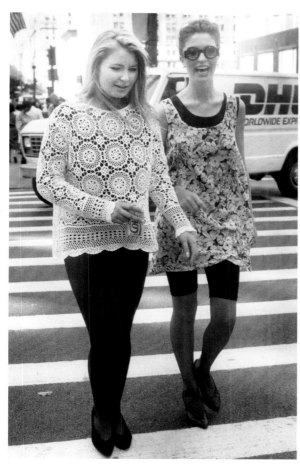

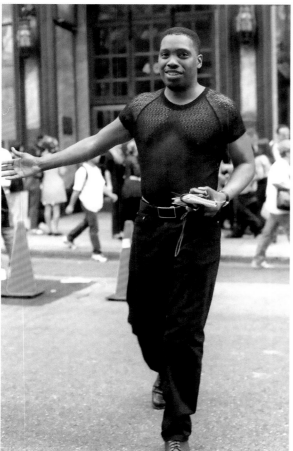

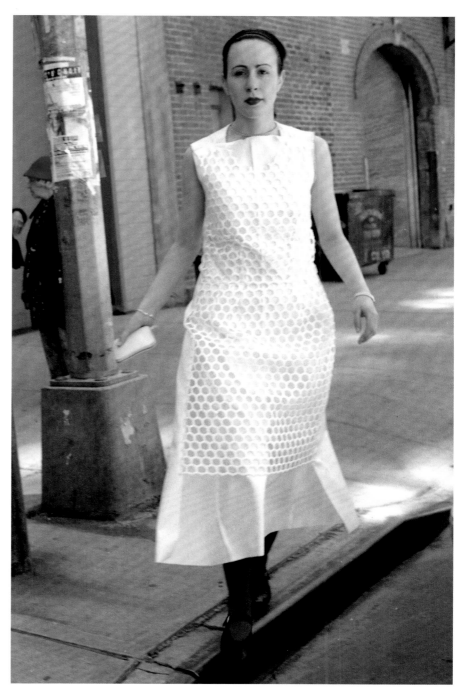

Lace, long ago reserved for weddings, appears in many forms: *(opposite, left)* as an afghan-patterned duster, for example, or as a top suggesting curtains from another era. Something can be worn under the lace, or perhaps not.

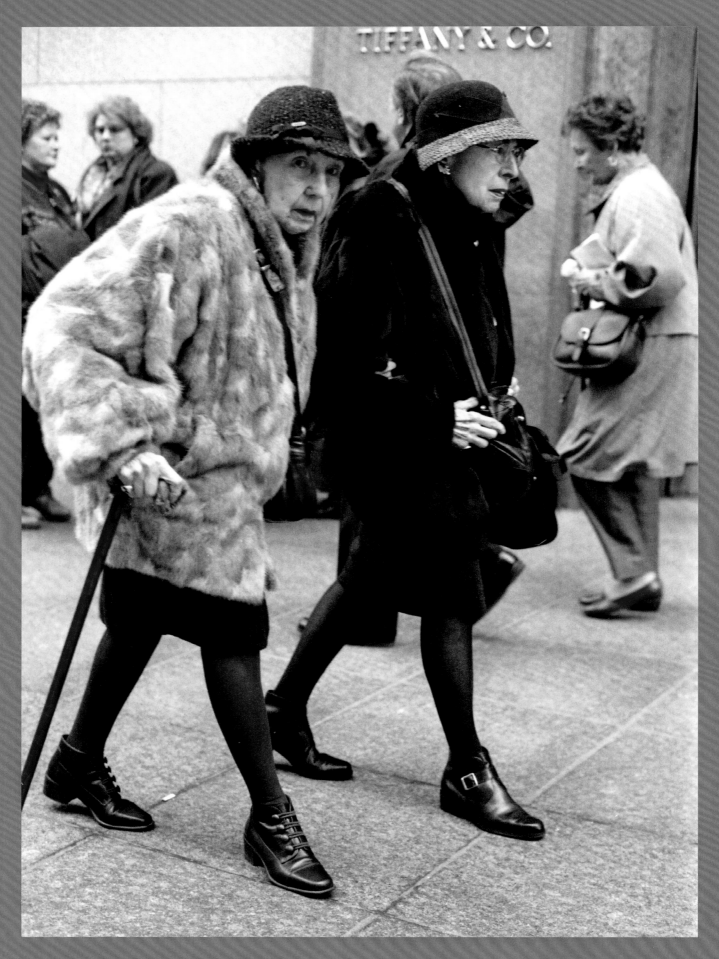

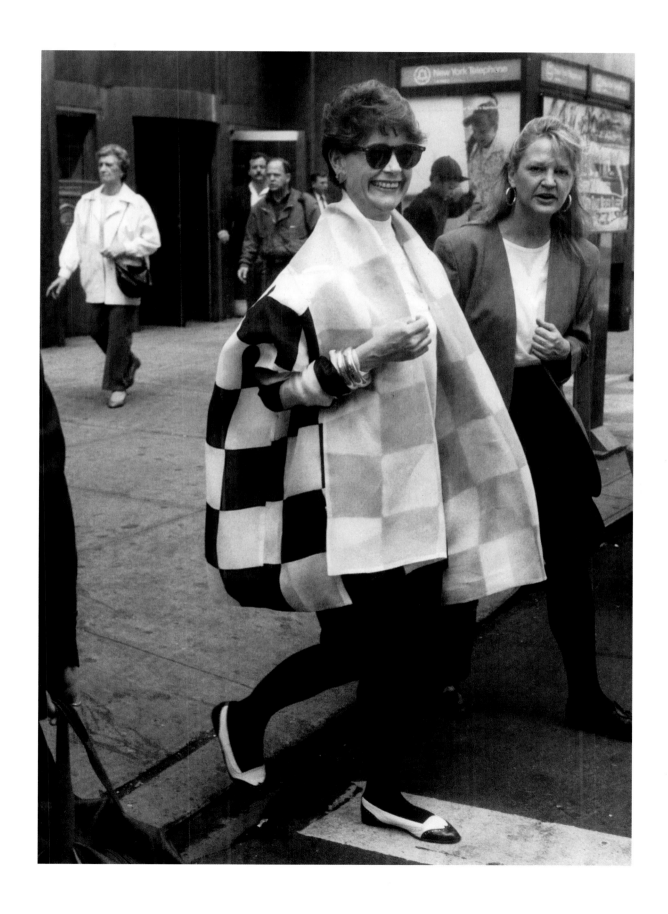

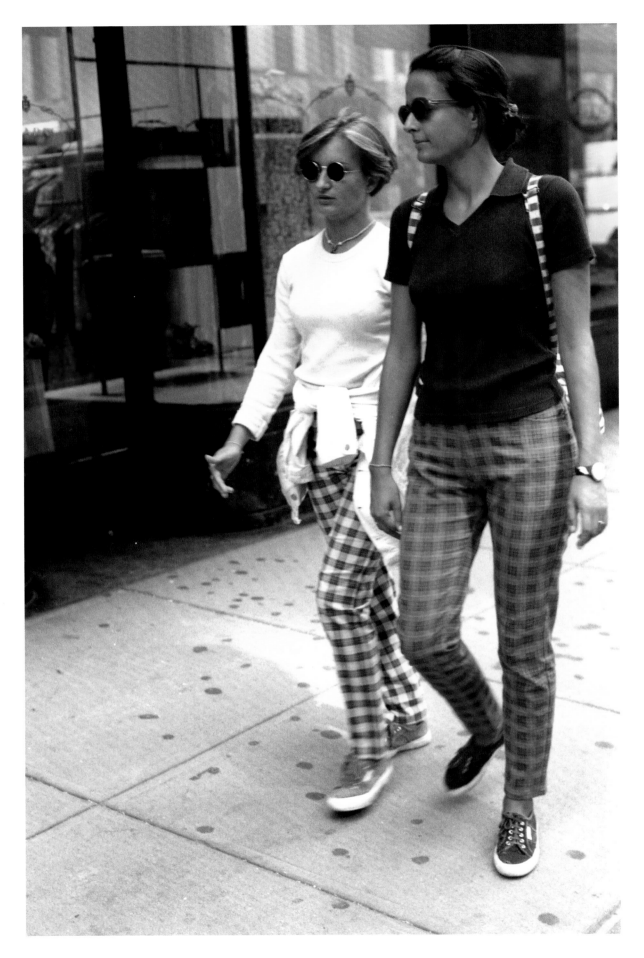

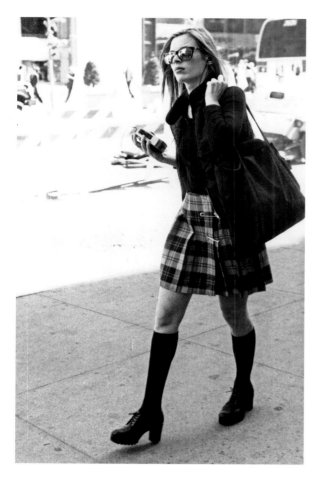

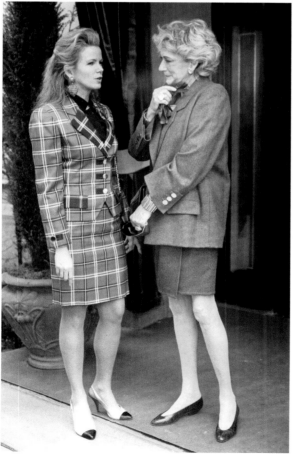

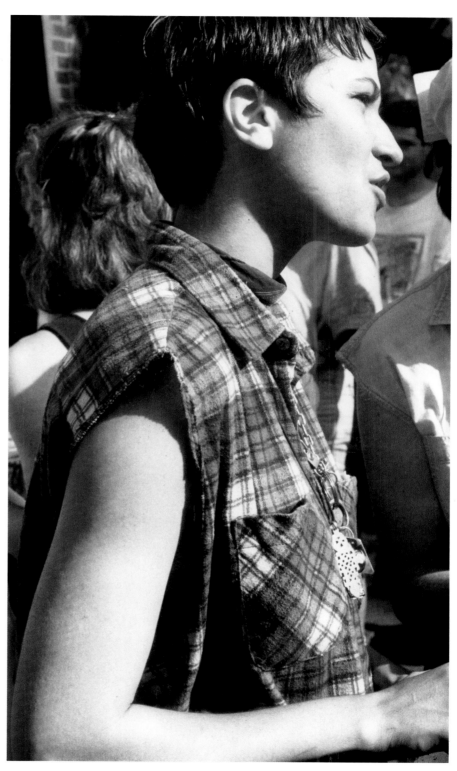

According to Bill, when one is wearing plaid, "the plaid does all the talking." **Below left:** Blaine Trump and Pat Buckley.

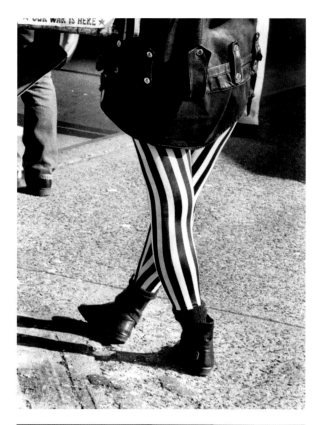

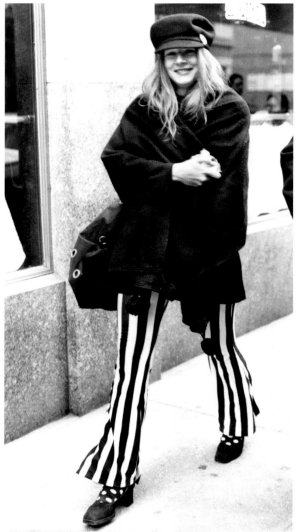

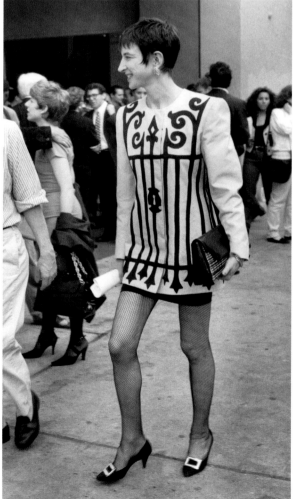

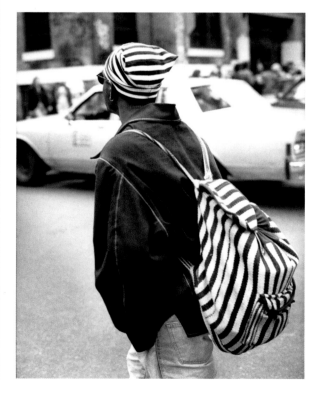

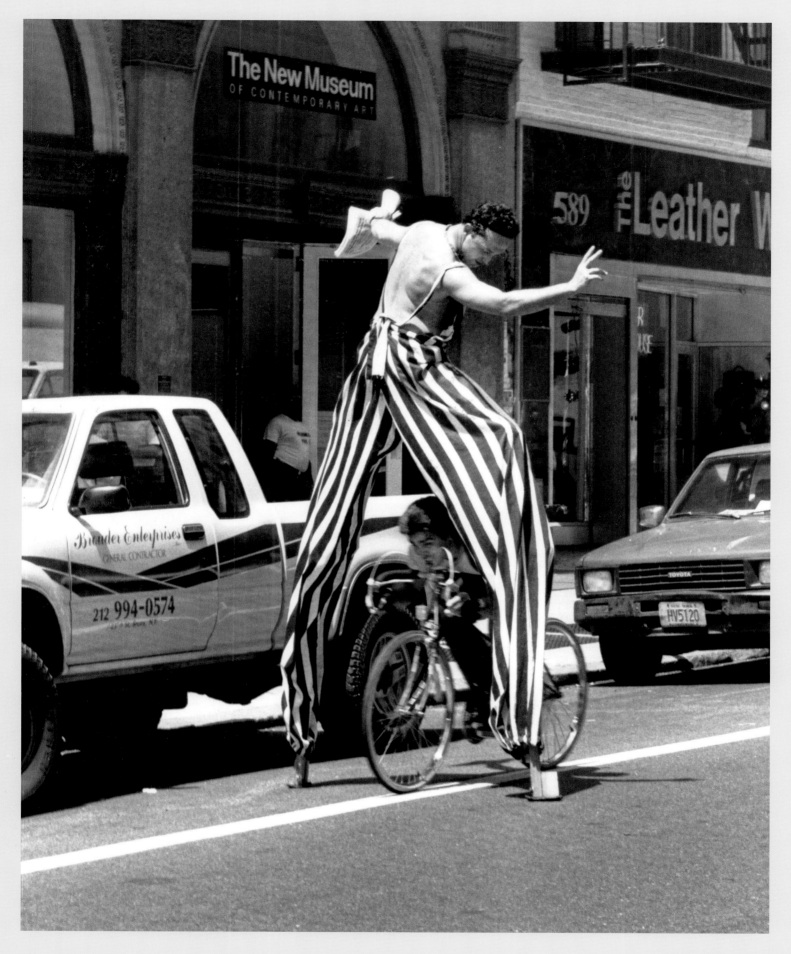

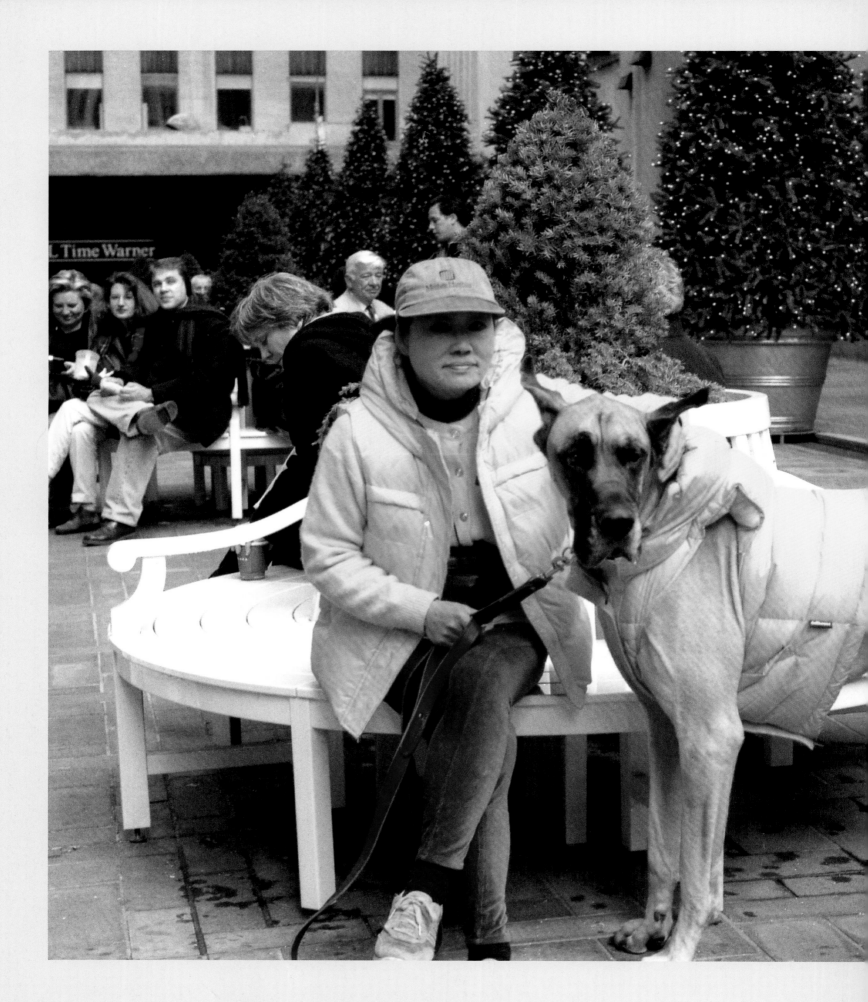

CITY DOGS, SUITED UP

GUY TREBAY
reporter and critic, *The New York Times*

As much as fashion ever was, the loneliness of cities was also Bill Cunningham's subject. During the decades he spent roaming the streets of New York and Paris, he assiduously recorded the individual isolated amid surging crowds, the pedestrian navigating a thronging metropolis, often with an inward-looking gaze.

Bill was himself a solitary man, and his lens instinctively detected subjects that mirrored his own psychic remove. Ostensibly photographing the latest in fashion, he simultaneously honed in on the vulnerabilities concealed from an inherently hostile world behind the armor of clothes.

This is nowhere more evident than in his images featuring people with animals. Although you will find in his work a certain amount of equine subject matter (cats seldom, if ever, make an appearance; his regular column after all, was called On the Street), Bill was particularly drawn to humans and dogs. This tendency had a lot to do with the canine place among humans—as companions, yes, but also as creatures governed by deeply coded laws of association—hounds being socialized differently from herding dogs and herders having in common with ornamental breeds little more than four legs and a tail. Dogs are often said to resemble their owners, but frequently the reverse turns out to be the case.

Indeed, the more we dress them like us, the more closely we come to resemble our

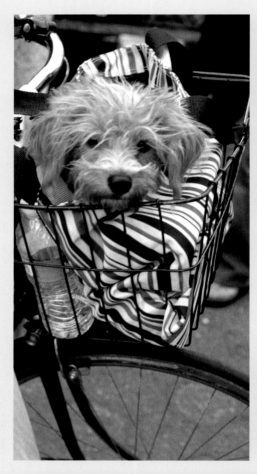

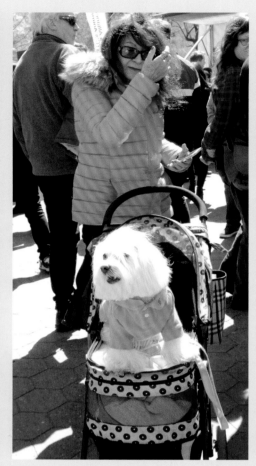

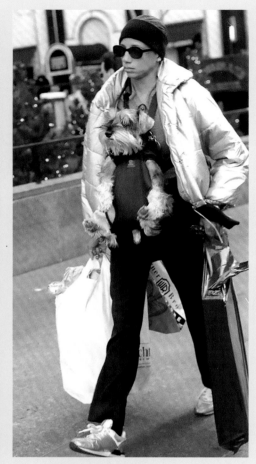

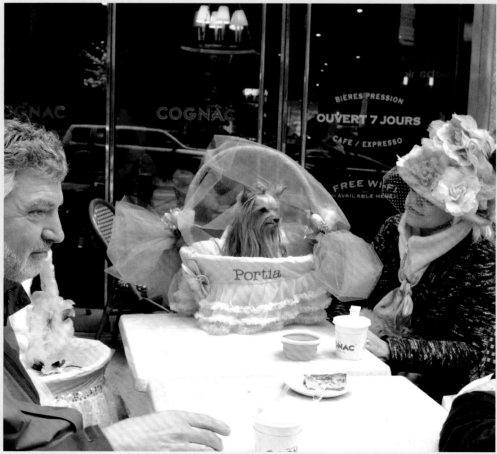

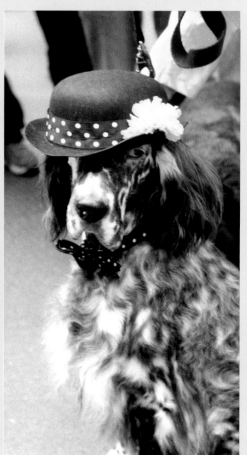

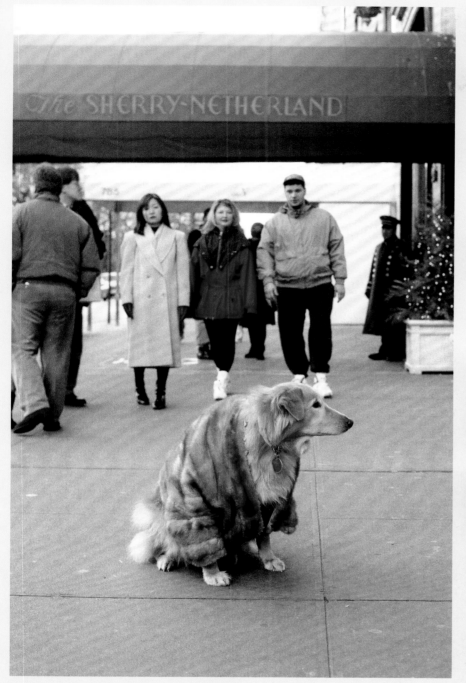

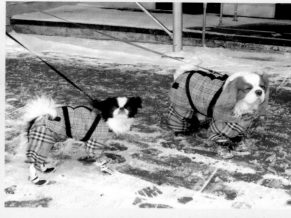

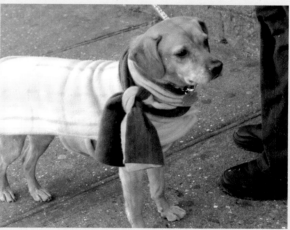

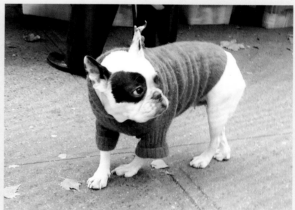

canine friends—this, too, was a stealth subject of Bill's. To be sure, there are elements of satire in his snaps of dogs kitted out in fur coats and booties; of pooches with ears humiliatingly scrunched under headbands or crammed into ball caps; and of canine ensembles that, even when they don't match those of their owners, reliably telegraph their owners' pretentions. (A belted Burberry dog coat with matching leggings is an affront to doggie dignity, even if worn as weatherproofing.)

Still, behind the gentle mockery of Bill's photographs of pets gotten up as humans or people dressed to match their pets is a very humane recognition of the place occupied by our four-legged friends in the solitary scheme of things.

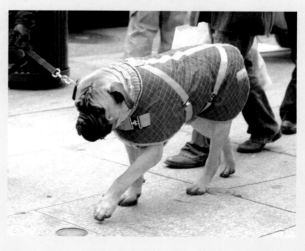

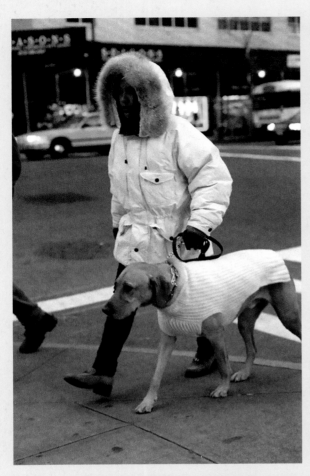
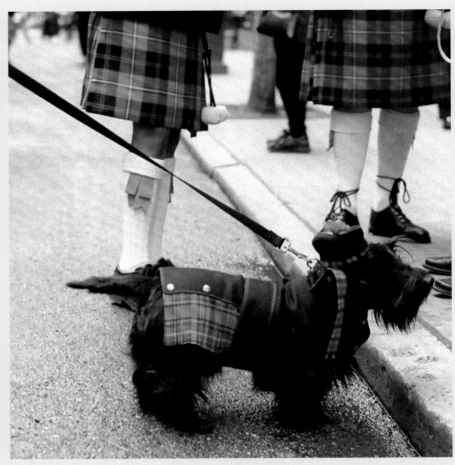

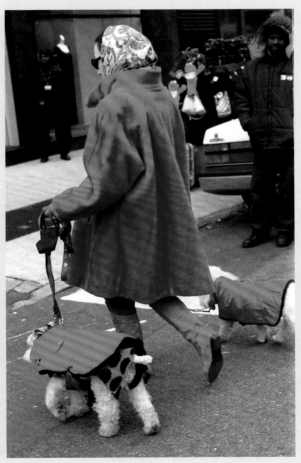

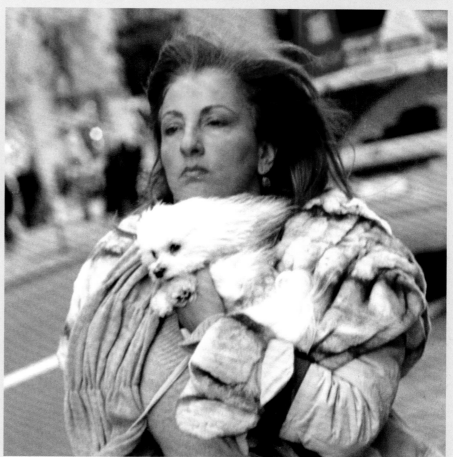

The Easter Parade was one of Bill's favorite New York events, and he was always thrilled to find attendees who brought along their dolled up canine companions.

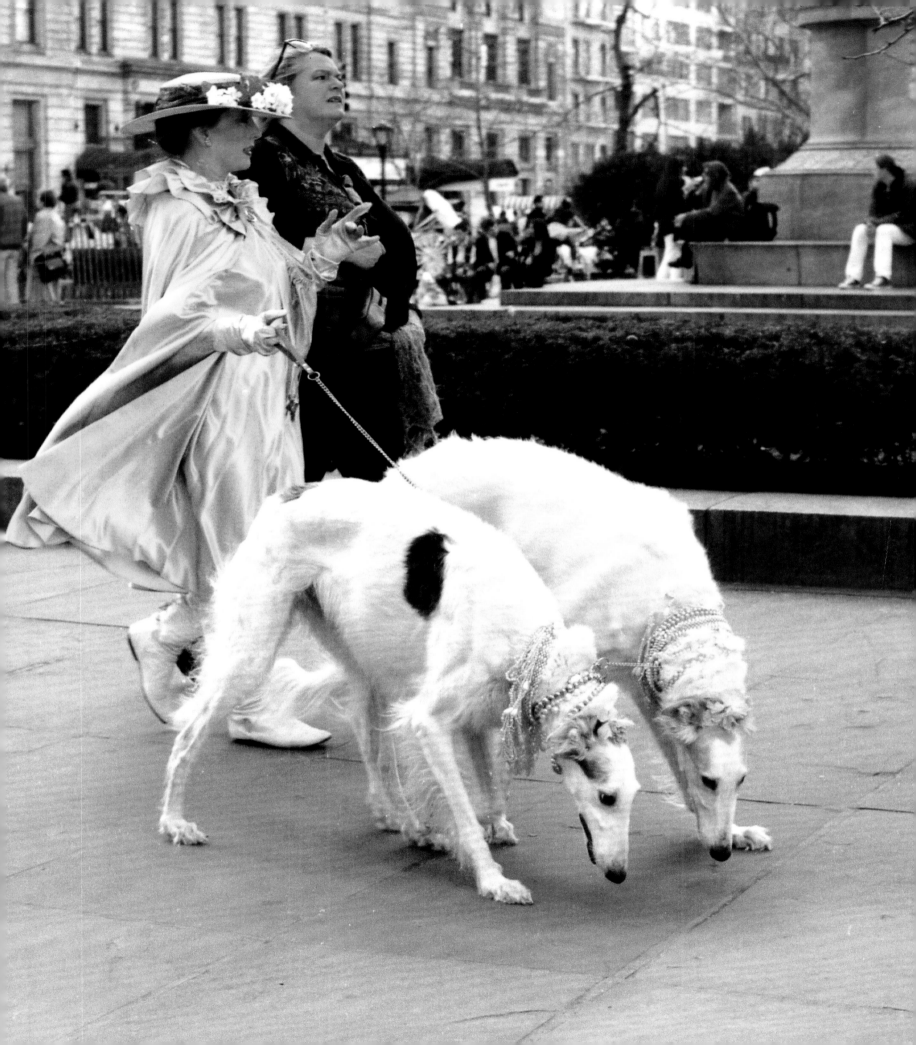

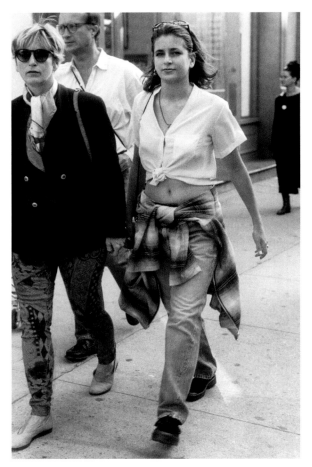

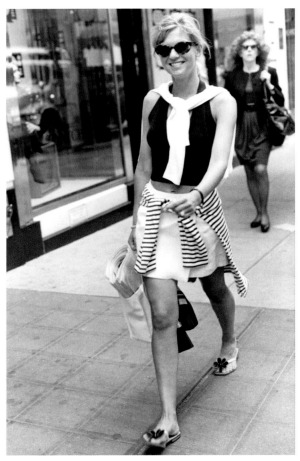

The shirt as a skirt: a plaid flannel shirt tied around the waist results in what Bill called "the ultimate deconstructed hip-hop look." Before using flannel shirts, strollers often tied sweaters around their waists or shoulders or tied shirttails to expose the midriff. With so many options, some people combined a few of those techniques.

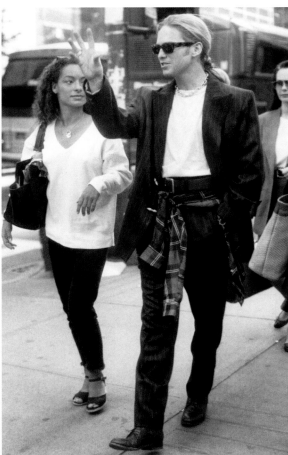

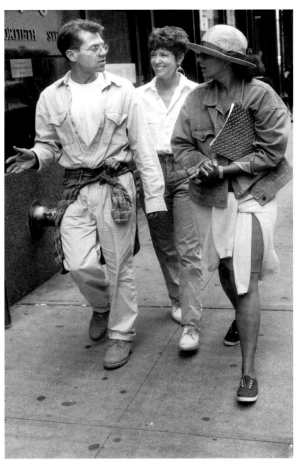

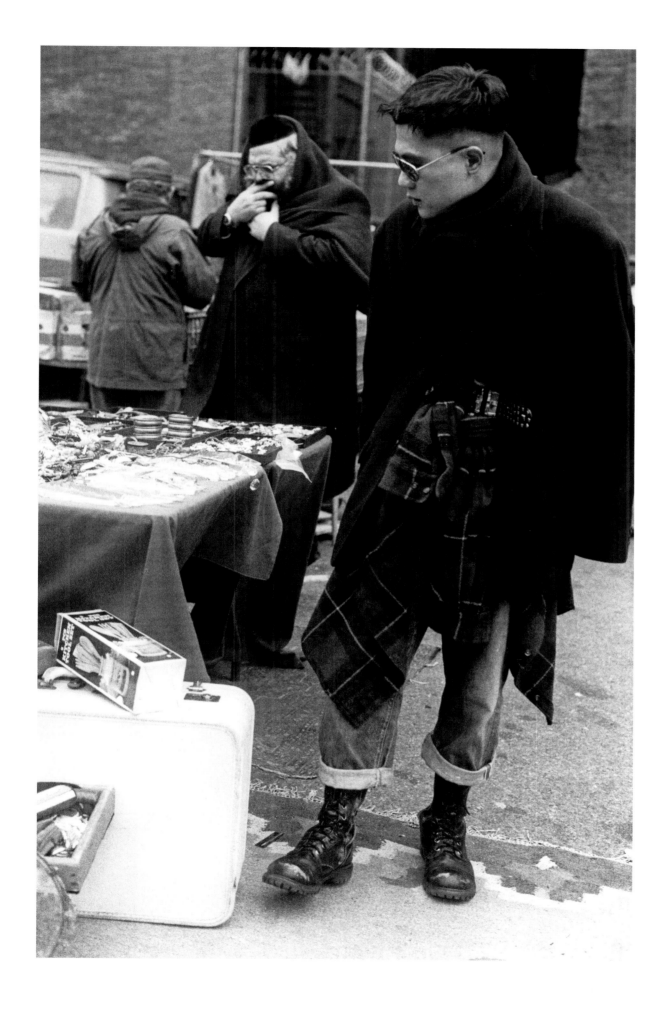

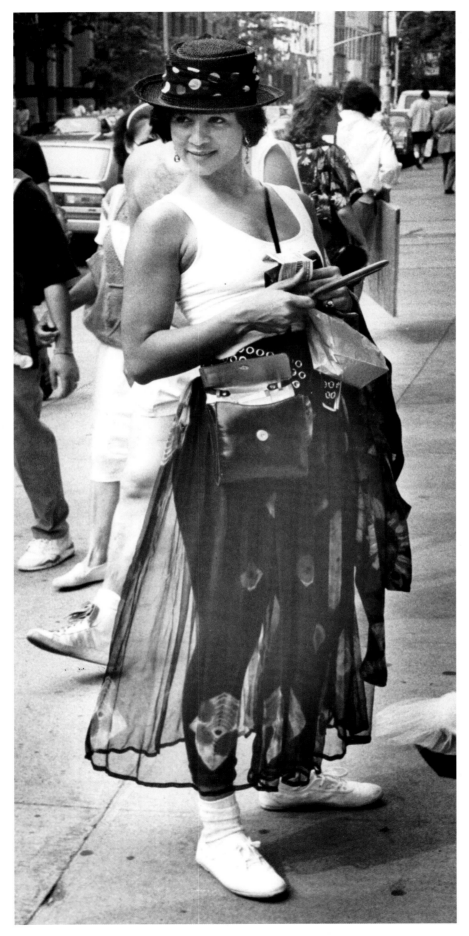

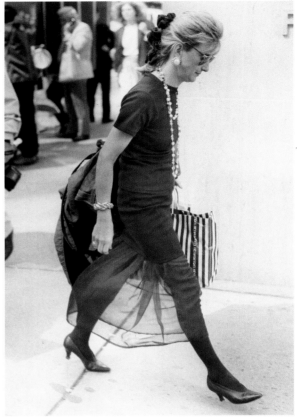

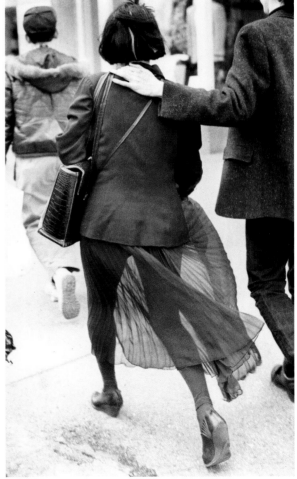

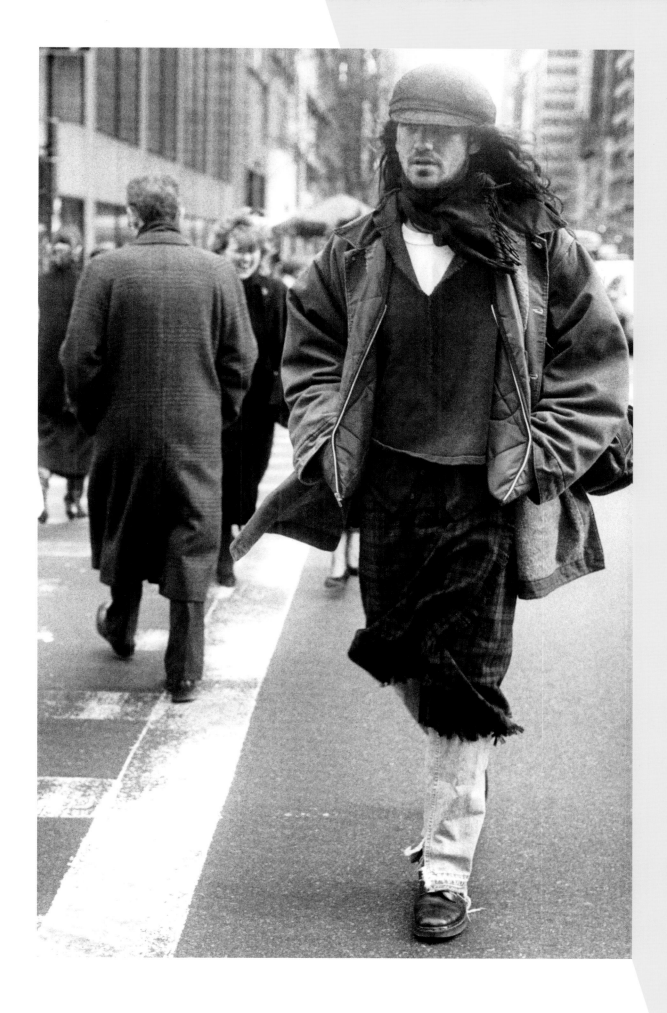

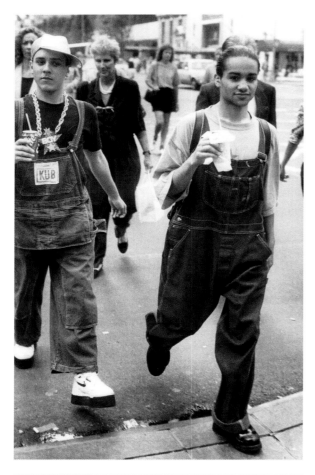

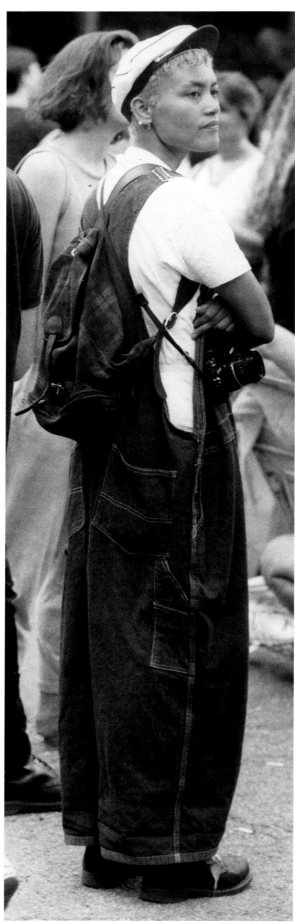

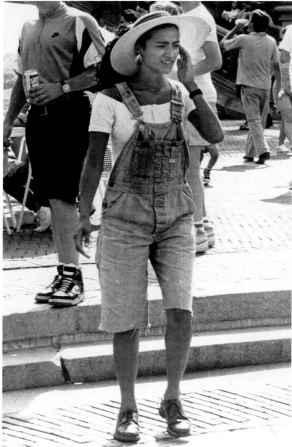

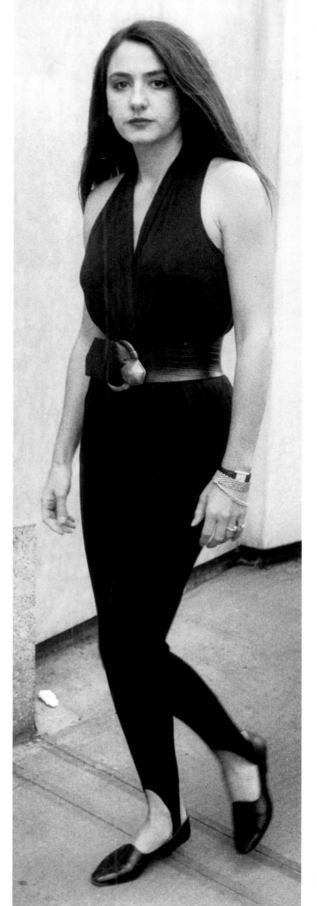

"If there's an explanation for the boom in urban overalls, it might be the continuing popularity of oversized clothes," Bill wrote. The pendulum then swung to what Bill called "second-skin dressing," exemplified by stretch bodysuits, unitards, tights, and leotards.

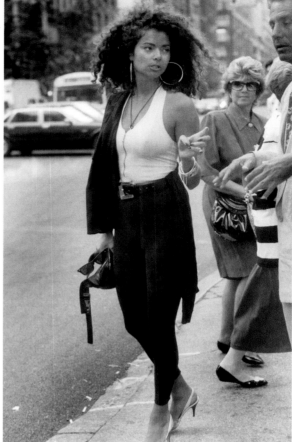

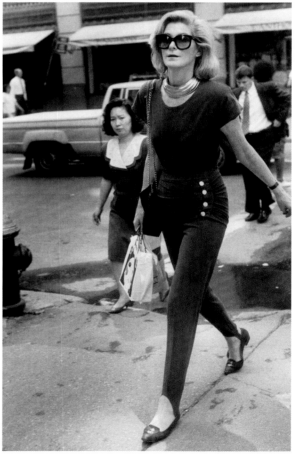

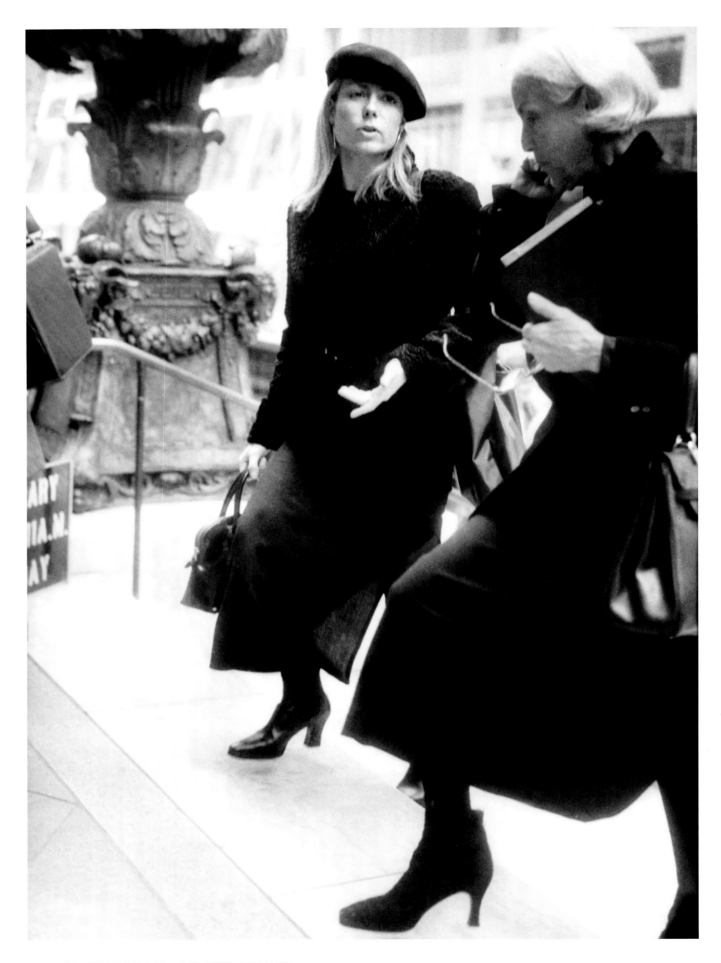

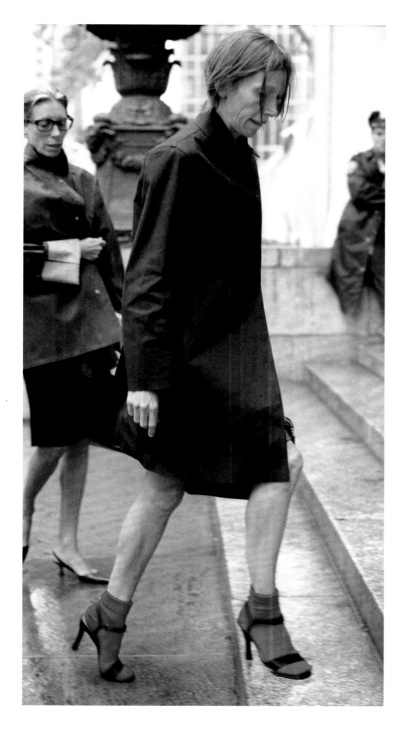

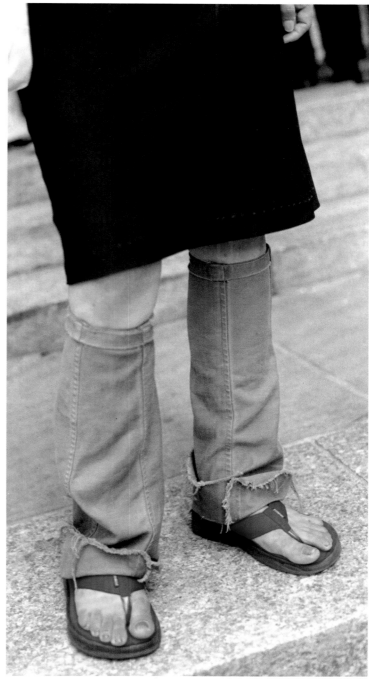

"There was a zip to the step of the fashion crowd," Bill noted. Boots that were ankle height *(opposite)*, ankle socks that added a pop of color to stilettos *(left)*, and military shirtsleeves that were worn as leggings *(above)*.

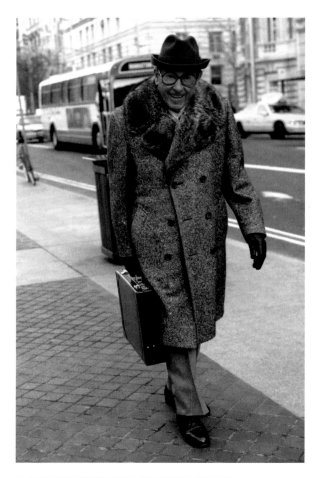

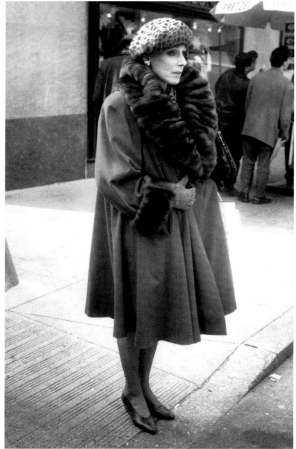

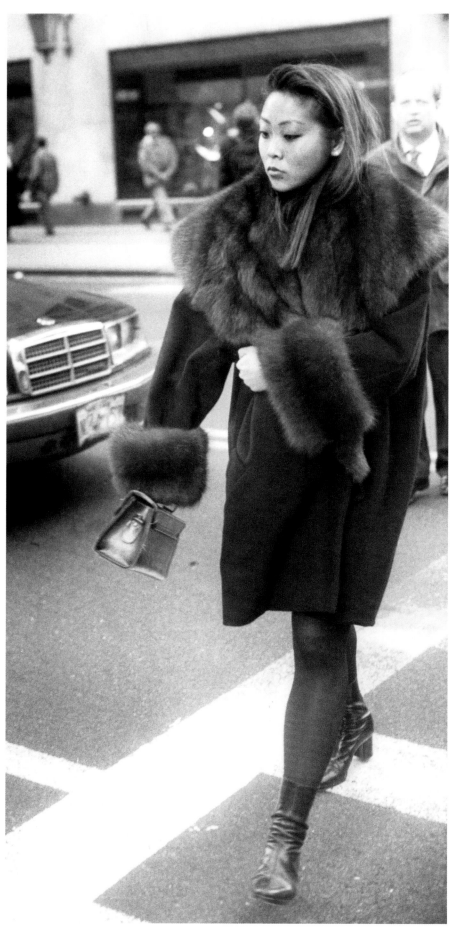

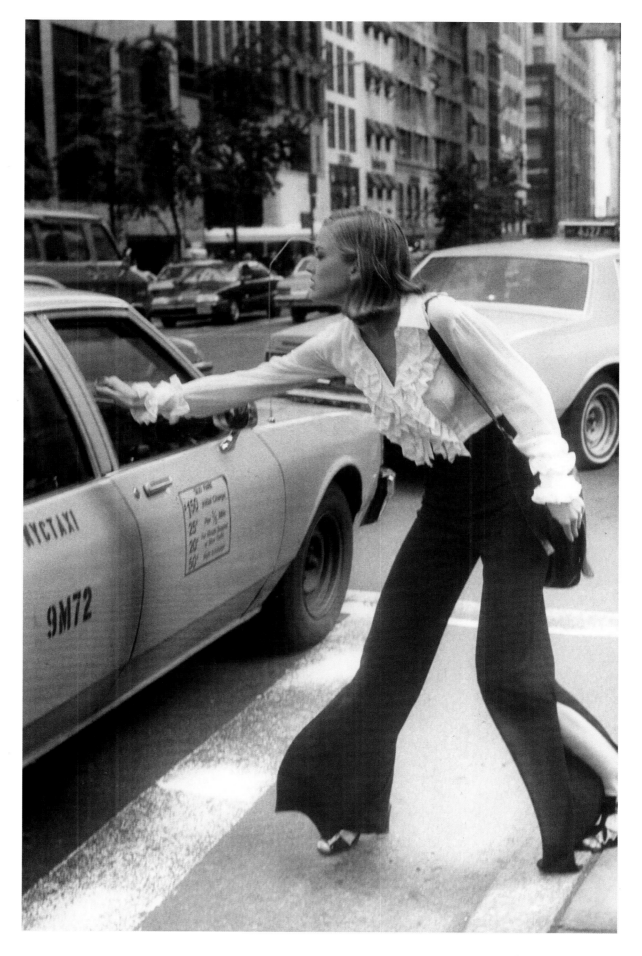

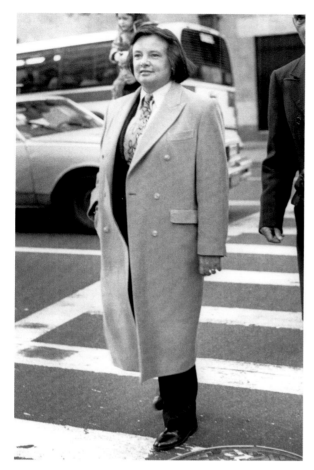

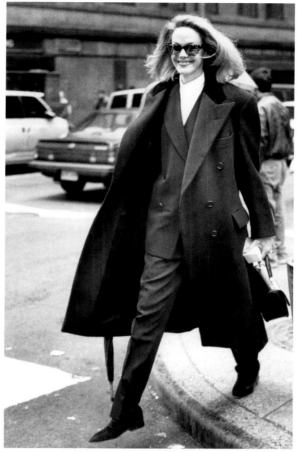

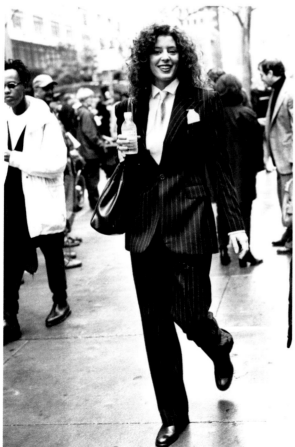

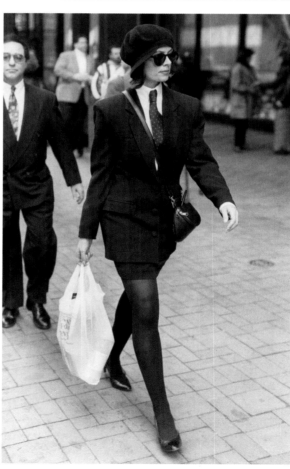

Left: Women wearing masculine attire. According to Bill, many were wearing clothes actually made for men, "and the fact that many women look particularly feminine in men's clothes doesn't hurt." *Opposite:* The photographer Steven Meisel and Madonna.

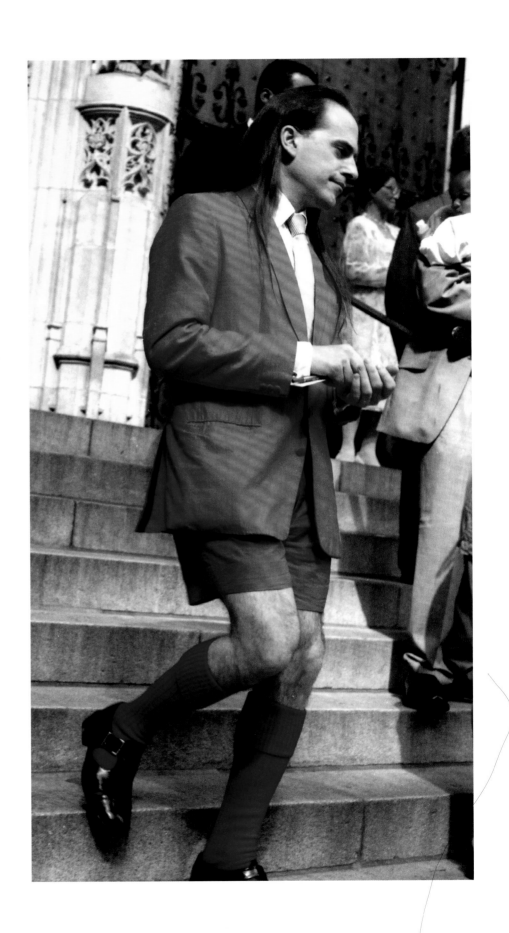

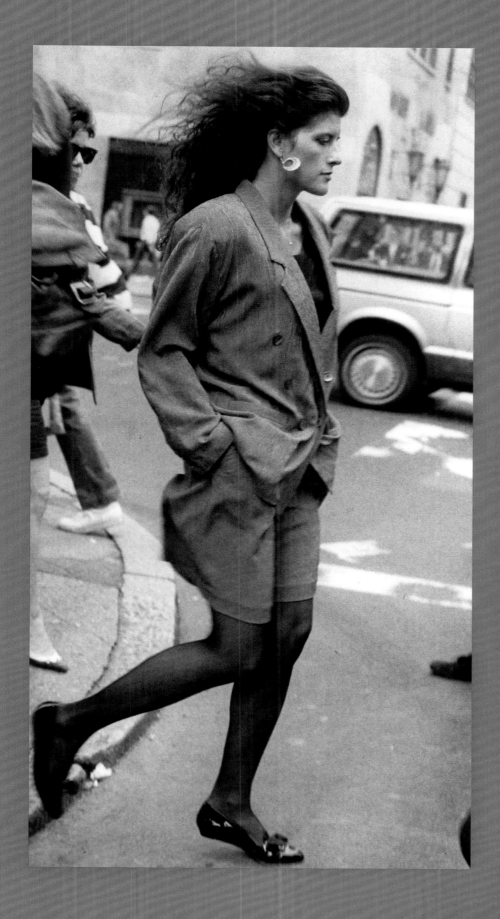

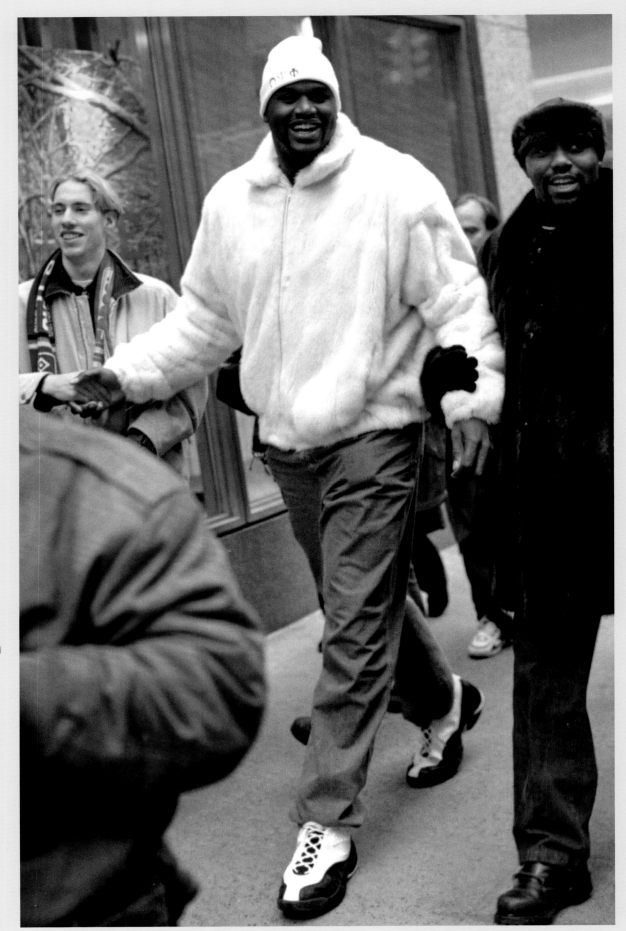

Right: While returning to his usual spot on Fifty-Seventh Street and Fifth Avenue one January day in 1999, Bill stumbled upon an assemblage of NBA players outside the General Motors building. The NBA's six-month lockout had just ended, and while basketball fans rejoiced, Bill was energized by what the players were wearing. It really wasn't Shaquille O'Neal that Bill was photographing; it was his white mink jacket. *Opposite:* Camel, an American fashion favorite, seen in men's and women's suits and coats, including for the former NBA player Tyrone Corbin *(bottom right)*.

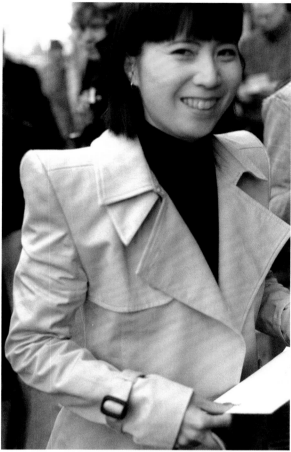

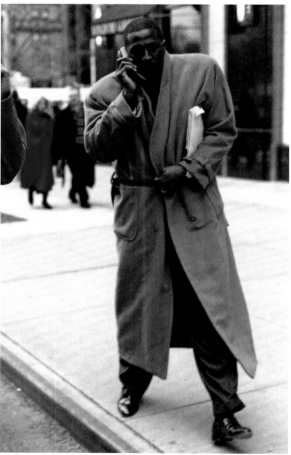

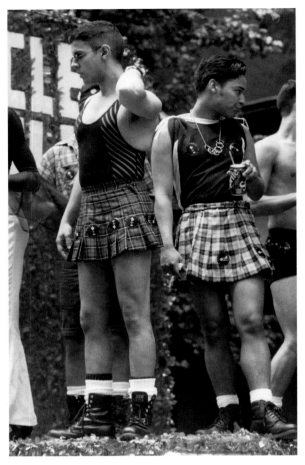

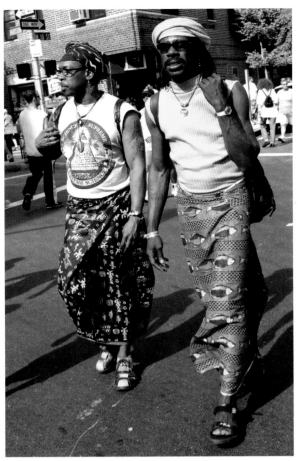

Right: Men in skirts—tartans one year, sarongs another— at the Gay and Lesbian Pride March. **Opposite:** A woman sports a feminized version of construction boots, which she pairs with a baby doll dress. Bill did many columns over the years on gender-bending fashion moments.

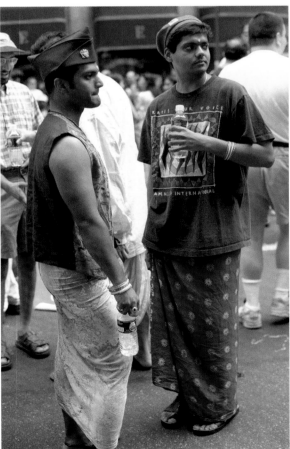

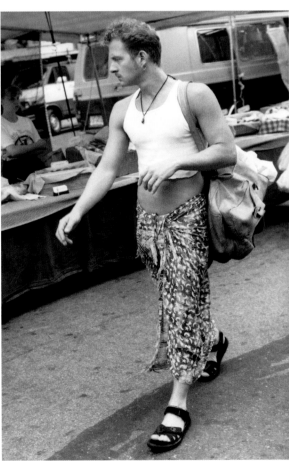

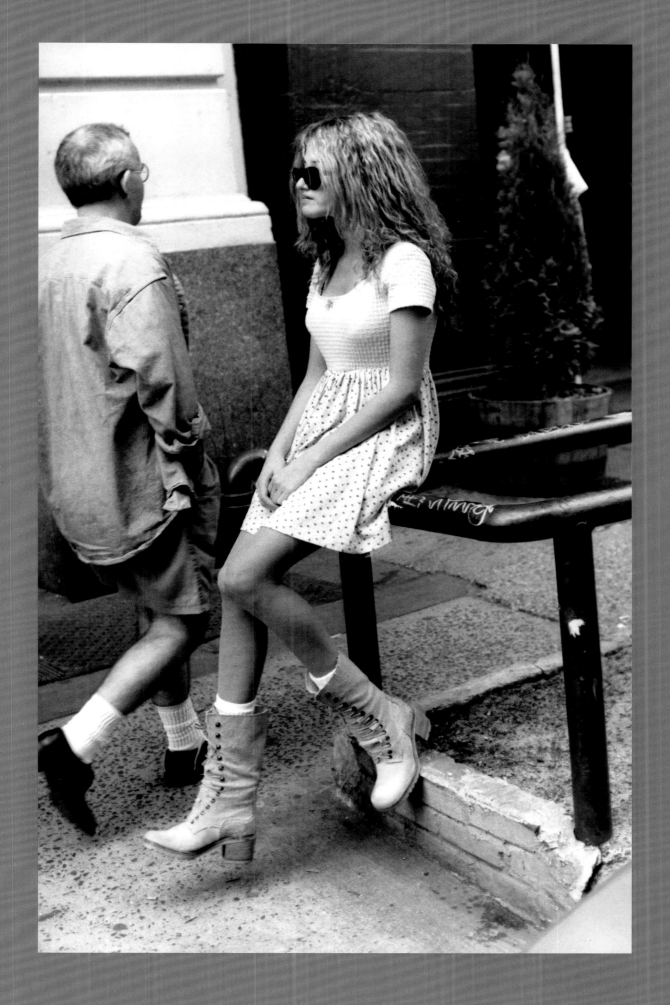

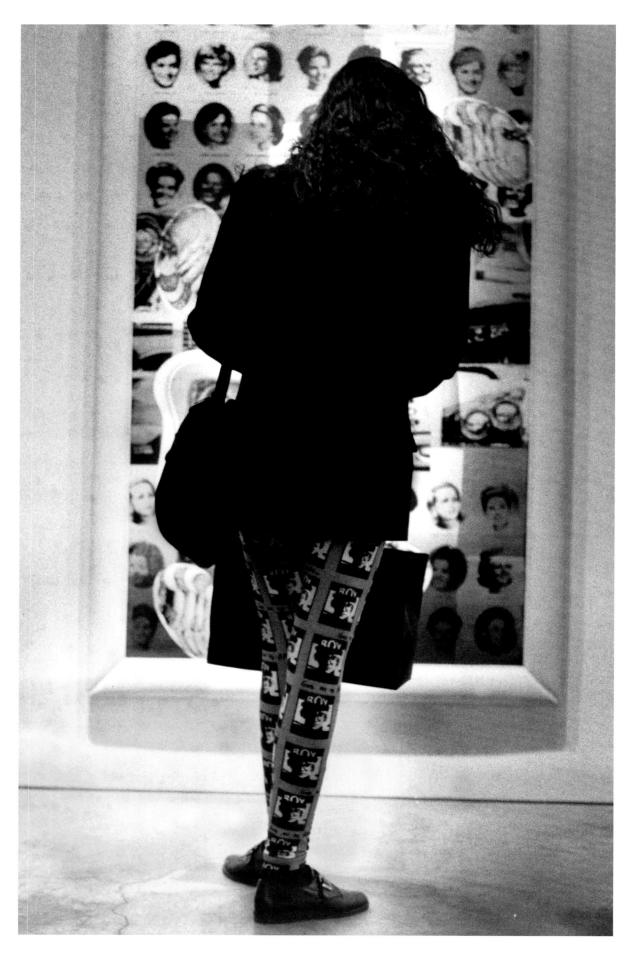

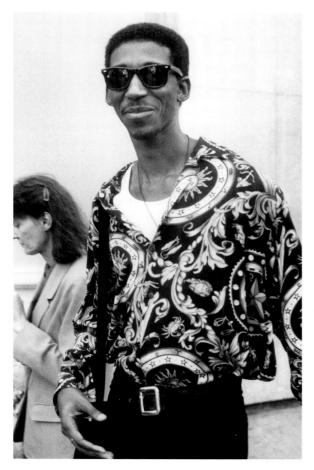

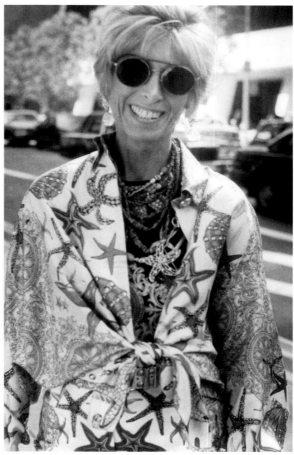

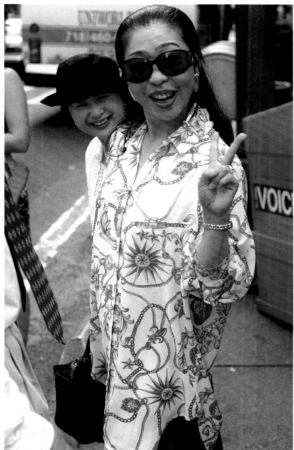

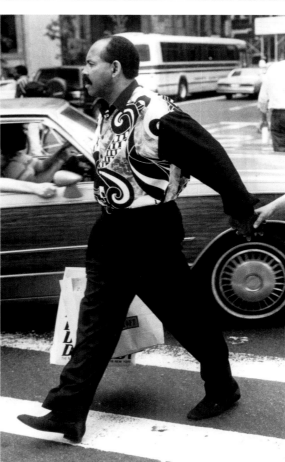

Left: In 1992, Bill proclaimed that the baroque motif shirt by Gianni Versace was the status shirt of that summer. When the designer was murdered in 1997, Bill included photos of the shirt in his tribute column to the designer. *Opposite:* Bill was at a SoHo art show opening and caught this guest standing before a Kenny Scharf canvas that echoed the pattern on her tights.

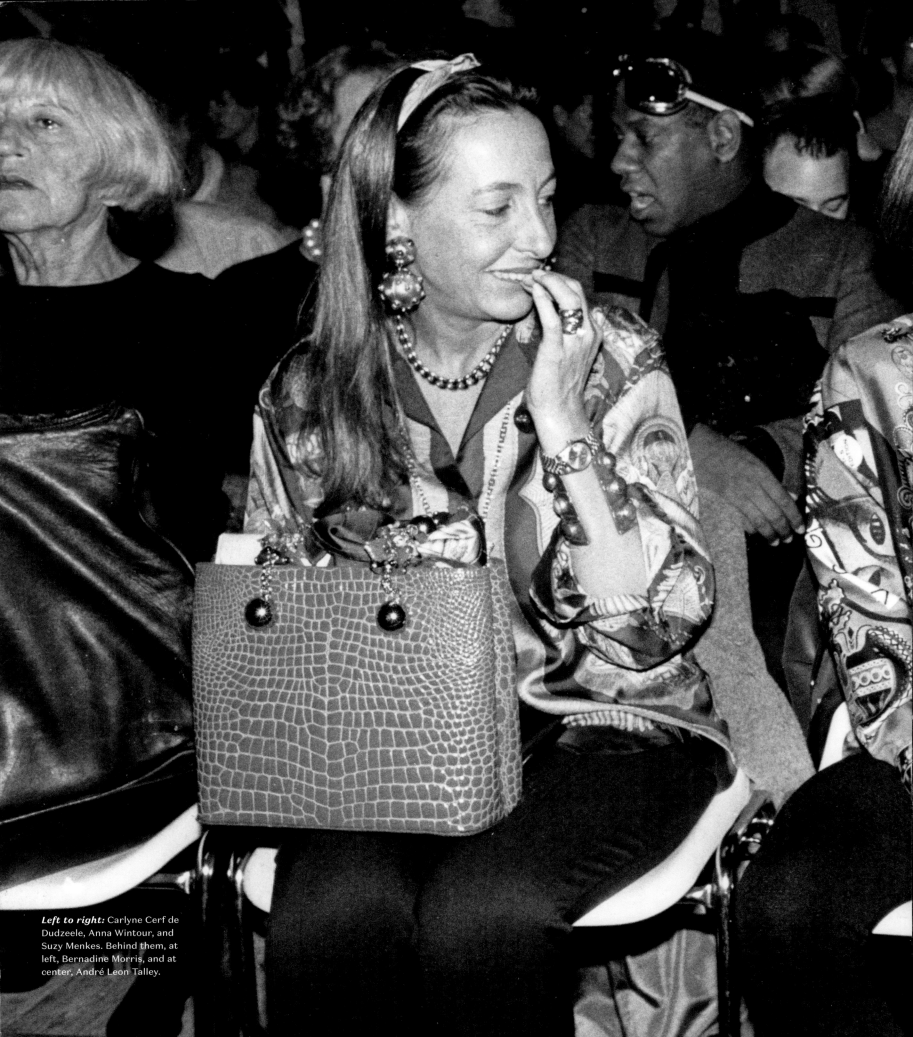

Left to right: Carlyne Cerf de Dudzeele, Anna Wintour, and Suzy Menkes. Behind them, at left, Bernadine Morris, and at center, André Leon Talley.

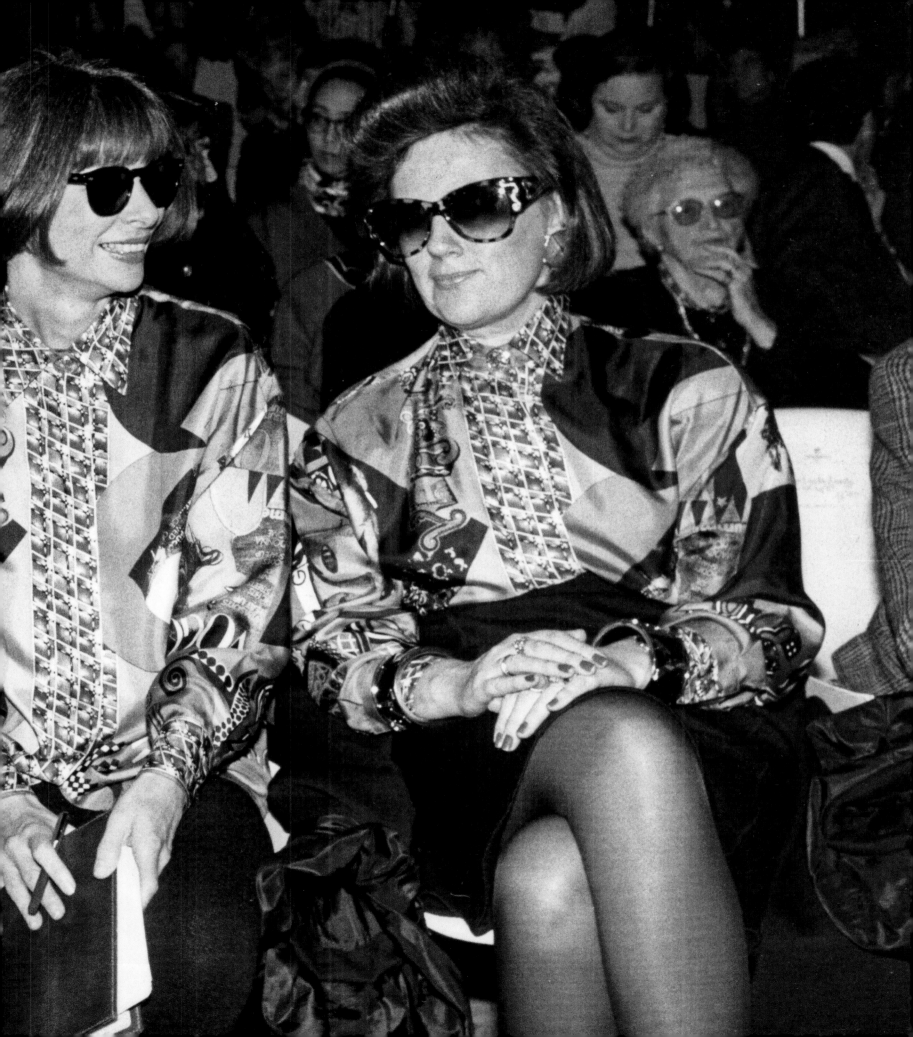

Right: Bill noticed a trend in what he called "wallpaper prints" in matching hats and shirts. *Opposite:* "Just when it appears that the uninhibited frontiers of fashion have been corralled by the forces of minimalism, weekend visits to SoHo reveal that many young people are putting the fun back into dress with imagination and vibrant color," he wrote.

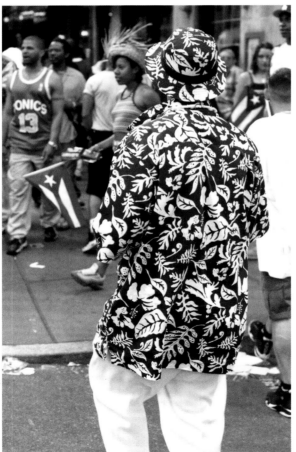

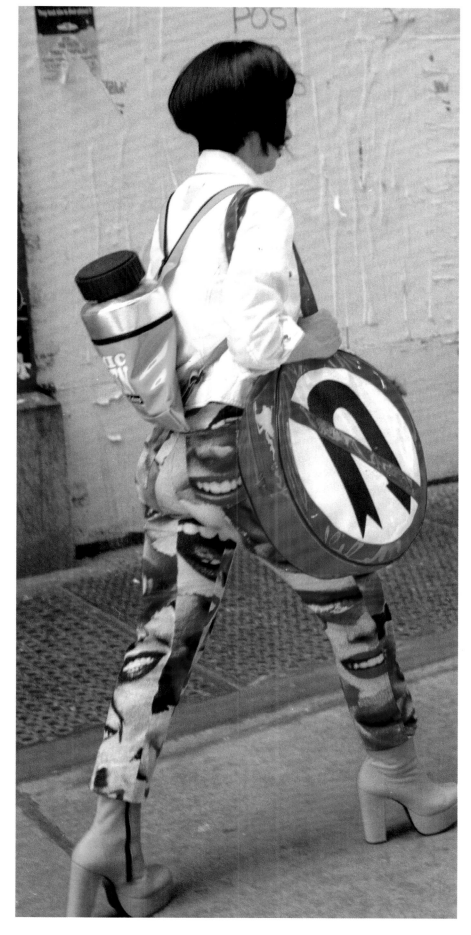

Right: Bill zeroed in on the work of Tokyo designers in the latter part of the decade. The woman on the right wears a Rei Kawakubo bump dress. *Opposite:* In a column about "young people who dress to their own drumbeat," he highlighted "the woman whose signature is inch-wide painted-black eyebrows . . . these free-spirited dressers are unfettered by uptown conformity and their often exaggerated style of dress champions self-expression."

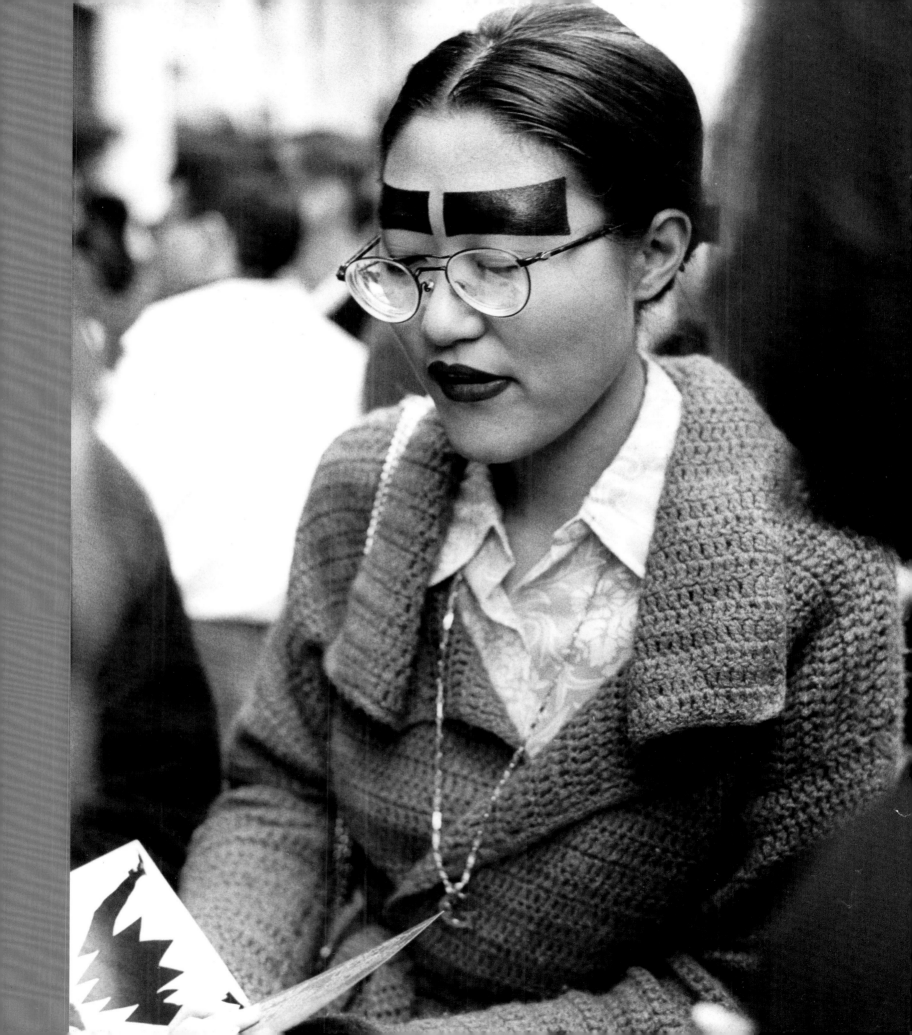

"I just loved to see wonderfully dressed women, and I still do. That's all there is to it."

Nan Kempner and Pat Buckley.

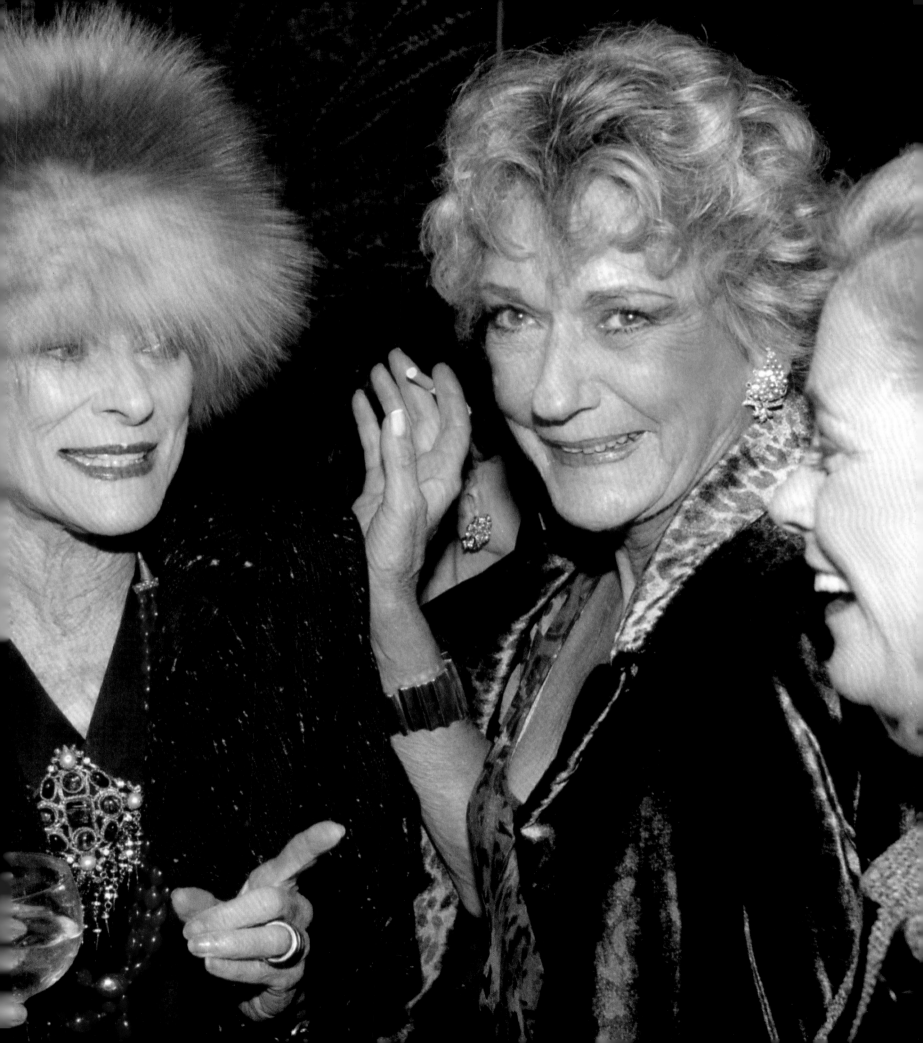

A THING FOR HATS

JACOB BERNSTEIN
features writer, *The New York Times* Styles section

Bill Cunningham once described his job by saying, "When I'm photographing, I look for the personal style with which something is worn—sometimes even how an umbrella is carried or how a coat is held closed. At parties, it's important to be almost invisible, to catch people when they're oblivious to the camera—to get the intensity of their speech, the gestures of their hands. I'm interested in capturing a moment with animation and spirit."

He photographed Rockefellers and Vanderbilts at uptown galas, voguers at the Christopher Street Piers, and fashionistas at Bryant Park. Although he described his columns as a "mirror of the times," he was also an indefatigable champion of charmingly anachronistic eccentrics.

Bill loved himself a hat.

Long before he became a living landmark, he was a milliner who owned shops on West Fifty-Fourth Street in Manhattan and Jobs Lane in Southampton, where he slept on a cot.

Some of his hats were made to be worn by the socialites who later appeared frequently in his Evening Hours column. But during this period of his life, he loved throwing people for a loop, with bizarre, oversize hats shaped like octopuses or flying saucers.

Even after the sexual revolution happened and hats became a declining business, even after he closed down his shops and picked up a camera, he found ways to celebrate what was, in effect, a style in decline.

The Easter Parade and the Central Park Conservancy Gala were no mere stops on his

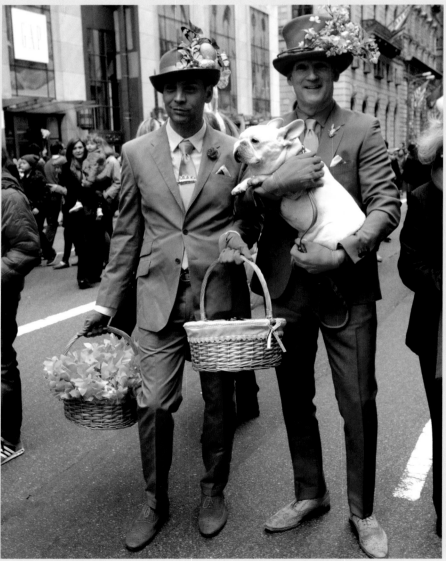

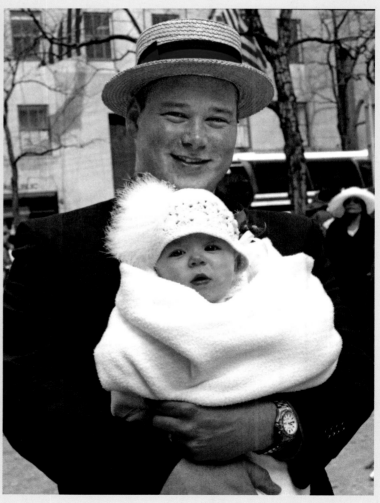

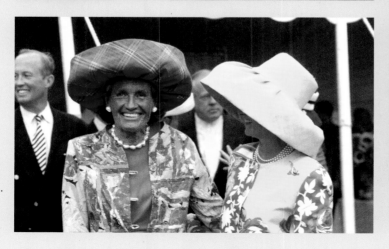

regular rounds. They were mini-safaris for an endangered species of women (and occasionally men) whose stunning headpieces served as rebukes to the increasing conformity of Casual Fridays and Sloppy Sundays.

Here was Lynn Yaeger in an embroidered aviator hat. There was Amy Fine Collins in a swirling topper that resembled an anemone with an egg yolk in the center.

"It's a sea urchin," she said. "The spikes were a way of keeping people at a distance."

But it didn't keep Bill at a distance. "He could see every bit of effort and imagination and talent and craftsmanship that went into odd little creations like that," Collins added. And his pull to capture the "rare and exotic" often defined his columns.

"He cared for people who went above and beyond," said James Aguiar, the fashion/creative director at *Modern Luxury* magazine, who was photographed countless times by Bill, including once at the Easter Parade, where he wore a bright-blue Paul Smith suit with a custom-made hat that was accented in lemons. In the picture, to Aguiar's right, was his husband, Mark Haldeman, who held their dog and sported an equally outré hat. "He appreciated men that dressed up and cared about the details," Aguiar said of Bill. "The tie, the pocket square, the boutonnière, the hat. He started as a hatmaker, so he was always drawn to those hats at the Easter Parade."

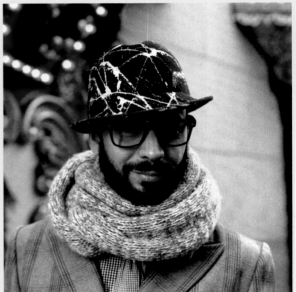

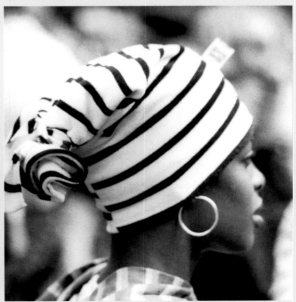

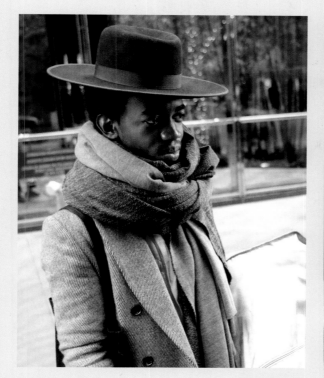

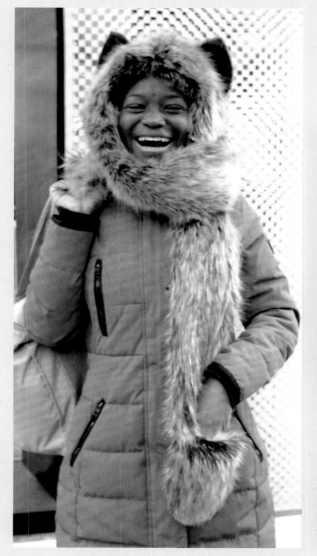

THE '00s

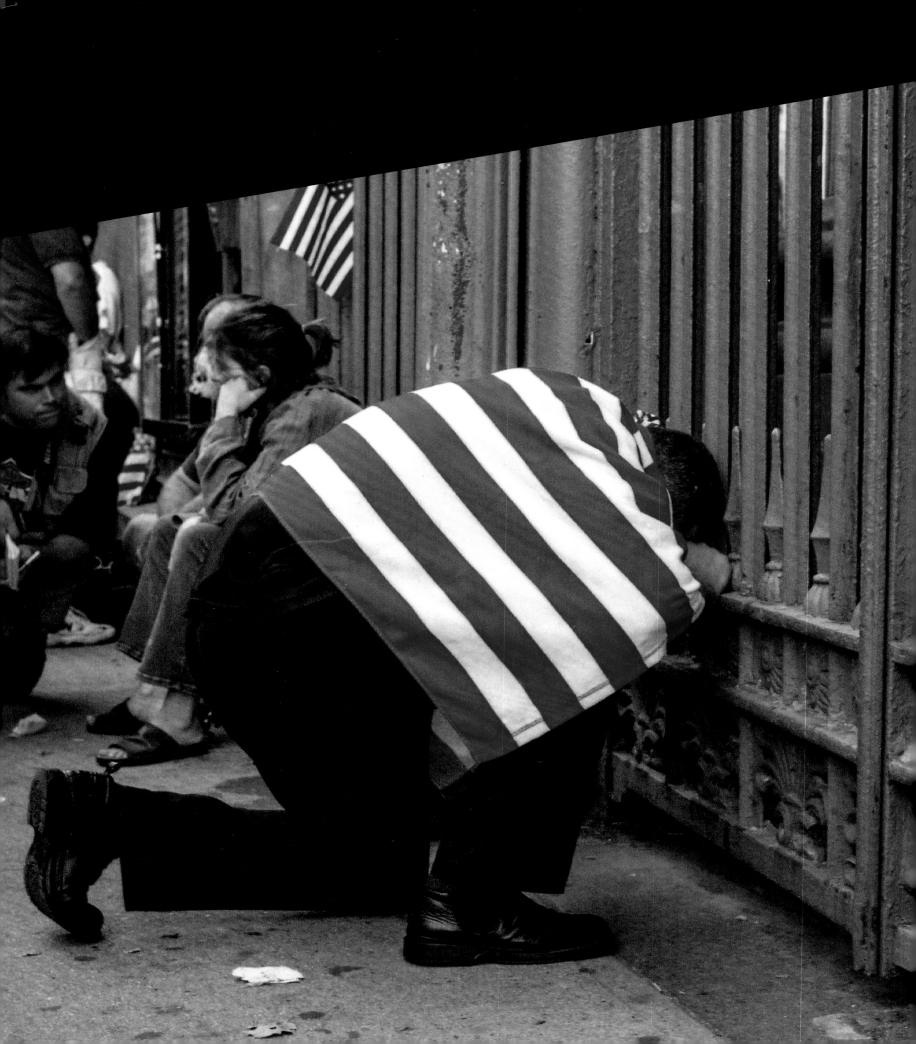

Even savvy New Yorkers feared that devastation might be wrought by the changeover of clocks and computers to the twenty-first century, aka Y2K.

A more benign-seeming technological development was the digital camera. Almost overnight, images were easy to come by, immediate and disposable—and so, too, were clothes, with the arrival of the Swedish giant H&M to midtown Manhattan, heralding an era of quick-turnover fads. "Present-day fashion is going in so many strange directions, from the sloppiness on the street to the joke designs on Paris runways, that it appears to be ready for a nervous breakdown," Bill wrote in June 2001.

Three months later, terrorists attacked the World Trade Center, killing almost three thousand people. The following months were devoted to displays of patriotism and solemnity, and when New Yorkers' joie de vivre returned, it was more in the form of accessories than clothes. Shoes were of paramount importance, from the Manolo Blahnik and red-soled Christian Louboutin pumps preferred by the stars, characters, and fans of *Sex and the City* to the increasingly baroque sneakers worn by hip-hop aficionados.

That most American of fabrics, denim, was now acceptable as the basis for a dressy outfit, with jeans narrowing by mid-decade to legging-like "skinny" proportions. Fedoras, newsboy caps, and other jaunty hats made a comeback. And the so-called It Bag grew to proportions that sometimes threatened to overwhelm its owner—as though residents, their sense of home having been fundamentally threatened, now wanted to walk around with what amounted to a small suitcase.

Bill was out on the streets on the afternoon of 9/11 and on the following days, aware that his column would need to address the tragedy. He ventured over to West Street to photograph the thousands of people with homemade signs and noted the appearance of American flags all over the city. In 2002, he devoted his column to the anniversary, when so many in the city paused in silence at the moment the planes had struck.

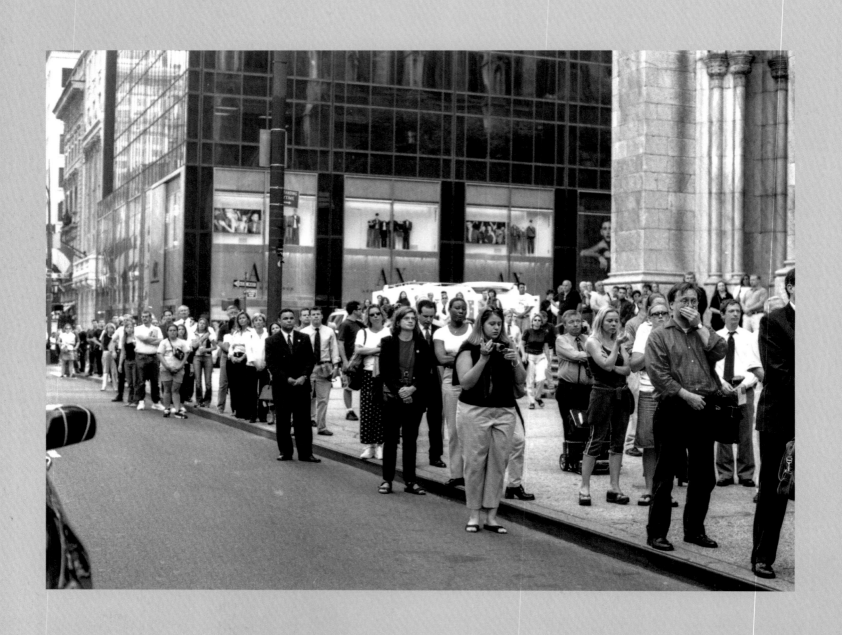

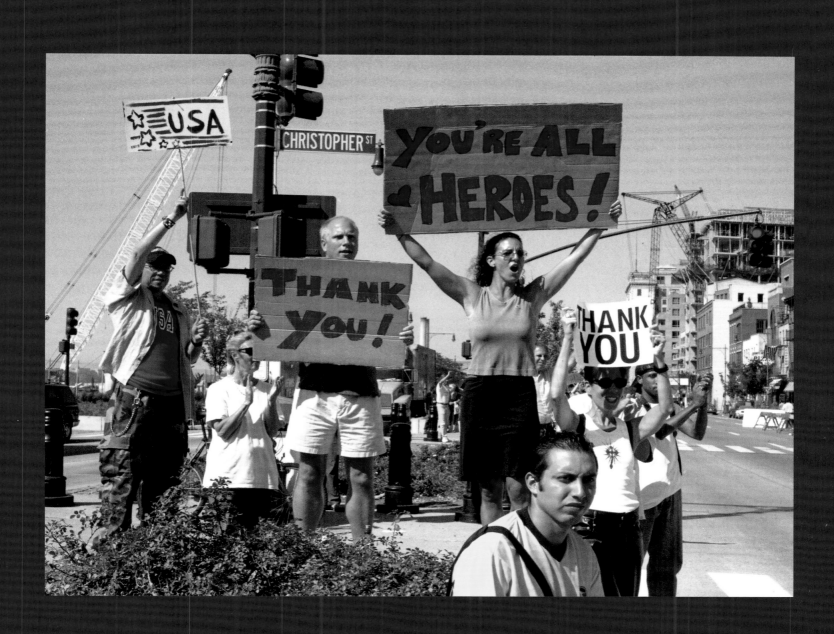

Left: Bill saw people wearing clothing with eyes, and Bill saw people wearing clothing with glasses. "Often the street parade is more original and exuberant than anything in the tents," he wrote, referring to the tents at Bryant Park where New York Fashion Week was held. *Opposite, above right:* Fern Mallis, former executive director of the Council of Fashion Designers of America.

Gender continued to be defined and redefined in the 2000s, with men in skirts *(right)* and *Vogue Paris* editor Emmanuelle Alt in military-style Balmain *(opposite)*.

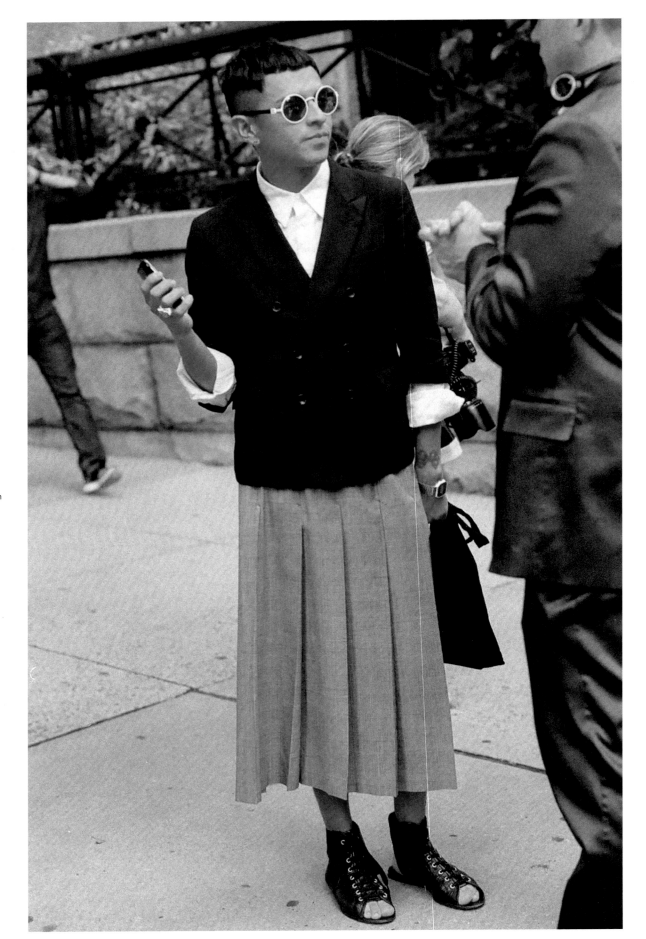

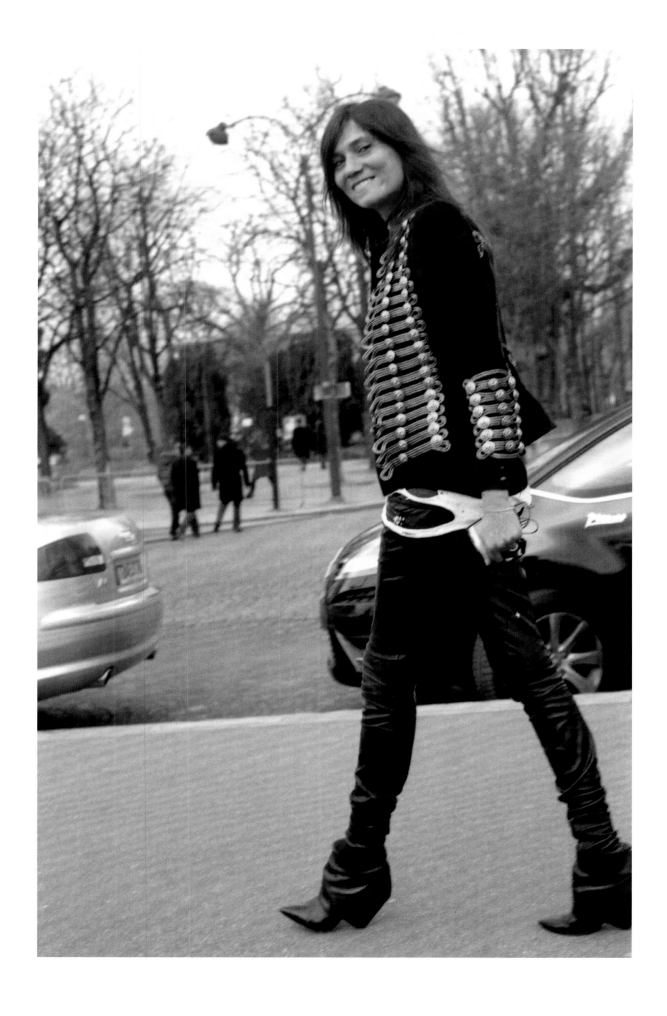

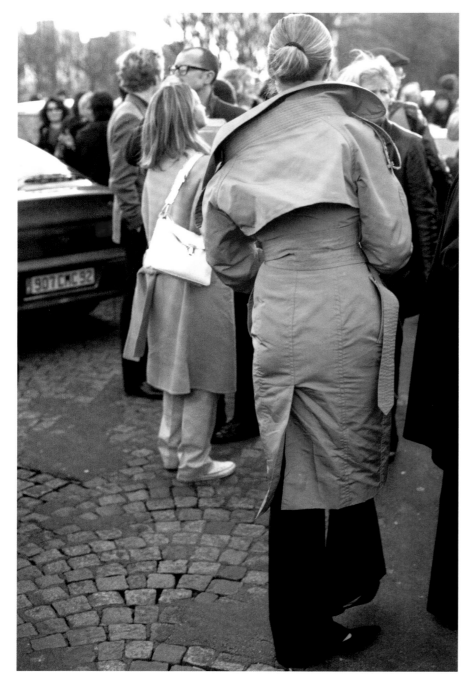

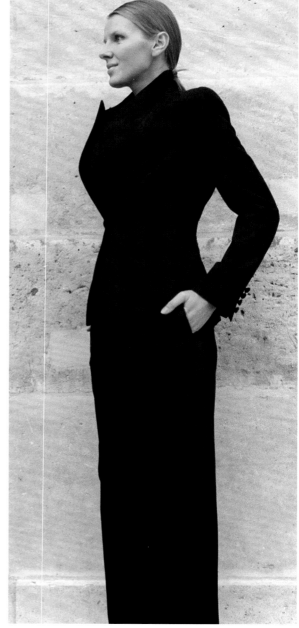

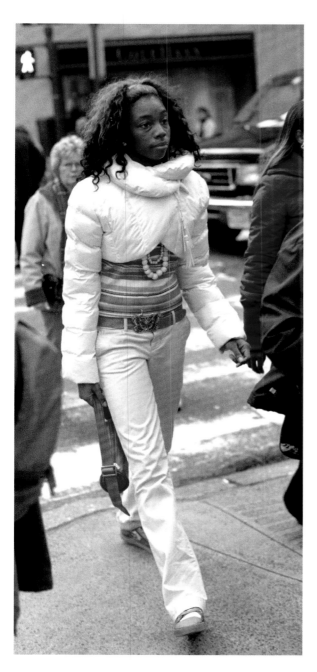

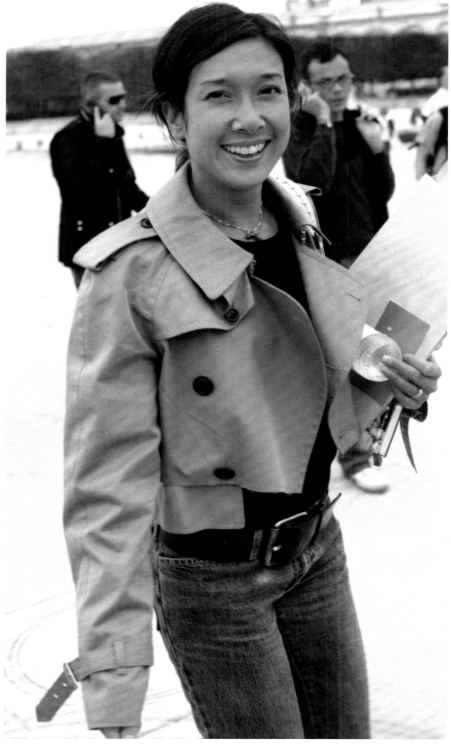

Bill saw how a new generation created its own silhouette, here with low-rise pants and boleros that emphasize a lean torso *(this page)*. Or with a more nuanced reinterpretation of classics like a tailored suit and a trench coat with a dramatic collar *(opposite)*.

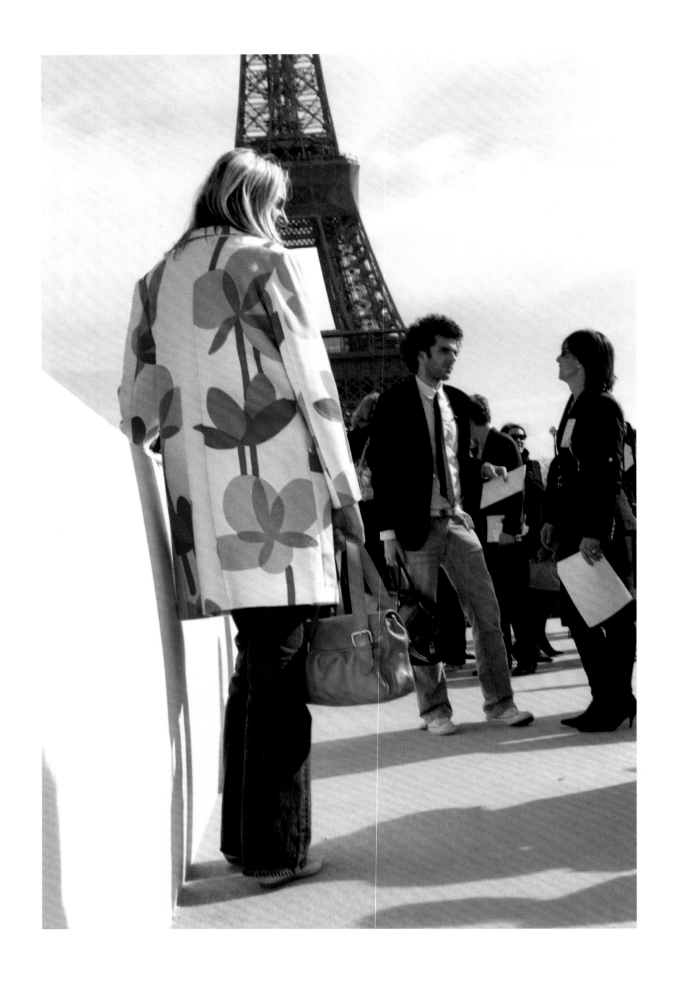

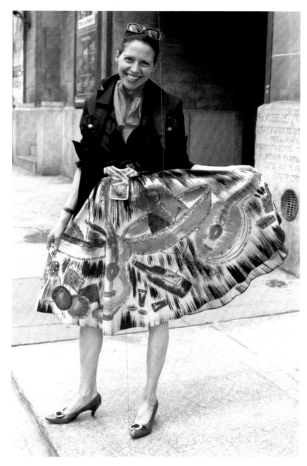

The summer of 2004 almost seemed the summer of the fiesta skirt. Bold florals and abstract patterns in an array of tones were also everywhere, including on Marilyn Kirschner *(top left)*, former fashion editor of *Harper's Bazaar*. **Opposite:** Petals on a coat in Paris.

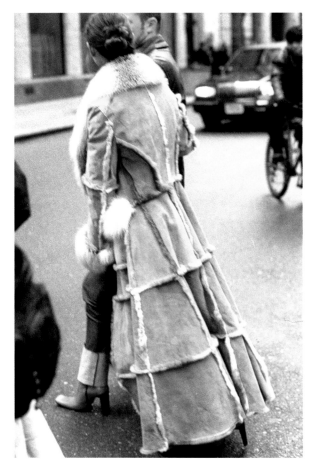

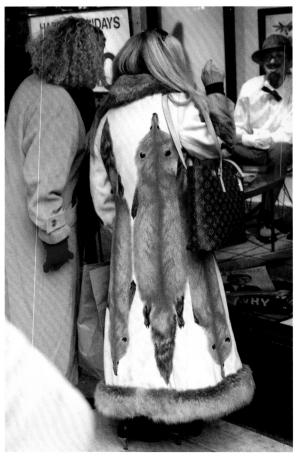

Bill photographed fur and shearling in all its variations and styles since the 1970s, always noting details like trim on pants and when the fur was actually fake.

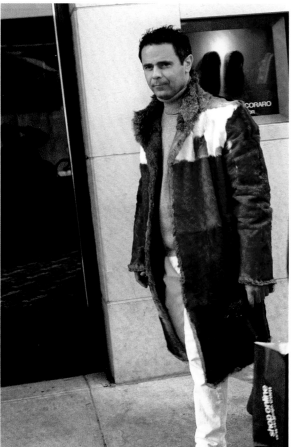

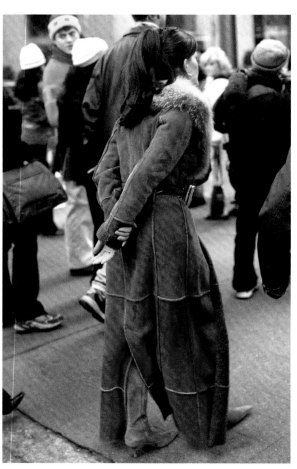

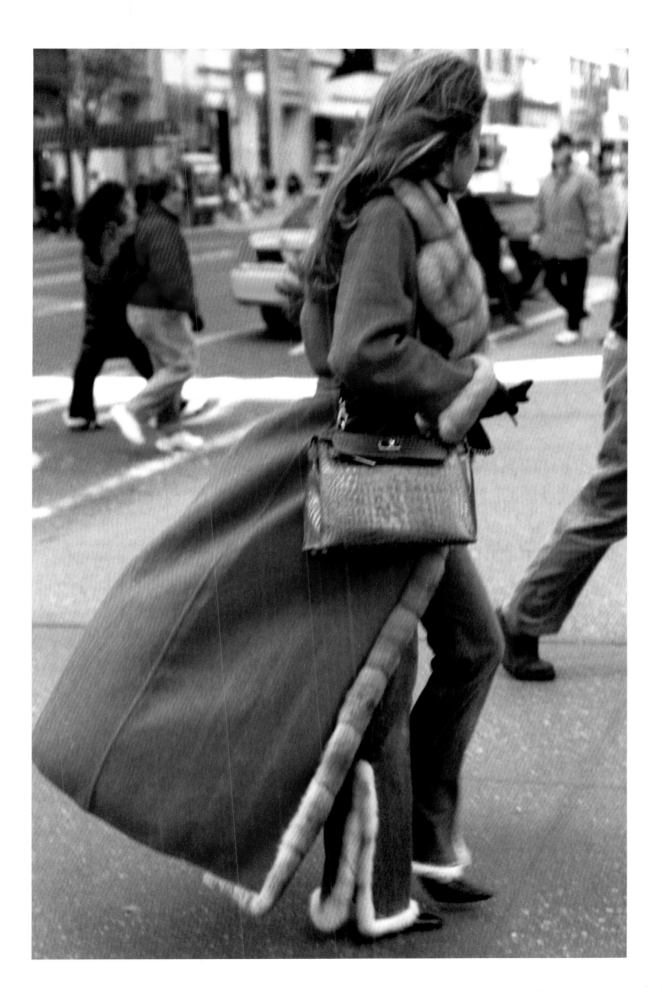

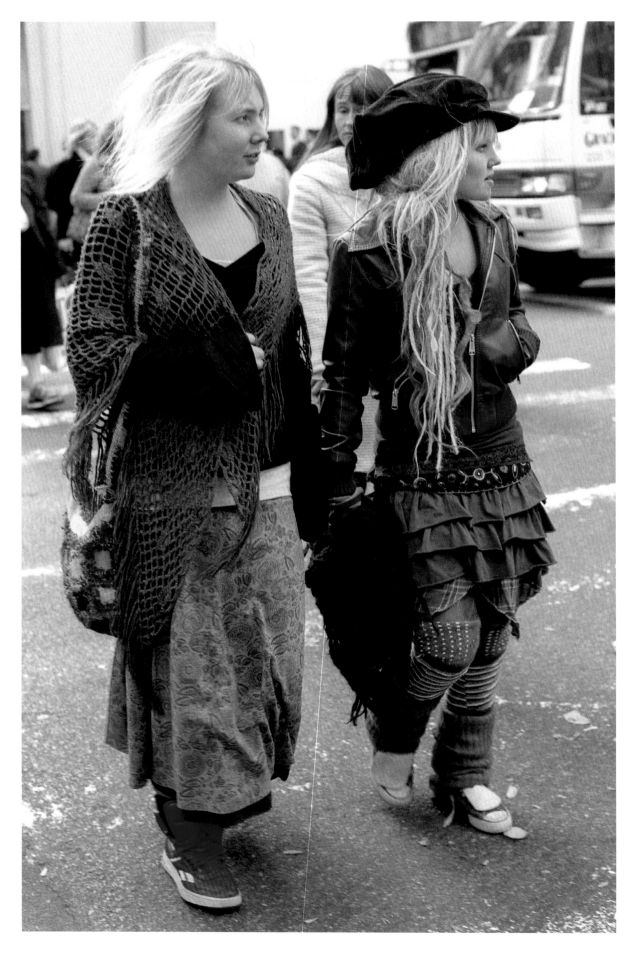

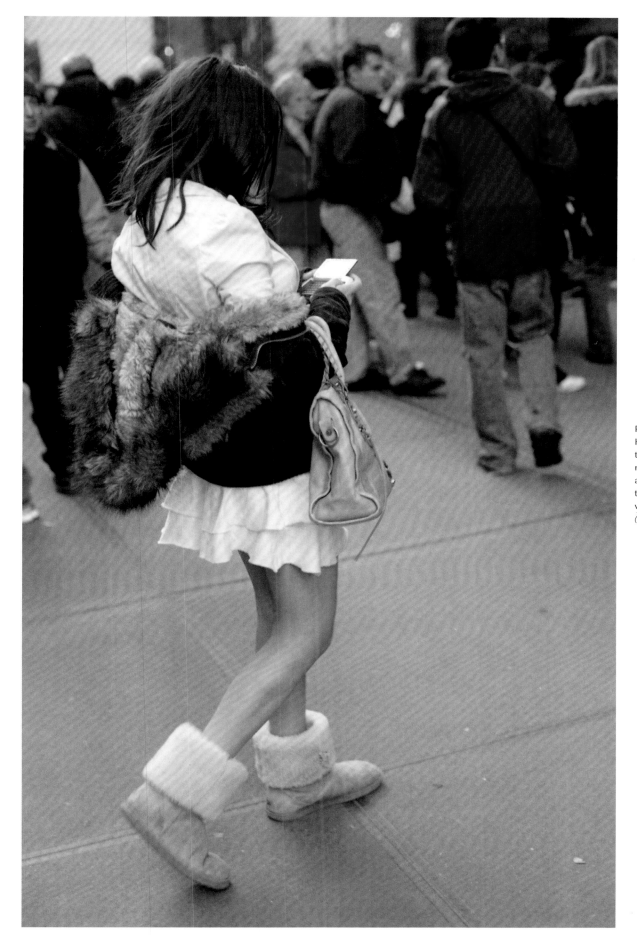

Paris Hilton and other Hollywood celebrities weren't the only people carrying off a mix of UGGs, miniskirts, and a jacket worn indifferently off the shoulders. Layers and leg warmers also made a return *(opposite).*

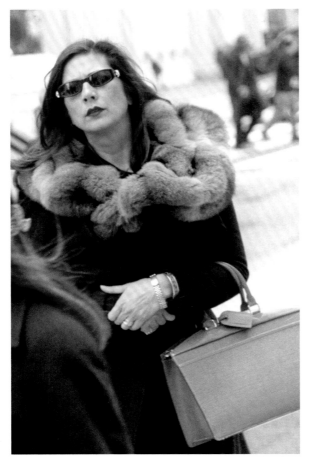

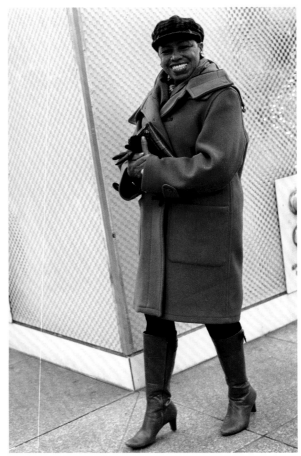

Right: In a column published around St. Patrick's Day, Bill noted that vivid Kelly green had been generally avoided in fashion until the 1940s and 1950s, when women began wearing pastel green at Easter. The color then took hold again. **Opposite:** A trio of striking silhouettes and accessory details.

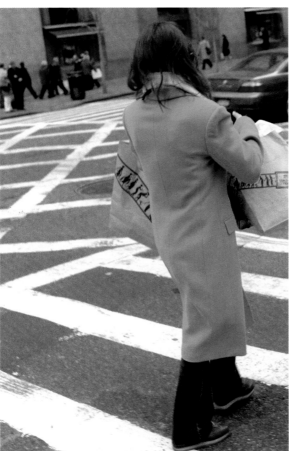

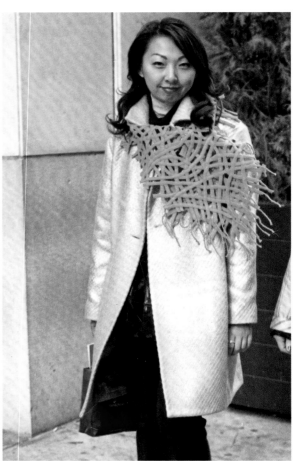

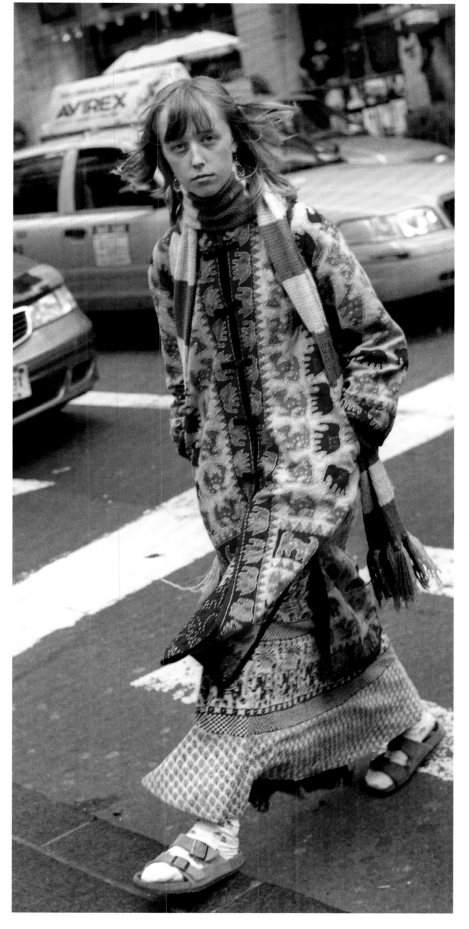

Right: The perennial love of black expressed in several ways, from the ultra-sharp shoulders proposed by the designer Martin Margiela in Paris (and a favorite style of the fashion crowd that year, *below left and top right*) to sophisticated office attire in Manhattan. *Opposite, top:* Bill even caught a group of women on the street dressed in black—and it was still August.

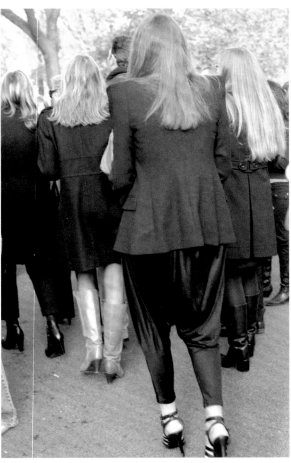

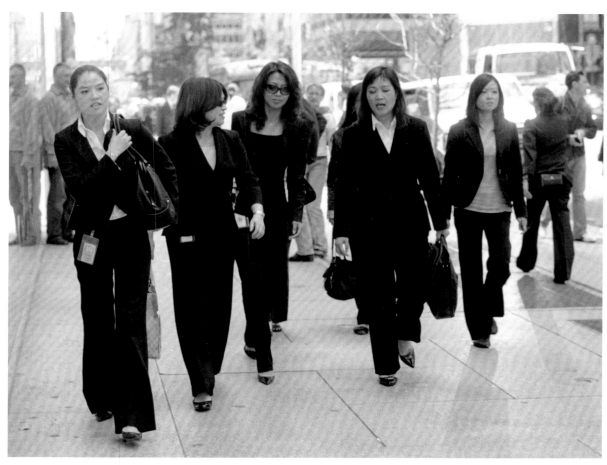

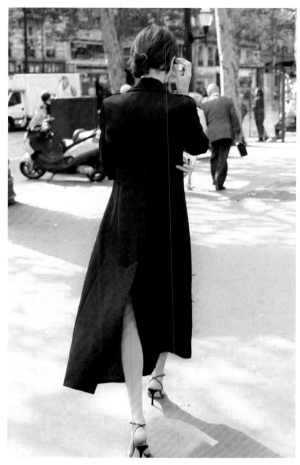

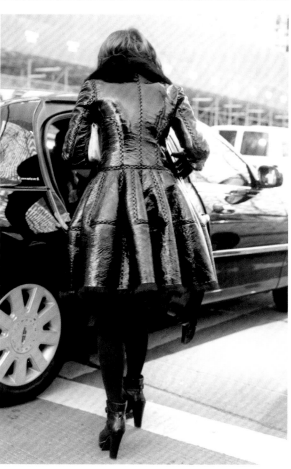

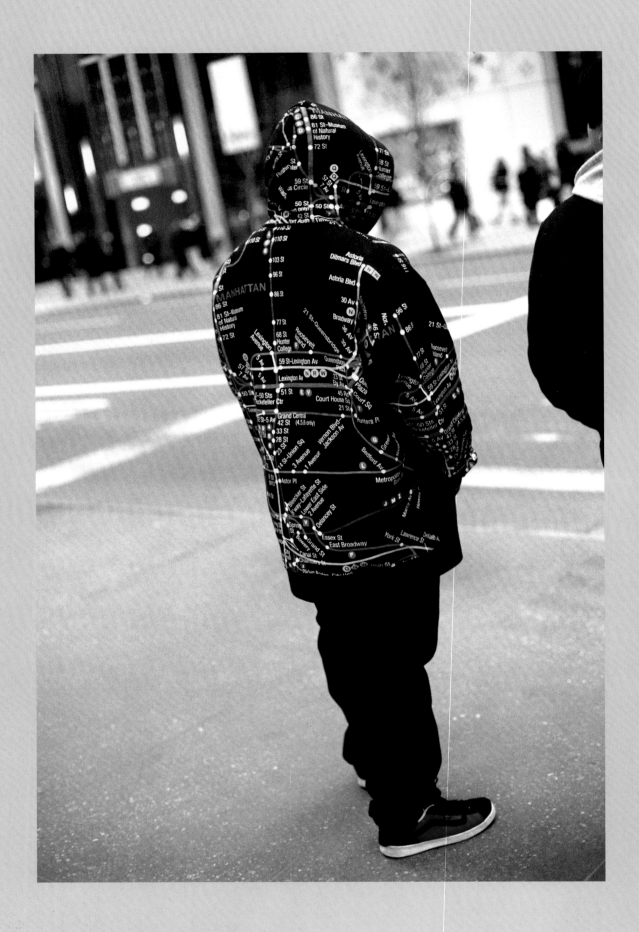

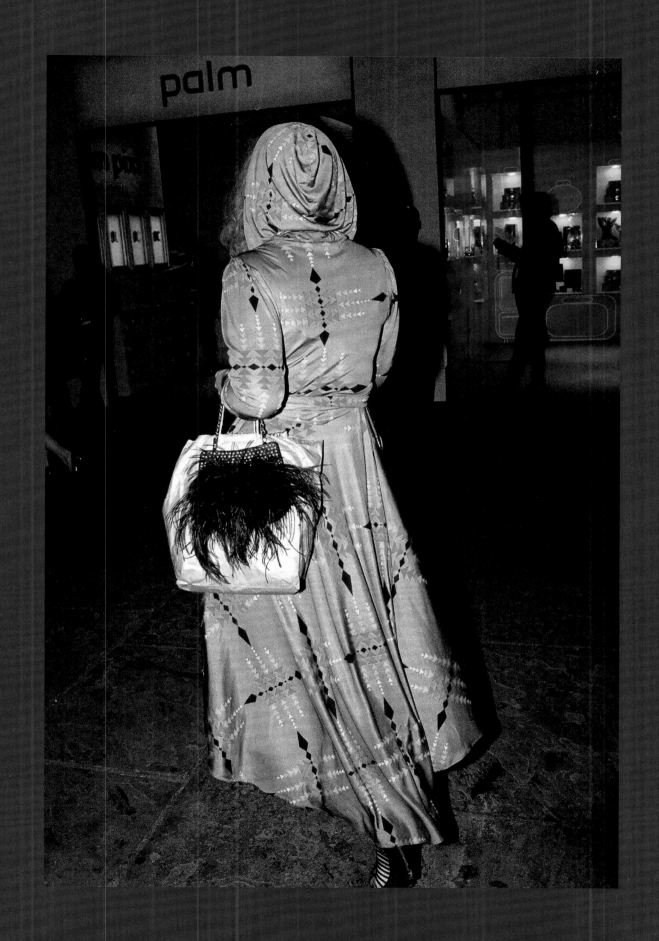

When a few designers played with a child's flap hat, exploding it into extreme shapes, in both real and fake fur, Bill found fans of the look on the street.

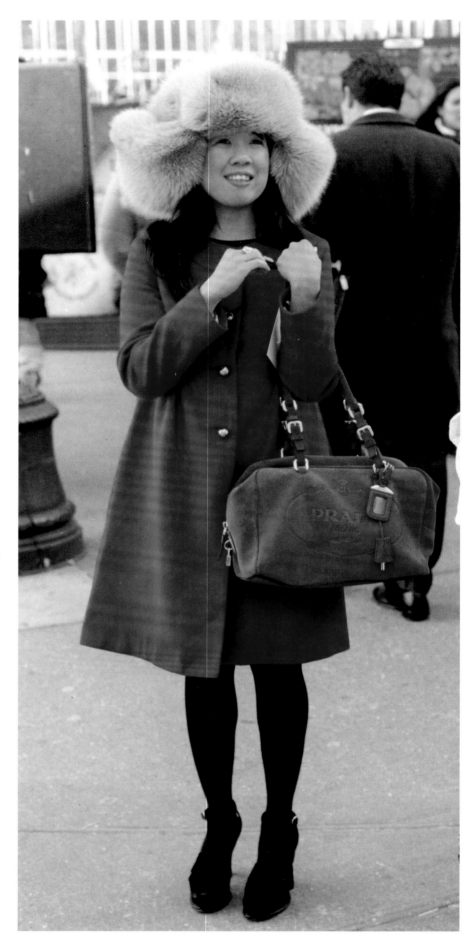

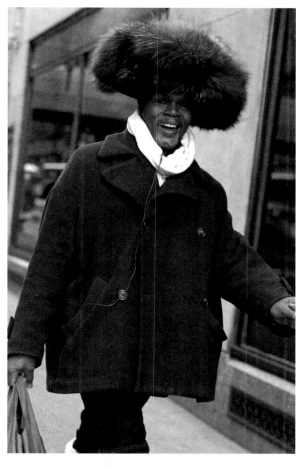

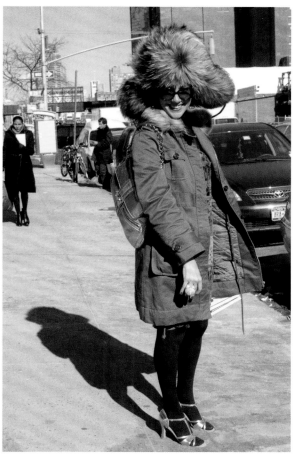

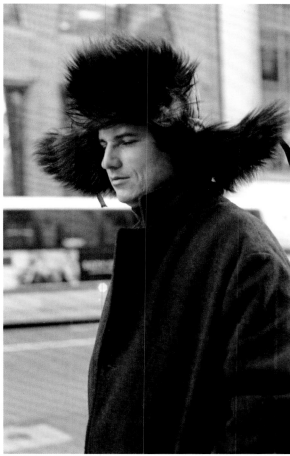

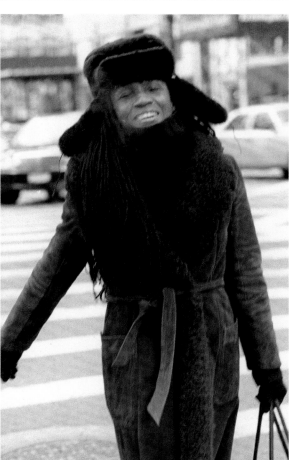

Bill often zeroed in on a detail in street fashion—here shrugs and high collars that seemed to hug the body or frame the face. The mink pullover *(opposite)* anticipated the fashion for stylized sweatshirts.

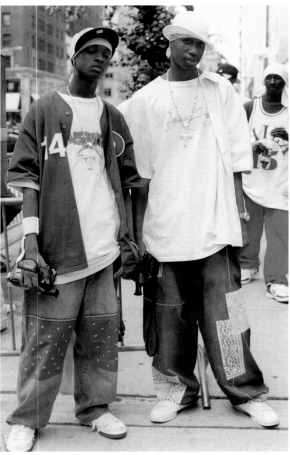

From checks to patches to rows of buckles, denim continued to evolve.

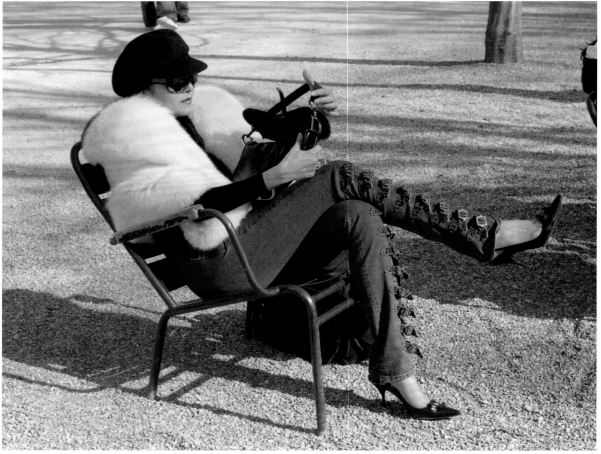

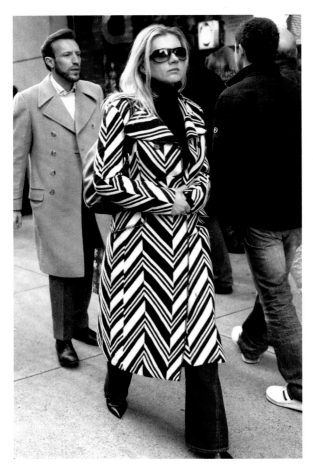

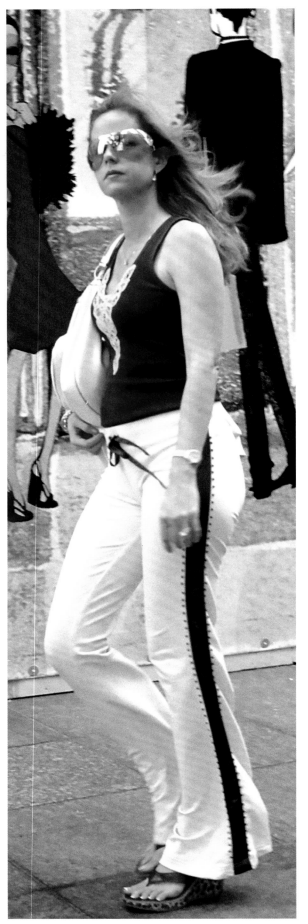

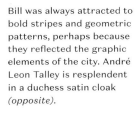 Bill was always attracted to bold stripes and geometric patterns, perhaps because they reflected the graphic elements of the city. André Leon Talley is resplendent in a duchess satin cloak *(opposite)*.

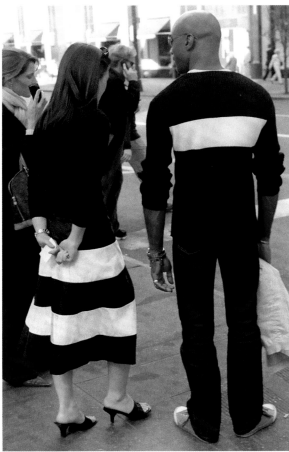

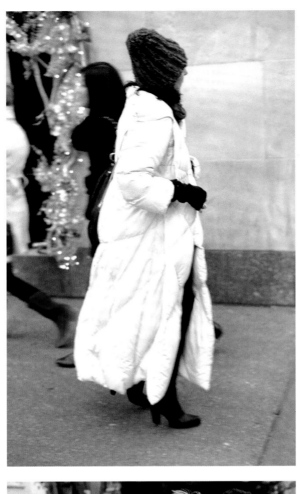

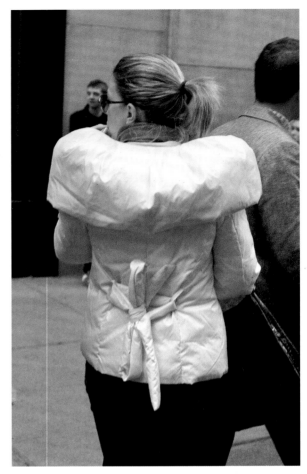

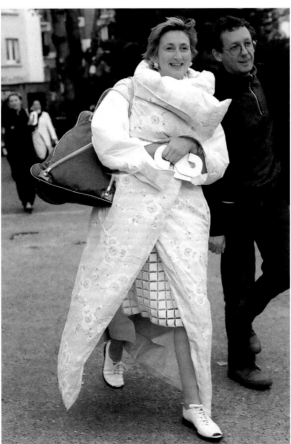

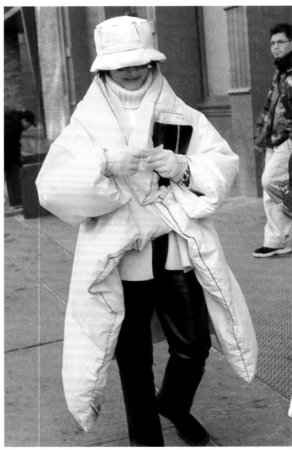

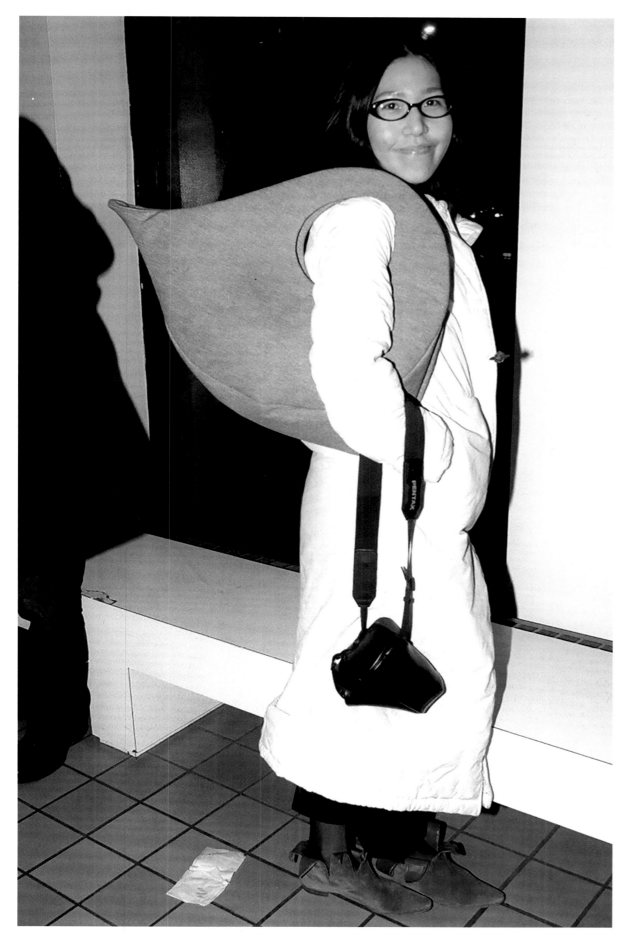

"In 1937, the designer Charles James showed a prophetic eiderdown-filled quilted evening jacket in white satin," Bill wrote in a column, explaining how designers have long experimented with a shape and materials typically used for bed comforters and sleeping bags. In addition to James, he also mentioned Norma Kamali and Martin Margiela.

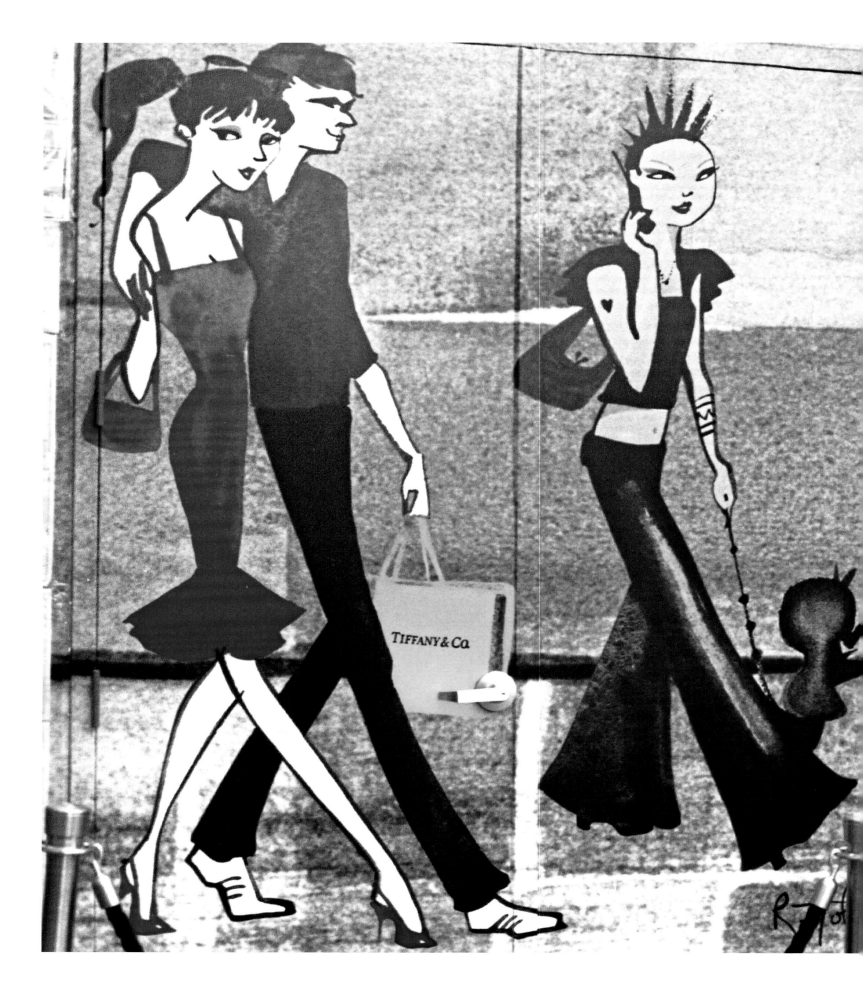

A whimsical fashion mural by Ruben Toledo adorned the side of Tiffany's in the summer of 2005. Bill staked out the mural, waiting for just the right passersby.

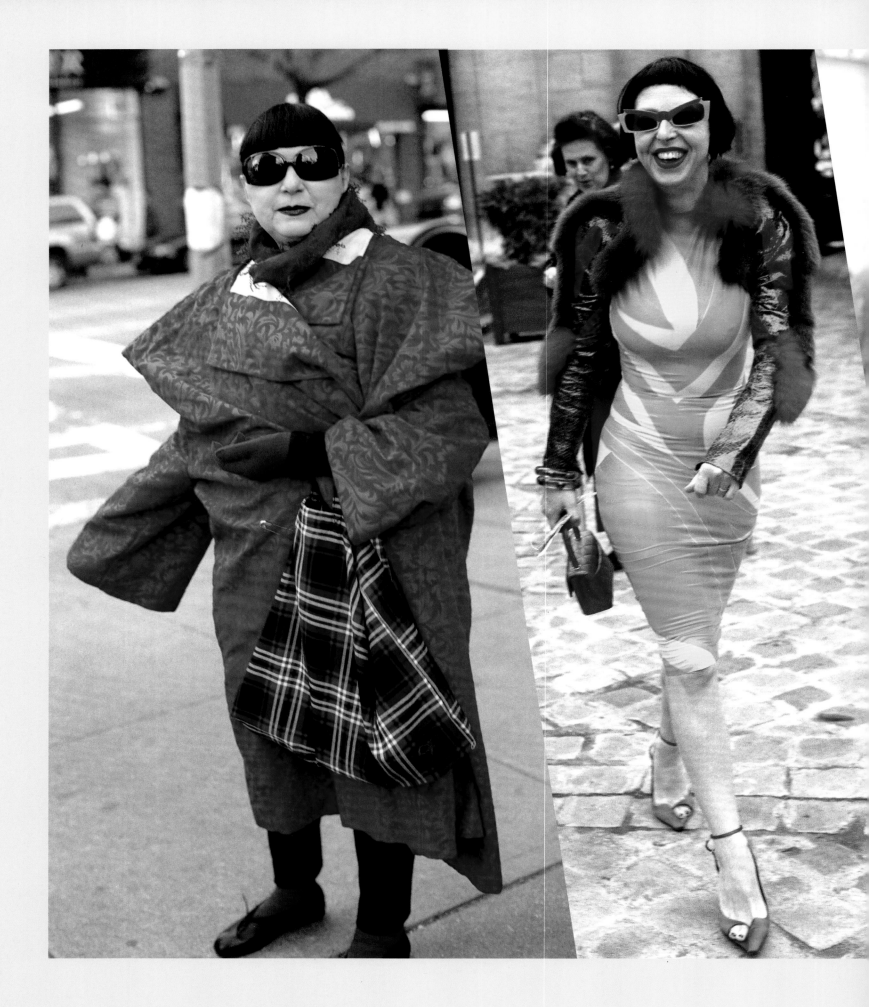

THOSE WHO REALLY CAUGHT HIS EYE

VANESSA FRIEDMAN
fashion director, *The New York Times*

Left to right: Louise Doktor, Isabella Blow, and Carine Roitfeld

In Bill's house there were many muses.

There was a time, in fact, where almost any interestingly dressed woman—or man; the original nine may have been female, but Bill did not discriminate according to gender—who passed through New York on a regular basis and caught his boundlessly curious eye could lay claim to the title. Most did, and then wore it as a badge of honor forevermore. But not all his muses were created equal.

A select few whose regular presence over the many years of Bill's reporting were singled out as what might be called these days "Supermuses," or "Hall of Fame Muses," though "muse" is really the wrong word for the fifteen people on these pages. (Yes, Bill had fifteen instead of the classical nine, though even winnowing it down to that number was difficult.)

It wasn't so much that, like in the stories of Erato and Homer or Urania and Plato, these individuals spurred Bill on to greater and greater works of art (and he would have taken exception to the term "art" anyway; what he was doing was cultural anthropology for the ages). Rather, they were his subjects of study—his discoveries and his source material.

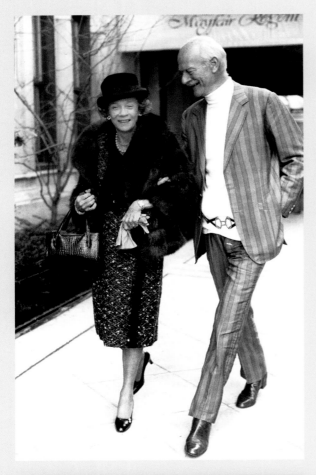

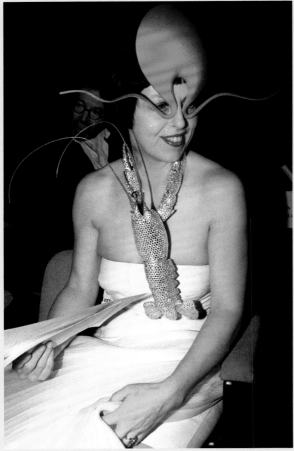

And what *was* so special about them?

They weren't necessarily famous, though some of them indeed were: see **Diana Vreeland**, whose stardom transcended her roots at *Vogue,* with her Kabuki makeup and statement-making dress; and see **Iris Apfel**, whose joyful more-is-more aesthetic has made her a nonagenarian social media star.

They weren't always fashion insiders, though many indeed were: witness **Anna Dello Russo**, the *Vogue Japan* editor whose enormous enthusiasm for designer work results in a cocktail dress at ten a.m., context be damned, or **Isabella Blow**, the British eccentric and original booster of Alexander McQueen, with her yen for surreal headgear.

They weren't always rich people who could afford a lot of fabulous clothes, though, again, many indeed were: **Brooke Astor**, who defined a certain grande-dame style with her gloves and lunch-at-Le-Cirque suits, and **Nan Kempner**, who reveled in breaking society's rules by showing up in leather shorts and fishnets instead of a polite polka-dot tea dress.

And they weren't always rule-breakers—not all of them, anyway—not, for example, **Amy Fine Collins**, whose penchant for architectural shapes and rigor was practically a stricture unto itself.

They were the people who embraced and employed the theater of fashion, who understood its signature potential, its ability to mediate between their essential soul and the world, to give it form and feeling. The people who wore clothes not because of what a garment or brand name or gold chain represented in terms of external achievement or aspiration but because of what it represented in terms of internal expression. It was their singularity that caught Bill's eye and imagination. They dressed for themselves, to reflect themselves. They did it consistently and with commitment, over decades. They never rolled out of bed and ran to get milk in their flannel PJs, but that wasn't because of fear Bill might catch them in non-fashion flagrante. It was because they hewed to their own private standards. To chronicle the evolution of their look was to chronicle the evolution of the self, as culture and politics around it changed. It was to create a record of a character—or maybe of character.

So there was **Anna Piaggi**, an editor at *Italian Vogue,* whose light-blue flapper hair, pink cheeks, tiny hats tilted just-so over an eye, and high-fashion court-jester layers created a mutating mood mosaic almost every day.

There was **Louise Doktor**, an executive secretary at a midtown banking firm, who refused to conform to any establishment dress code but instead crafted her own, combining a Clara Bow bob with clashing graphics and pumped-up volumes and the occasional four-arm sweater.

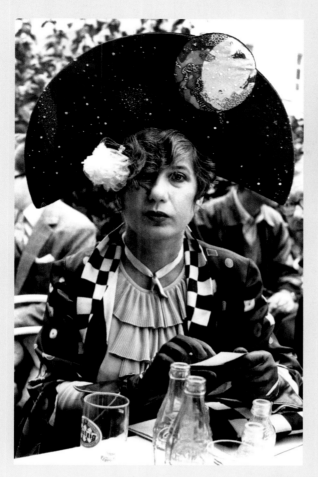

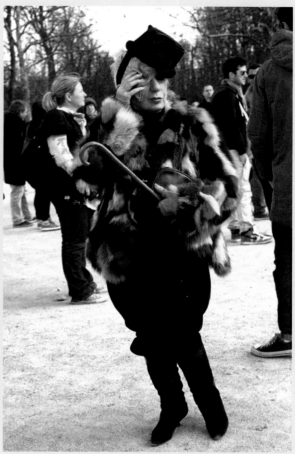

Right: Anna Piaggi and Carine Roitfeld.
Opposite, top: Brooke Astor and Norman Parkinson.
Opposite, below: Isabella Blow.

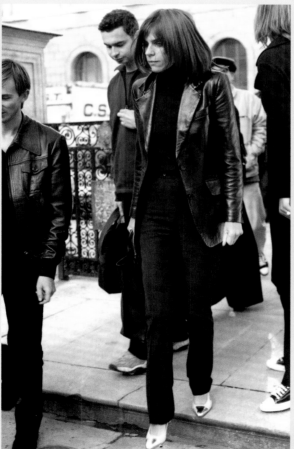

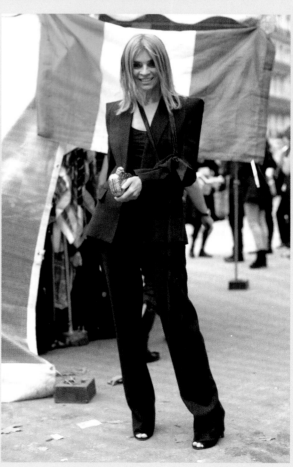

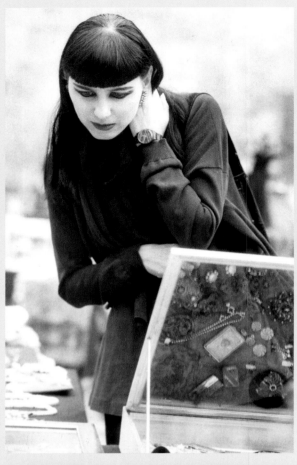

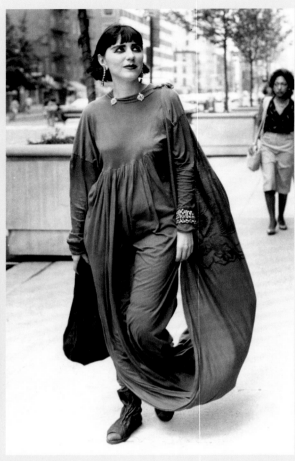

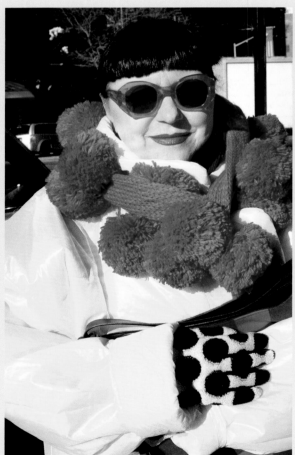

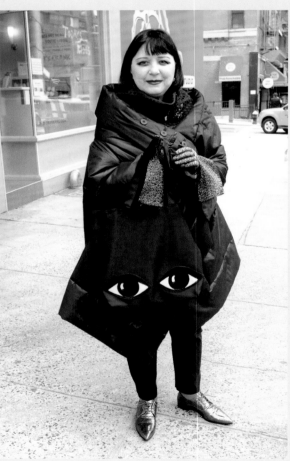

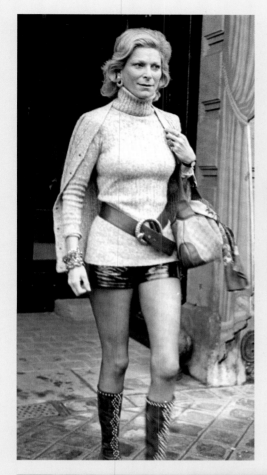
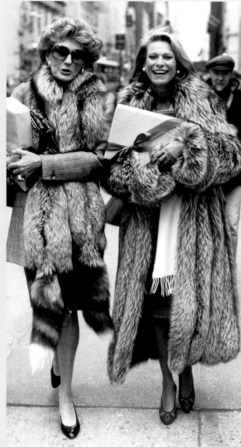
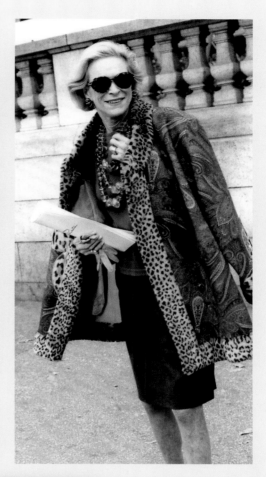

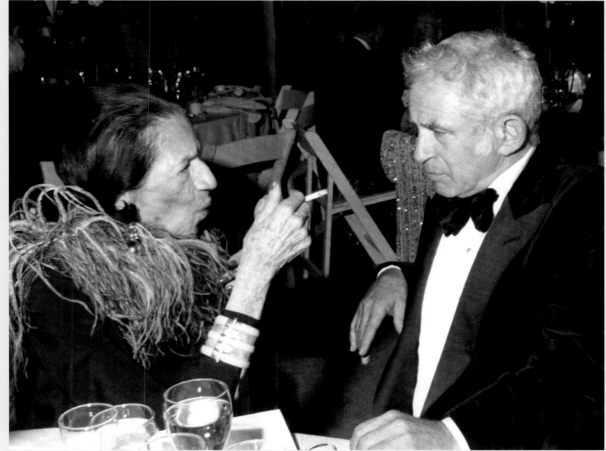

Above: Nan Kempner, in center photo with Pat Buckley. *Left:* Diana Vreeland and Norman Mailer. *Opposite:* Louise Doktor.

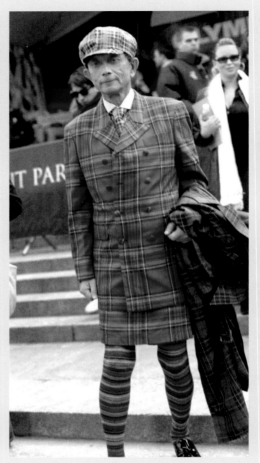
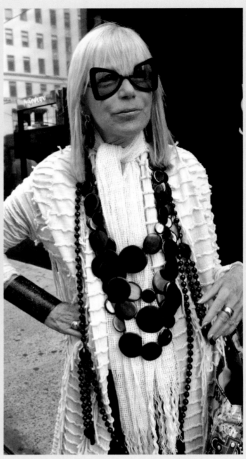
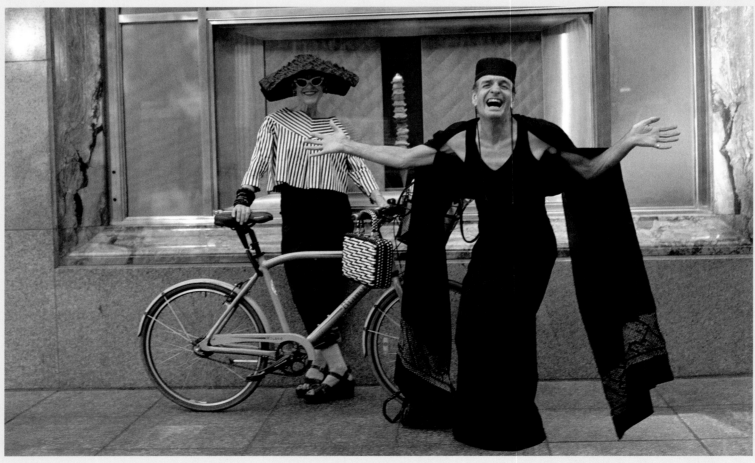

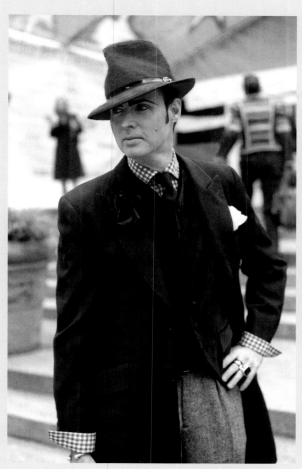

There was **Carine Roitfeld**, who helped define the 1990s (and create the Gucci look of the Tom Ford years) with her Francophone dominatrix stilettos and pencil skirts, her corsets and leather.

There was **Patrick McDonald**, the self-styled dandy; **Tziporah Salamon**, the Israeli-born author of *The Art of Dressing,* who believed "in order to have style, you have to have spirit" (as she told 1stDibs), and wore her brocade robes and capes and sashes in that swashbuckling manner. And there was **Shail Upadhya**, the Nepalese diplomat and United Nations official who loved pattern and print and once made an outfit out of an old couch.

There were **Timothy John**, the artist whose hats and skirts and baubles made an art of appearance itself, and **Marjorie Stern**, with her dark round glasses, white bob, and avant-garde robes.

Once Bill achieved what was probably to him an uncomfortable level of fame, and his pages in *The New York Times* became magnets for readers who viewed them as a barometer of success, there were those who would costume themselves to try to lure him into taking their picture, to make a bid for musedom. That was the surest way to turn him off. He searched for the honesty in the artifice, for the individuals whose abiding fascination with the ethos of clothing matched his own.

And then he enshrined them in his own Olympus. (And later, Nikon.)

Left: Patrick McDonald *(top),* Anna Dello Russo, and Amy Fine Collins *(left).* **Opposite:** *(top)* Iris Apfel, Shail Upadhya, and Marjorie Stern; *(below)* Tziporah Salamon and Timothy John.

"Constant change is the breath of fashion."

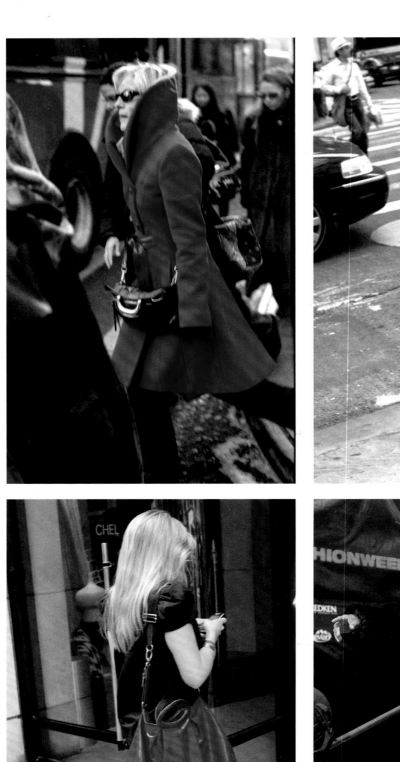

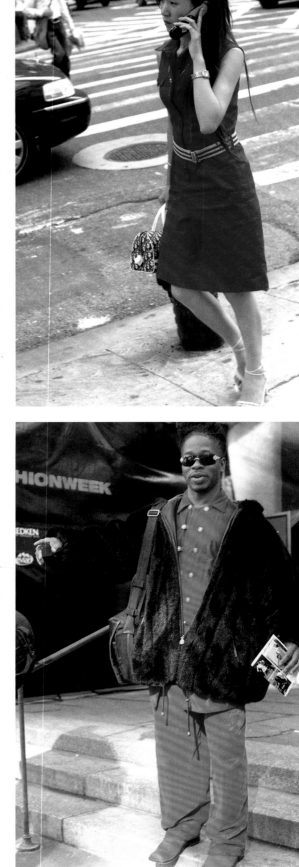

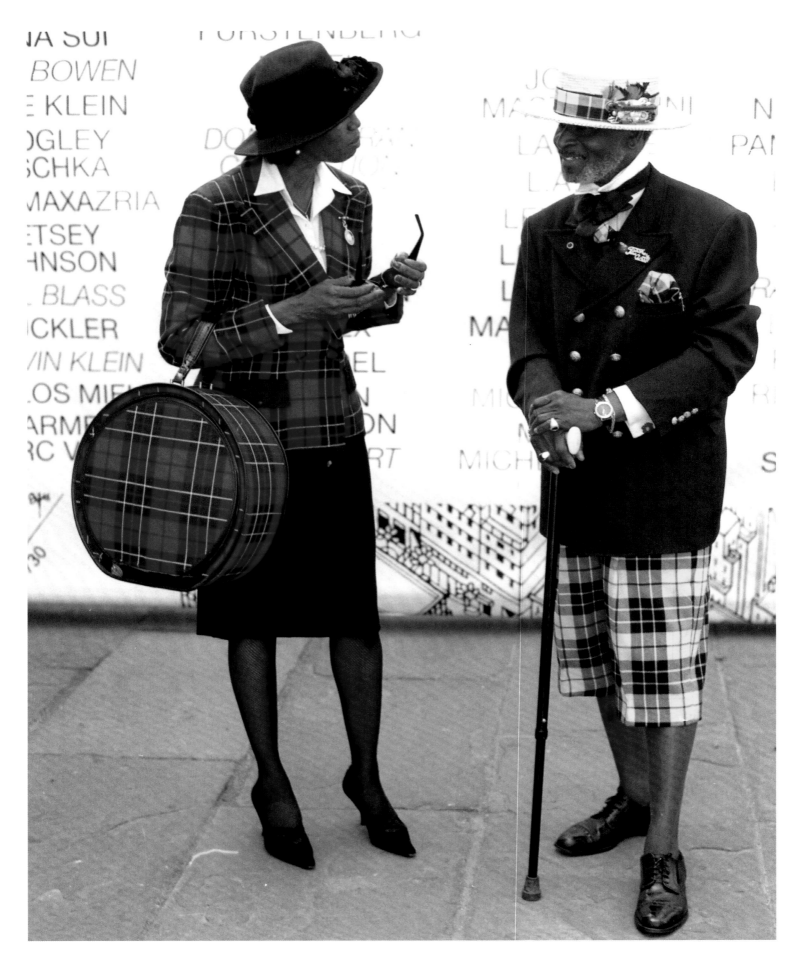

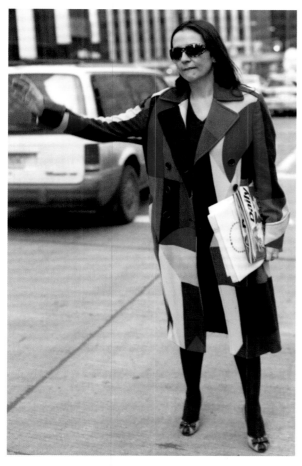

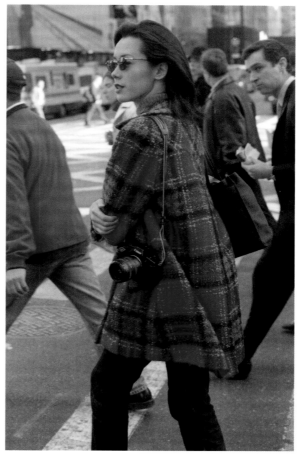

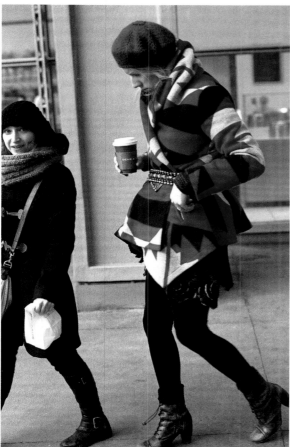

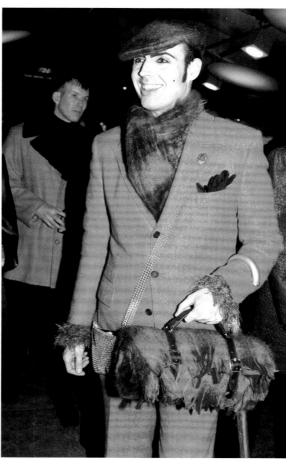

Not only did Bill have an eye for novel interpretations of tartan, but he also identified other variations on patchwork. Ionia Dunn Lee with the designer Bill Boiz *(opposite)*.

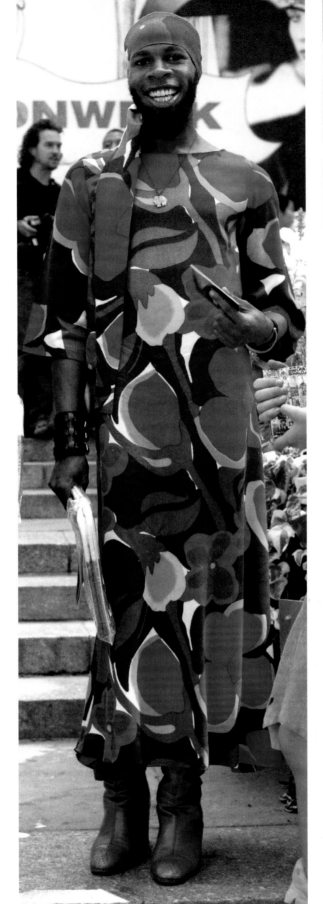

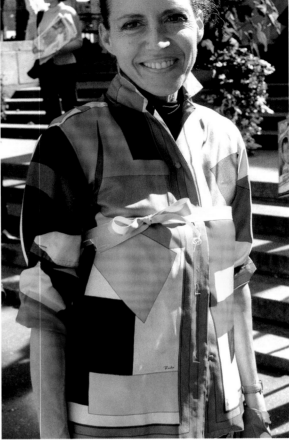

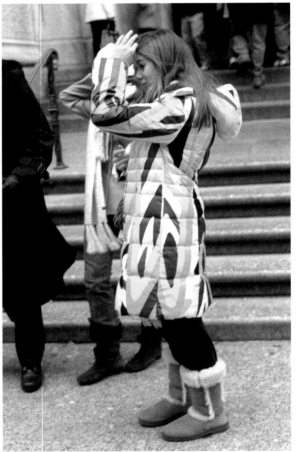

Bill relished Fashion Week for its displays of attention-getting outfits, and the opportunity to create collages of psychedelic prints, for example.

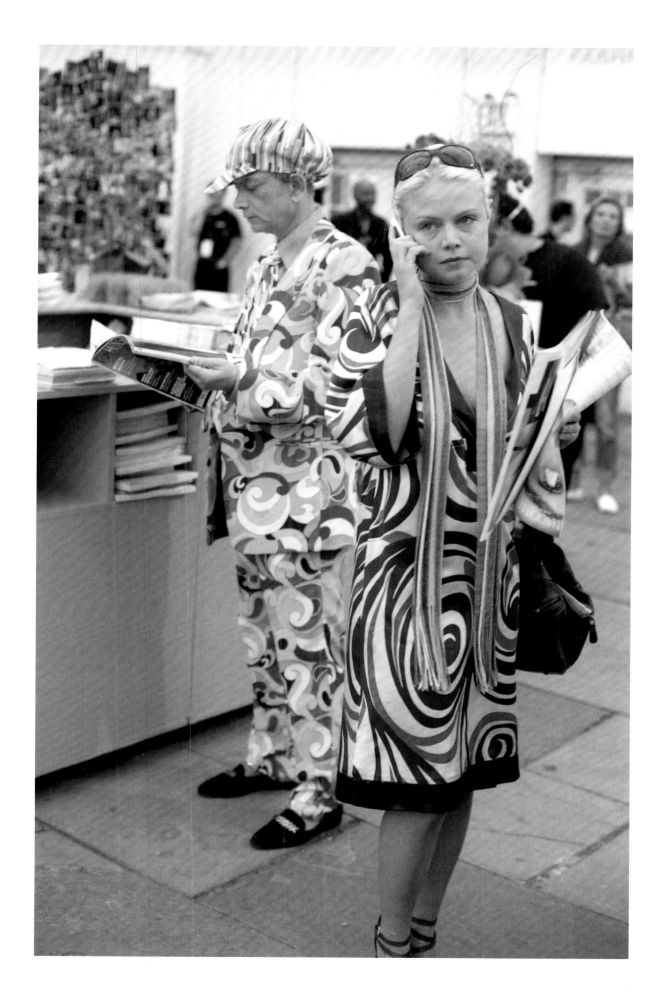

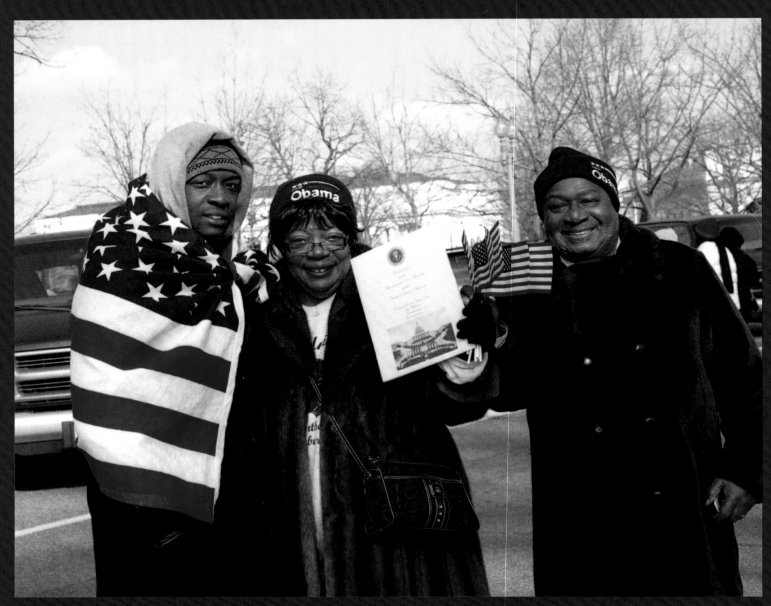

Bill traveled to Washington, DC, in January 2009 to photograph the crowds at the inauguration of Barack Obama. "Dressing was all about surviving the cold and reflected the multicultural taste of a democracy" he wrote.

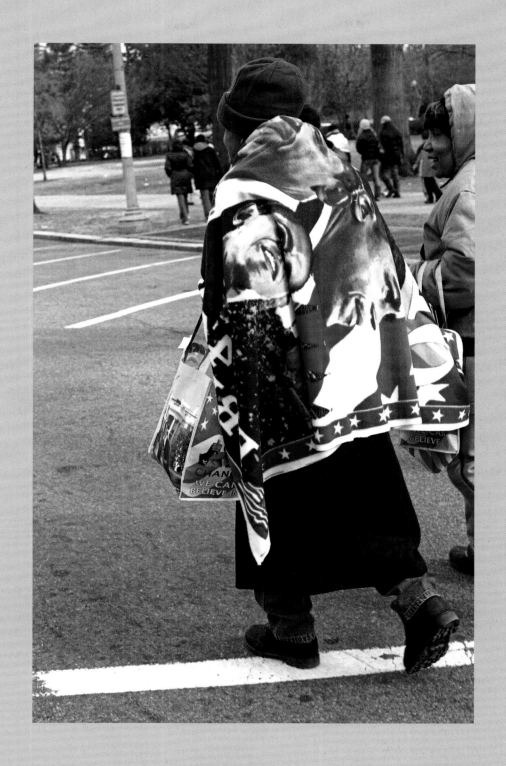

The minimalism of the 1990s gave way to an explosion of logos in 2000, often treated ironically on clothing and shoes. Bill noted these new "brand statements" from Chanel, Gucci, and Fendi—and, of course, documented them in the streets.

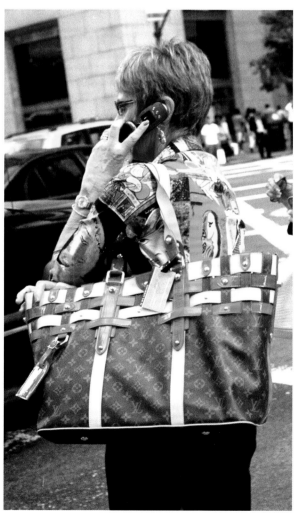

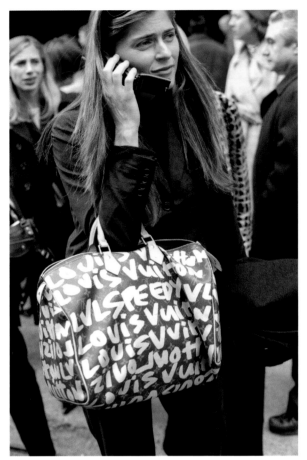

It was hard to ignore the "It" bag phenomenon of the late 1990s and early 2000s, when Marc Jacobs collaborated with Stephen Sprouse for a graffiti version of the Louis Vuitton Monogram bag and Tom Ford introduced the Mombasa bag at Yves Saint Laurent. Bill caught the mania for luxury handbags in all their sizes and shapes. Later on, he recorded the reaction to the craze by showing people proudly wearing fake versions.

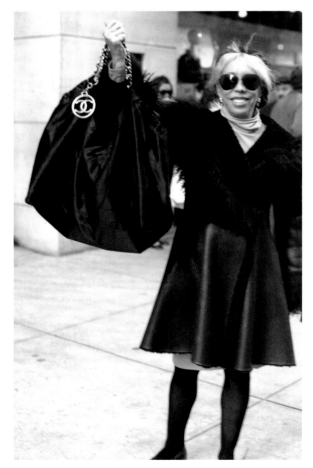

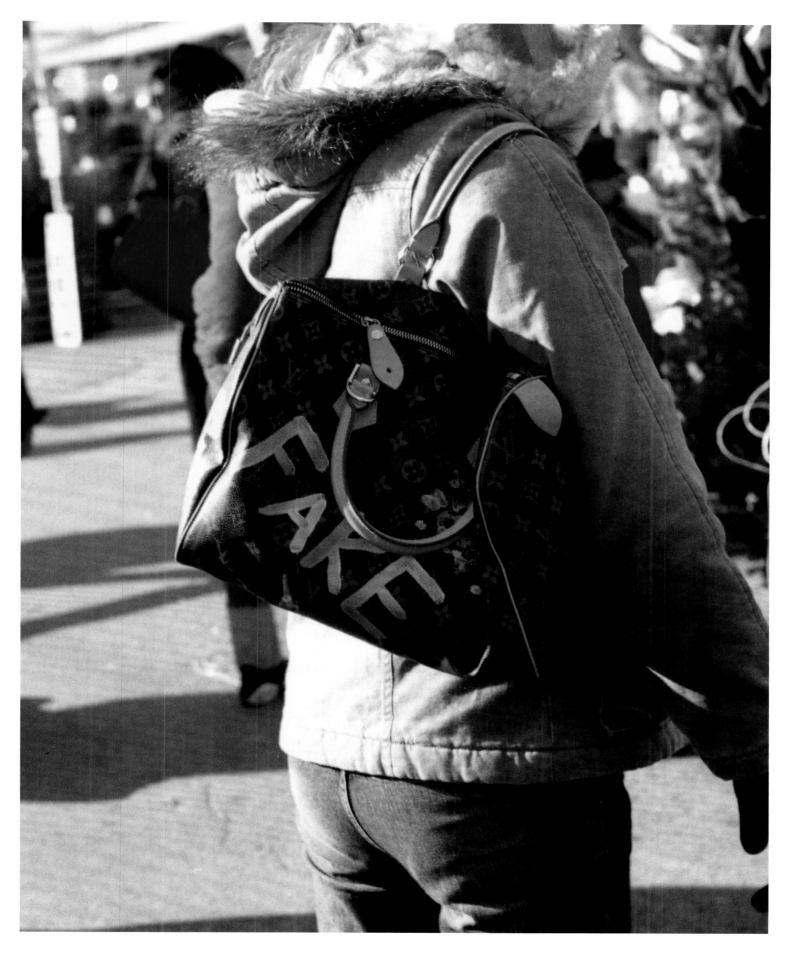

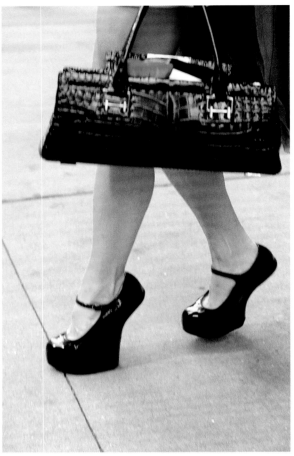

Near the end of the decade, shoes assumed new heights and occasionally surreal proportions, with a wedge style that looked perilously out of balance. Still, women wore them, and Bill recorded the shift in emphasis from handbags to sensational shoes.

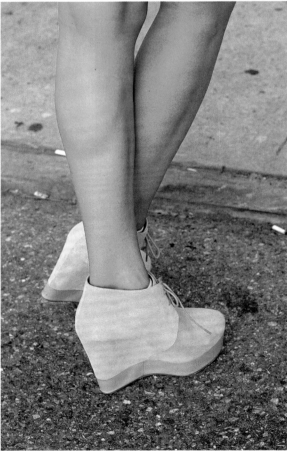

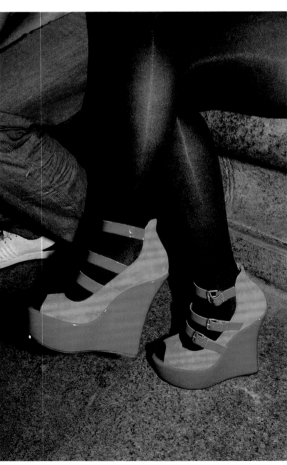

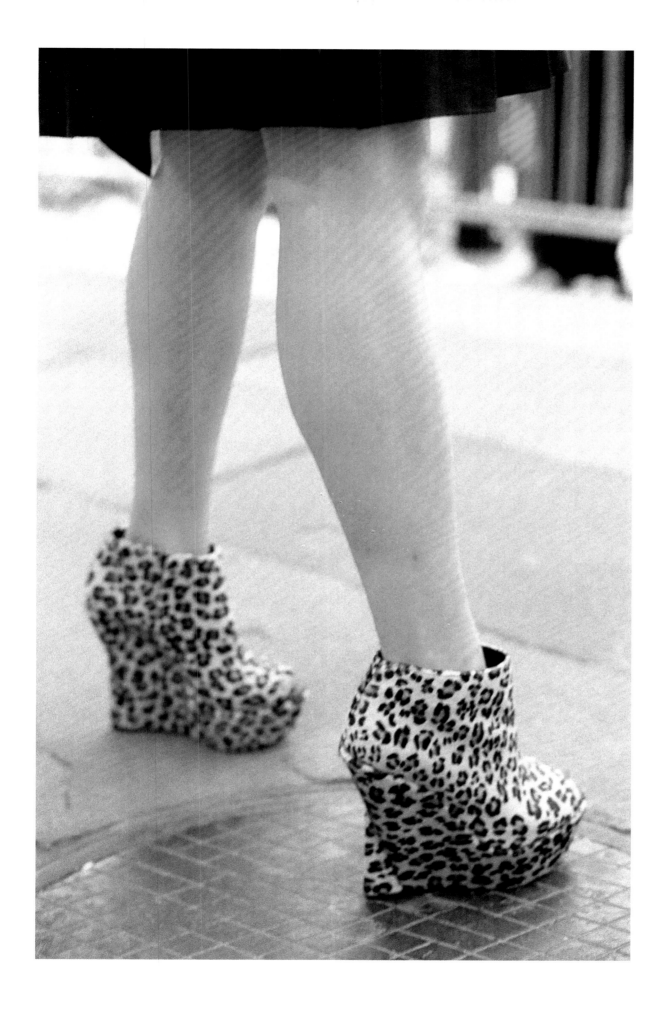

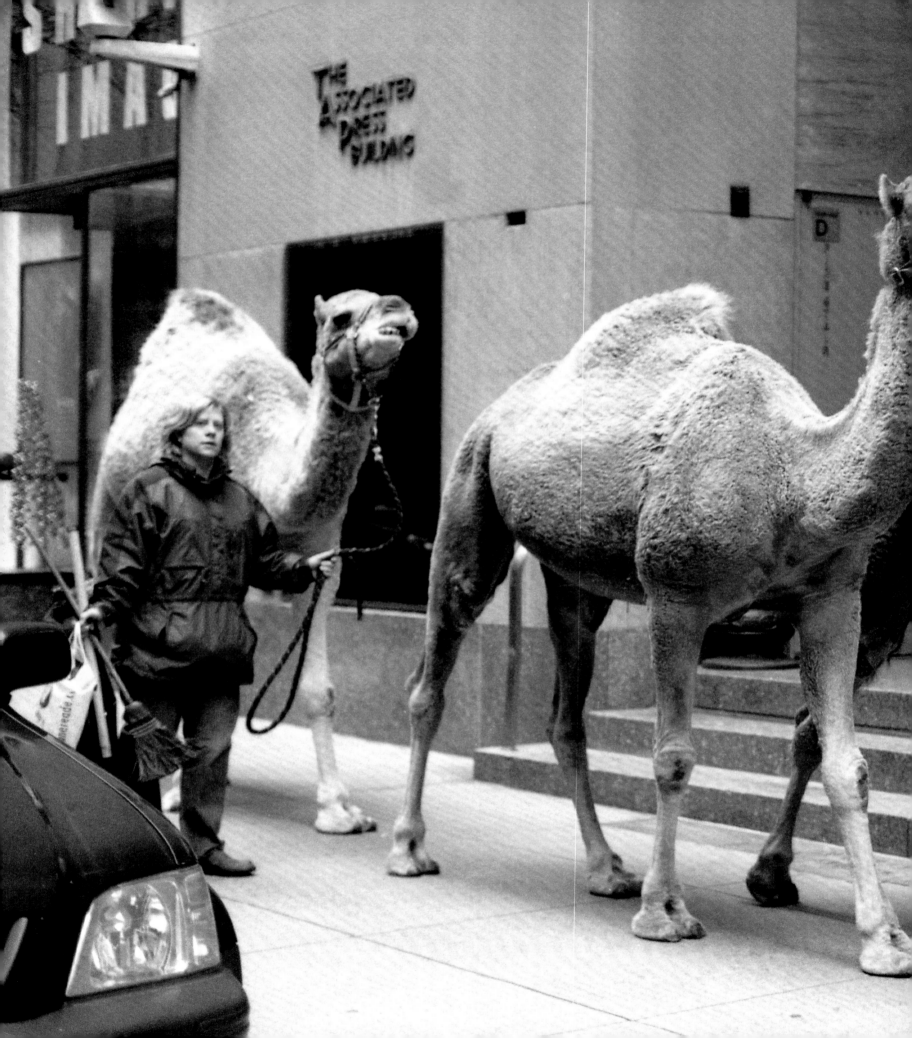

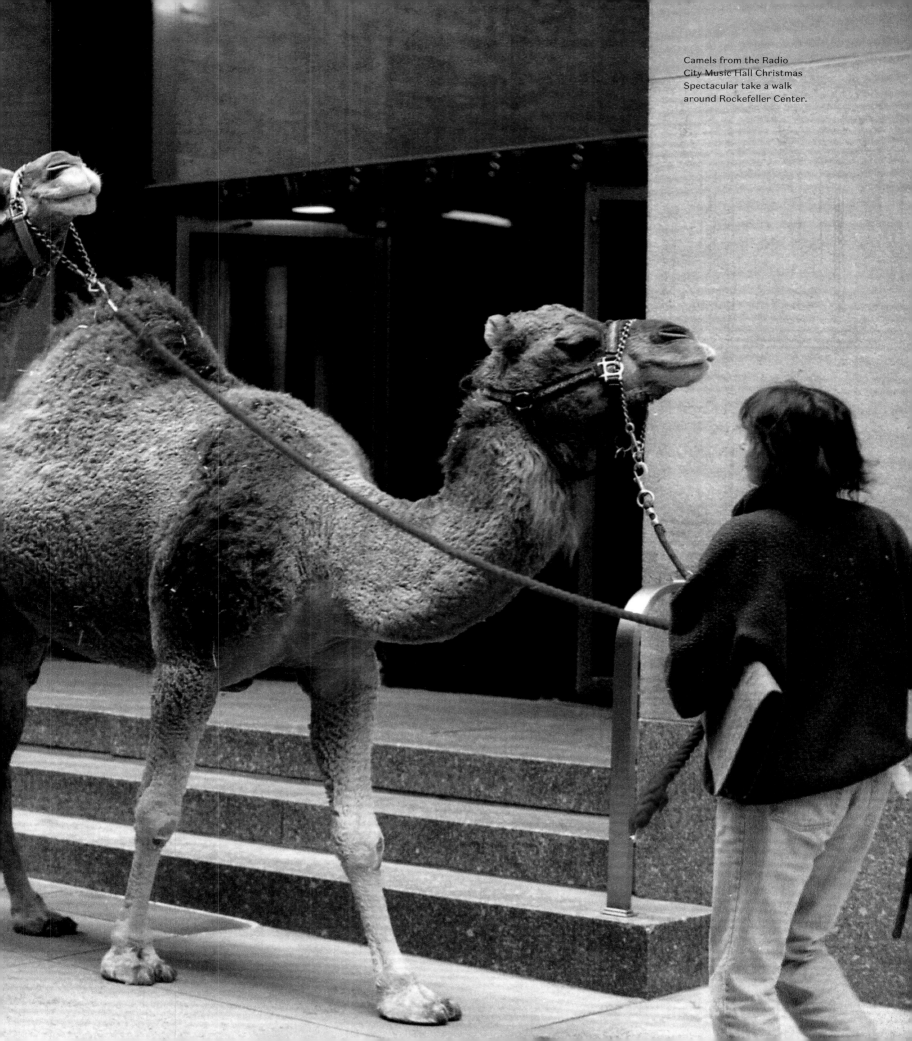

Camels from the Radio City Music Hall Christmas Spectacular take a walk around Rockefeller Center.

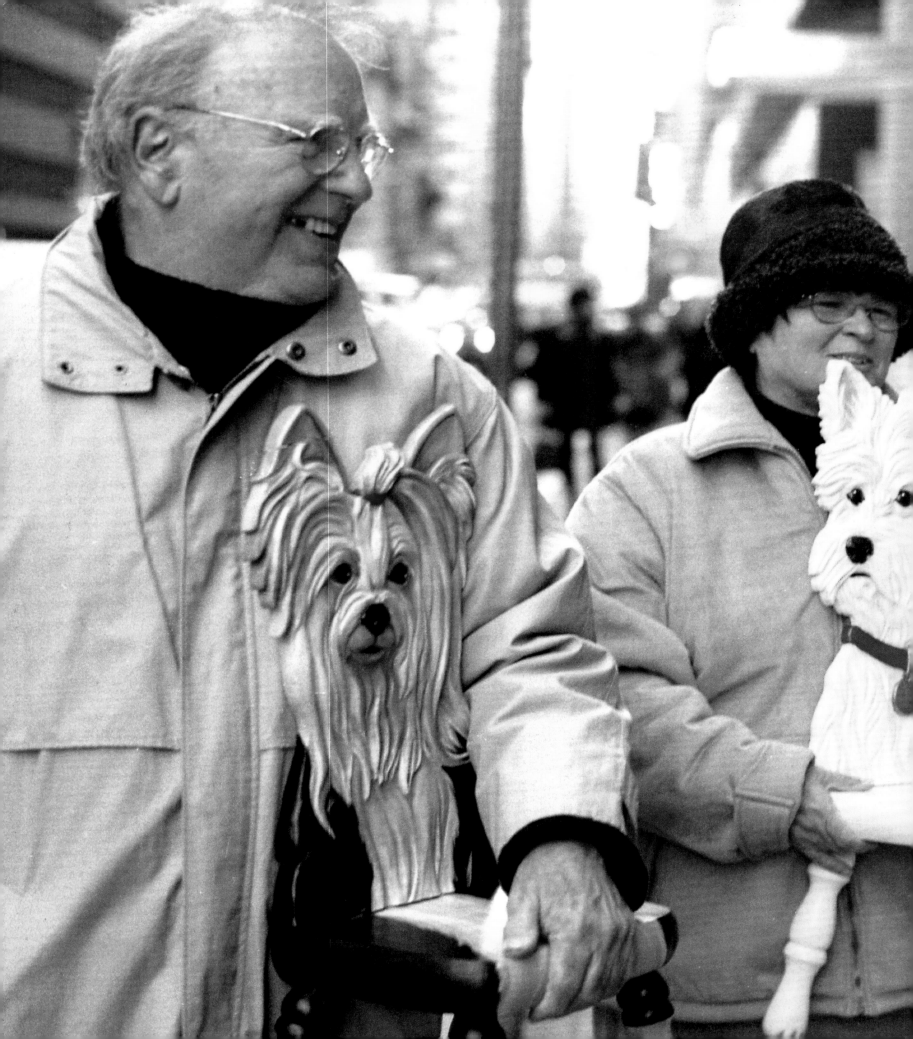

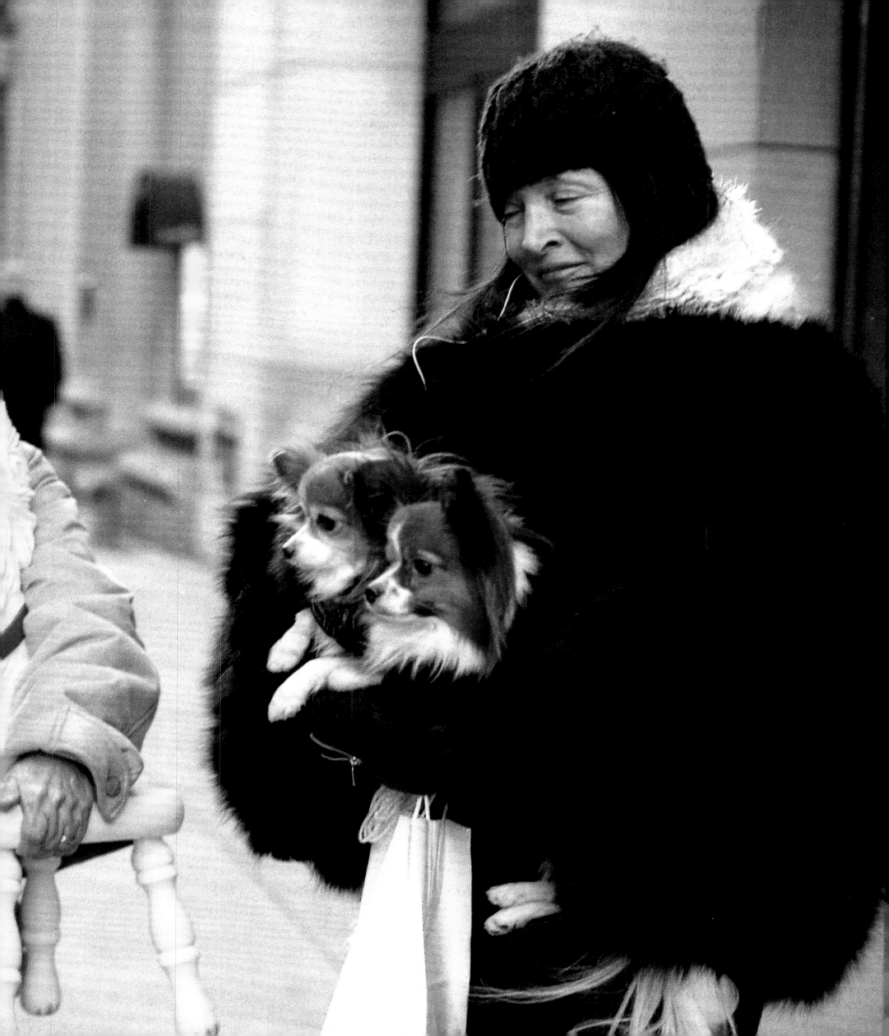

"The high fashion world is cringing as its favorite black is pushed aside by the mass success of pink," Bill wrote. And the color was not merely a spring/summer hue; Bill devoted a column in early 2005 to the emergence of pink as a winter color, overshadowing the usual holiday reds.

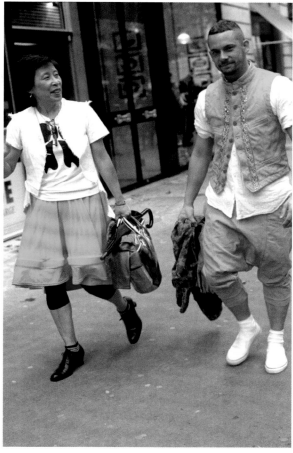

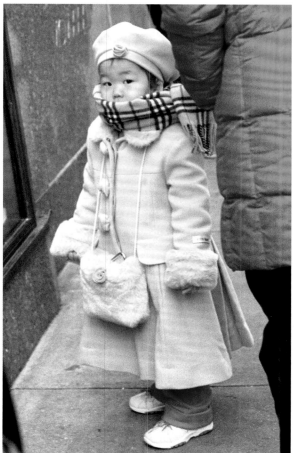

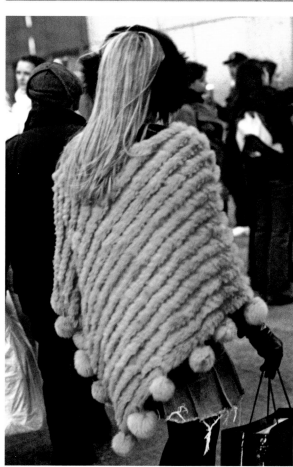

While stripes and polka dots are trends that come and go, Bill observed that "bold-color stripes suggestive of the paintings of the artist Gene Davis" gave some brightness and energy to a tried-and-true concept.

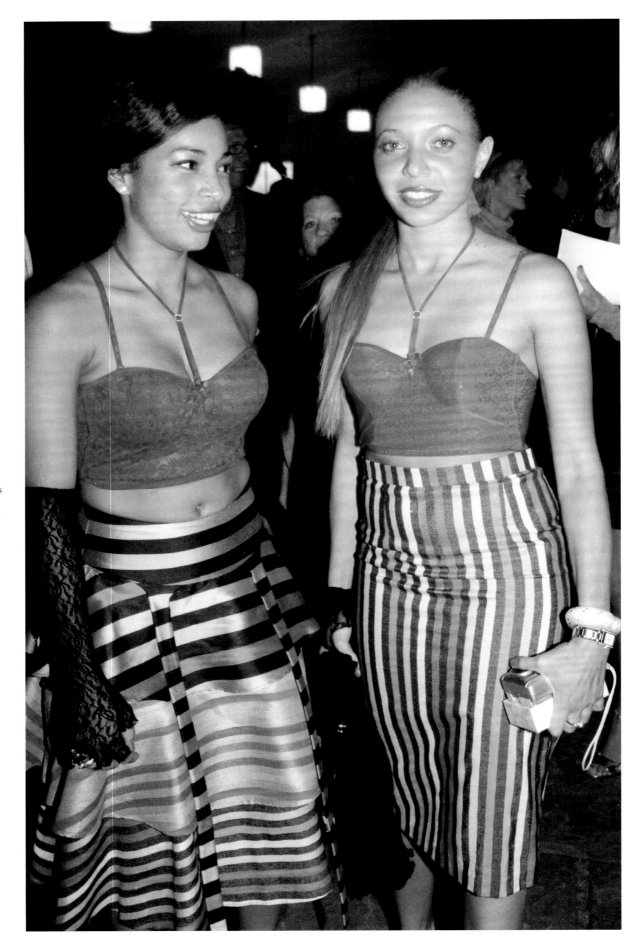

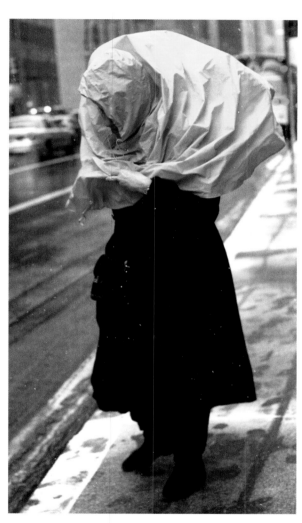

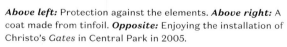

Above left: Protection against the elements. ***Above right:*** A coat made from tinfoil. ***Opposite:*** Enjoying the installation of Christo's *Gates* in Central Park in 2005.

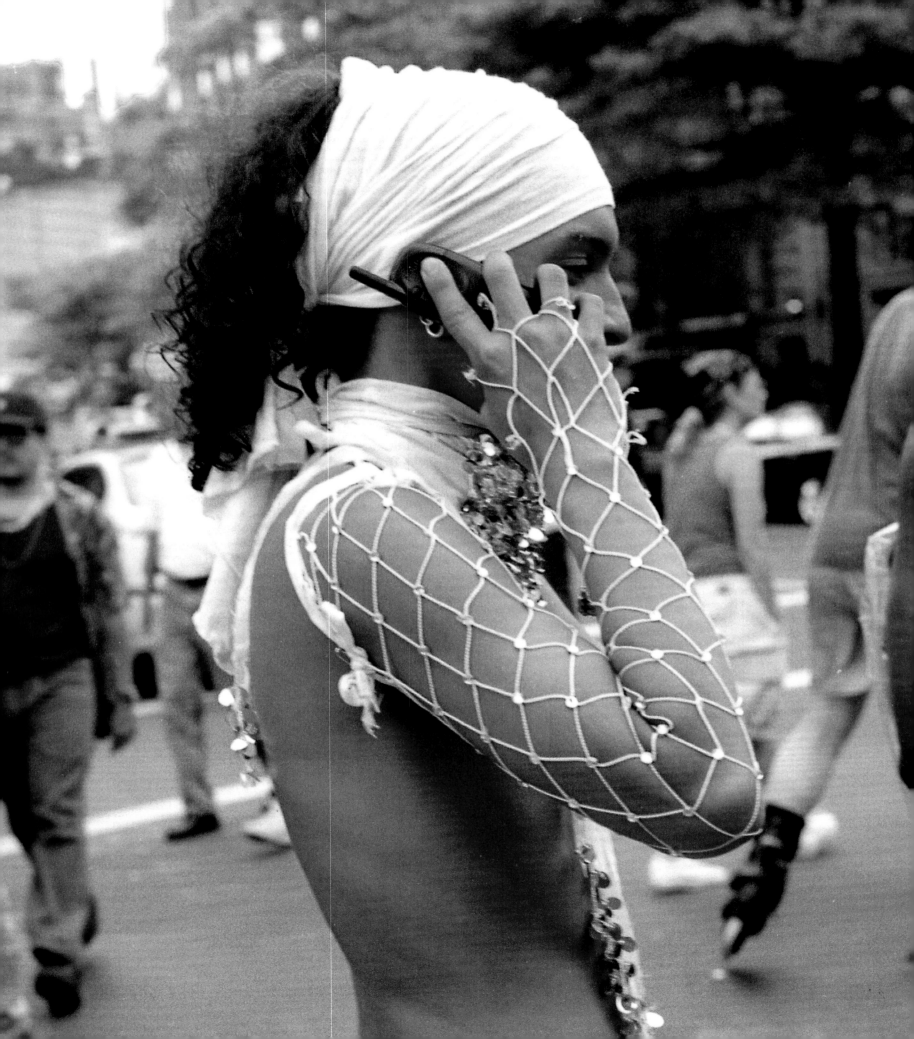

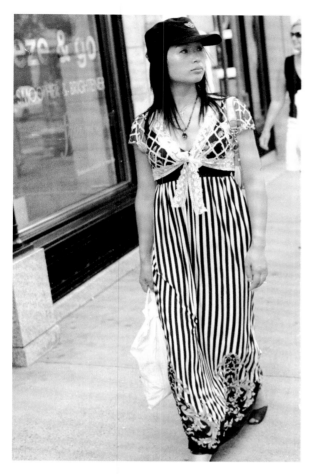

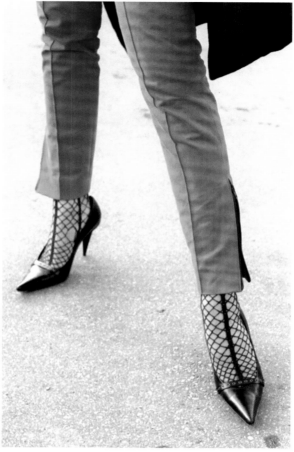

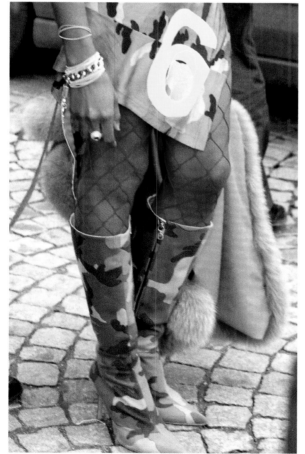

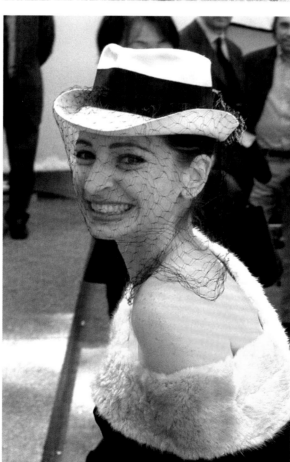

Variations on fishnet at the Paris fashion shows and at the Gay and Lesbian Pride Day Parade. After recording a style over a number of months, Bill would often assemble a column around a theme.

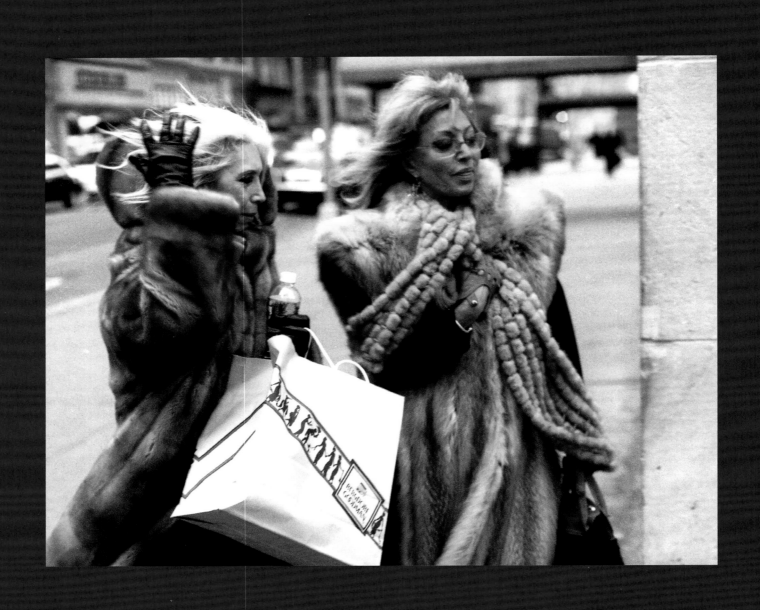

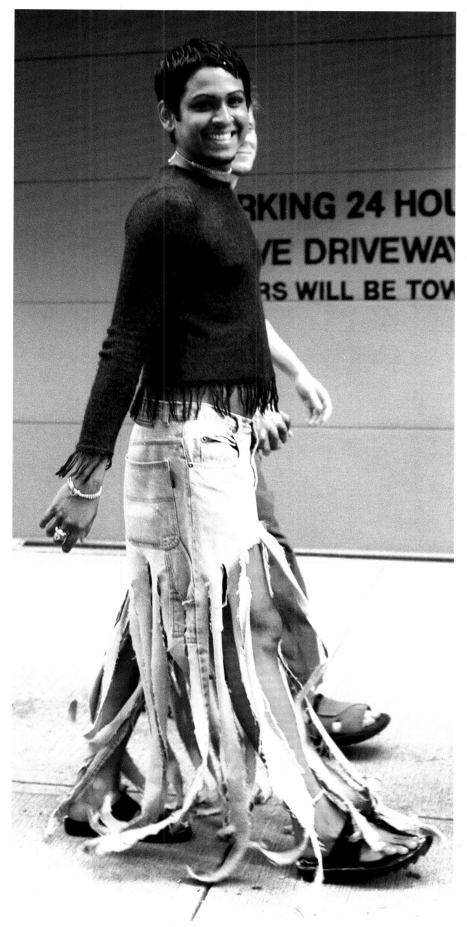

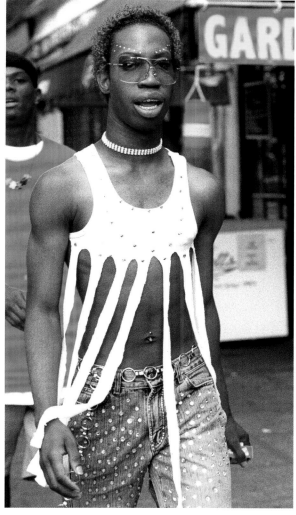

In a column called "Scissor Rebellion," Bill observed how people were reducing jeans and T-shirts to streamers and demolishing leather jackets to a single sleeve. He wrote, "A punk safety-pin revival made for jeans that might be dangerous in a lightning storm; fashion fads often reappear twenty years after their initial popularity in more extreme versions and then quickly disappear for good." The suggestion of streamers is also seen in winter, using fur *(opposite)*.

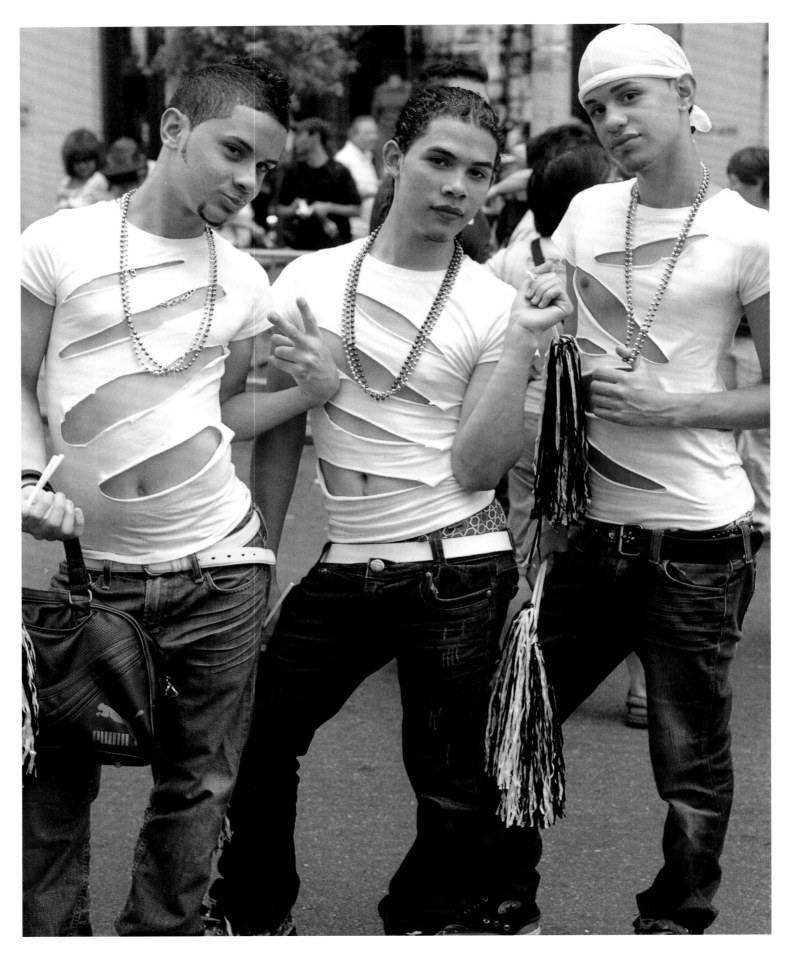

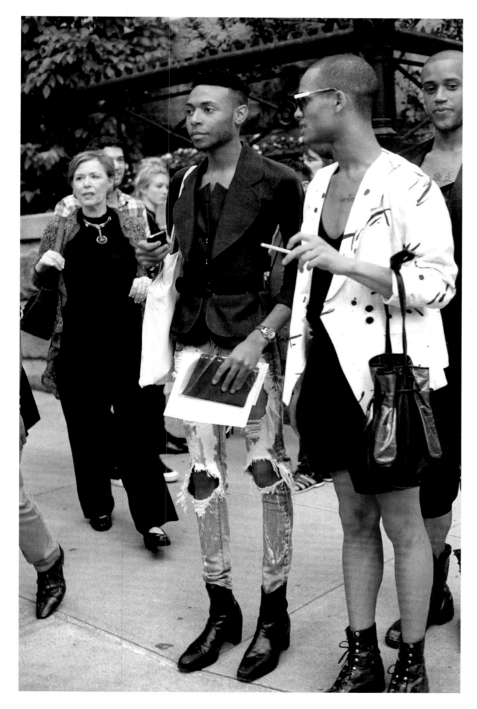

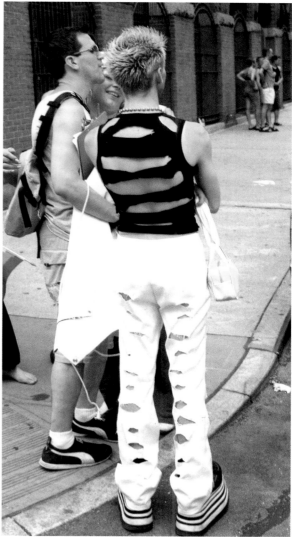

Many of Bill's images in this decade convey the sense that more people are creating their own style and are less influenced by the runway. Here, DIY versions of slashing.

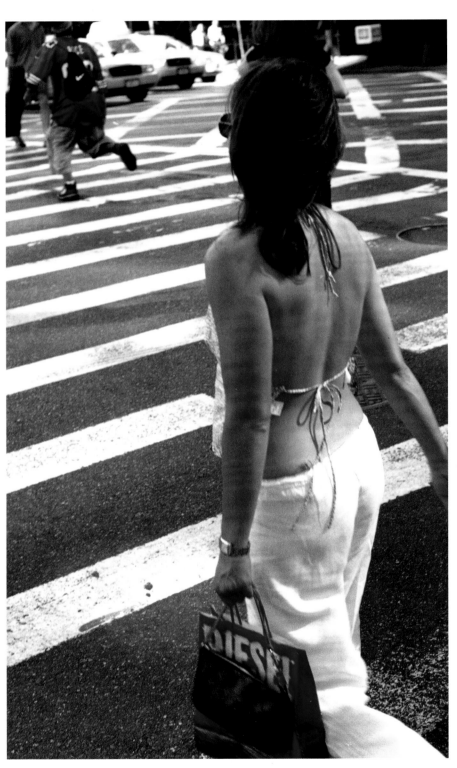

Bill referred to this trend as "meant-to-be-seen" underwear,
or in some cases, tattoos.

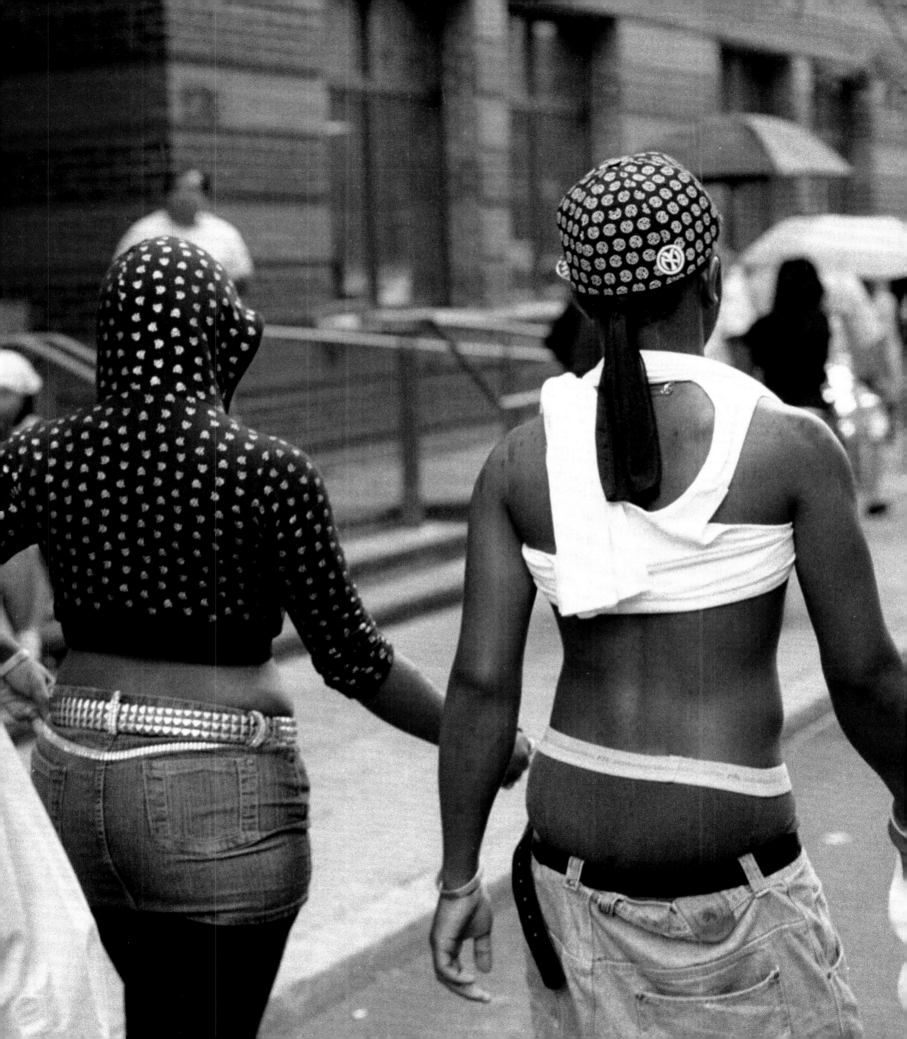

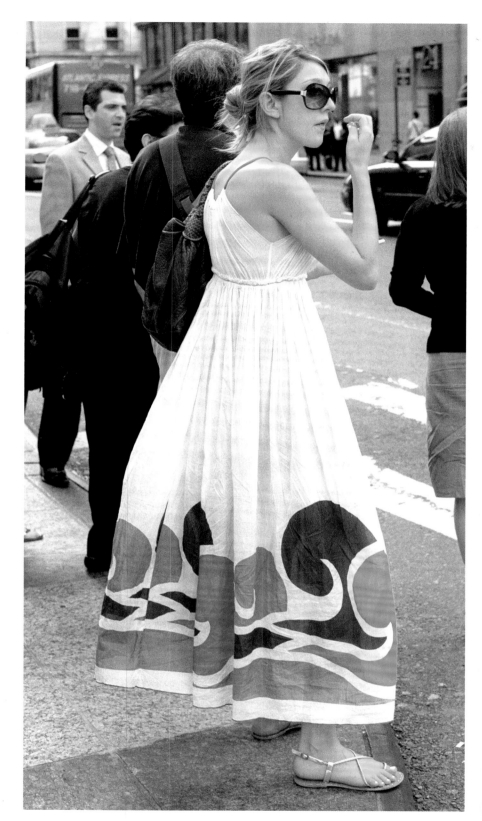

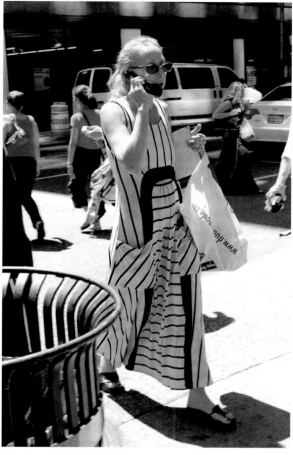

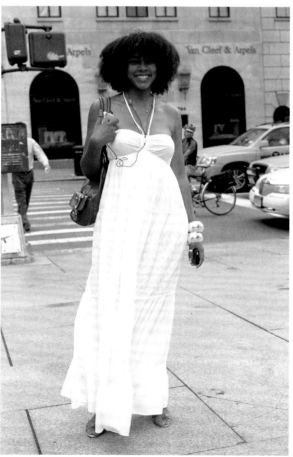

Above: "One of summer's surprising successes is the long daytime dress," Bill wrote. "The customer is the ultimate judge of what passes for fashion, and this year she is in a romantic mood." Dresses came in fluid jersey and cotton and in bold bands of color. **Opposite:** A quick dip on a hot summer day in midtown.

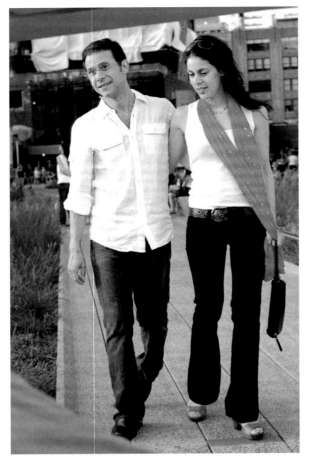

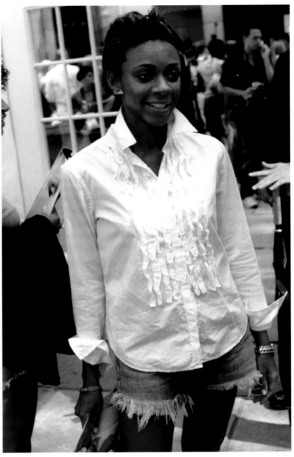

"Crisp white shirts" was a summer theme Bill occasionally returned to, but he also noted how the style was adopted for evening attire.

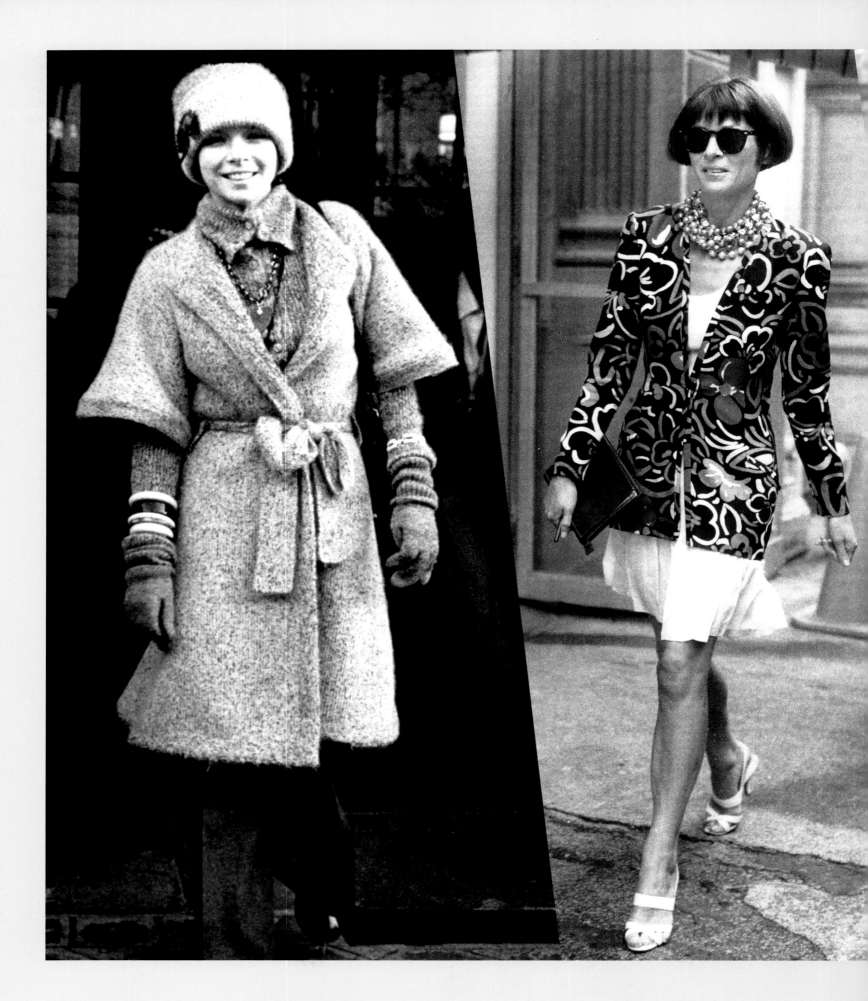

THE ATTRACTION WAS MUTUAL

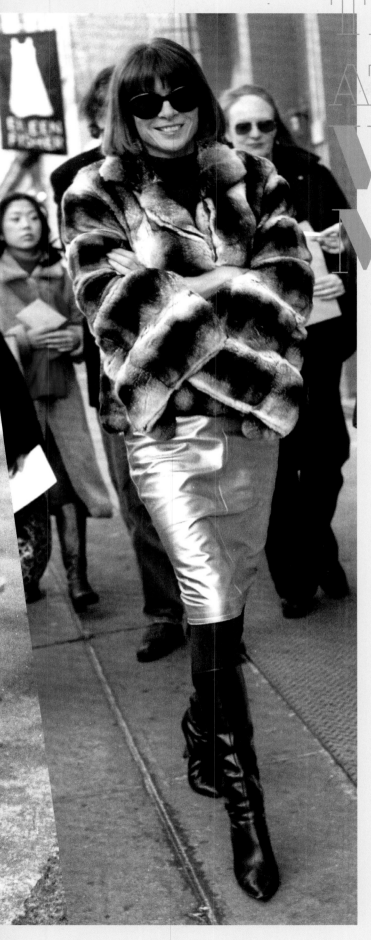

ANNA WINTOUR
artistic director, Condé Nast; editor in chief, *Vogue*

The truth is, we all dressed for Bill— because he always noticed, and he always seemed to care. If you put something on and went out, you felt rewarded by his smile and his enthusiasm. His eye was precise, discerning, and unfailingly kind. And he always chose a flattering picture. He chose carefully, wanting you to look your best. So you felt that he saw you and that he knew you. He was seductive in that way.

Were we to him?

I doubt it. Bill chronicled every single style trend, from the most glamorous parties to the grittiest Manhattan street corners, and yet he kept himself apart from the world he photographed.

You'd see him whizzing around on his bike, clad in that simple blue cotton jacket—as iconic as anyone he photographed (though he would never have thought that for a single second). And yet he was, to the end, his own man, intensely private, beloved by us all without quite being *known.* Which to me makes his loss that much more profound.

Speaking of that bike, I asked him so many times if he'd like a ride—at arrivals at Paris's Charles de Gaulle Airport, or exiting a fashion show positioned miles away from the

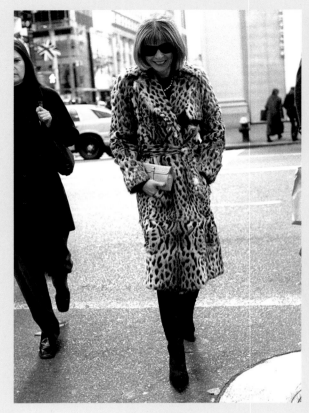

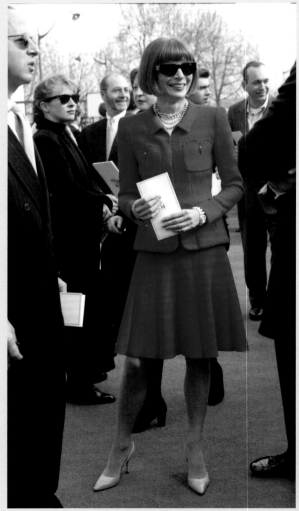

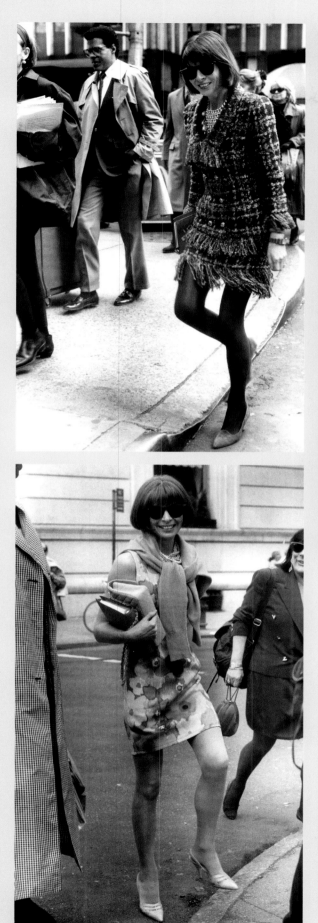

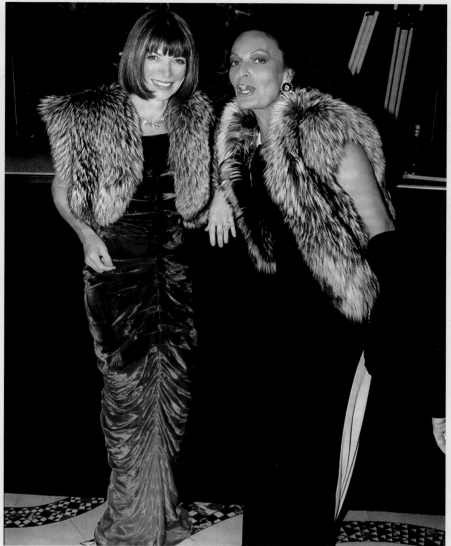

next. It was always the same response: a laughing "No, child," which, despite the cheeriness of the response, was firm enough to brook no further discussion.

Well, almost never, I should say: In 2013, with the streets of New York turned by enormous snowdrifts into near-impassable mountain ranges, I saw Bill valiantly struggling with his bicycle by Lincoln Center. I stopped my car and asked if he wanted some help. Even he couldn't refuse that time. On the journey to *The New York Times* Building, we laughed and talked about everything but fashion, Bill looking a little lost without his wheels. When I deposited him on Eighth Avenue, he shot out of the car as fast as he could, putting not only a physical but also a mental distance between himself and the fleeting moment in which he had had to sacrifice his scrupulously (and admirably) maintained standards. That beloved bike of his was always about more than a means to get from A to B.

We all miss Bill.

THE '10s

Perhaps the most remarkable thing about this decade is how, at least with respect to fashion, it fails to be recognizably distinct. The tendency and tradition of organizing trends this way, every ten years, might itself be out of date.

Certainly the increasing ubiquity of the Internet and the smartphone have permanently changed the street-style landscape. By 2010, many New Yorkers were acutely aware of being observed, and began to tailor their dress specifically for their handpicked (and -clicked) networks. They had gone in an instant from smart set to selfie, with everyone a would-be Bill Cunningham. In his eighties, Bill himself was—not always happily—revered subject as much as modest observer.

But his own eye never grew jaded, never stopped noticing patterns of human behavior. As the original social media, he detected and delighted in a longing for innocence, with animal-face hats and lumberjack prints. There was joyful gender-bending following the legalization of gay marriage, the influence of Michelle Obama (cardigans, Alaia belts), and the honoring of Alexander McQueen. There was the rise of "athleisure" and the strange morphing of clothes in response to environmental and technological change: sleeveless coats, toeless boots, fingerless gloves, and even wearable tech.

As if in homage to a man who had chronicled New York City life for so long and so tirelessly, there was also a move en masse to Bill's vehicle of choice: the bicycle.

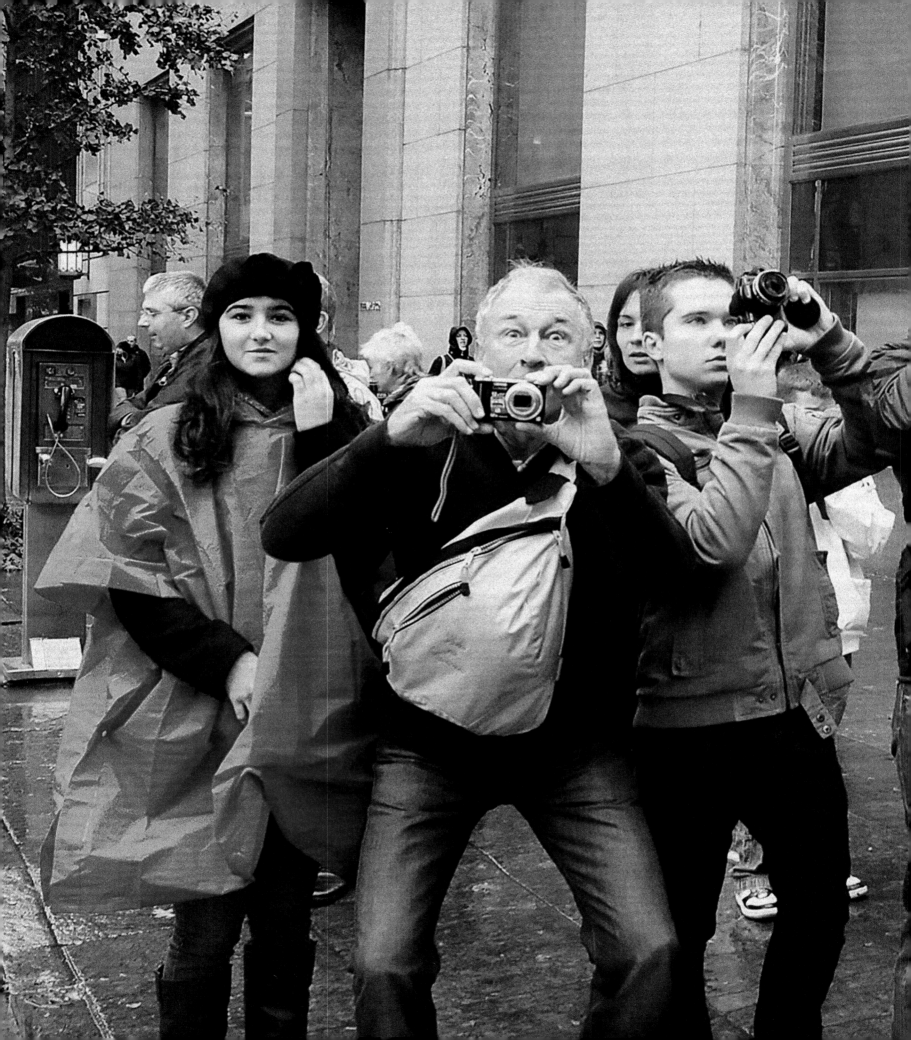

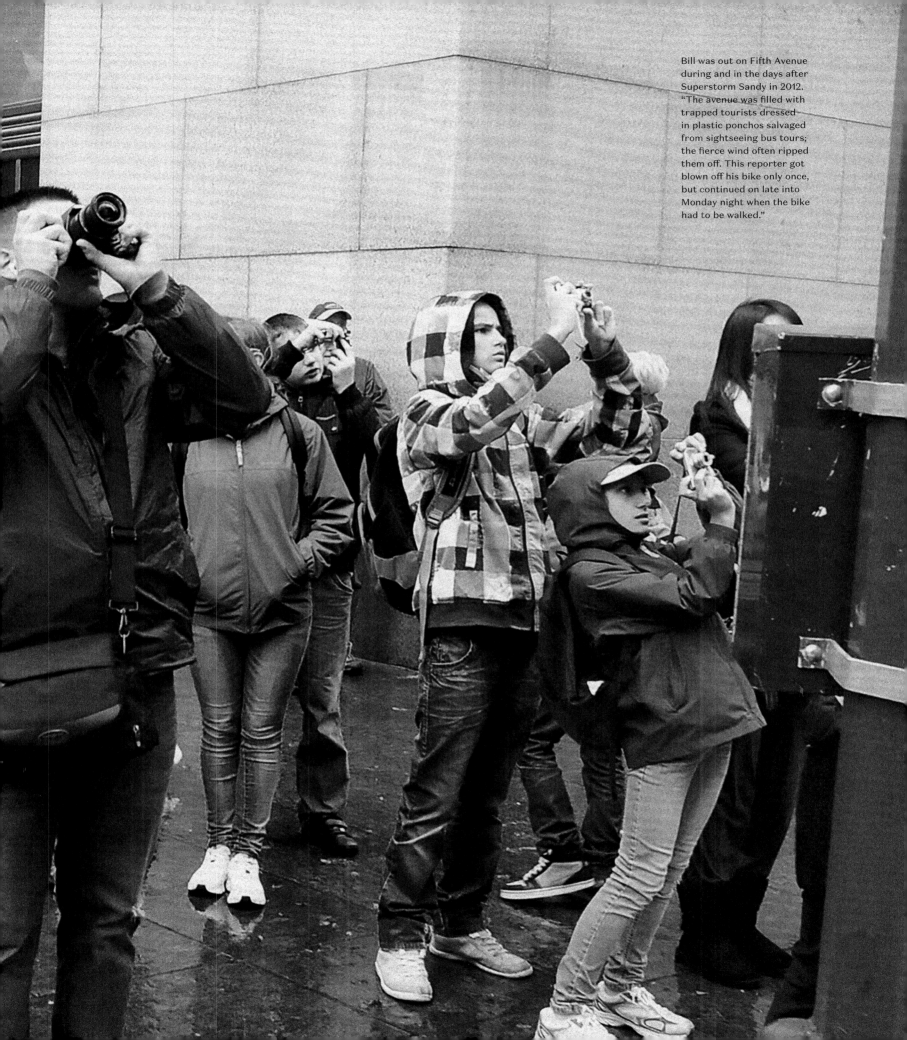

Bill was out on Fifth Avenue during and in the days after Superstorm Sandy in 2012. "The avenue was filled with trapped tourists dressed in plastic ponchos salvaged from sightseeing bus tours; the fierce wind often ripped them off. This reporter got blown off his bike only once, but continued on late into Monday night when the bike had to be walked."

"There is not a shadow of a doubt that the spotlight on dressing today is totally on men's wear," Bill wrote in 2012. The popularity of shorts (away from the beach) and Thom Browne's influential tailoring, with above-the-ankle trousers, were just a couple of the men's trends that he photographed.

There were moments in fashion when clothes needed to be read as well as seen. Words or letters became the design or trumpeted an attitude.

Clothing has long been a canvas for art, and artists often get inspiration from fashion. Think of the Impressionists. Here, Bill captured Pop Art and Old Masters reproduced on clothes. The woman in the fur coat *(lower right)* is the stylist and editor Katie Grand, wearing a popular Prada design.

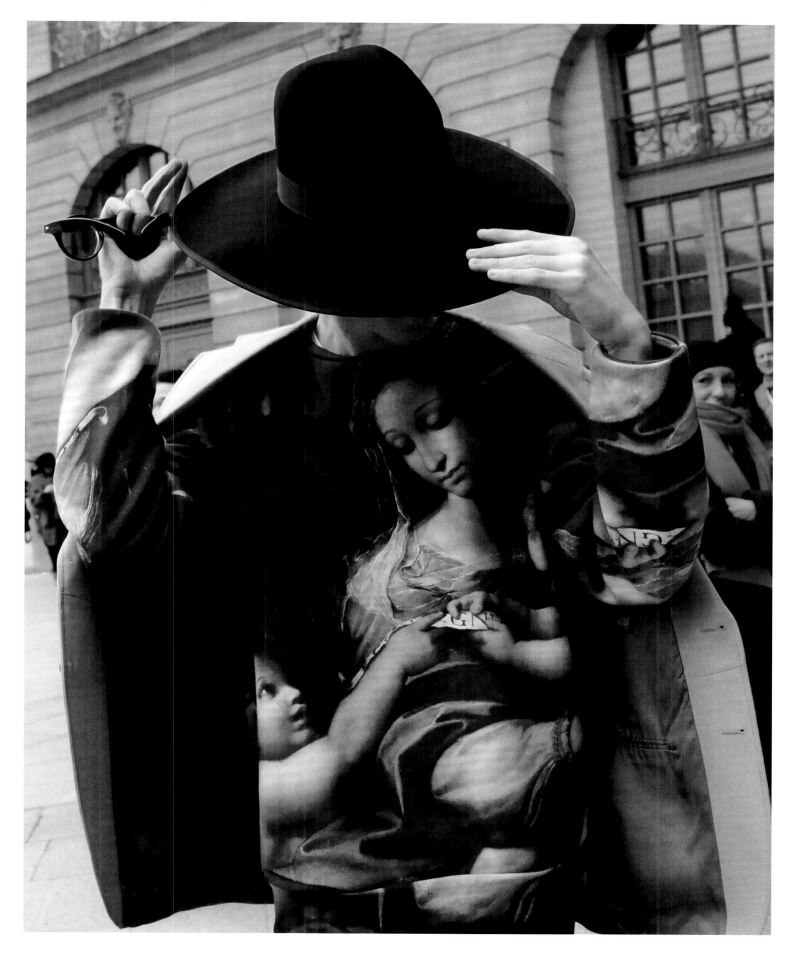

Gold washed over footwear and other accessories, illustrated by shoes worthy of a superhero, a goddess, or a gladiator. A dinosaur is similarly gilded to the delight or bewilderment of a young passerby *(opposite)*.

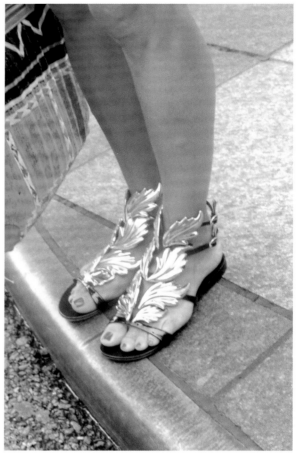

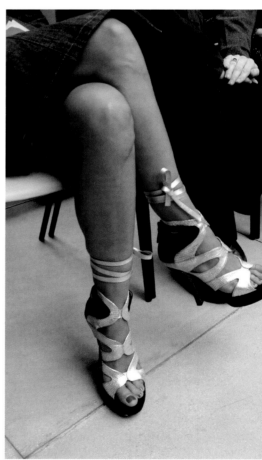

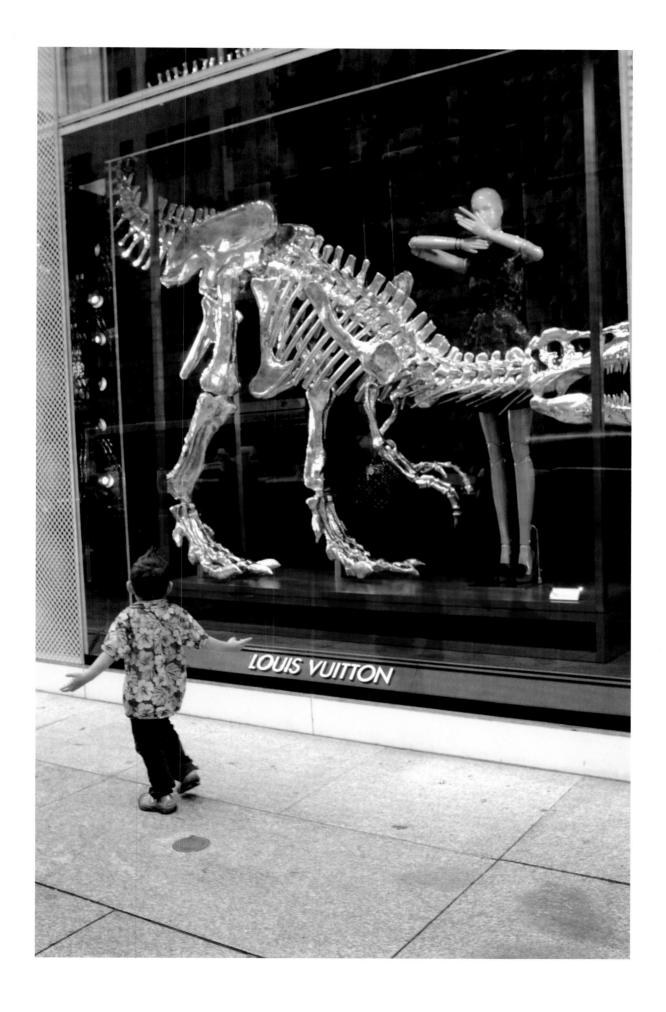

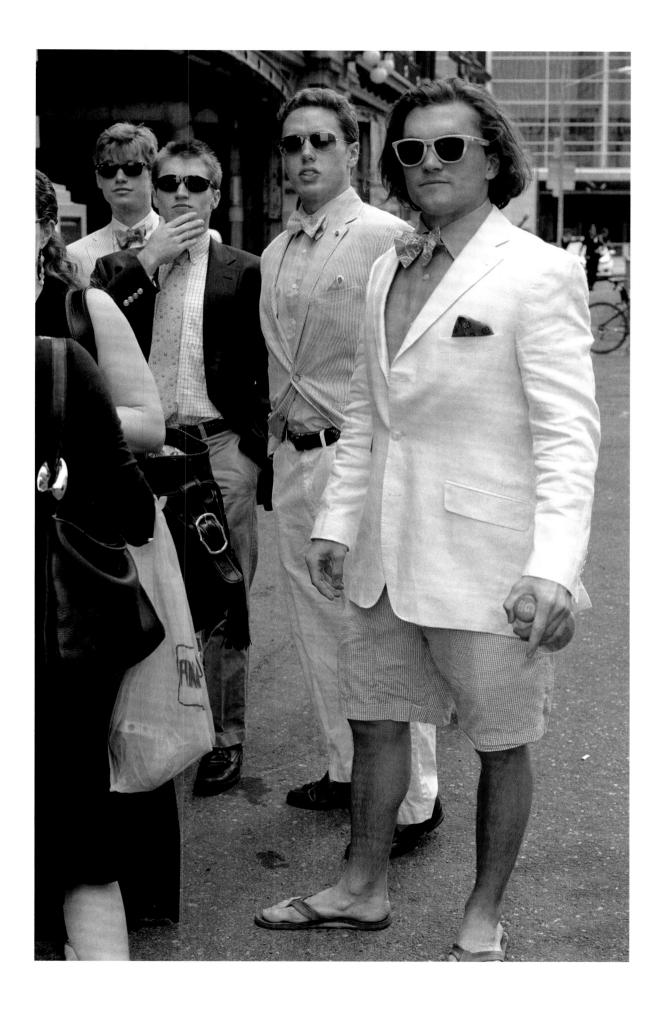

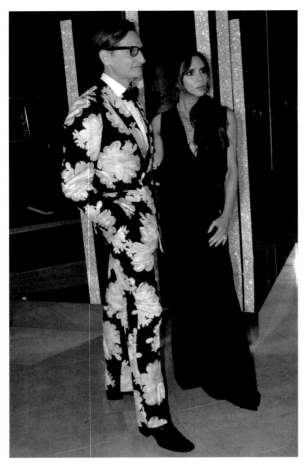

An abundance of suiting in vivid floral patterns, like Riccardo Tisci's bird-of-paradise print for Givenchy *(above right)*, was just one more sign of the men's fashion revolution that Bill documented. As he told readers in 2012, "There are some who consider such clothes to be little more than costumes and the wearers to be intoxicated with alternative styles of dress. But I'm always reminded that creative people like these often become the fashion contributors and fixtures of the future." *Above left:* Hamish Bowles and Victoria Beckham.

Flower prints and embellishment go in and out of fashion, but here they arrived in an explosion of wallpaper patterns. Among the trendsetters were Lana Turner *(above left)*, the socialite Mercedes Bass *(above right)*, Anna Wintour *(below left)*, and others.

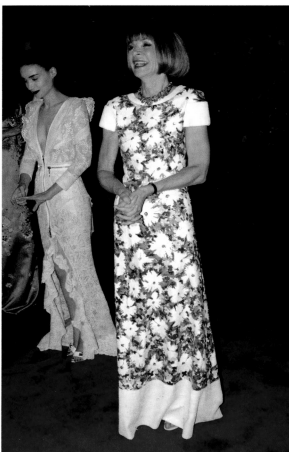

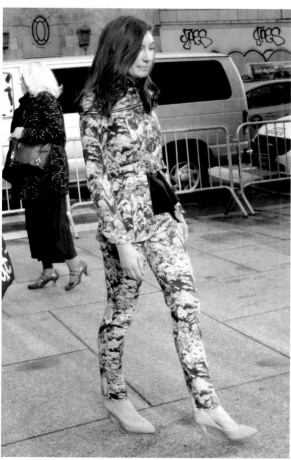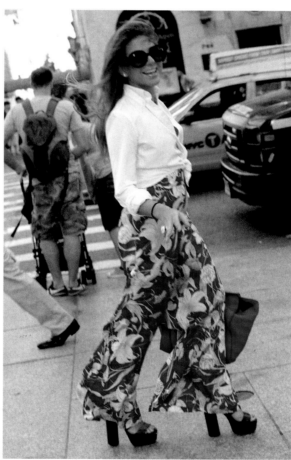

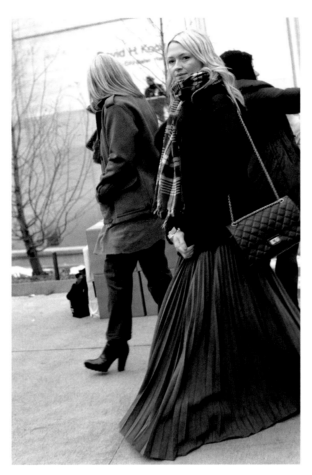

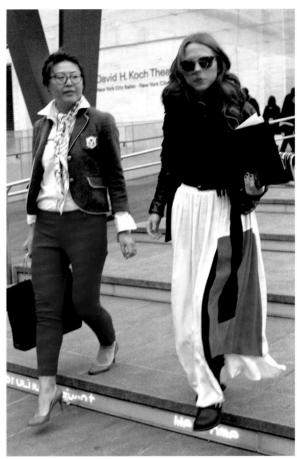

Mixed in with trousers and leggings, a burst of pavement-sweeping dresses and skirts.

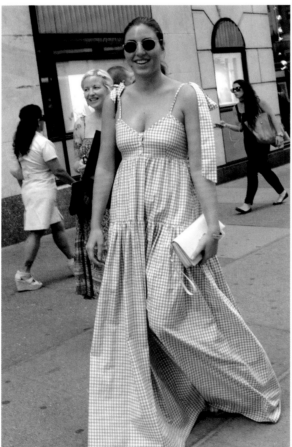

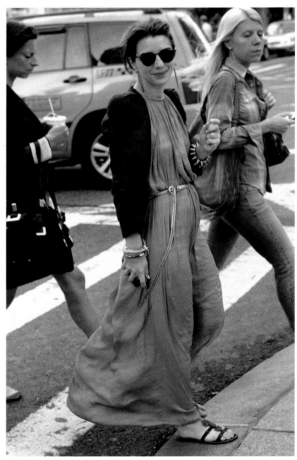

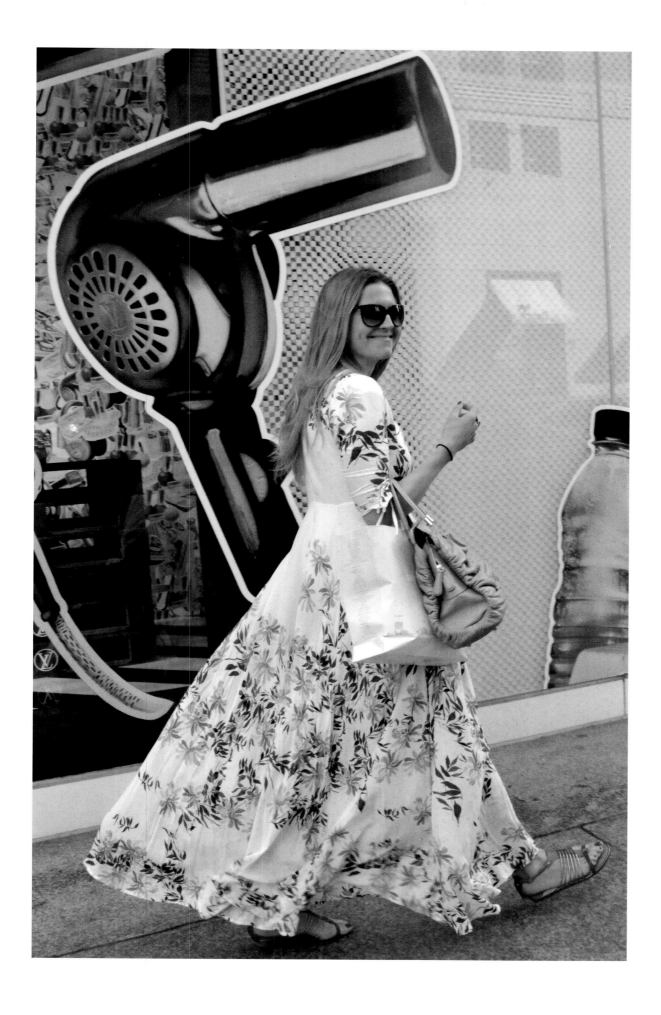

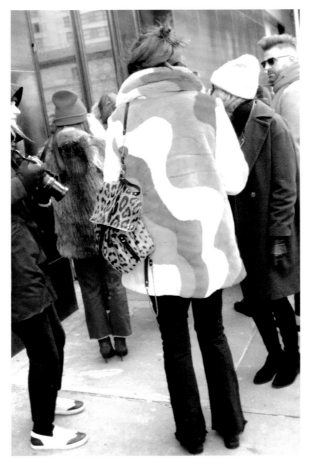
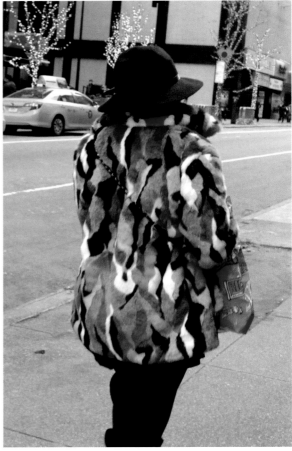

Bill remained open to the subtle changes in fashion, such as fresh interpretations of color and pattern. *Opposite:* Anna Dello Russo in a Comme des Garçons camouflage coat splashed with red.

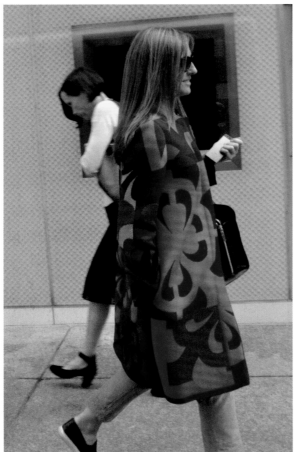
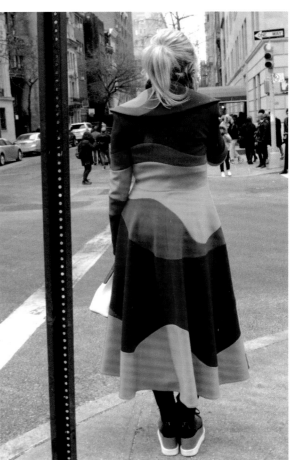

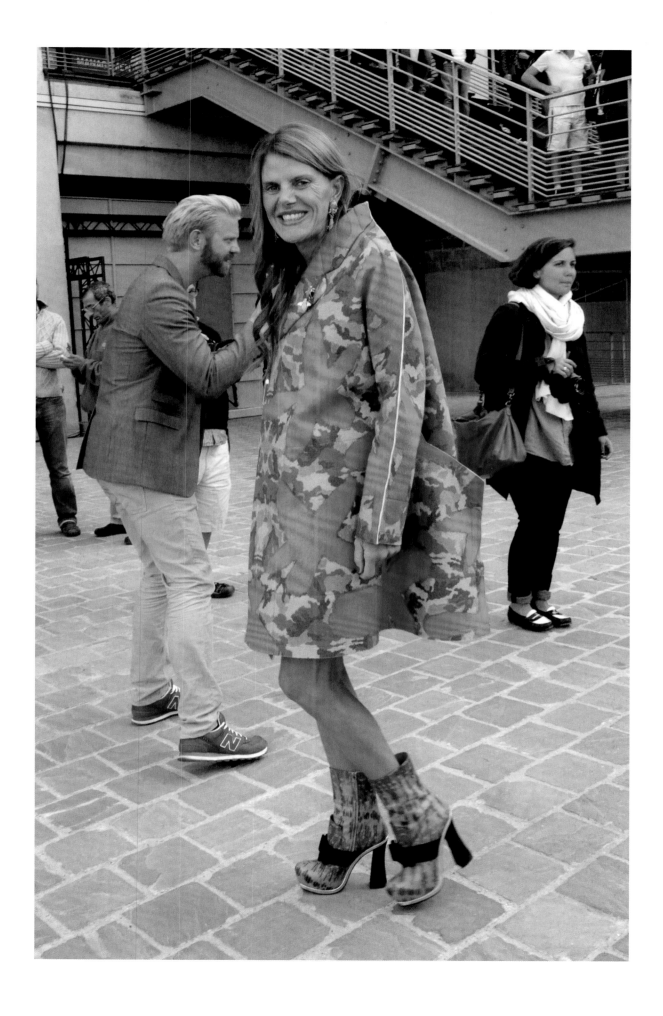

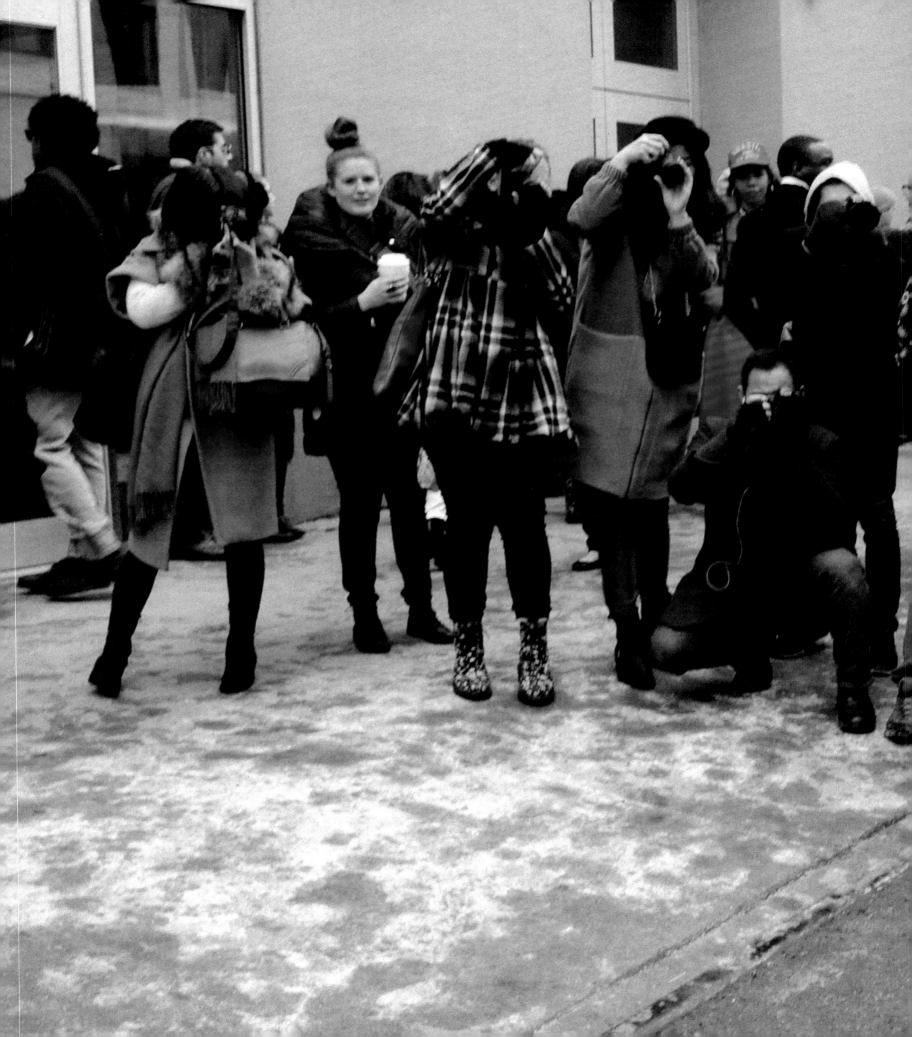

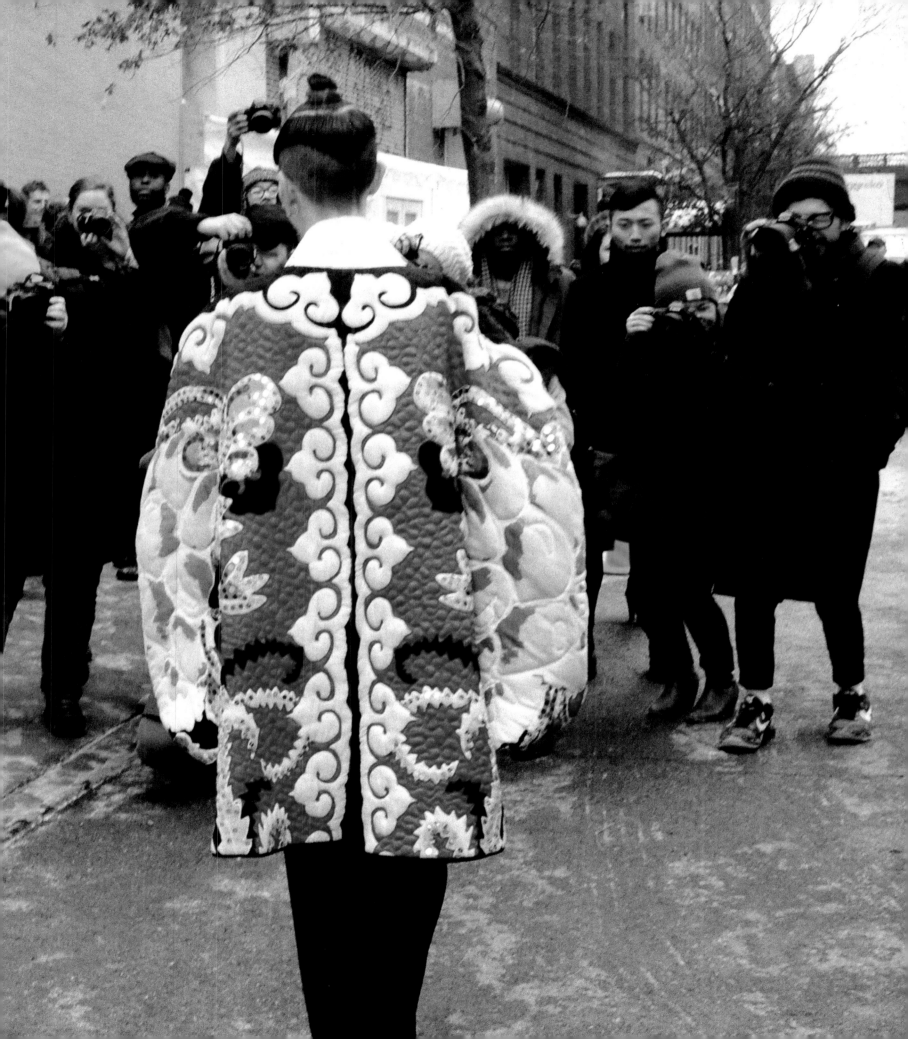

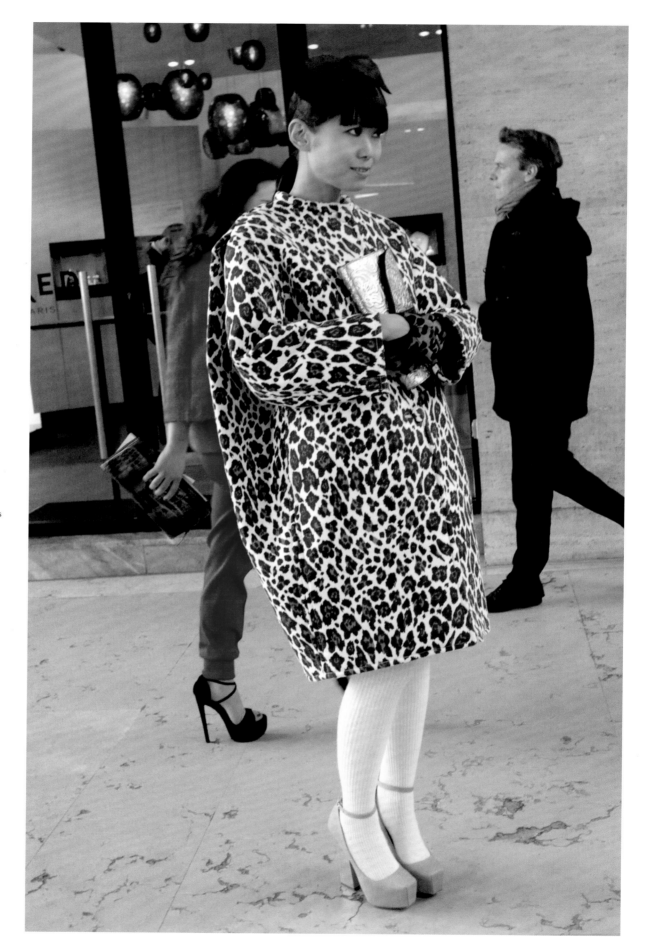

Sometimes today's street-style photographers—Bill's heirs—are as fashionable as their subjects.

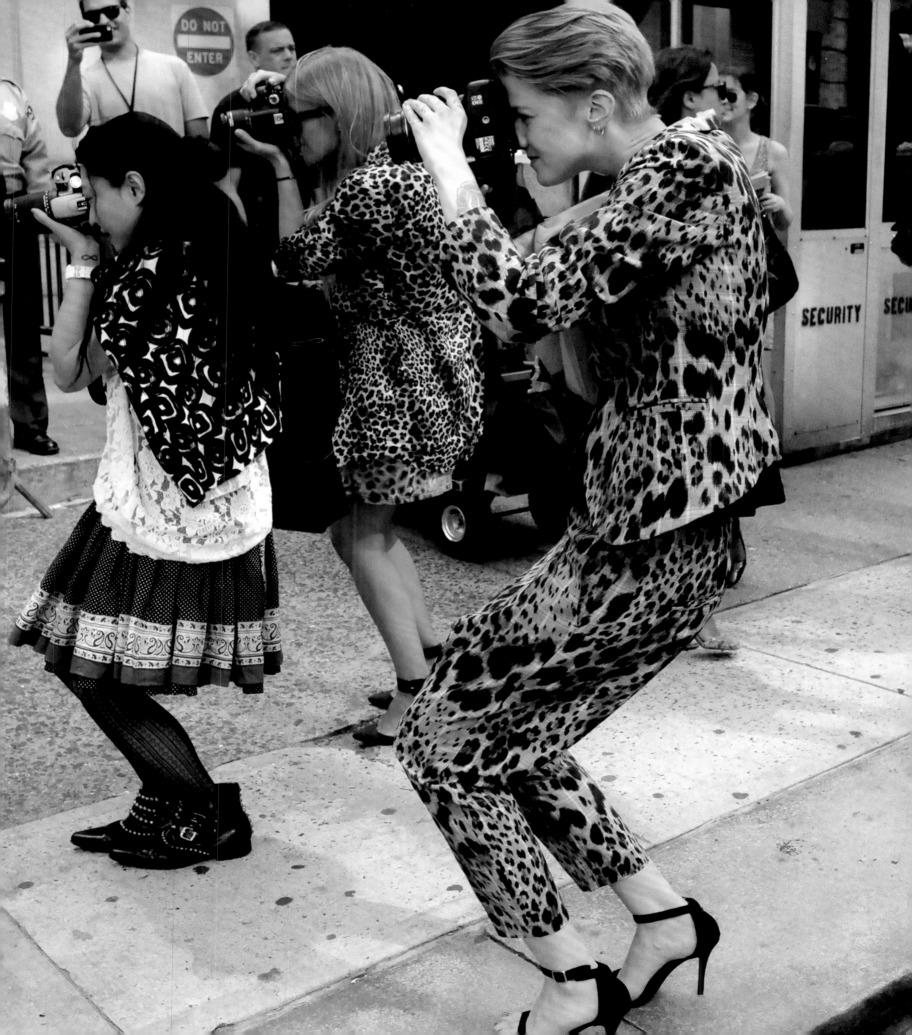

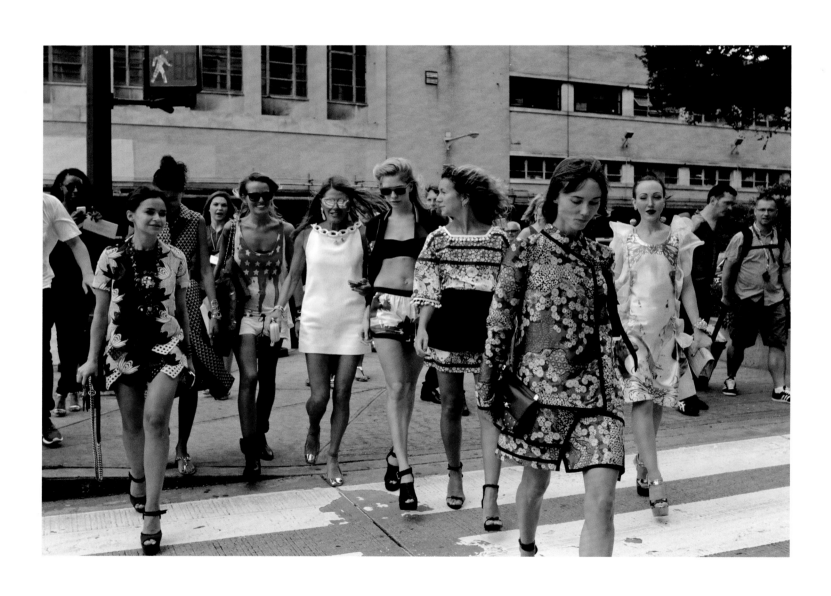

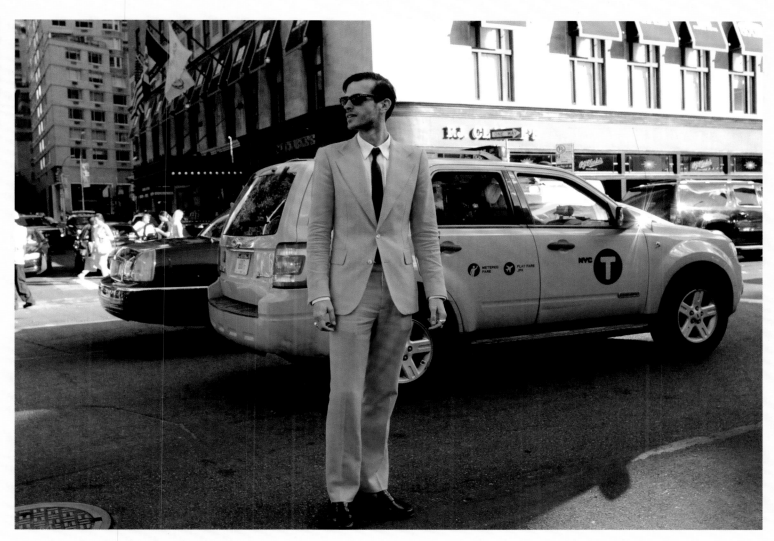

Fashion show attendees stand out *(opposite)* and blend in *(above)*.

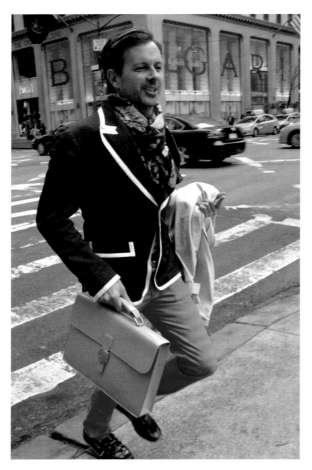

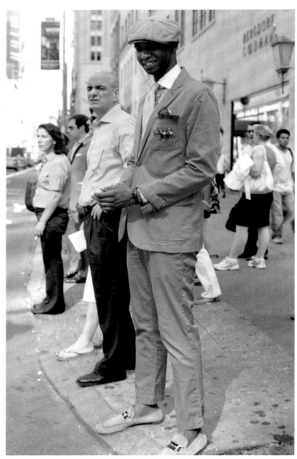

Men in mouthwatering summer colors, and with a conspicuous sense of polish amid the more casual looks on the sidewalk.

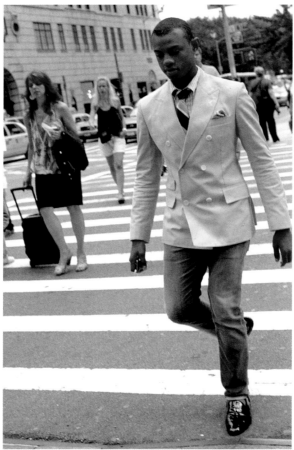

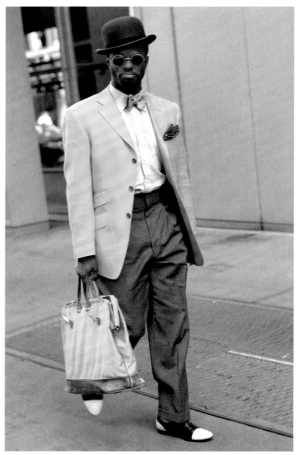

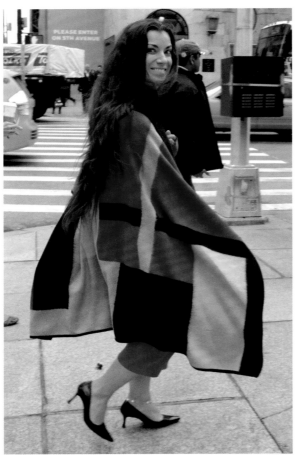

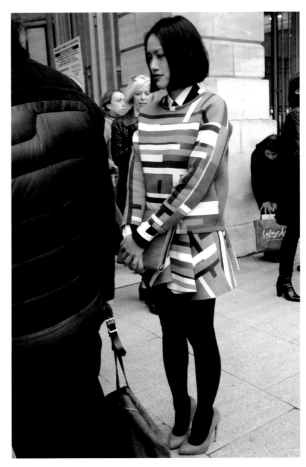

Many of the decade's looks, spanning all four seasons, involved "contemporary blocks of color mimicking unusual buildings," as Bill put it in one column. Ensembles were structural and colorful, with echoes of windowpanes, cantilevers, and columns.

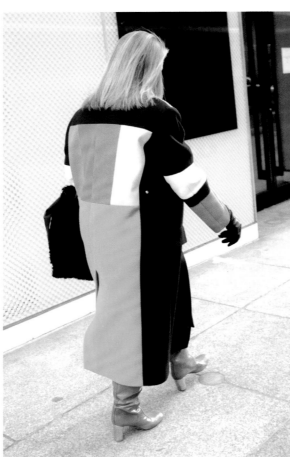

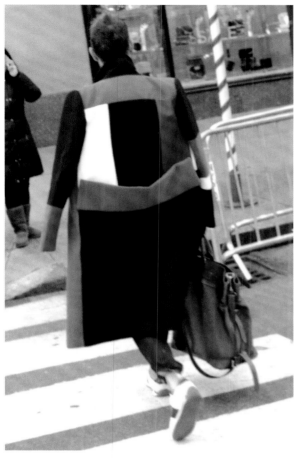

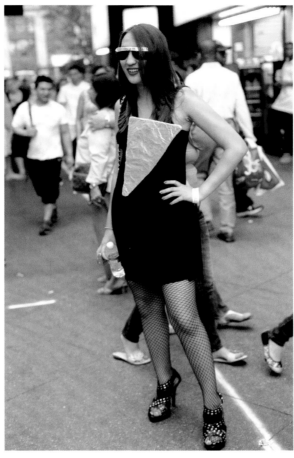

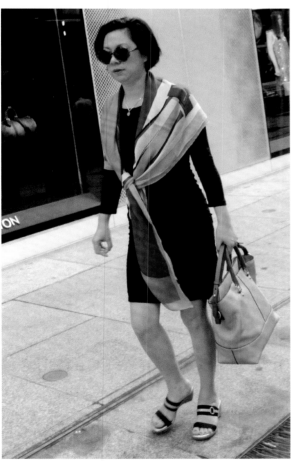

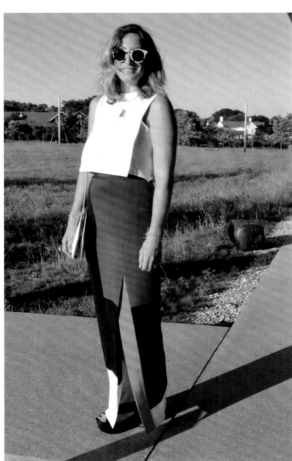

"It's the same today as it ever was. He who seeks beauty, will find it."

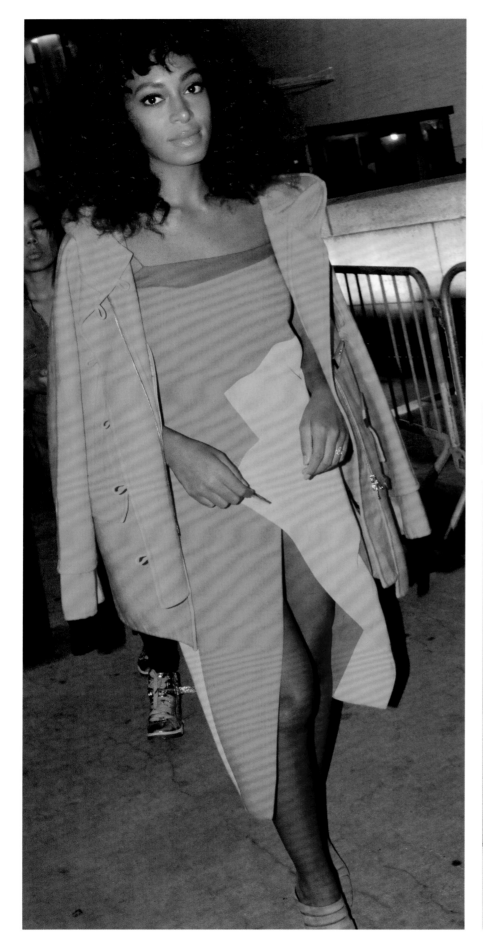

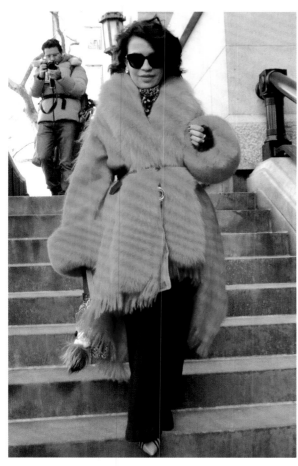

Often in this decade, a single color would take hold for a season or two, washing over shoes, clothing, and even hair. *Opposite, left:* Solange Knowles.

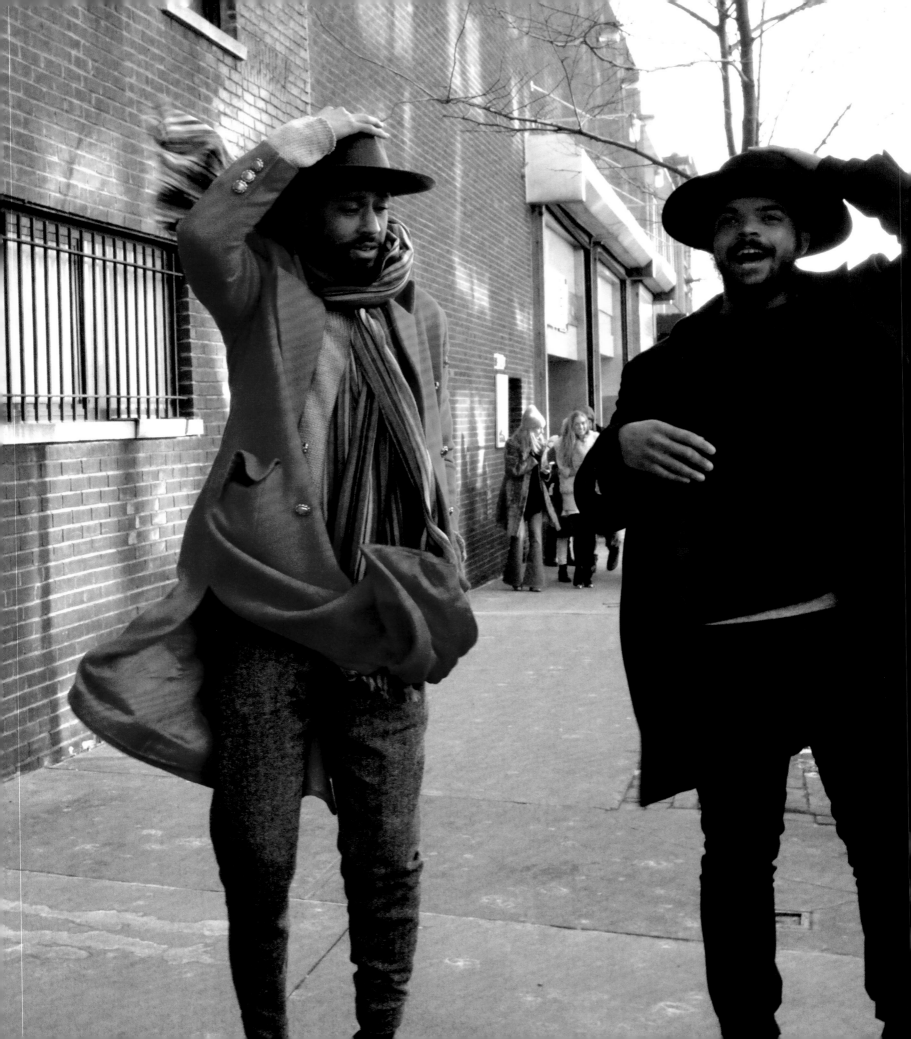

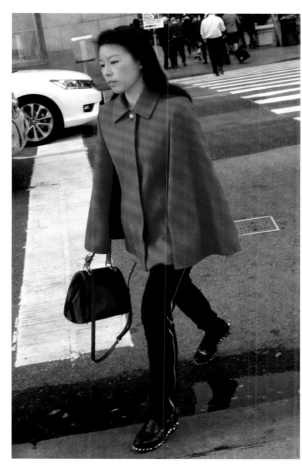

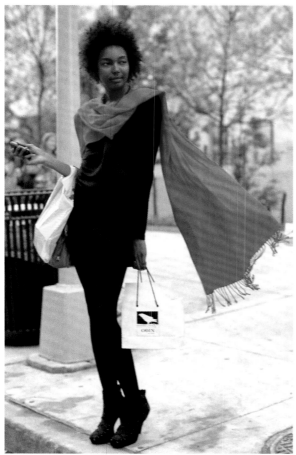

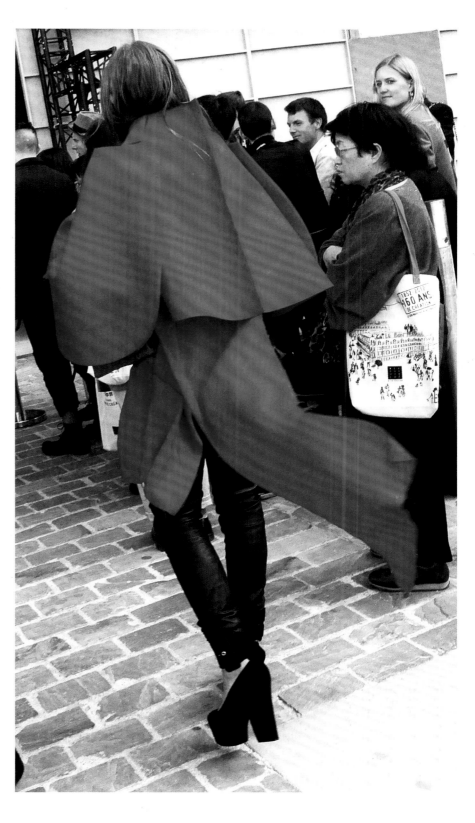

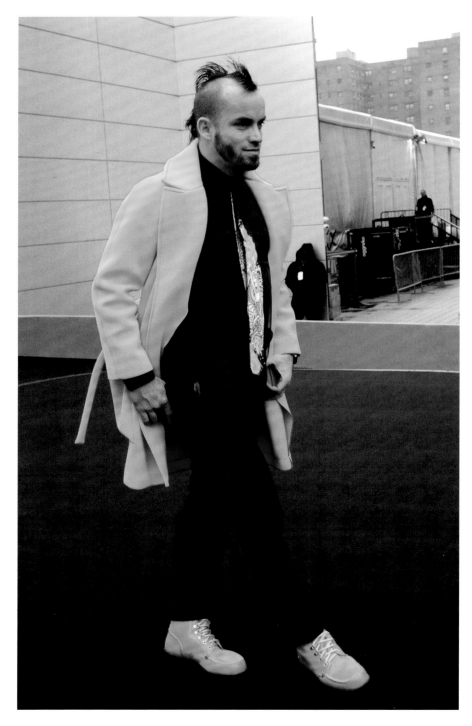

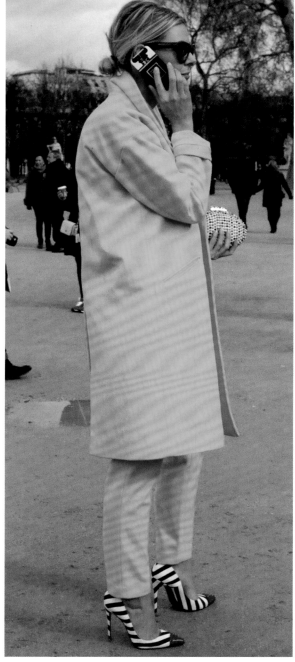

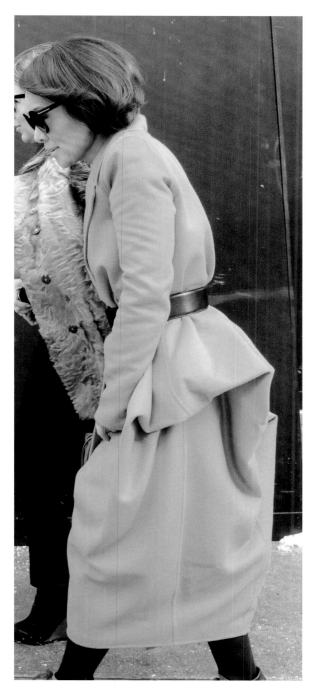

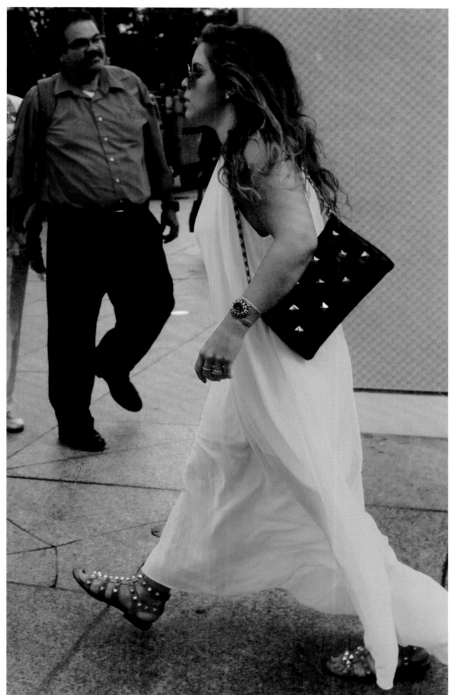

Colors that once seemed off the charts, like turquoise
and shades of neon, became more prevalent—and are now
commonplace.

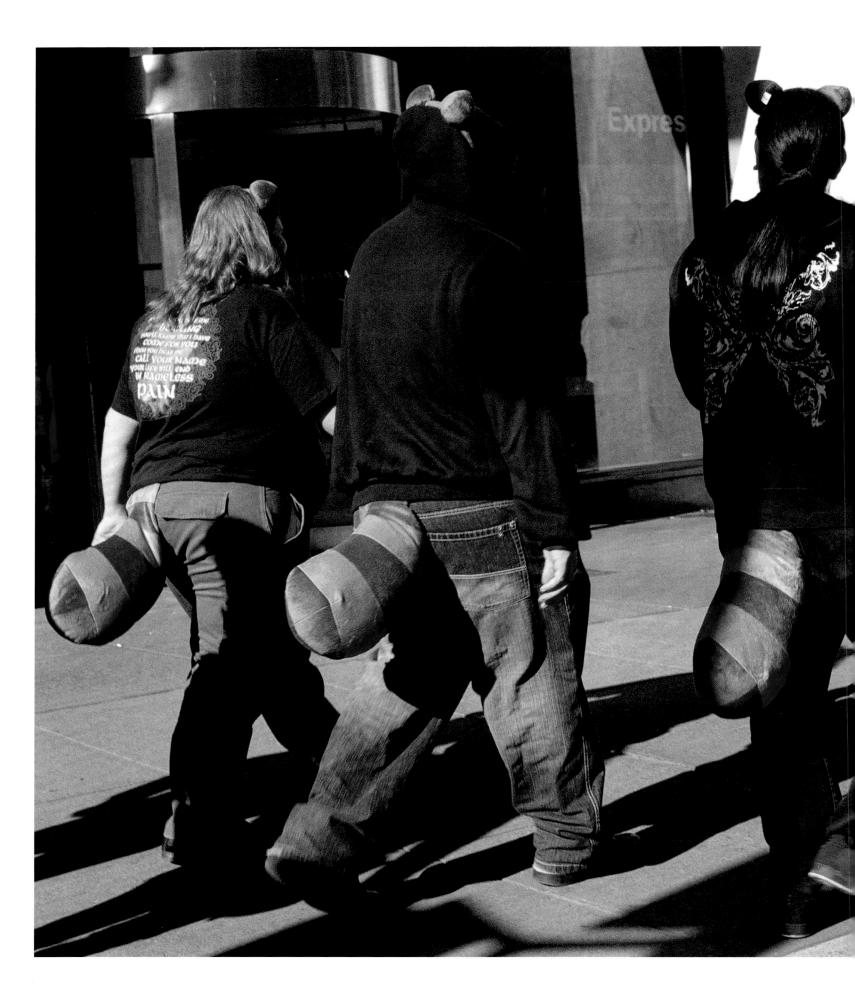

Tails were spotted as fashion accessories in the form of a belt charm *(above)* and also nonchalantly worn as actual tails by a trio strolling on Fifth Avenue *(opposite)*.

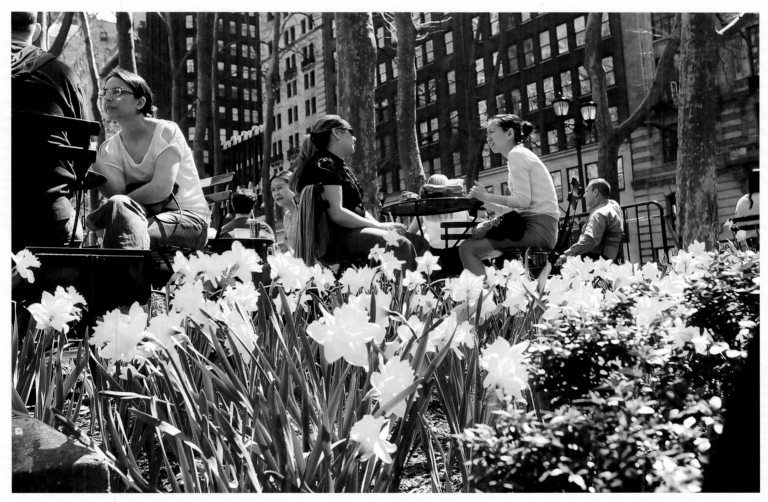

Bill used photographs of flowers in many of his columns. He
had a talent for finding people wearing clothing that matched
the nearby blossoms.

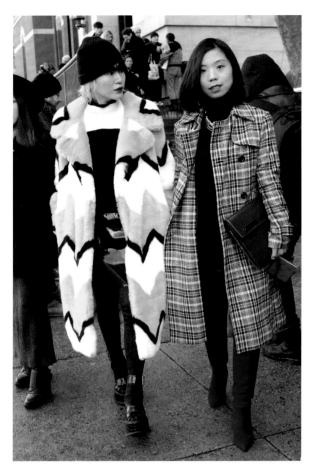

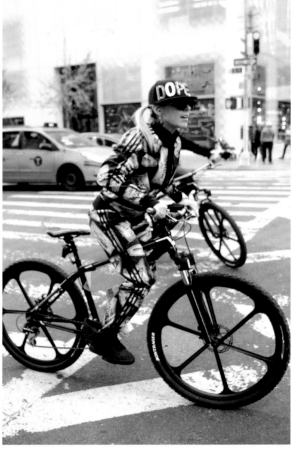

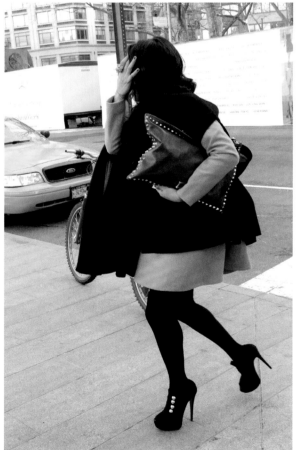

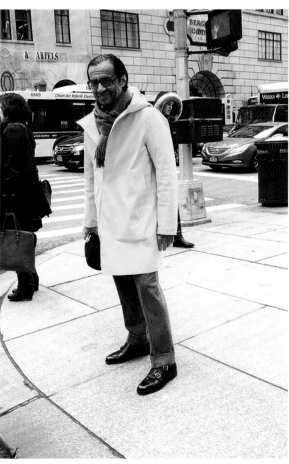

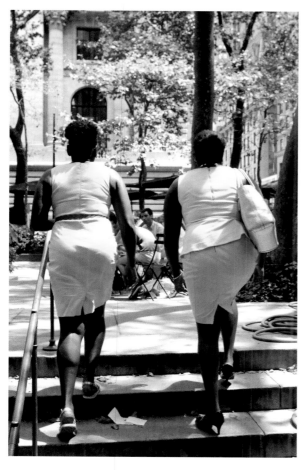

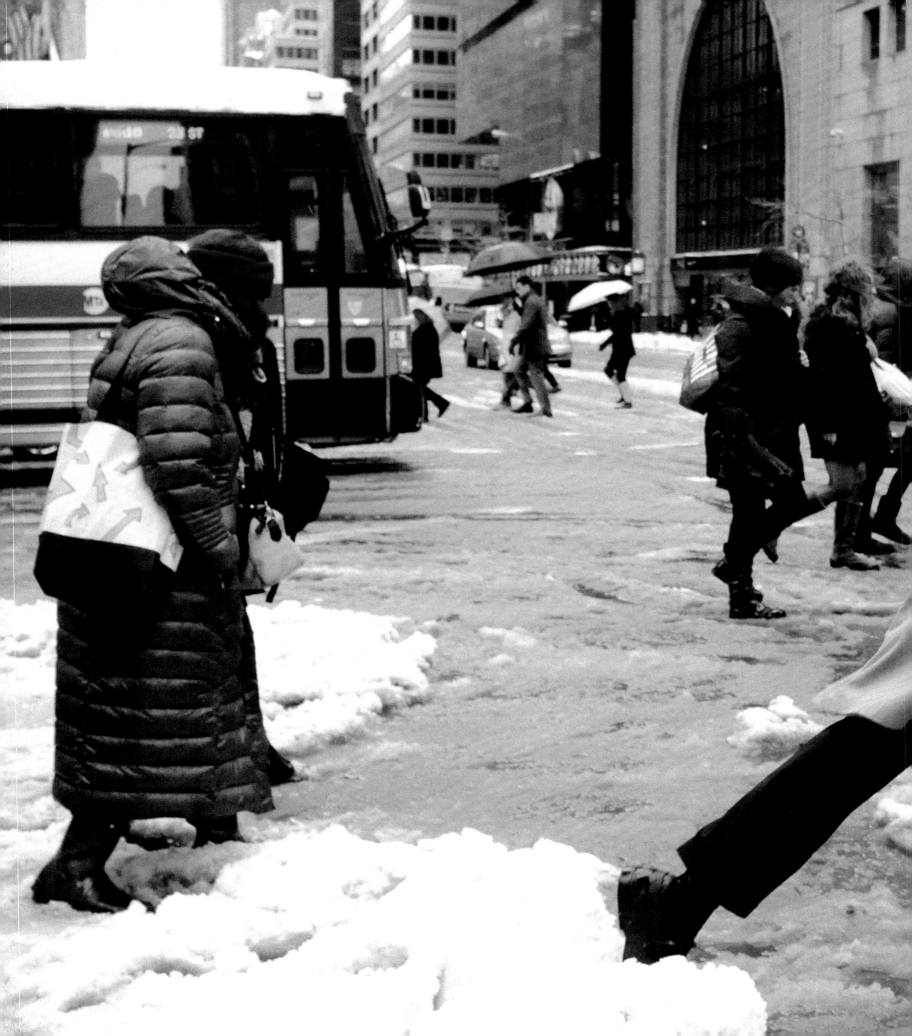

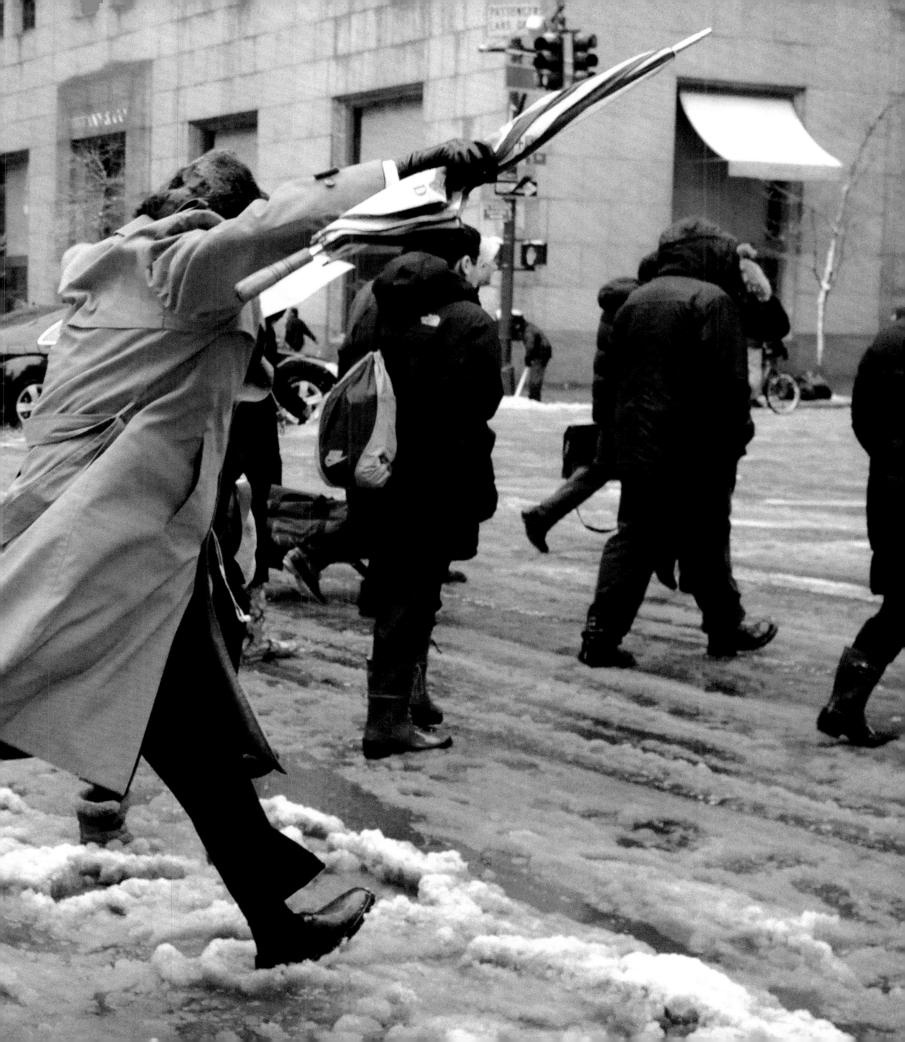

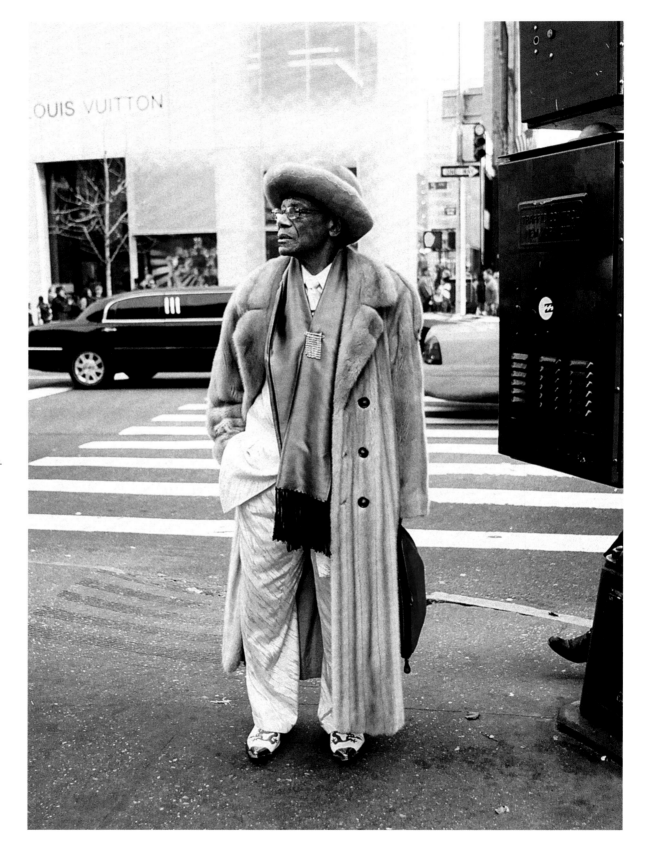

A spectrum of grays provides an alternative to black, at least momentarily.

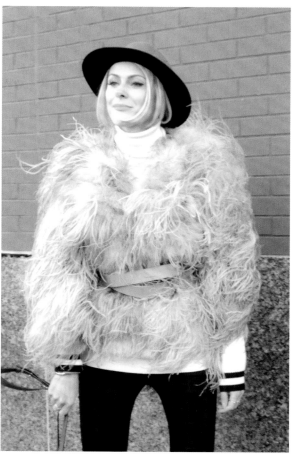

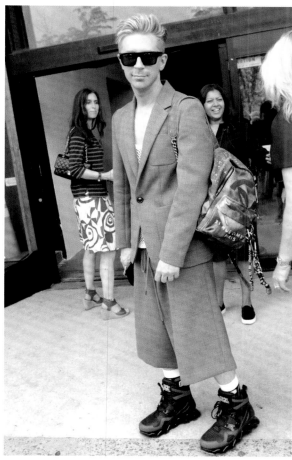

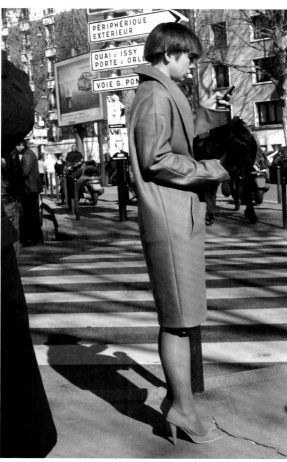

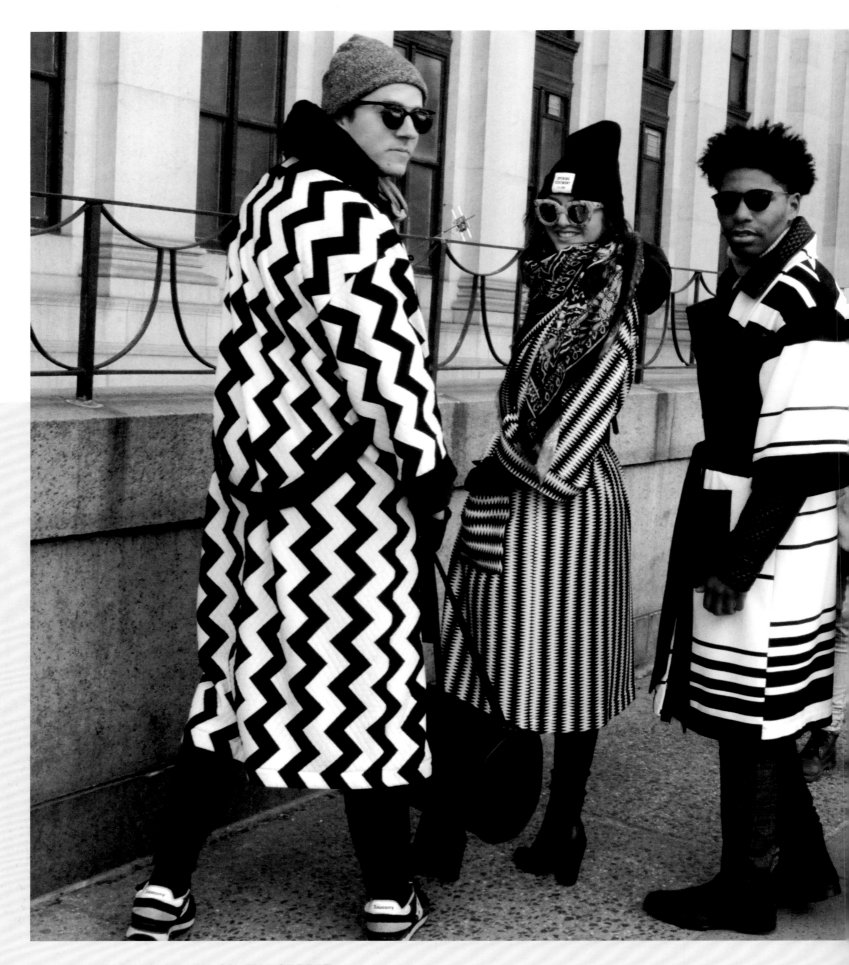

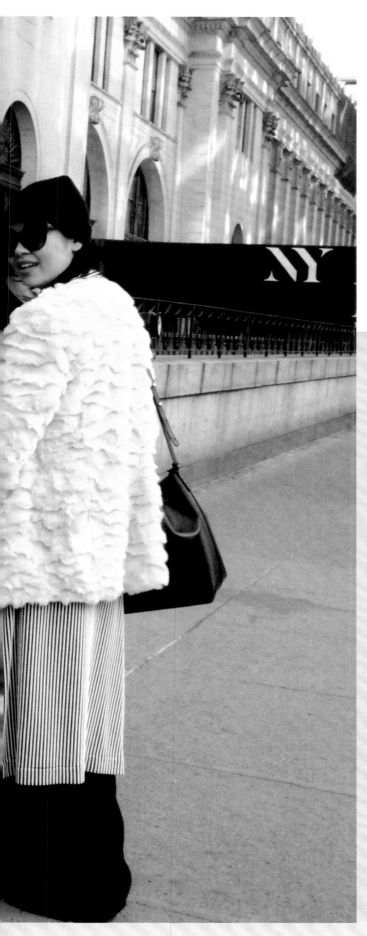
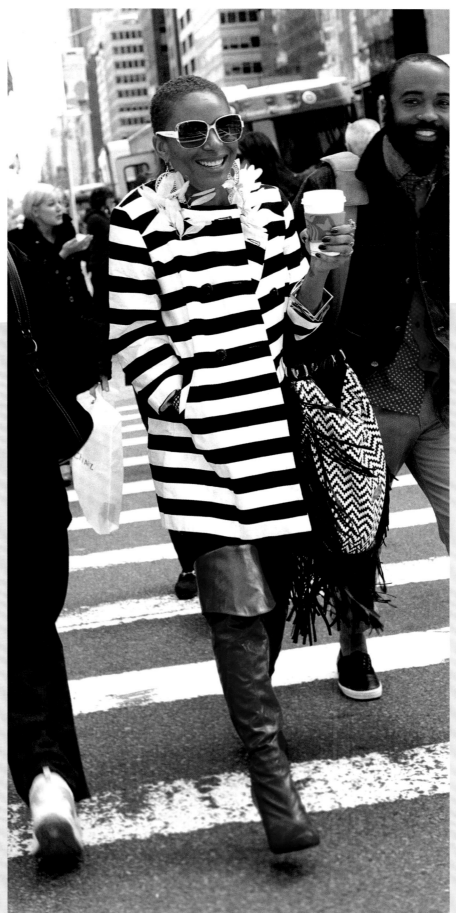

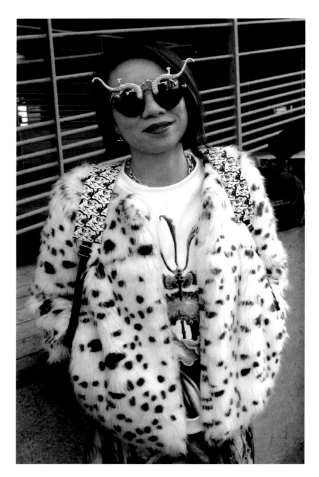

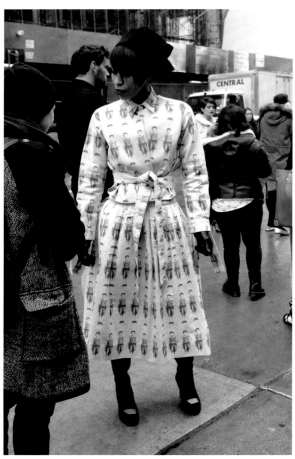

The shows provided Bill with more expressive fashion statements, including a variety of coats in black-and-white patterns that seemed to reference art, or perhaps textiles, from an earlier era.

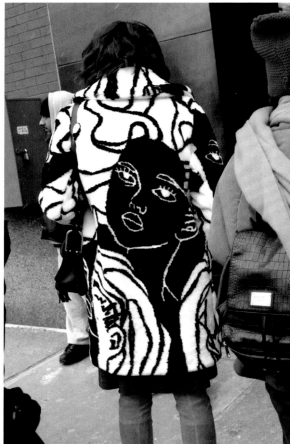

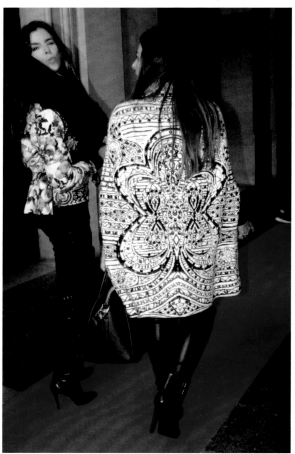

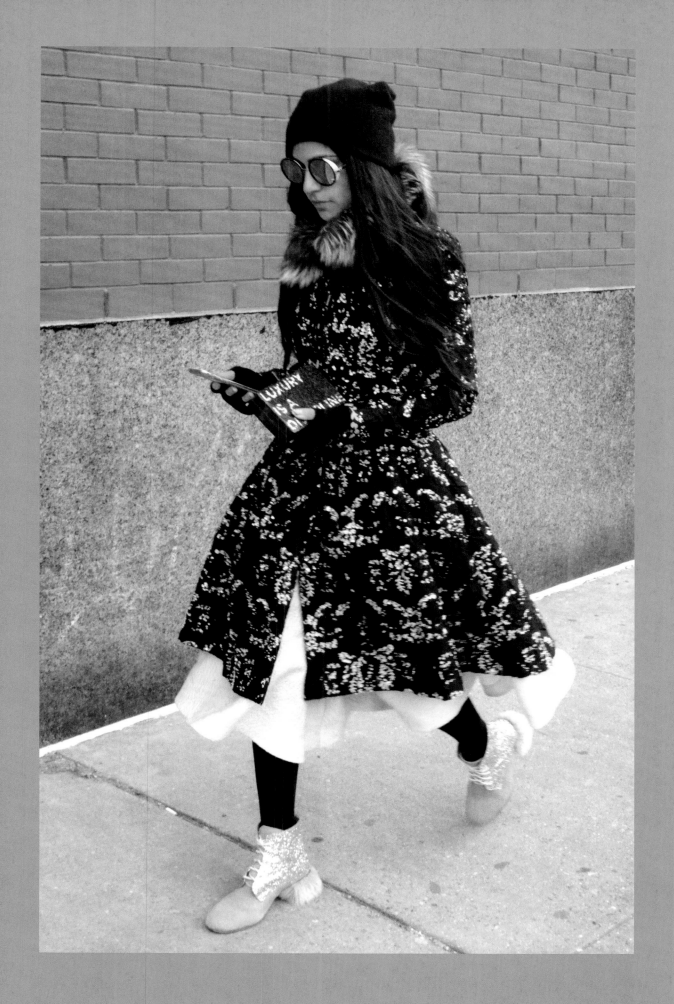

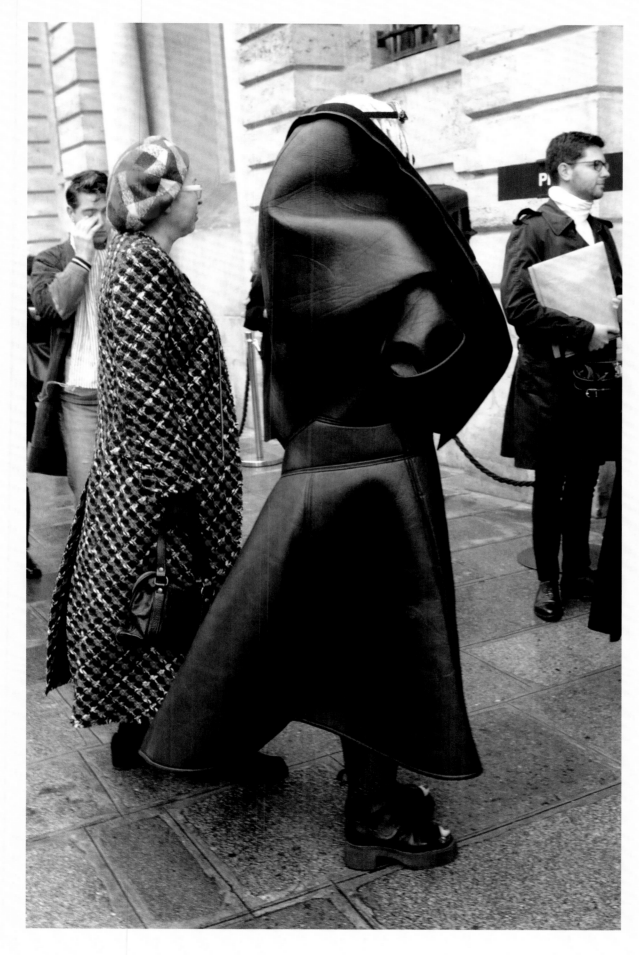

Although Bill did numerous columns on black clothing, he seemed to have a love-hate attitude toward it, perhaps because it's standard attire for the fashion crowd. But he celebrated it best when the subject was a silhouette. Here are a variety.

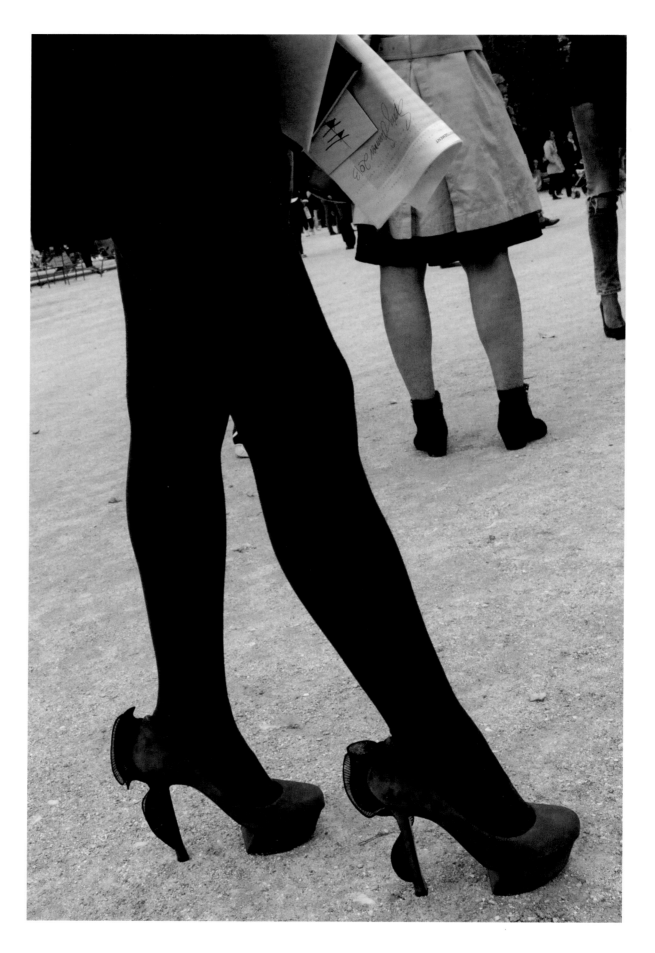

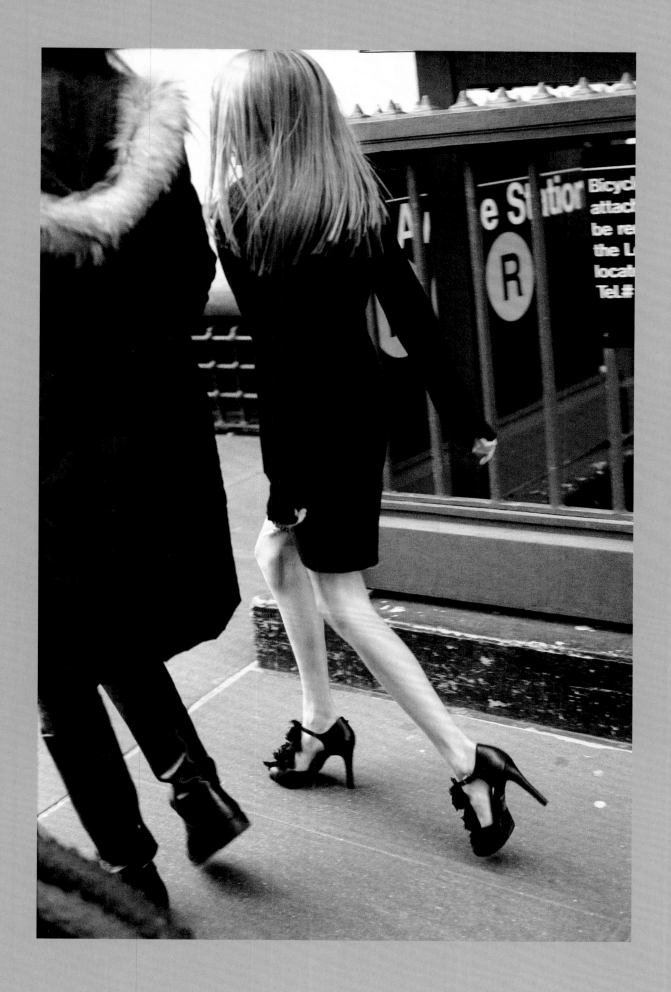

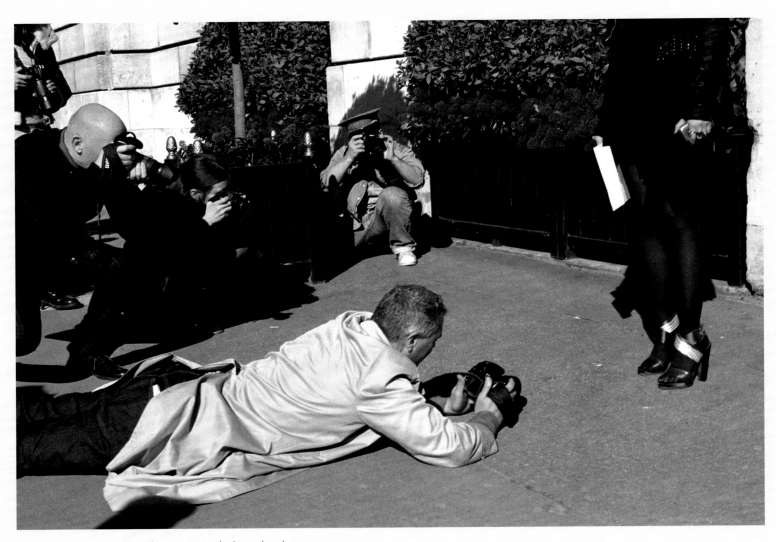

Photographers going to lengths to capture the latest bondage footwear at the Paris shows, including lattice boots worn by Carine Roitfeld *(opposite, top right)*.

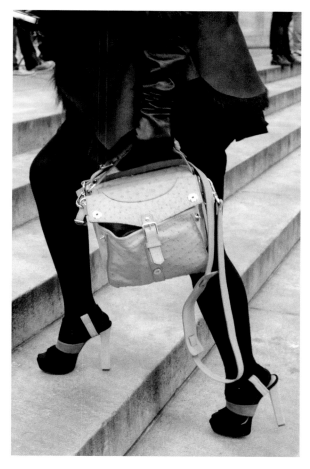

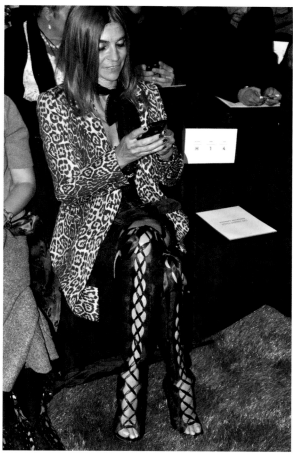

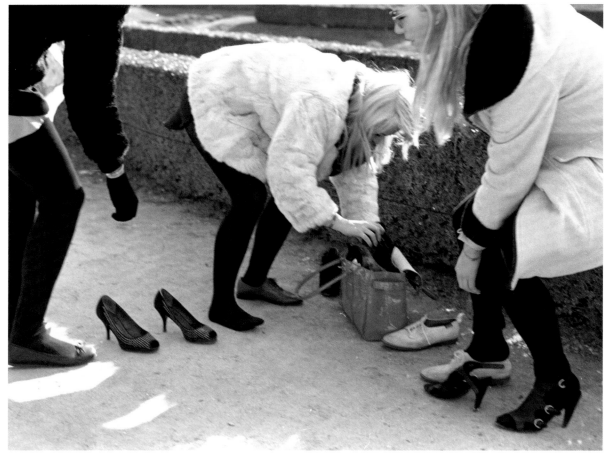

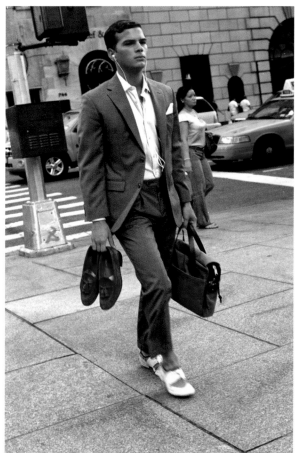

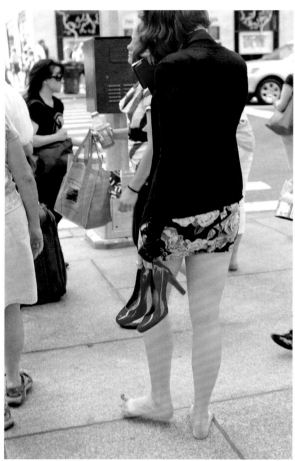

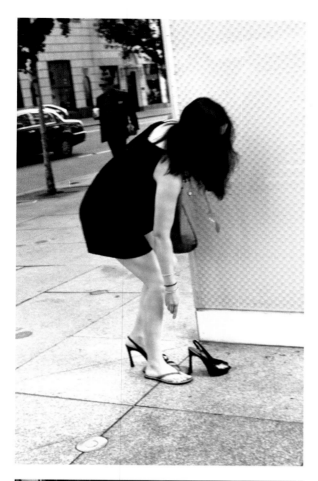

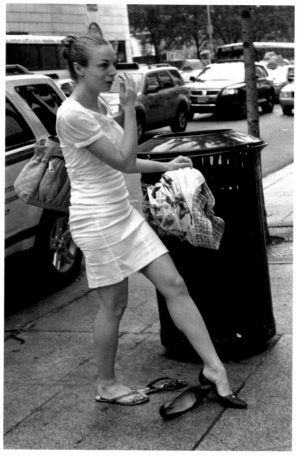

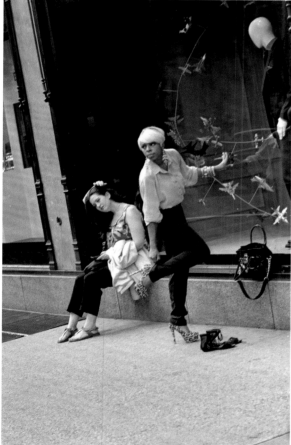

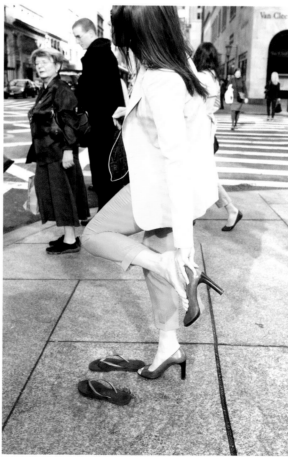

Bill captured the first wave of women to commute to work in sneakers in the '80s, like Melanie Griffith in *Working Girl*. Now the switch to more comfortable footwear, like flip-flops, takes place spontaneously on the street—or wherever.

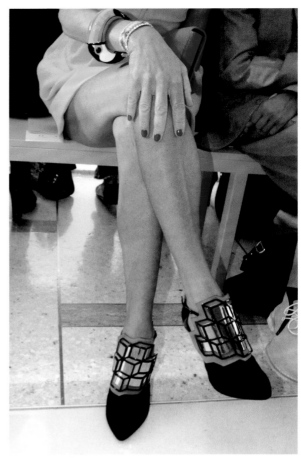

A season or two of challenging shoes with coral-like molded heels, metal spikes, and sometimes no heels at all.

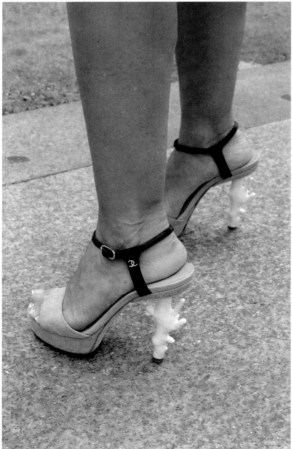

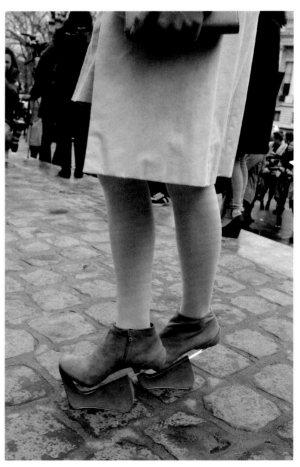

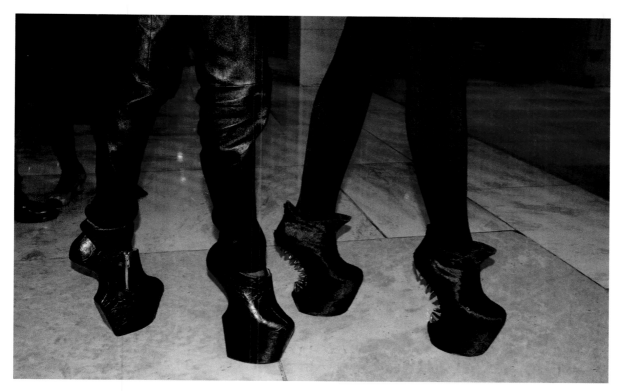

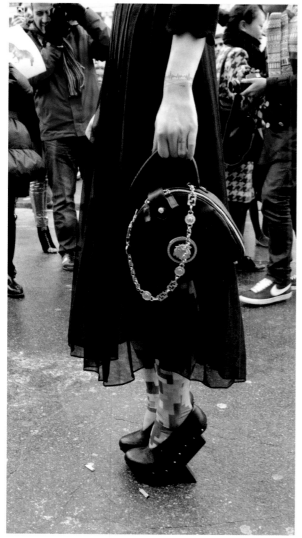

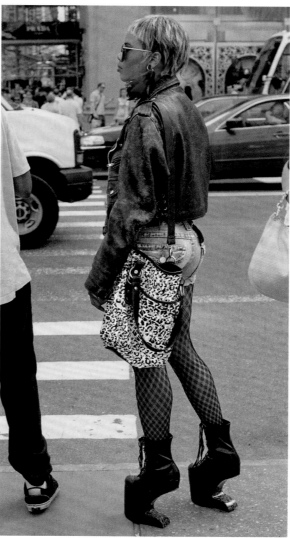

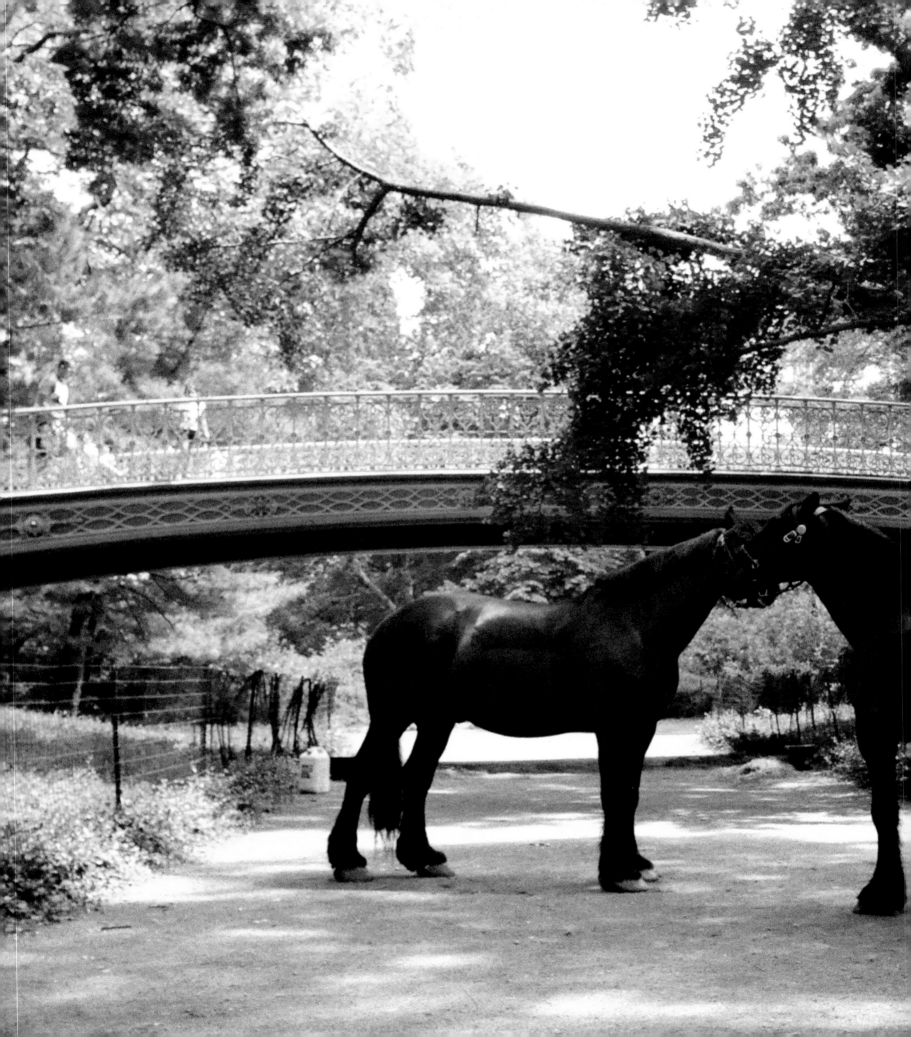

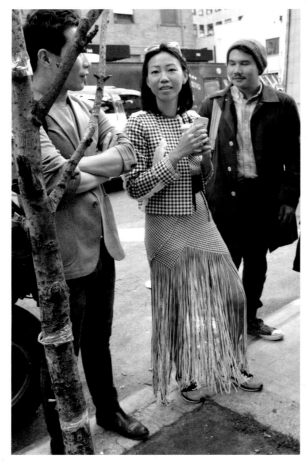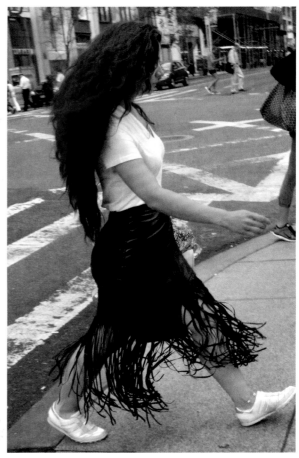

Bill's eye invariably picked out connections between details, like deeply fringed clothing and the texture of a frozen fountain.

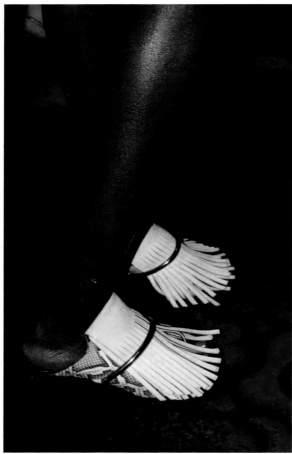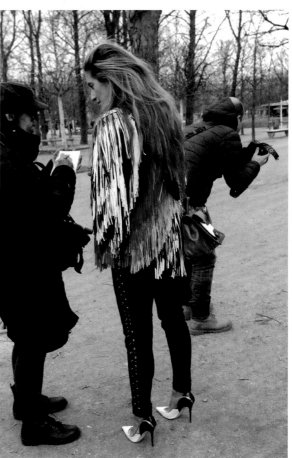

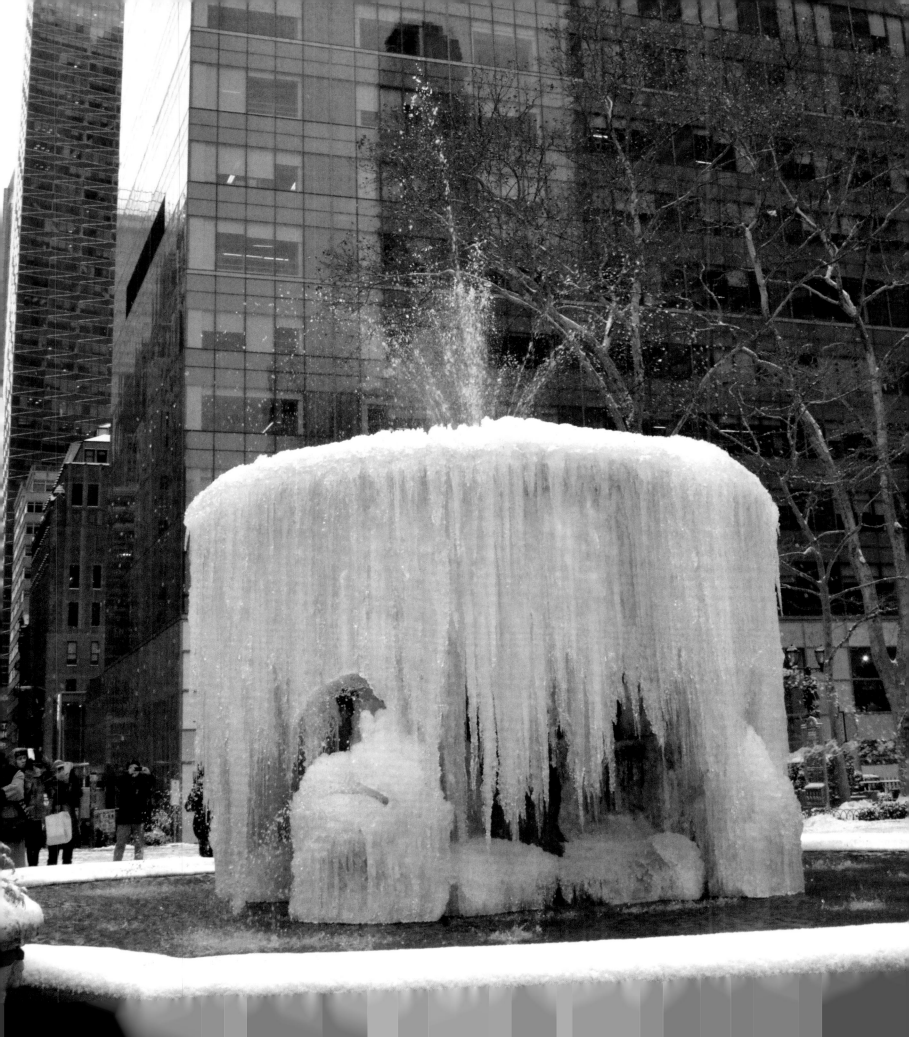

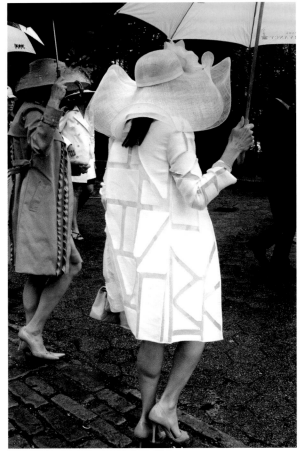

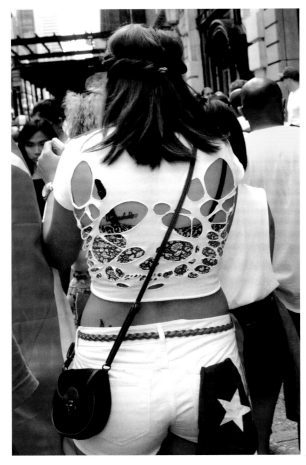

Bill noted that "white coats are perhaps the greatest luxury of fashion because of their need for constant cleaning." While white coats were seen in seemingly hard-to-clean designs, the color was a year-round staple, in similarly hard-to-clean but creative examples.

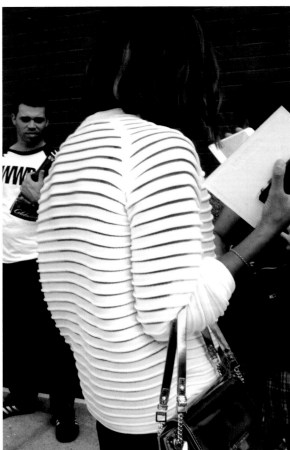

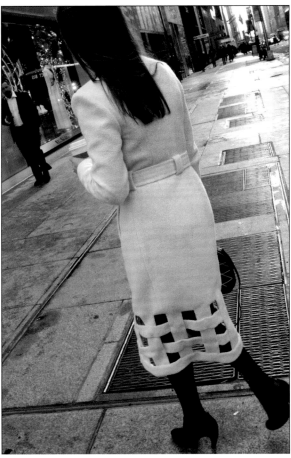

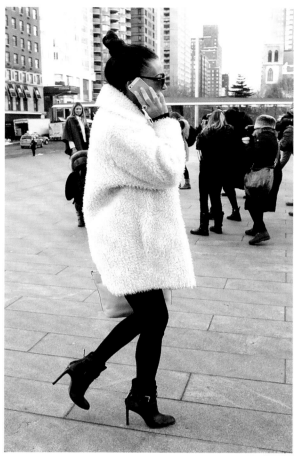

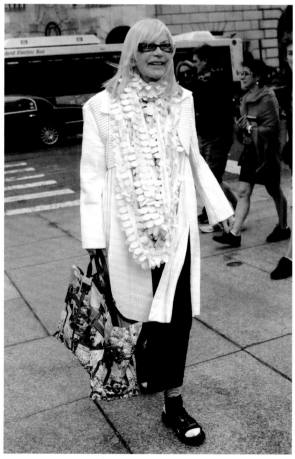

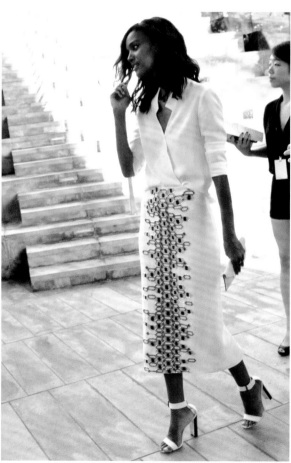

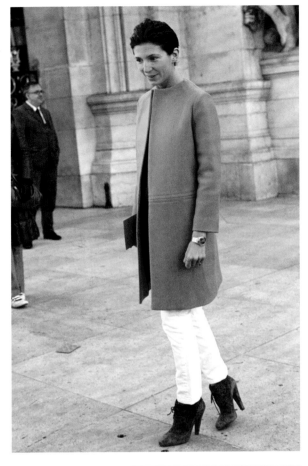

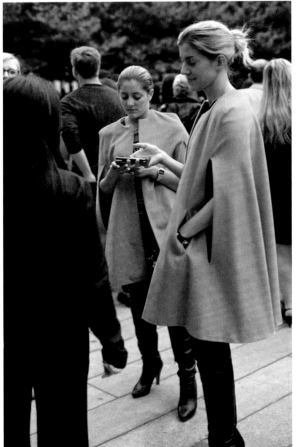

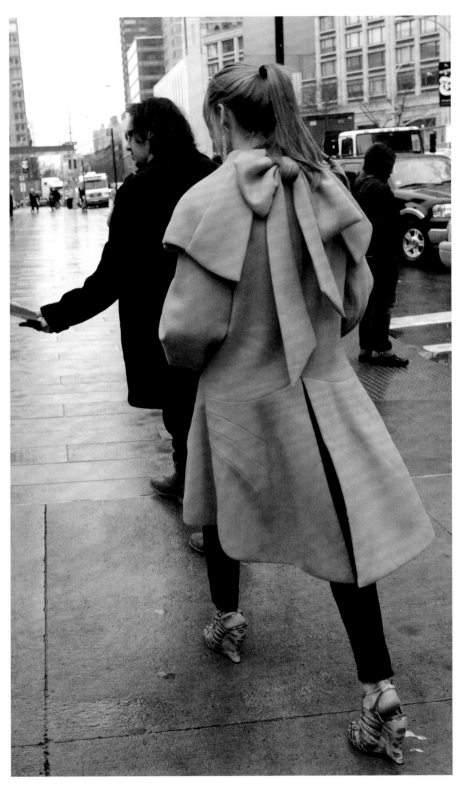

Bill once described camel-colored coats as a "tasteful, traditional style, giving a vote of confidence to the effortless American way of dressing that emphasizes comfort, function, and practicality." Designers always seize upon a classic and add what Bill liked to call "a dash of fashion" to the formula.

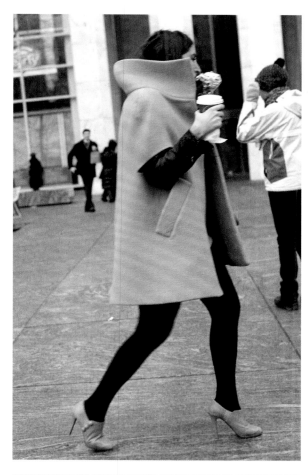

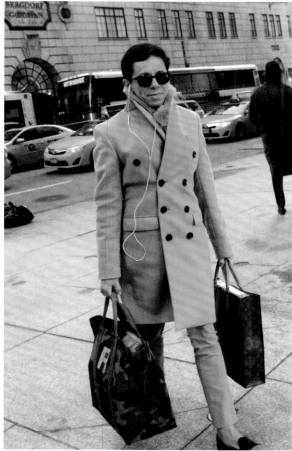

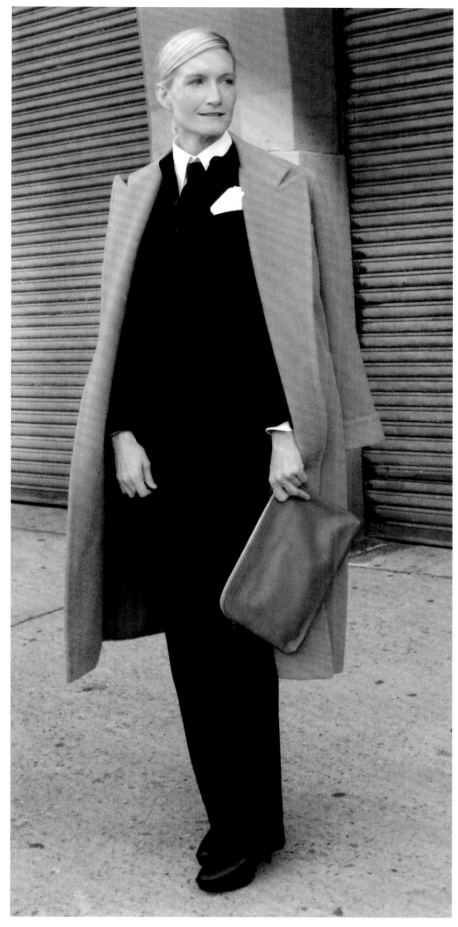

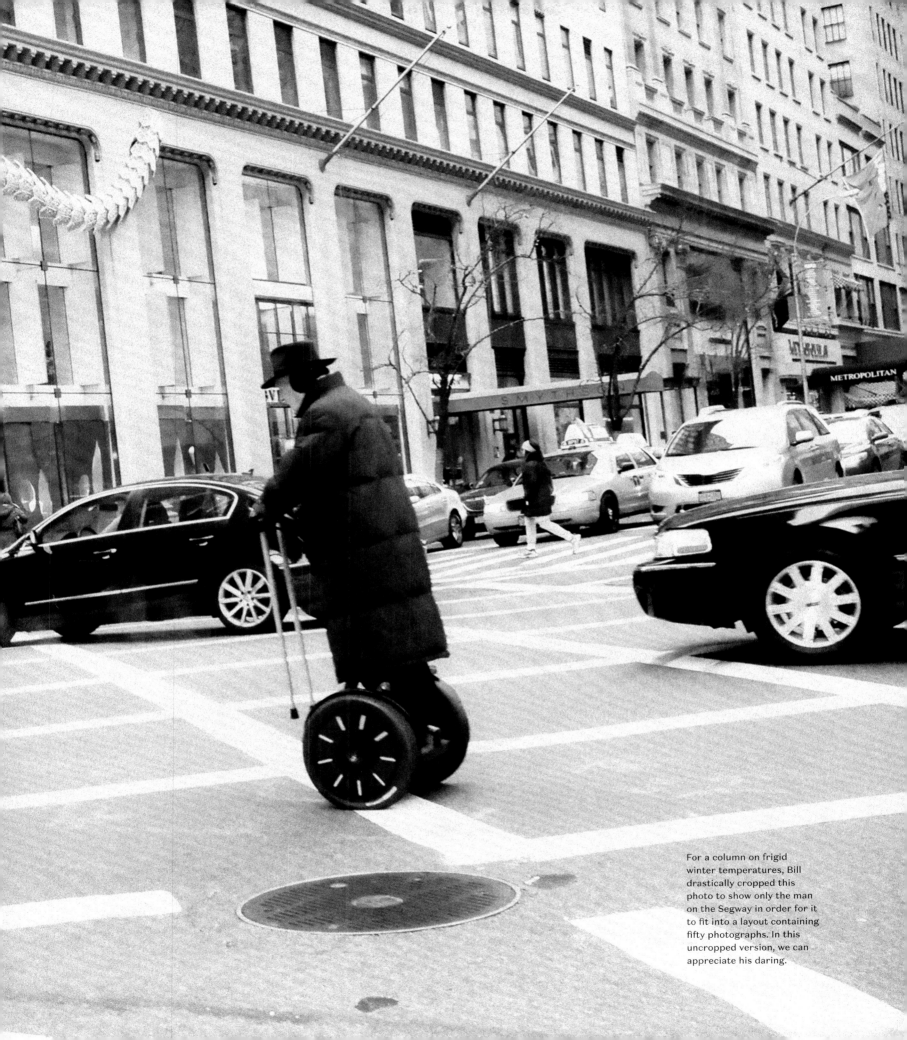

For a column on frigid winter temperatures, Bill drastically cropped this photo to show only the man on the Segway in order for it to fit into a layout containing fifty photographs. In this uncropped version, we can appreciate his daring.

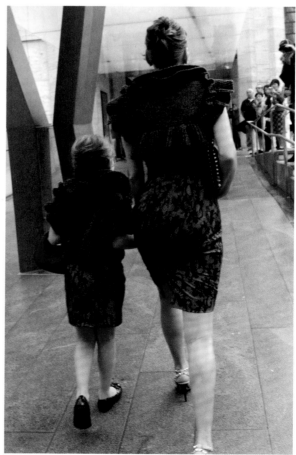

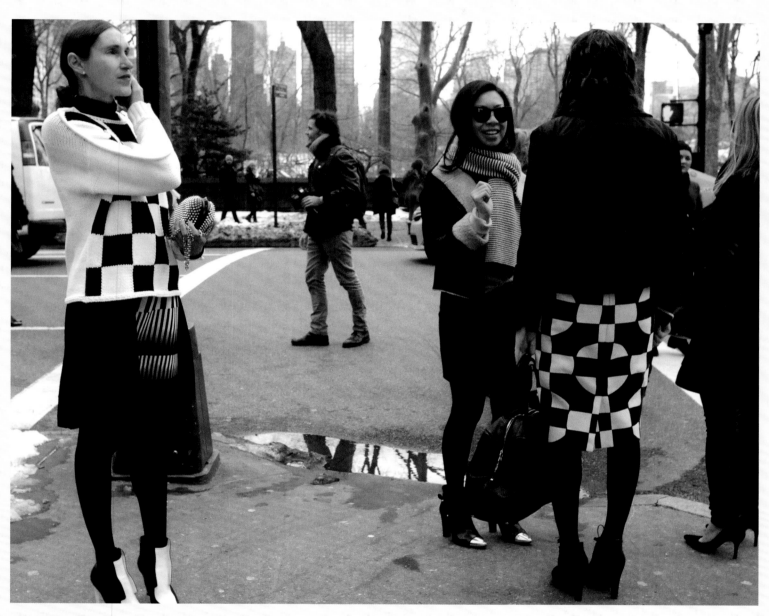

Since the 1970s, Bill had photographed couples who dressed alike. Here, the twins are both intentional and accidental.

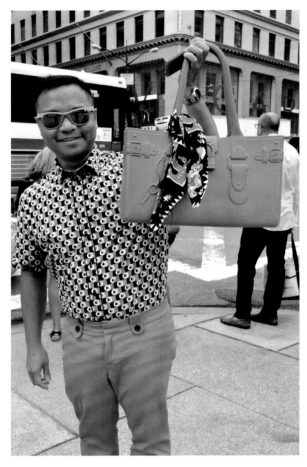

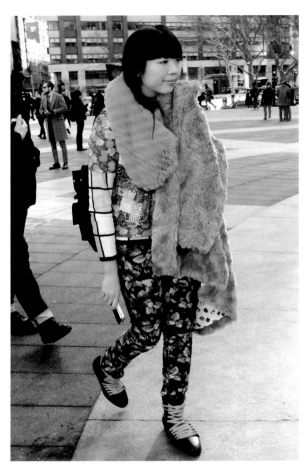

In a decade awash with color, the story here is not a single pop of orange, blue, or green, but instead the combination of all those shades.

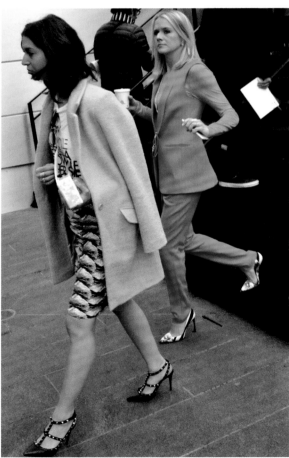

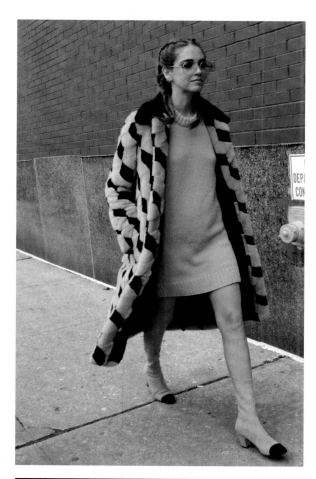

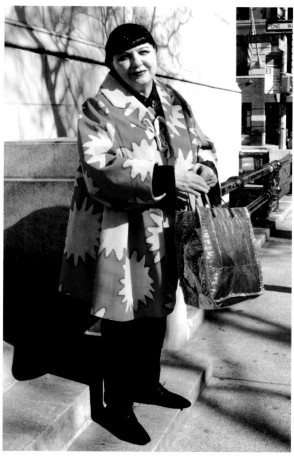

Bill could pick out a group of young women on Fifth Avenue in their citrus-hued summer dresses, and then capture a newer expression of individuality with unusual hair color.

Bill's subjects were as diverse as New York, and they were usually fans of his, eager to pose. Here, in a photo of women attending a popular luncheon benefit at Lincoln Center, he managed to touch on the themes of color and the uniform appeal of the shift dress.

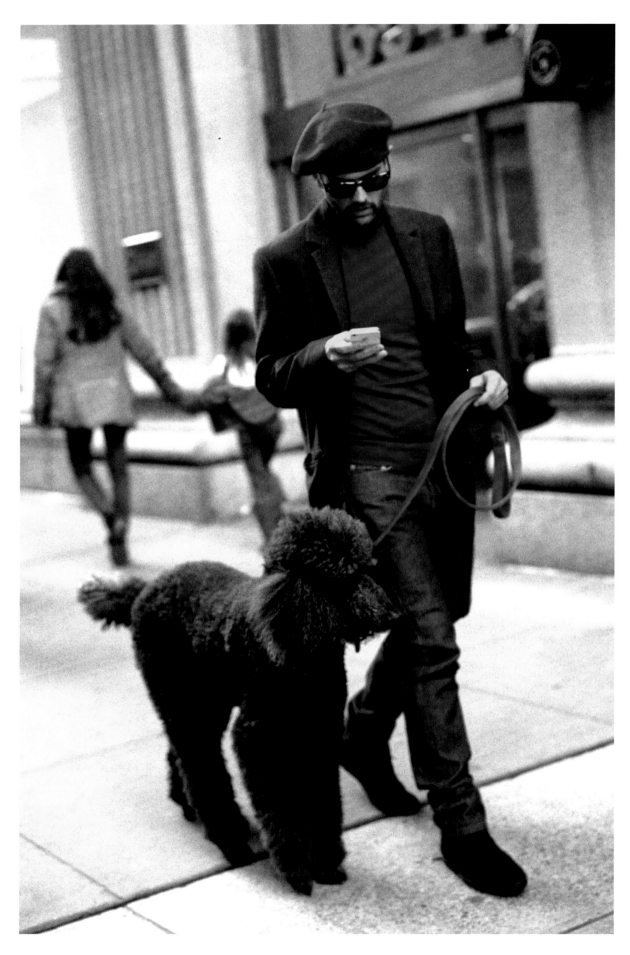

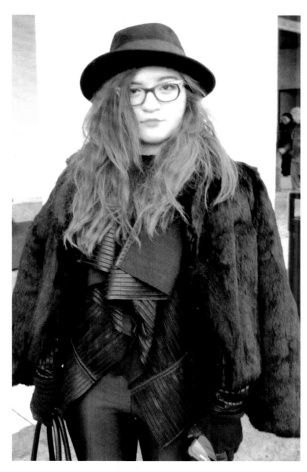

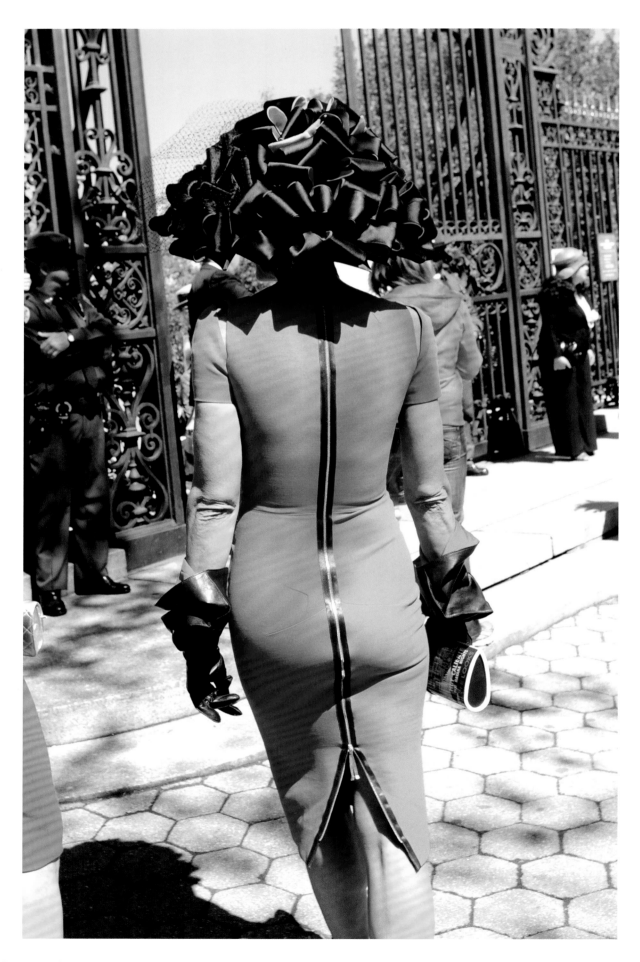

Guests at the annual Jazz Age Lawn Party, on Governors Island. *Opposite:* An attendee makes her way to the Central Park Conservancy luncheon.

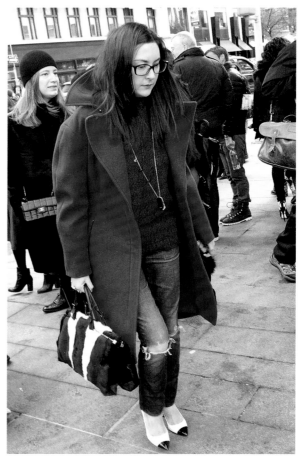

It's not Air France blue and it's not Yves Klein blue; it was something new and ubiquitous on the streets, and Bill caught it. Coincidentally, this particular shade was also his signature—Bill blue.

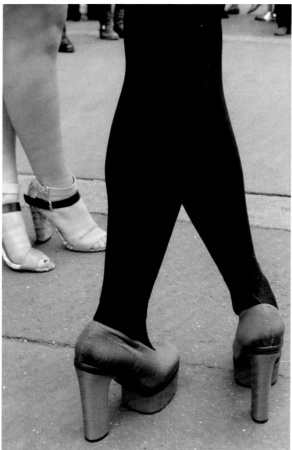

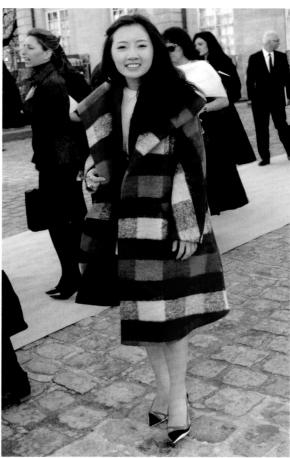

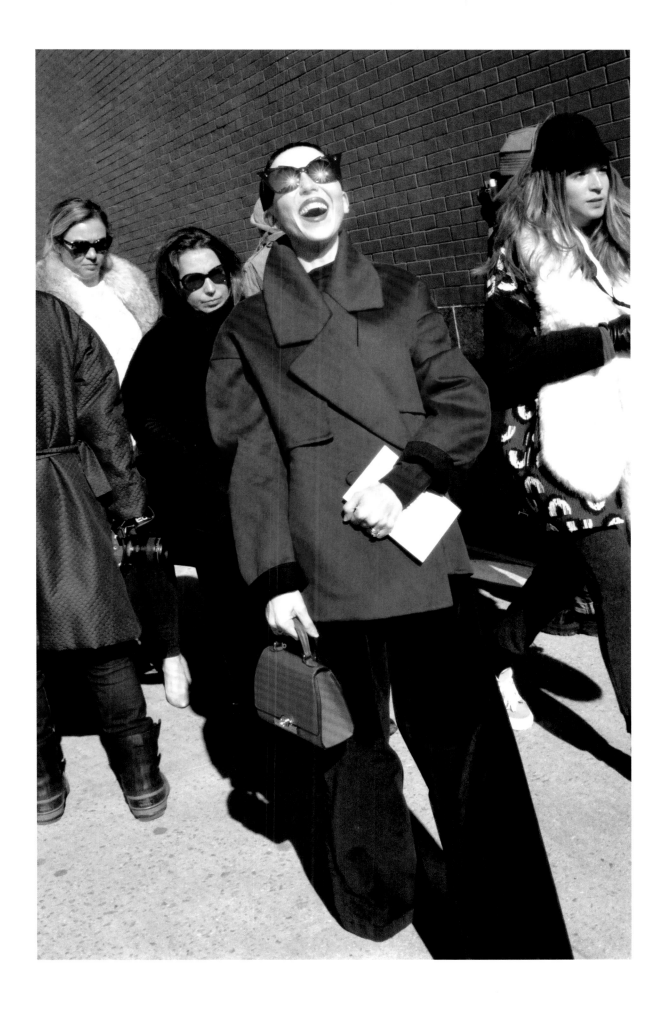

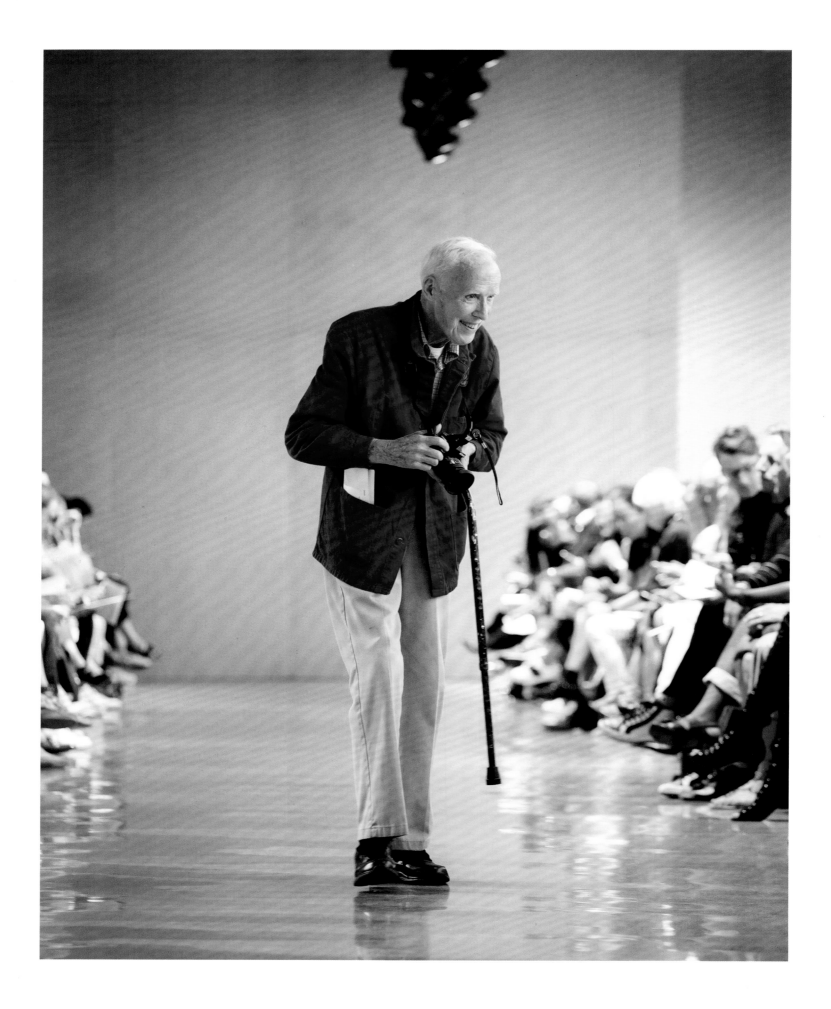

ACKNOWLEDGMENTS

In the world of fashion photography, Bill Cunningham was a singular figure. Assembling and publishing this collection of his work, however, involved a virtual army of players, to whom Tiina Loite and I are deeply indebted.

High on the list is the Clarkson Potter team of Gabrielle Van Tassel, Stephanie Huntwork, Patricia Shaw, Philip Leung, Jana Branson, Kate Tyler, Windy Dorresteyn, Andrea Portanova, and last but certainly not least Jen Wang, whose alluring designs grace this book. All of them worked under the keen eye and direction of editor Amanda Englander.

Trish Simonson, Bill's niece and the manager and overseer of his archive, was generous and patient in our attempts to seek out just the right photos. And at various times, Cecilia Bohan, Fred R. Conrad, Claire Evans, Anne Mancuso, and Nancy Ward formed search parties to locate them.

In addition to her superb introduction, Cathy Horyn offered wisdom and assistance on numerous matters, large and small.

At *The New York Times,* former legal counsel Richard Samson was key in getting this book under way. John Kurdewan, Bill's right-hand man; *Times* archivist Jeffrey Roth, and William P. O'Donnell and James Nieves in the photo lab provided valuable help. Michele McNally, the paper's retired editor of photography, was a constant supporter.

Our gratitude also goes to the literary agents Amanda Urban, who represented *The Times,* and Bill Clegg, representing the Cunningham estate.

ALEX WARD
Editorial Director of Book Development,
The New York Times

INDEX

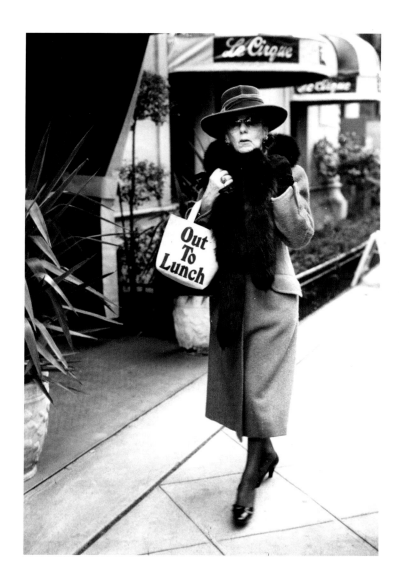

The New York Times is a daily newspaper published in New York City and distributed internationally. Founded in 1851, The Times has won 127 Pulitzer Prizes, far more than any other news outlet.

Additional photos were taken by:
D. Gorton, page 2
Fred R. Conrad/The New York Times, page 4
Anthony Mack, pages 8 *(top),* and 14–15
Lisette Price, page 8 *(bottom)*

Jean-luce Huré, page 10
Tony Cenicola/The New York Times, page 12
Valerio Mezzanotti, page 376
Chang W. Lee/The New York Times, pages 382–383

Published in the United States by Clarkson Potter/ Publishers, an imprint of Random House, a division of Penguin Random House LLC, New York. clarksonpotter.com

CLARKSON POTTER is a trademark and POTTER with colophon is a registered trademark of Penguin Random House LLC.

Library of Congress Cataloging-in-Publication Data
Names: Cunningham, Bill, 1929-2016. | Loite, Tiina, editor.
Title: Bill Cunningham: on the street : five decades of iconic photography.
Other titles: On the street
Description: First edition. | New York : Clarkson Potter, 2019. | Organized by Tiina Loite.
Identifiers: LCCN 2018061294| ISBN 9781524763503 (hardback) | ISBN 9781524763534 (ebook)
Subjects: LCSH: Fashion photography. | Street photography. | Fashion—New York (State)—New York. | Cunningham, Bill, 1929-2016. | Fashion editors—United States—Biography. | Photojournalists—United States—Biography. | BISAC: PHOTOGRAPHY / Subjects & Themes / Fashion. | ART / Subjects & Themes / Portraits.

Classification: LCC TR679 .C86 2019 | DDC 779/.4— dc23 LC record available at https://lccn.loc.gov/2018061294

ISBN 978-1-5247-6350-3

Printed in China

Book design by Jen Wang
Cover design and illustration by Jen Wang

10 9 8 7 6 5 4 3 2 1

First Edition